CAPITAL
CULTURE

OUS RICH AND FAMO

OUS RICH AND FAMO

OUS RICH AND FAMO

OUS RICH AND FAMO

OUS RICH AND FAMO

OUS RICH AND FAMO

OUS RICH AND FAMO

OUS RICH AND FAMO

OUS RICH AND FAMO

OUS RICH AND FAMO

OUS RICH AND FAMO

OUS RICH AND FAMO

OUS RICH AND FAMO

OUS RICH AND FAMO

OUS RICH AND FAMO

RICH AND FAMOUS RI
RICH AND FAMOUS RI
RICH AND FAMOUS RI
RICH AND FAMOUS RI
RICH AND FAMOUS RI
RICH AND FAMOUS RI
RICH AND FAMOUS RI
RICH AND FAMOUS RI
RICH AND FAMOUS RI
RICH AND FAMOUS RI
RICH AND FAMOUS RI
RICH AND FAMOUS RI
RICH AND FAMOUS RI
RICH AND FAMOUS RI
RICH AND FAMOUS RI
RICH AND FAMOUS RI

Previous pages:
YVONNE SINGER
Rich and Famous Wallpaper

CAPITAL CULTURE

A Reader on Modernist Legacies,
State Institutions, and the Value(s) of Art

EDITED BY

JODY BERLAND AND SHELLEY HORNSTEIN

McGill-Queen's University Press
Montreal & Kingston · London · Ithaca

Legal deposit second quarter 2000
Bibliothèque nationale du Québec

Printed in Canada on acid-free paper

This book has been published with the help of a grant from Atkinson College, York University.

McGill-Queen's University Press acknowledges the financial support of the Government of Canada through the Book Publishing Industry Development Program (BPIDP) for its publishing activities. We also acknowledge the support of the Canada Council for the Arts for our publishing program.

Canadian Cataloguing in Publication Data

Main entry under title:

Capital culture: a reader on modernist legacies, state institutions, and the value(s) of art

Includes bibliographical references and index.
ISBN 0-7735-1725-1 (bnd)

1. Art – Economic aspects – Canada. 2. Art and state – Canada.
3. Art – Canada. I. Berland, Judy II. Hornstein, Shelly

N70.C36 2000 709'.71 C99-901597-4

DIE CUT

DIE CUT

Contents

Illustrations

Acknowledgments

The authors extend grateful thanks to the Office of the Dean, Atkinson College; Associate Vice-President, Research, and the graduate program in Art History, all at York University; the Association of Canadian Studies, the Ontario Arts Council, Visual Arts Ontario, and the Consulate General of France, particularly Frédéric Limare; John Browne, principal of Innis College, University of Toronto; Daniel Drache, director of the Roberts Centre, York University; Gary Wihl, Department of English, McGill University; and the Harold Innis Foundation and Research Institute for their support of the original workshop from which this collection has grown. We are indebted to Svatka Hermanek, Diane Stanicki, Hazel O'Loughlin-Vidal, and Diane Habel for their generous administrative and technical assistance.

We would like to warmly acknowledge the participation of a dedicated group of scholars in the 1994 Art and Money Workshop held at York University. In addition to the authors in this volume they include Louise Dompierre, Glenn Lowry, Brian Fawcett, Kass Banning, Will Straw, Myriam Merette, Richard Fung, Kirsten McAllister, Leslie Sanders, Andy Patton, Dianne Chisholm, Dot Tuer, Derrick de Kerckhove, Larry Richards, and Ruth Cawker. This volume benefited from the editorial assistance of Jeremy Stolow and Theresa Kiefer, and especially from the work of Eleanor Mihalcin, without whom this volume would still be floating in the hazy zone of incompleted works. She was key to the success of this enterprise.

The book was made stronger from editorial comments from several anonymous reviewers, and from Mark Cheetham, Kevin Dowler, Zoë Druick, Ned Rossiter, Cheryl Sourkes, and Gary Wihl, and above all, our editor, Aurèle Parisien, whose commitment to this project was always felt. Thanks also to Joan McGilvray and Maureen Garvie at McGill-Queen's University Press.

Jody Berland extends personal thanks to Tony Bennett and the Key Centre for Cultural and Media Policy, Griffith University, Brisbane; to Terry Smith

and the Power Institute Library of Fine Arts, University of Sydney, for their inspiration and generosity with this research; to *Culture and Policy*, and to her family and friends.

Shelley Hornstein wishes to thank Anne Maddocks, Delwyn Higgins, E.J. Lightman, and the Workscene Gallery board members. For her, this project is marked with the arrival of Elias. This book is dedicated to Lara, Ariel, and Sam, for completing the picture.

Where Was I/See the Sights

John Marriott

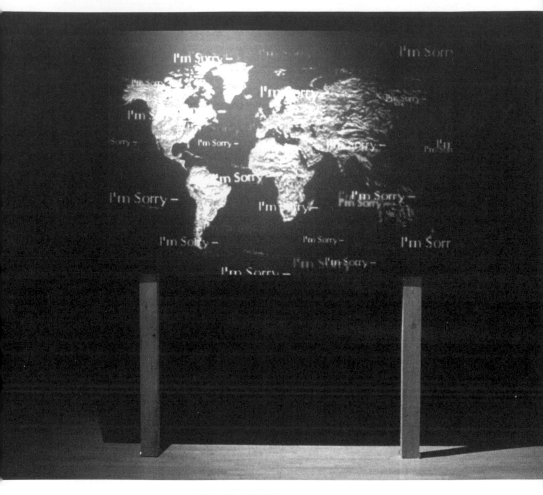

Where Was I? 1995
Electrostatic print mounted on gatorboard
Photo: David Otterson

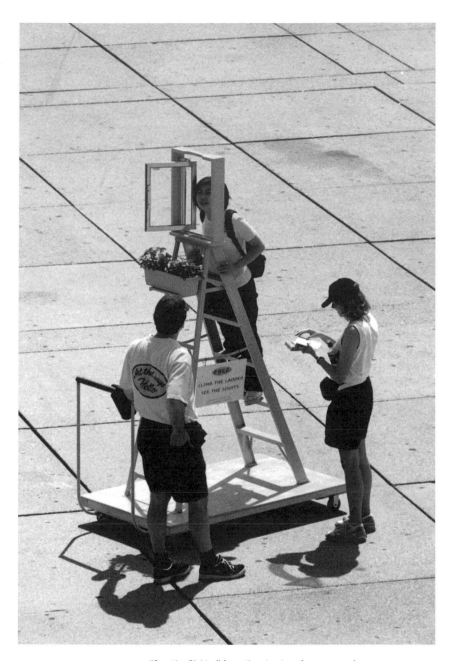

"See the Sights," from the street-performance series
Art That Says Hello, 1997
Street performance with portable observation tower
Photo: David Otterson

Introduction

Shelley Hornstein
and Jody Berland

Some genealogies

As culture becomes increasingly vulnerable to policy, fiscal, technological, and institutional changes in Canadian society, the task of understanding these changing social contexts becomes increasingly foregrounded for scholars and critics who think about "culture." We can no longer assume we draw on the same meanings, assumptions, or values when we use this word. Many communities in many countries are finding that what they have traditionally defined as cultural value is shifting, often so rapidly that public participation, democratic negotiation, and cultural egalitarianism are all in different ways endangered rather than enriched by the changes. Those who seek to define coherent and stable cultural values or policies across an ostensibly homogeneous community find they can no longer succeed in satisfying or, just as often, even legitimating their search for consensus. The new challenges are complex. In an age when globalization and its attendant effects are on everyone's lips, what does it mean to talk about a local or a national culture? What institutional practices has such talk helped bring into effect? Do we want to lose these institutions, these policies, or just the particular values that invented them? What are the responses and implications of the modernist project as it bumps up against the chorus of voices now resisting established cultural institutions, policies, and values? What is the "value" of art practice in this changed context? How is such value established, and by whom?

Such questions are central to current research in the material history of culture which speaks to the particularities of colonial histories and cultures, and has contributed thereby to informing important models for theoretical inquiry. The investigations of contemporary cultural theory are informed as much by conceptual transformation as by continuity with these histories. The modernist approach to culture informing the nation-building project has arguably been displaced if not demolished in almost every respect. Whether we think in terms of cultural theory and analysis, the relationship between

nationalism and aesthetic ideologies, cultural and economic frameworks for government policy, the relationship between national cultures and the globalization of cultural marketplaces, or, more broadly, the perceived relationship between culture, space and economics as a whole, all these have been radically altered over the past ten or fifteen years. This book emerges then from a constellation of changes that are forcing scholars, artists, critics, policy-makers, and art administrators to reconsider their assumptions about culture, nationhood, aesthetics, and government policy. Such rethinking is both the subject and the purpose of this anthology.

This collection was inspired by the need to wrestle with these issues. It arises from a workshop titled Art and Money, held in 1994 at York University, part of the Innis Centenary celebrations commemorating the work of the influential Canadian economic historian and communication theorist Harold Innis. Perhaps it is no accident that the genealogical narrative for critical Canadian scholarship in politics, economics, and communications traces its origins to the same historical moment to which historians of Canadian culture commonly trace the origin of Canadian cultural policy. Innis's research in the material history of culture speaks to these Canadian particularities and has contributed thereby to forming a specifically Canadian model for theoretical inquiry while at the same time informing international theory.

The purpose of the Art and Money workshop was to assemble academics, freelance writers, curators, architects, critics, and artists to exchange ideas and perspectives on policy issues related to the economics of art in the context of globalization and the spreading influence of the practices and ideologies of market culture. Through their participation, the process evolved from the initial Innisian springboard. The essays and artworks in this volume explore the legacies of modernism in relation to new controversies surrounding national identity, political economy, and cultural policy as these pertain to the production of art.

It is important to add that the disciplines that traditionally give rise to thinkers to represent and develop these ideas have themselves been subject to change: some to moderate reshaping, others to complete transmutation or even demolition.[1] Such disciplinary transmutation has helped to nourish new methods and assumptions in both scholarship and art. The richness of this process is revealed by the range of scholars and artists (and of the critical perspectives embedded in their images and ideas) participating in this project. The contributors to this book speak to themes and issues that emerged during Innis's lifetime and continue, however changed, to plague and perplex us in our own. The 1990s, like the 1950s, have been a period of great transformation in the cultural, aesthetic, and policy frameworks that seek to define nationhood in new colonial cultures like Canada. Like so many other groups, Canadians are re-evaluating their own social, political, and cultural milieu. Many defining characteristics of this milieu originate after World War II, when Canada's culture was said to be "coming into its own." New cultural policy and important cultural institutions were intro-

duced to guide and administer that process, while new media technologies were helping to create a continental cultural marketplace. Many of the contributors speak of specific Canadian examples in their discussions of cultural policy and the social mediations of art. But the issues raised in these discussions spin beyond this geographic location. In a sense, the more they emphasize the particular contradictions and complexities of Canadian culture, the more they shed light on the growing interpenetration of locality and globality. Today it is not possible to speak of the local without reference to the global, and the process of globalization itself is neither significant nor intelligible without reference to local experiences and effects. In other words, space does not manifest itself in bits, nor is it independent of other times and spaces. *think global / act local*

Some art politics

In tandem with the workshop organized for the Harold Innis Centenary Celebration, seventeen artists were invited to participate in an exhibition exploring the theme of art and money in honour of Innis's work on culture and communications in the global economy. The purpose of the exhibition was both to highlight Innis's ideas about the linking of cultural communities to global market economies and to explore the ways artists find themselves bonded to such changing economies. The artists were more particularly invited to respond to questions about value and money within our culture. The exhibition's objective was to reach out to a broad population, to popularize the material and ideas exhibited, and to bring art to one of the headquarters where commodity transactions effect capital gain. *Commodity TRANSACTIONS.*

linking cultural communities to global market economies + how artists are bound by these changing economies

The venue selected was BCE Place in downtown Toronto,[2] in the heart of the banking and exchange district of the city. Two smaller portions of the exhibition were to be held at the downtown artist-run gallery Workscene and at Innis College, University of Toronto, in order to reach the art community, university students, faculty, and staff. The path of this exhibition came to an abrupt end, however; because of insufficient funding, it never took place. This is an excellent opportunity to honour all of the artists who were part of the initial exhibition project. They are Kim Adams, Michael Buckland, Carol Conde, Karl Beveridge, Vera Frenkel, Will Gorlitz, Janice Gurney, John Marriott, Tanya Mars, Luke Murphy, Andy Patton, Yvonne Singer, Becky Singleton, Cheryl Sourkes, John Veneema, and Ronald Wakkary. The late David Buchan was also part of the project before his untimely death.

A smaller one-day exhibition and symposium, curated by Shelley Hornstein, was held 1 June 1995 at Innis College. Entitled "Rates of Exchange: The Changing Value(s) of Art," the event included participation by Jody Berland, Carole Conde and Karl Beveridge, Janice Gurney, and Yvonne Singer. *Rates of Exchange the changing value of art*

The visual component of this book evolved from the exhibition project but moved beyond it. We have conceived this book to be a dialogue between verbal and visual expressions. The artworks in this volume were commissioned

2 exhibition park / business district / art community

Is art monetised thru' our powerful cultural media

specifically for this publication and serve to introduce and elaborate the sections and themes of the anthology. They are no more "illustrative" to the written works than are the written works to them. The artists were invited to comment on the relationship of art and money and any ramifications of this theme. Is art monetized through our powerful cultural media? Or is its message gift-wrapped as a seductive vision of market-driven individualism? Can a monetized culture be participatory and democratic?

The answers require an examination of the cultural dimension of the global trading system. Money links communities to market economies. The production of culture has always been subject to exchange but is becoming even more apparent in an increasingly global society of supply, demand, and accumulation. Artists are bound at all times – however unwittingly – to a market economy. And yet the discussions about the relationship between money and cultural production are sensitive ones. The artworks in this volume challenge the impact of money on cultural production. The pieces are woven through the volume to encourage an exchange, an ongoing relay between image and text. The contributing artists are (in order of artworks): Ronald Wakkary, Yvonne Singer, John Marriott, Cheryl Sourkes, Michael Buckland, Janice Gurney, Vera Frenkel, John Veneema, Luke Murphy, Carol Conde, and Karl Beveridge.

Some frameworks

Our own chapters serve as thresholds for the volume into and beyond the limits of their own analytical spaces. Jody Berland returns to the formative postwar period of cultural thought and policy to look at the historical intersection of intellectual, institutional, and aesthetic forces which together constituted the foundations for Canadian modernism. The essay interprets ideas and artistic movements through a contemporary spin on Innis's ideas about communication, culture, and geo-political space. This context helps to elucidate the relationship between nationalism and modernism, and the unique entanglements between the two that came to define postwar Canadian cultural policy. Berland's re-reading of this history simultaneously contextualizes Innis in his own historical and political milieu and makes use of his ideas to analyse the complex transformations from his own time to the programmatically postnationalist present.

Shelley Hornstein underscores the complicated relationship between nationalism and the value of art. Nations serve as contexts established by evaluating art. But the idea of a nation as a cultural identity is challenged when the idea of physical space does not necessarily coincide with its organization. This chapter focuses on the role of modernist thought in shaping artistic and historical canons as a result of a need to build a sense of community, locality, nation, and national heritage. Hornstein demonstrates the importance of disturbing the security of determined national symbols, narratives, set forms of valuation, and above all, the tranquillity of tradition.

The first section, "Aesthetics and Politics in the Age of Global Markets," considers concepts of universal value that have in the past been seen as eternal, true, and necessary parts of the aesthetic tradition. Indeed, the notion of values transcending particular times and places was once considered fundamental to the aesthetic experience. Perhaps belatedly, art critics, philosophers, and administrators are now recognizing that cultures (particularly those of the New World) have always been plural, but that this knowledge was deferred by the precincts of institutional authority and judgment. Today players in the arts (artists, educators and students, critics, policy makers, and audiences) are bringing new challenges to the concept of aesthetic judgment as a singular and autonomous value.

In "Monopolies of Censorship: A Postmodern Footnote to Innis," John Fekete aims to illuminate "the disintegration of the modernist defensive shield around artistic and educational freedoms" and to explore how contemporary artists and activists have contributed to the "de-institutionalization of modernism." In his compelling discussion Fekete notes the increasingly embattled terrain of cultural authority and institutional censorship, highlights controversies that surround the connection between artistic merit and political autonomy, and raises difficult questions about the protection of art and artists from state interference and control.

In his paper Thierry de Duve also takes to task the assumption that "aesthetic judgements [have] … a 'built in' claim to universal validity." We hold the right, he argues, to disagree about aesthetic value. Referring critically to Kant's concept of transcendental aesthetics, de Duve questions the ideal of a universal time/space or *sensus communis*, maintaining that aesthetic experience is dependent on, and bound to, culture. But, claims de Duve, although we may not think alike about the value of a work of art, we can still engage in dialogue and the search for a common language in considering the question of artistic value. In this context it is instructive to read Paul Mattick Jr's "The Old Age of Art and Money," which contextualizes the discussion by tracing historical antecedents for the troubled relationship between art and money. This project provides a historical context for considering de Duve's argument about aesthetics and ethics, which itself is predicated on his insistence that critics have misrepresented the notion of universal aesthetic values in modernism.

In the critical discourse circulating in journals, museums, classrooms, television, the Internet, and the scholarly and popular press, the artistic (and by extension, economic) value of artworks may be attributed to the talent of the artist and the perceived timeliness of the vision. This assumes that the artistic work appears in a cultural and aesthetic context which is itself stable (even in its necessary progress) and consensual. In the second section, "Marketing Culture and the Politics of Value," our contributors undo this seemingly obvious assumption. For it obscures an important realization that is relevant not only to our cultural analysis but to criticism itself: the knowledge that the creation of such value is a collective, institutionally mediated process. Like magic, it depends on a community of actors with shared beliefs and practices which

motivate a complex set of valuative-economic transactions and relations.[3] In the modern era this "magic" of aesthetic judgment is permeated with social intentions related to national identity, social prestige, romantic freedom, civic cohesion, and so forth. However much (or little) these values collide, all of them interact with the funding, pricing, and marketability of art. Between state-funded cultural practices and those in the private and commercial spheres, we find both similarity and difference in this respect. Authors in this section of the book explore these issues and address the question: How does a politics of value intersect with the interpretation and valuation of art?

Bruce Barber begins the section by challenging our traditional concept of work. In "Ideas without Work/Work without Ideas," Barber identifies a serious lacuna in modernist art criticism and analysis, which lack an engaged discussion of the place or *value* of work in cultural production and reproduction. Yet modernism has consistently sustained itself by establishing a clear split between high and low culture, elitist and folk or craft art, identifying the latter as a practice whose evaluation is based predominantly on a specific notion of work. In this context Barber entertains a detailed examination of the thoughts of American critic Harold Rosenberg, interrogating Rosenberg's late modernist ideas about the art object, or commodity, as the key index of value in the history of art.

When a national institution acts on behalf of the nation's "people," and invests heavily in art in the nation's name, it issues an open invitation to controversy and dissent. Nicole Dubreuil recounts in her "The Cost of the Sublime" the tribulations of the National Gallery following the 1989 purchase of Barnett Newman's *Voice of Fire*. The value of Newman's work may be unequivocally established in the transnational marketplace of contemporary art; indeed, Berland notes his (among others) considerable influence on the development of postwar Canadian painting. Still, many Canadians contested the value of Newman's painting to their National Gallery and objected to the sizable dent in its purchasing budget that made the acquisition possible. Dubreuil describes the dramatic split that arose between the professional artistic community and Canada's general population, the former emphasizing the work's importance and its contribution to the prestige of the National Gallery and the latter contesting its usefulness or relevance to their lives. Critics speaking for the "general public" also protested against what they perceived as social indifference in the administrators responsible for the purchase and in their various critical apologists. No doubt the increased impoverishment of Canada's middle class and working poor exacerbated this tension, for justifying large public expenditures on a single painting to the general population is a delicate matter at the best of times, and this context enhanced the difficulty. While the National Gallery and its supporters hinged their arguments on the necessity for professional judgment on the history and market value of the object, the disposition of the suddenly vocal "general public" was to consider such professional judgments irrelevant or even hostile to their own concerns as members of that same public. Dubreuil reports her experience as a panelist invited to dis-

cuss the acquisition. In her discussion she considers Newman's "special position and relevance within the development of modernist art" and the public outburst of incomprehension and resentment in response to the National Gallery's heavy investment of public funds to honour that special position. If there was a line of credibility being drawn here, it divided not only the general public from the experts but also the traditionalists and nationalists from the modernists within the academic and critical community.

In "Colville and Patton: Two Paradigms of Value," Mark Cheetham presents us with two evaluative case studies in contemporary Canadian art: one of an artist with a distinguished career who was embraced by a wide audience and has long since joined the Canadian art canon, Alex Colville; the other of Andy Patton, a younger artist accruing considerable national regard, whose work defies traditional standards of evaluation. Cheetham carefully plots these two artists' "entrepreneurial interactions with their ideal publics." He suggests that their ideologies, at once similar and different, are shaped by the knowledge that their different publics recognize the exchange value of the work and that this in turn configures the kinds of work they make.

"Whiffs of Balsam, Pine, and Spruce: Art Museums and the Production of a 'Canadian' Aesthetic" is Anne Whitelaw's analysis of the collective manufacture of a "Canadian" aesthetic tradition. The nationalist narrative is produced by the Group of Seven with the collaboration of scores of curators, directors, and art community members hoping to foster a new aesthetic patrimony and thus a national identity. What the art world accomplished during the 1920s and its critical aftermath was to invent a Canadian canon. This was not only an exercise in linear national construction, she argues, with the express purpose of collecting and exhibiting Canadian works with Canadian content (mainly landscape painting); it was also an exercise in value building, the creation of an artistic canon to firmly root Canadian-ness in Canadian soil. This required the creation of visible difference from British and French antecedents, and the appearance of a consensus around what curators, academics, and other specialists could accept as a uniquely Canadian aesthetic tradition.

Section 3, "Culture and the State," is devoted to a discussion of cultural policy and funding in Canada. Artists have demanded government financial support since the 1940s and have been eligible for state funding since the Canada Council (the national funding agency for art) was founded in 1957. Today public support comes in many guises, not only federal grants to individual artists and institutions but also exhibition budgets, public commissions, grants from provinces and cities, subsidy programs supporting various aspects of the development of dance, visual art, theatre, music, film, television and curatorial work, publishing and sound recording, tariffs and export policies, and various programs designed to address specific issues such as multiculturalism. Cultural producers have therefore developed relations of complex and contentious reciprocity with the various levels of government. If the Canadian Parliament approved public subsidy for the arts with the purpose of defending cultural difference (Canada/United States, Quebec/Canada), such

difference is now undoubtedly different from what its architects intended or imagined. With politicians bent on diminishing government support for culture, and with the growth of markets, institutions, and communities oblivious to national borders, many of us are immersed in the process of rethinking our approach to government support and intervention.

Michael Dorland offers a valuable perspective on the history of the state in Canadian culture. Citing perspicacious commentary by Harold Innis on the nature of Canadian cultural development, in "Policying Culture" Dorland describes the metapolitical implications for state intervention in cultural production. Arguing that culture is subsumed within modern modes of governmentality, Dorland concludes that the policy state "does not facilitate but, on the contrary, blocks the emergence of civil society." This problem is both highlighted and exacerbated with the growth of the market economy. In his discussion Dorland notes the deplorable lack of archival research that would have helped him to develop his thoughtful historical analysis of culture and government in Canada.

Johanne Lamoureux's "Le trésor de la langue: Visual Arts and State Policy in Quebec" offers a close scrutiny of cultural policy documents in Quebec. Lamoureux argues that the state's definition of culture is narrowly construed yet ultimately determines the "master key to a narrative of identity." Her article explores what she sees as an alternate narrative emerging in the visual arts in Quebec, which challenges the state's construction of an exclusionary model of Quebec culture. As she illustrates in her discussion, artists face particularly complex dilemmas in Quebec, for their medium is not primarily language-based, yet they must negotiate with the language-focused principles of state funding and the implicit hegemony of language as visual fact.

With the rise of the postwar "information society," information has become a primary commodity in global trade. Numerous technical innovations have helped to accomplish this transformation: computers, telecommunications, satellite communications, biotechnologies, data processing, and imaging of all kinds. For Innis, writing in the early postwar period, the material infrastructure of modern communications provided the necessary foundation for the political organization of power in the shape of empires and colonies, centres and margins. To what extent do these new technologies corroborate his vision? Can contemporary technologies contribute to the empowerment of marginal worlds or to the transcendence of national, ethnic, gendered, or other inequities? How have such technologies transformed the shapes and spaces of culture itself?

The final section, "Technology, Globalization and Cultural Identity," brings the analysis of technology and cultural identity to the fore. These issues are at the core of Innis's thoughts on communication. Innis reminds us to think of technology historically. His research traces the emergence and impact of the written word and, subsequently, of the mass press, which, he suggests, enables writing itself to serve as a new marker of national progress. Newer technologies both intensify and reverse print-based strategies for creating social cohesion. As

they achieve the ever-faster conquest of social space, nationalities and nation-states are pressed into tighter and more intricate social, political, and economic relations with each other. Their internal unities appear to be less and less convincing, more and more subject to challenge.

Brenda Longfellow, in "The Crisis of Naming in Canadian Film Studies," poses such a challenge. She argues that the founders of Canadian cinema studies developed their critical strategies on the premise that a coherent national identity precedes and explains the representation of Canada in Canadian film. Since much early criticism in literature, music, and the visual arts begins with the assumption that Canada's cultural identity is absent or incomplete (thus the need for public support for the arts), this raises an interesting question: how much have critical strategies and cultural suppositions varied between the arts? The premise of a coherent national identity then operates on two false assumptions: first, that a colonial culture like Canada can produce a national identity previous to and independent from its symbolic representations; and second, that such a national identity can be as singular and coherent as the narrative of a film. Longfellow points out that such "singular concepts of identity are inevitably bound to a politics of exclusion." She carries her challenge to this critical tradition into a close study of three Canadian feature films: *Black Robe* (a Canadian/Australian production), *I Love a Man in Uniform*, and *Calendar*.

Vera Frenkel leads us inside and outside *This Is Your Messiah Speaking*, the video/text work documented here, as she muses on "The Place, The Work, The Dilemma." Her contribution is a memoir/essay that grapples with place, itinerant patterns of movement and attachment, the sexual and economic politics of built and manipulated forms, and memory. These themes coalesce in a shopping-mall video wall piece for Public Access in Canada, an ICA (London) commission for an unrealized exhibition, and a multidisciplinary performance piece presented at the Music Gallery in Toronto. Her work galvanizes the sense of loss and subsequent recuperation in a process of continuous exchange.

In "Learning the New Information Order," Janine Marchessault returns to Innis's critical commentary on modern education to evaluate the educational claims of new interactive media. Innis predicted that institutional technologies would be used to produce "useless knowledge of useful facts" – in other words, would eliminate the distinction between information and education, education and marketing, thus furthering the promotional aims of "large organizations." Marchessault makes a suggestive connection between Innis's critique of mass education and the modernist characterization of mass cultural technologies as feminine, and traces these themes through an AT&T advertising campaign for new interactive technologies. Her analysis points to a new approach to globalization, to be distinguished from that imperialism analysed by Innis involving "the intended spread of a social system from one centre of power across the globe." In contrast, globalization, she claims, involves complex and contradictory forms of interdependency which serve to weaken all

nation states, including economically powerful ones. This context requires a more dialectical approach to cultural technologies, which Marchessault explores with reference to the Internet – in particular, its capacities for centralization and decentralization, its capacities for disseminating diversity, its usefulness as a counter-public sphere. In each case the Internet is seen to both disperse and consolidate institutional structures of power.

Whether building on current community practices seeking to discover their own cultural breadth, restoration, or renewal, or negotiating a new gestational space for artistic life, the swell in the arts arising from various forms of critical thought about globalism and the effects of the modernist legacy, indeed modernity, broadly put, cannot be underestimated. So rich and layered is the accumulated material that perhaps there has been too abrupt a move to label it all, at least in the last two decades, "postmodernism." The thorny twists and turns of the debates over the "end" of modernism and the marking of postmoderism are palpable and noteworthy. Yet, there is no end to the complexity and contradictoriness of the term postmodernism itself. As Terry Eagleton observes, the word conjures all sorts of ideas about contemporary culture which are still being evaluated and debated. Postmodernism, like other "isms," implies a more or less coherent enactment of collective intentionality and/or collective practice. But critics cannot agree on the relationship of this intentionality, this practice, to modernism itself. Does postmodernism represent the death of modernism or rather its logical – or, to think in more historical terms, its contingent, socially determined conclusion?

We do not aspire to answer such questions in this collection of essays but rather to explore some of the historical and philosophical dynamics that have both produced and negated the forces of modernism. A more accurate term for the shared context of these essays might then be postmodernity. Eagleton suggests that we understand this specific historical period as a "style of thought … suspicious of classical notions of truth, reason, identity and objectivity, of the idea of universal progress or emancipation, of single frameworks, grand narratives or ultimate grounds of explanation … It sees the world as contingent, ungrounded, diverse, unstable, indeterminate, a set of disunified cultures or interpretations."4 We have invited our contributors to comment on (and from the vantage point of) this newer period as an axis on which turns a whole constellation of ideas about global economy and contemporary culture. One way or another, the secure sense of measuring art's value is being shaken; what was once reliable no longer is, regardless of whether one "buys into" the postmodern project in any of its forms. We pause to re-read the template of modernism and the role of modernist practices in the contemporary period. Our objective is to describe a sense of continued unrest and to leave the reader in a space that encourages a continued challenging and relaxing of the boundaries circumscribing how we think about art. We hope to honour history while disturbing fixity, to acknowledge convention while tugging at its edges.

NOTES

1 A collection of articles addressing the changing intersections between art practice, art theory, art pedagogy, and art marketing is contained in J. Berland, Will Straw, and David Tomas, eds., *Theory Rules: Art As Theory, Theory and Art,* Toronto: University of Toronto Press and YYZ Books.

2 Shelley Hornstein would like to thank Ann Maddox, special events coordinator of Brookfield Management, who embraced her project from the first meeting. It was due to Ann Maddox's enthusiastic response that Brookfield Management granted us permission to use their Galleria Space, designed by Santiago Calatrava, to mount the exhibition. Ms Maddox also generously invited the artists to consult with her and offered advice and support that was well beyond the call of duty.

3 The relationship between magic and aesthetic judgment is richly explored by Pierre Bourdieu. In his "Intellectual Field and Creative Project" (Michael F.D. Young, ed., *Knowledge and Control: New Directions for the Sociology of Education,* London: Collier-Macmillan, 1971), Bourdieu offers a social history of the ideal of aesthetic autonomy, traces its connection to the glorification of the individual artist and the commercialization of art itself, and comments on its necessary relationship to the growing "objectivization of the creative intention" which involves the necessary complicity of artists, dealers, critics, and others. He elaborates on this "complicity" in his "The Production of Belief: Contribution to an Economy of Symbolic Goods," *Media Culture & Society* 2, no. 3, 1980, 261–93. Here Bourdieu writes: "The artist who puts his name on a ready-made article and produces an object whose market price is incommensurate with its cost of production is collectively mandated to perform a magic act which would be nothing without the whole tradition leading up to his gesture, and without the universe of celebrants and believers who give it meaning and value in terms of that tradition." How cynical this sounds! "The problem with magic," Bourdieu explains, "is not so much to know what are the specific properties of the magician, or even of the magical operations and representations, but rather to discover the bases of the collective belief, or more precisely, the *collective misrecognition,* collectively produced and maintained, which is the source of the power the magician appropriates" (ibid.)

4 *The Illusions of Postmodernism,* Oxford: Blackwell, 1996, vii. Eagleton's book targets what he sees as the dangers of postmodernity, but he seeks to underline its strengths in tandem with its failings. As a contemporary work, it provides much insight in hindsight.

Thoughts to Begin

Nationalism and the Modernist Legacy: Dialogues with Innis

Jody Berland

Nationalism and the Modernist Legacy: Dialogues with Innis

Jody Berland

The self-conscious postmodernization of academic and political life in national communities has catalysed a widespread investigation of the cultures of nationhood. These investigations derive from widely and diversely transformed concepts of culture and an unprecedented interest in place. Culture and place demand our attention not because our concepts of them are definite or authoritative but because they are fragile and fraught with dispute. In scholarship culture and place evoke passionate debates, and in the everydayness of social and political life they confuse us utterly. In this commotion attitudes toward historical formations like nationalism and modernism are inevitably altered. History beckons, but it's hard to know how to address it.

These two "isms," nationalism and modernism, are the dominant frameworks in which artists, intellectuals, and administrators grappled with changing relationships between culture, space, time, and identity in the present century. Each country has done it differently, but the century now drawing to a close was powerfully shaped by the alliances and antagonisms between nationalist and modernist beliefs. These twin aspects of modernization have become the focus of an international critical dialogue challenging the way these frameworks are understood. This era is now the subject of history, but how we talk about this history has been much altered by new avenues of investigation opened up by contemporary work in discourse theory, post-colonial theory, and cultural studies. In theoretical terms, we are better prepared to write this history than the people who made it. This is not an entirely cheerful situation; such intellectual innovation is occasioned not just by the evolution of theoretical acuity but also by dramatic changes transforming culture and the administration of social space. In trying to understand the historical changes signified by terms like "postmodernity" and "postmodern culture," we need to remain alert to the changing implications of our own theoretical choices and unresolved about the final meanings of these histories in relation to the present situation.

This is the context in which I propose to revisit the formative coalition between nationalism and modernism which arose in Canada in the 1950s. In reflecting on the history of culture and/in space, many Canadians are rediscovering their indebtedness to the work of Harold Innis.[1] Innis's research on communication, space, and culture occupied him from the end of war until his death in 1952.[2] It thus coincided precisely with the proceedings, studies, and published report (1951) of the Royal Commission on National Development in Arts, Letters and Science, today known as the Massey Commission, which laid the ideological and institutional foundations for Canada's cultural administration from the 1950s to the recent past. Both Innis's and the Massey Commission's publications represent the attempts of powerfully influential intellectuals to lift Canada from its colonial status. Both were grappling with strategies for a peripheral country seeking to empower itself through the political analysis and deployment of culture. The defensive connection between national identity and high culture through which Canada responded to this challenge is commonly traced to the influential Massey Commission Report,[3] which shares many of the preoccupations that informed Innis's research of the same period. Both express opposition to the expansion of American mass-mediated culture, although their analyses of this expansion occupy quite different ideological ground. Both continue to be read (not always positively) as formative responses to the anxieties of shaping a new colony in a new world that was seen to be as simultaneously defined and endangered by limitless modernization. Their response to the postwar spread of media culture constituted a decisive convergence of influences on Canadians' thoughts, practices, and policies. They helped to form the discursive categories which to this day shape how and what we think when we think about culture.

My purpose here is to explore the spatio-historical conjuncture from which the nation-culture discourse emerged in postwar Canada. I am not going to offer a comprehensive critique of the history or theory of nationalism or modernism, or of Innisian thought. But seeking to arrive at an adequate account of the Innis-Massey constellation requires some reflection on the narrative logics that have accumulated around this history. Untangling them may help us to understand and to resituate ourselves in relation to the forces that contributed to, and developed from, the alliance between nationalism and artistic modernism which made such a definitive impact on Canadian life. The Massey Report has been implicated in every positive and negative development in Canadian culture and cultural administration for nearly half a century. Yet we need to remember (and Innis's work helps in this regard) the limitations to focusing on the report or any other government document as a rhetorical text, as though it were a blueprint that outlines and accounts for everything that followed. Between principle and practice lie many force fields of influence and power.[4] Keeping this in mind while tracing this history will give us a better sense of the diverse components of politics, contingency, and conquest that have in concert brought us to our present situation.

Modernism and the nation: a history

When Innis turned his attention to the history of communication, Canada was immersed in the unsteady glow of postwar celebration. Because of Canada's position as an underdeveloped, ostensibly less "civilized" colony that had nonetheless contributed greatly to the victory of the Allies, the mood of its citizens was dominated by a blend of national self-esteem and introspection, renewed anti-imperialism and both enthusiasm and anxiety about the rapid spread of American culture. The war had cured the Depression, it was a new world, there was money. Movies, records, television, and other entertainments (mainly imported from the United States) were warmly appreciated. Yet American popular culture, as an aggregate, also represented the expansion of a new empire. The more enthusiastically the products were consumed, the more they were also viewed by some as a threat to (the possibility of) collective sovereignty.[5] Innis, an influential economic historian, turned his attention to the history of communication and the rise of empires. Seeking to explain the interconnectedness of communication technology, colonial geography, and culture, his last work emerged from a time when these terms were acquiring new meanings.

Innis's explanation for the new threat to Canadian sovereignty differed from that of his contemporaries; he was an historian interested in the role of transport and communication technologies in the creation of empires and margins, while the approach of Massey and his colleagues derived from a synthesis of liberal nationalism and European humanism. Both thinkers reacted against postwar media culture as a dangerous brew of impermanence, hedonism, and imperial expansion. What Massey termed the "longest undefended border in the world" between Canada and the United States was becoming the subject of that strong anxious attention which a less powerful partner always grants to the dominant. The anxiety was magnified by the new political conservatism which by the late 1940s (with the rise of the cold war and Russia's 1948 invasion of Czechoslovakia) dominated U.S. culture.

The Massey Commission responded to the challenge by proposing to defend the nation's future with the safeguards of high culture. Ironically, the war created a very different response in Europe, where there was a widespread retreat from nationalist politics and a move towards articulating new ideas of the social. The traumatic experiences of the war, coupled with fascist attacks on everything associated with modernism and modernity, helped to fuel the programmatic internationalism of the postwar ethos across Europe and further, to all the distant countries to which Europe's emigres had fled. Intellectual and artistic communities were meeting (and emigrating) across national boundaries, rejecting national and regional traditions and goals. Boulez, for instance, safely ensconced in Paris, demanded a complete rejection of all the old music in favour of the new; it was, after all, the old music, he claimed, that had started the war.[6]

How paradoxical, then, that Canadians seeking to advance the collective interests of Canadian artists should come to embrace this forward-looking

modernism as the means to cultivate a national culture. They had no national tradition weighing on them like the nightmare of the living. They were not protesting against a culture that weighed them down, that disapproved of or sought to circumscribe their creative freedom in the name of established aesthetic standards, but against a culture that was not there (they felt, returning enviously from Paris or New York) and had no idea what to do with them. Culture had to be made, and support was sought for the project of producing it. Because the culture already percolating in Canada could not live up to European standards, the task involved both the creation of art and the creation of professional standards with which to judge and legitimate the art. It meant the creation of a public, critics, a legitimate process of peer review, an entire artistic milieu within which art could be read in its own language. Then Canadians could, through the process of seeing and knowing themselves (so the argument went), finally come into being.[7]

In the political sphere, artists' briefs sought to improve their status and visibility through support from the federal government. Such support, they argued, should be based on principles of artistic autonomy, the professionalization of artistic goals and standards, and the space to pursue artistic form separate from aesthetic and cultural traditions – all formative principles of modernism (which in other contexts also encompassed their antitheses), all taken up as ingredients for the new nationalist strategy for culture. These goals required that art be judged and financed autonomously, according to "arms-length" professional standards; the deflection of government control was itself necessary to defending Canada as an advanced and sovereign modern nation.

In this context, I use the term "modernism" to refer to a strategic representation and consolidation of specific values, dispositions, and administrative processes that constituted postwar cultural discourse in English Canada.[8] Modernism, like nationalism, has conveyed dramatically different meanings in different historical and national configurations, and this was of course a local version. English Canadian modernism conveyed little antagonism toward traditional aesthetic values or artistic institutions, few combative gestures against the privileged autonomy of the artistic field, and no interest, however ambivalent, in technology and popular culture, which only emerged in the 1960s. Artists learned from the new modernism to make art that could separate the world of experience from the field of memory, but they were not busy imaging a future contingent on its subsequent obsolescence.[9] Avant-garde metaphors were replaced by consensus-building anxiety about national autonomy.

Judging from the Massey Report and other writing of the period, English Canada's modernist covenant combined in the place of these contestations a dignified antipathy to the dominance of American commercial and popular culture, and the consequent eviction of popular and/or commercially based culture from the terrain of public good; an agreement that artists and artistic works should inhabit an autonomous professional world, accountable only to juries of professional peers who could judge artistic

value in its own terms; the belief that national subjects were (or would evolve to become) united by shared cultural values and beliefs, nurtured by the country's art; the arguably countering belief that art ought to be disengaged and free from local traditions, community standards, commercial markets, politically motivated strategies of representation, or other "idiosyncrasies"; and the notion that it is artists' responsibility to advance their art. Framing these together was the consensus that the Canadian state had an interest in and responsibility for furthering these cultural values and practices.[10]

English Canadian modernism partook enthusiastically of the movement to modernize and rationalize cultural production, then, but the movement was deeply marked by its colonial context. To the extent that postwar art adhered to an evolutionary mandate, it was attached to the fate of collective sovereignty (a concept wider and perhaps more vague than identity) rather than to the progress of art itself. The movement succeeded in establishing autonomous art as a legitimate concern of government by positing art as a discourse which (as Foucault puts it) could "develop those elements of individual lives in such a way that their development also fosters the strength of the state."[11]

The architecture of Canada's cultural policy was centrally shaped by the transitional conjunction of nation-building and artistic modernism. The period immediately following World War II witnessed many changes that encouraged government's commitment to the arts while consolidating the largely defensive orientation of its cultural policies. These changes included the very rapid introduction of television to Canada, and, since TV was largely financed, manufactured, programmed, and broadcast by American corporations, new levels of anxiety about the domination of Canada's marketplace and minds; the revival of social democratic nationalist alliances; the widely cast proceedings and publications of the Massey Commission, culminating with the Massey Report's powerfully reiterated warnings about American commercial/cultural invasion; the beginning of economic decline in Quebec, which was then producing Canada's most internationally successful artists and its only defiant artistic manifestos; and Canada's acquisition of the right to an independent foreign policy.[12] These developments coincided with a new international balance of power, which featured among its many changes the shift of modern art's centre from Paris to New York, and the important geopolitical, financial, and aesthetic changes that accompanied that shift. This was the context in which Canada sought to make a place for itself as a modern sovereign nation equal in status to other nations of the postwar world.

Both popular and government approval for arts subsidies were cultivated and won on the basis of a link between cultural patronage and national defence.[13] The alliance between citizens and government emerged from the argument that an independent nation (now deserved on military grounds) required a distinctive culture expressing Canadian experiences and values. This culture must also represent Canada abroad, to help bring Canada into the world of modern advanced nations following World War II. "A cultural

nationalism that cultivated a unique culture identity was an appropriate cap-
stone for the nation-building process," writes Paul Litt in his chronicle of the
Massey Commission. "In internationalist circles there was also general agree-
ment with Pearson's feeling that now that Canada was rubbing shoulders on
the world stage with older nations with venerable cultural traditions it should
do something to match their refinement. Postwar nationalism gave govern-
ment cultural initiatives a broader base of popular support and a new politi-
cal relevance."[14]

To join the partnership of modern nations Canada had to learn to adver-
tise its own progressive modernity. "Art has been central to the modern con-
sciousness because the new, as the fundamental value of the age, has long
found its justification in it," claims Antoine Compagnon in his study of
modernity.[15] Since Canada lacked a strong industrial base in either manufac-
turing or culture, the message conveyed by the arts may have been doubly
important. There's nothing obviously innovative about lumber, or fish, or
branch-plant automobile production. Canada's modernity could advertise
itself in the arts, whose creators found justification in turn as signifiers of
Canada's modernity. They were a sign of Canada's capacity to catch up with
the more "advanced" victorious allies – without posing a techno-military or
competitive market threat.[16]

It is no accident that Innis was simultaneously writing so insistently of
the interdependency of colonialism and modernity, space and time; these
pairings were reaching qualitatively new levels of imbrication. "It was
through the temporalization of the founding geopolitical difference of colo-
nialism," Peter Osborne reminds us, "that the concept of modernity first
came to be universalized." Modernity's definition of progress contains geopo-
litical as well as temporal implications, Osborne argues, since it is posited "in
terms of the projection of certain people's presents as other people's
futures."[17] This was certainly Clement Greenberg's belief, when he
announced in the late 1940s that "American art ... was now at the forefront
of world art."[18] In connection with its emergent temporal and spatial man-
date, modernism acquired new inflections: the successful "signature" now
conveyed a (rather masculinist, Denise Leclerc notes) will to formal innova-
tion, attributed to the drive to express inner experience, combined with a
rejection of European traditions or any nostalgia towards them. In Canada as
elsewhere, Leclerc writes, "The need to be up-to-date on international trends
became as important a requirement among modern artists as the need to
demonstrate anatomical precision or to avoid anachronisms in historical
paintings had been among artists of the past." This was, Leclerc argues,
"unquestionably to [Canadian artists'] advantage."[19] This is true, if we accept
the modernist frame of reference.

"Because the modern era is open-ended," notes Compagnon, "progress –
an empty value in itself – has no other meaning than to make progress possi-
ble."[20] Obsession with progress as both value and sign is certainly evident in
the new high-octane world of modern art settling in New York in the years

after the war, especially if we recall that the attribution of non-meaning to modern art is as much a strategy of the critic as of the artist. Many Canadian artists were eager to join that world. Most of them were more knowledgeable about what was happening in New York than in other parts of their own country, and the logic of newness and emphasis on self-unfolding was more compatible with their experience than the evocation of tradition.

Still, Canadian artists and intellectuals showed a cautious approach toward the ideology of progress. Commentaries of the time seem relatively agnostic regarding art's preoccupation with progress and formal purification which Greenberg called, in his 1955 article of the same name, "American-Type Painting."[21] The artistic community's initial indifference to the idealized evolution of art[22] reflects a deeper ambivalence toward progress as a social doctrine evident in Canada in the early 1950s. Innis's critique of the growing monopolies of communication and the spread of what he termed the "mechanized vernacular" articulates this mood in scholarly terms. His critique of modern media's "continuous, systematic, ruthless destruction of elements of permanence essential to cultural activity"[23] centres on the pursuit of and preoccupation with progress which inheres in media expansion, which Innis sees as the defining strategy of the new empire. His outlook on the communication revolution is characteristic of a wider tendency in Canadian philosophy, literature, and humour to view "progress" with great scepticism. Innis's contemporaries do not seem to have approached art so much in terms of the progressive unfolding of artistic language as a constellation of personal statements and natural encounters wed inevitably (that is, deliberately or otherwise, and better not) to the unfolding of Canadian culture.[24]

Perhaps it was too soon to demand significant formal innovation from Canadian art; for whatever reason, that did not yet seem to be the point. For many artists and critics, the "serious purpose" of art meant (if I can posit a large but perhaps useful generalization) the need to connect through/with space (landscape, territory, idea), not to measure oneself and one's language through/against the inevitable unfolding of time. When Barnett Newman arrived to address Canadian artists in 1959, however, a "brief stay ... was apparently sufficient to convince these artists of the importance of their calling and the vital necessity of placing their art above all else." Newman convinced them that great works were "profound, uncompromising and totally unaffected by the artist's idiosyncracies,"[25] i.e., not located in or engaged with the realm of the social imaginary. The excitement generated by his visit expressed subtle but significant changes in the aims and practices of Canadian art.

During the 1950s, concern about U.S. ascendancy in the cultural industries fueled and was intensified by the Massey Commission. There is no comparable alertness to the "dangers" of other foreign influences on painting or music. Nowhere does the Massey Report note that artists and composers, critics, dealers, and producers who were to weave their raw materials into Canadian nationhood were adapting their practices to the aesthetic values of international modernism. Gail Dexter claims that the Massey Commission "detailed

the dangers of American imperialism ... in broadcasting, scholarship and publishing but celebrated the Canadian spirit manifest in the new abstract art of the 1940s."[26] The commission's haughtiness toward American culture also overlooks the substantial funding for the arts in Canada coming from American private foundations.[27] For the commission the danger to sovereignty flowed from the commercial mass media; therefore the route to national defence was to elaborate and popularize the European tradition. Their report and ensuing policies encouraged artists to direct their work to preserving European cultural traditions or the new, apparently uninflected languages of modern art.[28]

The Massey Commission legitimated but did not invent the association between high culture and national defence. The wartime coalition of artists' organizations, later titled the Canadian Conference for the Arts (still active today as a national lobby), advanced a strategical connection between a cultural policy focused on the fine arts, and national defence. Their goal was to elevate art's status as professional work, and to win government financial support for art production, on the basis of culture's potential contribution to national morale. The high culture/national defence connection left an indelible mark on subsequent policy. When cultural policy was implanted as part of the mandate of the federal government, "culture" was separated from the "cultural industries" both philosophically and through the assignment of responsibility to separate government bodies. From the 1950s to the 1980s only "autonomous" art was understood to be useful and deserving of government support.

Let me illustrate this with reference to an interesting historical coincidence. The first innovation in cultural administration was the 1957 founding of the Canada Council with funds from a private endowment. Its first chairman was Brooke Claxton, former minister of defence. Just as this recommendation of the Massey Report finally came to fruition, another was overturned. The Massey Report had recommended that Canadian broadcasting should (continue to) be largely produced and supervised by the Canadian Broadcasting Corporation (CBC), in order to ensure a continuing non-commercial creative space for journalism, literature, and the performing arts. The commission argued that the private sector acted as a profit-seeking vehicle for American programs and did not invest in Canadian talent – an allegation confirmed by every study from 1929 onwards. Unlike the report's call for public funding for the fine arts, the recommendation that the public broadcaster be mandated to regulate as well as to produce within one broadcasting system was overturned in 1957–58, when the new Conservative government formed a separate agency, the CRTC, to regulate the (expansion of the) private sector in radio and television. This had the effect of redefining the CBC as "competition" against the commercial broadcasters, satisfying demands from the private sector and justifying the creation of a separate, ostensibly neutral regulatory body that would view public and private broadcasters as part of one market. In this way broadcasting was re-defined as an essentially commercial rather than cultural venture. This legislative change anticipates the

contractual redefinition of culture as a commercial enterprise imposed by the 1989 Free Trade Agreement between Canada and the u.s. The recommodification of a publicly subsidized cultural domain did not originate in the 1980s, in other words, but rather in the late 1950s, with the birth of cultural policy.

After 1958 the Canada Council assumed the primary mandate for commissioning works and funding artists and institutions. The change brought greater emphasis on peer-regulated professionalism, a stress on autonomous forms, and a shift away from the generation of multi-generic, multi-disciplinary, or technologically mediated artistic production, which much later was selectively admitted to the mandate of the Canada Council – though not to the broadcasting system, once the primary patron and disseminator of Canadian culture, which abandoned these resources. Fiddlers, crooners, and accordian players were no longer welcome at the talent festivals, and art critics no longer discussed book illustrations or graphic design. The council's approach worked to marginalize the "idiosyncracies" of the popular, applied, and electronically mediated art, and facilitated the embrace of modernist values as dominant and exclusionary standards for cultural production.[29]

These events placed modernist art discourse – nationalist in their rhetorical claims but international(ist) in aesthetic strategies and terms of reference – at the centre of the country's new official culture. Modernism thereby served the apparently antagonistic but actually complementary goals of nationalism and internationalism which motivated and defined Canada as an emergent nation of the postwar period. The connection between the arts and national defence – between autonomous art and an autonomous nation – was a fundamental component of postwar reconstruction and continued to lay the rhetorical foundation for cultural policy. In 1976 the Royal Commission on Publications stated that "the communications of a nation are as vital to its life as its defences, and should receive at least as great a measure of national protection."[30] In 1981 the Federal Cultural Policy Review Committee evoked the cultural threat of American mass media to legitimate its proposal for strict divisions between publicly funded fine arts and the profit-oriented mechanisms of the cultural industries. In its brief to this committee, the National Arts Centre argues that "a policy of national defence which excludes the arts is vain; as the arts are included, the defence becomes impregnable."[31] We can trace this evolving trajectory to the mid 1980s, at which time then Prime Minister Mulroney, during free trade negotiations with the United States, proposed to buy off artists, who were mainly opposed to the agreement, through increased government support for the fine arts. Not surprisingly, this was a policy more honoured in the breach; funding for art and artists has declined steadily since then. Nor did it succeed in winning over the culture-producing community. The process of governmentalizing art had succeeded, but only partially, in disentangling art's means and objectives from the broader social trajectories from which it had so hopefully emerged.

The colonial past from which Canada was supposedly emerging

The model for state support of the arts was not crafted from the particular conditions of Canadian cultural life. It was drawn from British antecedents of the nineteenth century, in which art was conceived as an intellectually motivated, professional, essentially upper-class tradition, strongly contrasted with the emergent popular culture of urban amateurs and consumers. Nineteenth-century arts policy was founded on an aristocratic distrust of the fate of art in the marketplace and in the hands of new social classes. Thus "the importance and expertise of the 'professional' (art historian, art expert, artist, art lover) is asserted against the taste and habits of the general population ... Aesthetic judgements, it is argued, require expert knowledge, advice and guidance. The social and public importance of art is asserted; at the same time a need for art to be controlled, nurtured and guided apart from the general society and public is also asserted."[32]

This guiding principle reiterates the formidable influence of Matthew Arnold, whose definition of culture as "the best that has been thought and made" had dominated humanist education since the 1880s. His views have informed approaches to culture in contexts ranging from arts pedagogy to anthropology to the cultural policies emerging in many countries in the early to mid twentieth century.[33] James Clifford describes Arnold's influence in anthropology as "a powerful structure of feeling [that] continues to see culture wherever it is found, as a coherent body that lives and dies. Culture is enduring, traditional, structural (rather than contingent, syncretic, historical). Culture is a process of ordering, not of disruption. It changes and develops like a living organism. It does not normally 'survive' abrupt alterations."[34] Massey and his contemporaries uphold this position. If culture is a coherent, ordered, but fragile body, then it is logical that the culture whose life is endangered should be protected from disruption and change (or, in the anthropological context, documented as it dies). Ironically, the emphasis on new, internationally based strategies of artistic innovation may not always contribute to that end, particularly if culture's body is conceived within the geopolitical confines of a colonial state, however much the search for tradition and the search for the new derive from the same modern apprehension of the transience of time.

Whether we see this as ironic, tragic, or simply the effects of a changing disciplinary regime, Arnold's definition pinpoints what separates the commission's beliefs from the programs and policies that followed. When emphasis on the new becomes a privileged mode of artistic judgment, art's success at defending a culture's coherent but fragile body is doubtful – particularly where (in terms of accepted tradition) that body is imported from the mother country. Yet modernism was endowed with this guardianship role, across Europe between the wars and, in newer countries like Canada, after World War II. This modernism encompassed both the loyal preservation of European traditions (symphony orchestras, painting, ballet – all pre-technological forms) and support for select innovatory practices (performance art, installation, electroacoustic music) approved by international modernist aesthetics. It did not

encompass folk culture, jazz, electronically mediated art, indigenous or "eth-nic" art, popular culture, film music, or accordians. Here postwar aesthetic politics replicate what it sought to surpass: the previous generation's painting, which made beautiful images of an empty landscape as though, until they got there, no one was there.

The irony here should not be hard to detect. In rebelling against the hier-archical preservation of an aristocratic cultural tradition, modernism exempli-fies both the progressive, rebellious spirit of the modern century and its trag-ic ongoing complicity with the rootless and ruthless commercialization of objects and meanings required by contemporary capitalism.[35] A rebellion against tradition transformed into a tradition (though as Compagnon remarks, a tradition of rupture is neither a tradition nor a rupture), mod-ernism was placed at the forefront of state cultural policy as figurehead of modern western culture. In that position modernism has been as effective in displacing or disempowering artistic practices as in inspiring them.

Williams pursues this point in his critique of British arts policies which, under the joint influence of Arnold and Maynard Keynes, insisted on a dedi-cation to "the fine arts exclusively." This meant abandoning regional, experi-mental, community, and non-traditional arts, whose constituencies continue to support high-level state-supported art, but who themselves are "being excluded by that most potent criterion: standards!"[36] Williams's difficulty lies not just with the undemocratic intent and effect of such policies, but with the misinterpretation of aesthetic "standards" which they perpetuate. Keynes and others speak of "serious purpose," he argues, but fail to recognize that there are diverse "serious purposes" in art practice; indeed, Williams maintains, "changes of purpose are the real history of art."[37] If Impressionism is now a sacred possession of art history, museology, and high-end private collecting, it was not welcomed at its arrival. Nor were the Group of Seven, until European critics expressed their approval, or technologically mediated arts (radio, video, film) until they were established as profitable cultural industry (film as export/coproduction) or successful art export (video art as favoured interna-tional representation in the 1980s). Like other new, "disruptive" artistic visions, neither accorded with the aesthetic standards or values of their time, which (we perhaps now realize) were never purely aesthetic.

Why, then, do arts councils assume a permanent and exclusive association between "serious purpose" and the professional norms and standards of the established fine arts? This points to an important paradox in nationalist mod-ernism. In its proponents' haste to define and police aesthetic standards and practices (imported, if necessary, from Europe or New York), the art world betrayed the emergent practices that might have led to local and indigenous "changes of purpose." What might such changes be, and how might they have differently constituted the country's artists, citizens, cultural consumers? Where are the artistic responses that were not taken up, not celebrated in the nation's museums, commemorated as new tradition, thrown open to (state subsidized) experimentation and delight? And what of the culture envisioned by Innis?

Modernism and the state

Canadian artists attained state funding by drawing on an established rhetoric drawn from British and European antecedents but applied to a new and different political and social situation. As inhabitants of a colonial culture, they sought to encourage an association between the educated aesthetic sensibility and the cause of national sovereignty. Their cause was successful because they called upon the state to undertake something that was in its own interest: to underwrite the creation of a new type of Canadian citizen, able to withstand imperialism in general and the invasive seductions of American culture in particular. Their success supports Michael Dorland's argument that Canadian governmentality evolved within an emergent framework emphasizing culture as one of the "technologies of 'good government.'" Dorland draws on Foucault's concept of governmentality, which describes the modern exercise of power as an imbrication of state policing activities and modes of self-government. "Self-government" implies a willed negation of dangerous pleasures: anarchy, violence, crude market or "low" culture, moral degeneration. It describes a polis that accepts moral power and authority as the basis of state power, much like architects of British and Canadian arts policy who assumed that social cohesion would be advanced by the beneficial effects of the fine arts.[38]

The Massey Report heralds the emergence of this discourse in Canada. In its distaste for mass culture and its concern for the viability of a more elevated Canadian culture, it argues for the necessity of introducing what Bourdieu calls the "aesthetic disposition" to the formation of the Canadian subject.[39] Bourdieu defines the "aesthetic disposition" as a particular mode of perception, socially constructed and reproduced, which is characterized by kind of pure, distanciated, disinterested gaze. "Great art is not a direct sensuous pleasure," Langer says, in a memorable passage cited by Bourdieu: "Otherwise, like cookies or cocktails, it would flatter uneducated taste as much as cultured taste."[40] That aversion to "direct sensuous pleasure" echoes Innis and his contemporaries, who did so much to give Canada the reputation of being a puritanical culture. But never mind, we do love our cocktails and cookies.

In Bourdieu's cartography, the special kind of apprehension reserved for art is not only a response to art; it is a precondition for art itself. For art comprises a special class of objects that "demand to be perceived aesthetically, i.e. in terms of form rather than function." Despite the apparent disinterestedness of this type of perception, this mode of apprehension is not an ahistorical phenomenon: as Bourdieu argues, "the ideal of 'pure' perception of a work of art is the product of the enunciation and systematization of the principles of specifically aesthetic legitimacy which accompany the constituting of a relatively autonomous artistic field."[41] The "artistic field" is constituted as "relatively autonomous" in the sense that it discursively refuses direct communicative and economic function (i.e., direct social and market value): its production of meaning thus affirms, however unconsciously, the "strictly negative conception of ordinary vision which is the basis of every 'high' aes-

thetic."[42] This rejection of ordinary vision comes to incite expressions of popular rage like those aroused by the National Gallery of Canada's recent purchase of Barnett Newman's painting, *Voice of Fire*. What the enraged public perceives is that the artistic discourses' refusal of commonplace communicative and (ostensibly) economic function operates with and contributes to a different kind of value that bears no direct relation to their own interests. Bourdieu calls this value "cultural capital." Williams reminds us that the works endowed with this special status do in the end command large sums of money, indeed constitute "a significant and enduring part of wealth in our societies" – which is rarely returned to the state.[43] Both critics agree that the value of such works bears a complex distancing relationship to direct economic use-value but ultimately translates into, and fundamentally legitimates, the growth of economic capital.

The triumph of modernism in the institutional fabric of cultural regulation in Canada was dependent on the perceived usefulness of the "aesthetic disposition" – with its rejection of immediate use value, whether pleasure or the market – to the creation of a citizen able to separate herself from the seductive appeals of American mass culture. An aesthetic discourse dedicated to good citizenship was thereby modelled on an aesthetic discourse dedicated to the reiteration of class distinction. By wanting us to resist the (pleasurable) erosion of our own cognitive and corporeal boundaries, our colonial legislators conjure the same distracted oblivion McLuhan would later describe as the new media environment: "active processes which work us over completely, massaging the ratio of the senses and imposing their silent assumptions. But environments are invisible. Their ground-rules, pervasive structure, and overall patterns elude easy perception."[44] Massey and Innis both sought to protect us from succumbing to these pleasures, so intimately associated with the temporal and corporal strategies of the new imperium. The world of the popular is thus disdained and rejected, e.g., left to the market fluctuations of a continental economy.

For policy-makers of the postwar period, faced with the overwhelming cultural and economic onslaught of American media culture, art was a viable strategy for collective self-improvement. Governmental discourse dedicated culture to the task of forming the post-colonial citizen. Of course "governmentality" incorporates more than belief. As Foucault reminds us, "Discursive practices are not purely and simply ways of producing discourse. They are embodied in technical processes, in institutions, in patterns for general behaviour, in forms for transmission and diffusion, and in pedagogical forms which, at once, impose and maintain them."[45] In the domain of culture, such embodiment occurs in arts funding bodies, national museums and cultural agencies, and arts education and adjudication. The values reproduced through curatorial and critical strategies help to consolidate a binary policy distinguishing between fine arts and the suspect "ordinary vision" informing commercial, popular, indigenous, and traditional cultural domains.

Rewriting Modernism and the State

This narrative has enacted a familiar critique of modernism's hegemony. It is correct in every detail, but I am not altogether happy with it. History is best written when we try to understand the actors in terms of their own (contradictory) objectives and the obstacles to their realization, and when we admit that we are both continuous and discontinuous with them. The story I have presented is a history of the formation of a discourse. But the history of a specific (modern) discourse does not require an autonomous (modernist) historical logic, which fails to encompass all the contradictory forces at play.[46] Like the critic who declares modern art meaningless to the extent that it invests in the ideology of progress, this logic declares our predecessors defunct because they invested in the efficacy of art in the context of cultural policy – because they believed in the efficacy of their own cultural commitments in the face of indifferent power.

How much have I myself inscribed the doomed autonomy of the modernist discourse into this past? The narrative I am hyperbolizing traces a history of the privileged isolating of artistic culture, but itself isolates that discursive construction from the more complicated contexts and intentions of the time, while critiquing its producers for succumbing to a discourse of autonomy. This narrative demonstrates the power of the (colonial) nation state, whose internal divisions, weakness, and crises are made incidental to the totalizing narrative. A modernist history of modernist discourse can only highlight one particular thread, mediating power, place, and practice – just as Innis's history of communication (to make the contrast/connection explicit) highlights the mediation of economically and spatially motivated media technologies rather than ideologically cohering discursive technologies. Neither can offer a complete account of historical change; their partiality and relevance are motivated by present as much as historical concerns. In this connection I remain alert to Williams's warning against any critical position that collaborates with anti-government pressures on the arts "to be reinserted in a new kind of market" dominated by commercial interests; as he claims, this will enable "dropping the non-traditional arts, dropping the roadshow and small touring companies, dropping or 'devolving' arts centres and community arts and various kinds of low-cost experimental works" – all beneficiaries of arts councils in recent decades, all victims of the evisceration of arts council budgets in both countries.[47] With the right marginalizing the public mandate in every domain, it remains important to protect arts production (along with health, education, resources, and environment, etc.) from a pure market economy. It's a problematic situation. But if we dismiss our predecessors as carriers of a now obsolete modernist discourse, the damage is not merely to history. For then progress as we define it depends entirely upon our rupture from them. Could we be less "post" modern than we suppose?

In the 1940s artists invoked the national interest as the best strategy for defending and advancing the boundaries of what they understood as culture. Their alliance with other groups concerned with postwar reconstruction pro-

duced a political discourse predicated on broad connections between culture, democracy, and the public interest. The postwar coalition was similar in constitution and aims to the coalition that joined together in the 1930s to fight for public broadcasting and again in the 1980s to oppose Canada's Free Trade Agreement with the United States. Rather than being constituted solely of artists and their middle-class patrons, it also combined teachers' and students' federations, local and national women's groups, nurses, chicken farmers, small businesses, national religious organizations, small businesses, the Canadian Labour Congress, journalists, record producers, country singers, novelists, and poets. Litt observes that this nationalism "was bolstered by a strain of utopianism": not only culture, but welfare, democracy, "the opportunity to forge a better world" in a new and distinct society, were all part of the postwar nationalist vision. Litt traces this link between culture, fraternity, and national distinction back to World War I, when people like Brooke Claxton (later minister of Defence and first chairman of the Canada Council) participated in organizations like the Association of Canadian Clubs, the Canadian Institute of International Affairs, and the League of Nations Society, which shared a mutual purpose to "disseminate information and foster discussion about national issues; they hoped to foster democratic responsibility and a Canadian consciousness."[48] The elite neither possessed nor uniformly opposed these concerns.

Note that several sets of oppositions are being articulated, each of them both reliant on and seeking legitimation for state involvement: culture and commerce, Canada and the United States, nation and empire, education and ignorance, public good and private interest, welfare and war. Today we reject this as a list of modernist binary oppositions, Canada naming itself as "one" against each hostile "other." This may reinforce a sense of theoretical superiority (*we* know what kind of constructs these are), but it also places us in danger of forgetting how interconnectedly these categories manifested themselves in the social domain. Just as we now recognize that power is articulated through multiple discourses, so this resistance relied on the evocation of multiple interdependent categories. Perhaps the people who evoked them were already postmodern; they knew their independent "identity" depended on demonstrating the efficacy and interconnectedness of these oppositions. Perhaps the oppositions were modernists constructs mobilized in a postmodern locale. Canada's nationalist modernists were informed by a constellation of interdependent ideas expressing strong social as well as cultural purpose. Their shared goal was a social democracy and the eradication of colonial rule.

What they achieved was the modernization of cultural production. Innis seems to anticipate this when he notes that "Most organizations appear as bodies founded for the painless extinction of the ideas of the founders." He explains, "Concentration on learning implies a written tradition and introduces monopolistic elements in culture which are followed by rigidities and involve lack of contact with the oral tradition and the vernacular."[49] Notwithstanding Innis's own historical reductions, this points to a further paradox of nationalist modernism: it simultaneously reacts against and partakes of

the modernizing project. "Insofar as they are historically effective," Hobsbawm has written of the dilemma for nationalist intellectuals, "their effect is at odds with their intentions."⁵⁰ While wary of generalizing about nations or nationalism, I find this poignantly relevant to Canadians of the postwar period. Their anti-imperialist nationalism did further the modernization and rationalization of cultural production; one effect of this has been to diminish the ability of intellectuals and artists to work outside of or to adequately contest the dualistic discourse of fine art versus cultural industry. Still, their intentions were not the sole authors of their effects.

Between 1950 and 1980, arts policy advocates imagined that the increased autonomy and professionalization of art production would serve to develop the expression of Canadian difference, and would thus enable Canadians to meet international standards for artistic quality, confirm Canada's commitment to values of progress and innovation, and honour and distinguish Canada in relation to the European tradition. This mandate is as paradoxical as it was honorific. Modernism was supposed to distinguish Canada as a sovereign nation by reiterating European values. It would establish clear difference from the past, yet demonstrate the efficacy of the territorial space which that past so arbitrarily produced. It would symbolize, legitimate, and defend Canada as a distinctive territory yet enter the increasingly American-centred internationalist discourse of artistic modernism. Artists and art would challenge and transform everything without accountability to a larger public, yet consolidate citizens around basic values like democracy, social justice, progress, and peace. We confront then not only the paradoxes of nationalism but also what Compagnon describes as the fundamentally paradoxical effect of modernism. It is not (he argues) the continuing idolatry of the new, or modernism's strong ambivalence towards mass culture, or the "religion of art" and the heroization of artists authorized by modernism but the paradoxical trajectory created by these values that constitutes the legacy of modernism. Its paradoxical history "will be contradictory and negative: it will be a story going nowhere." For Compagnon, the evolutionism of modernist discourse precludes an adequate relationship with either the past or the future. "It betrays itself and it betrays true modernity, which consists of the rejects of this modern tradition."⁵¹

Of course *we* are the legacy of that modernism. If we are to remedy its contradictions we need to understand it as a historical palimpsest of two contradictory projects: the universalizing self-transformative capabilities of modernism, and the progressive anti-imperialist efficacy of nation-building – neither of which could enact what it promised. The peculiar relationships between rationale, goal, and actuality engendered by each were further complicated by the joining of the two projects in the name of national defence. This distinctive conjuncture arose from a colonial society simultaneously producing and disciplining a potential consensus on social and cultural goals associated with national sovereignty.

The forces shaping Canada's culture between then and now – policies and institutions, categories of value and judgment, international markets, movements

of people and things – are in part the product of that consensus resisting the dominance of such practices. For instance, the 1941 Kingston Conference's resolution to regionalize the National Gallery helped to focus attention and resources on the gallery, but a regionalized culture was not a major effect. The relationship between achievement and destruction is a discontinuous one, involving a range of causes and so exposing the limits of "paradox" as an explanation. The alliance between citizens and "the state" cannot singularly account for these paradoxes. Commercial media, American trade policy, the international art market (which today discourages collectors from buying Canadian art), technological change, film and video distribution, art education, contemporary theory, new identity politics, privatization and the decline of the public sector, and globalization have all been powerful determinants in (re)shaping the production of culture. These pressures engendered many fissures and contradictions. Together they implicated a social democratic nationalist coalition in the functional rationalization of culture within a colonial society experiencing the transition from one imperial power to another.

Innis and colonial modernity

Like his contemporaries, Innis saw the victory of commercialism over culture (translated then as the victory of American over Canadian interests and institutions) as threatening civilization itself. For what is civilization without rich collective memory, complex perpetuity in time, and oral history to keep these alive? What is culture without ethics, or reflection, or difference?[52] "We must rely on our efforts," Innis pronounces near the beginning of his essay "A Strategy for Culture," his "footnote" to the Massey Commission, "and we must remember that cultural strength comes from Europe."[53] Imagine writing that now, or even then! But Innis was not pursuing the same vision as the Massey Commission or the people who set out to enact its recommendations, regardless of echoes such as these. His respect for the values and resources of classical civilization was very strong. But he also recorded his antipathy to "the Monarchy, various Churches, Lester Pearson, MacKenzie King ... the genteel, the Englishman in the colonies, or what he regarded as self-conscious cultural propaganda, Canadian, British or American."[54] Imperialism could take military or cultural form, but it was still imperialism.

Innis's cultural politics arose from a disposition broadly shared with his contemporaries: a kind of radical conservatism, opposed to centrist monopolies in politics, economics and culture, suspicious of progressivist rhetoric, and antipathetic toward the commercialization of culture, media, and knowledge (including – how perspicacious – education), so quickly transforming Canadian life. His contempt for the "mechanized vernacular" of the electronic media was directed simultaneously at American expansionism and what he perceived as the decline of democratic discourse. Though influential in U.S. academic organizations and private foundations, Innis was traumatized by Canada's continued subservience to the power of the metropolitan centre. In

his essay "The Strategy of Culture," Innis joins his voice to those urging the Canadian government to support Canadian culture. "A cultural heritage is a more enduring foundation for national prestige than political power or commercial gain," he argues. "The effects of these developments (e.g., mechanization, and the ensuing monopolies of knowledge) have been disastrous. Indeed they threaten Canadian national life."[55]

Innis's polemics are fuelled not by allegiance to national culture but by the conviction that living on the periphery creates distinct perspectives whose preservation is important to the future. He introduces a concept of reflexivity that is quite distinct from the vague principles of reflexivity central to nationalist modernism. He is not interested in the nationalist goal of reflecting a unique identity, or the modernist distancing from common perception with its reliance on conceptual and aesthetic linguistic strategies. Rather, he evokes the reflexivity acquired from living on the periphery of an imperial power and in the margins of its dominant cultural and epistemological forms. He argues that peripheral cultures must resist assimilation through the evocation and embellishment of collective memory, the preservation of local knowledge, and the liveliness of oral culture, flourishing in diverse media rather than dispersing in favour of transient technological innovations disseminated from the centre.

Innis's critical response to capitalist modernization offers a contrast to Massey's response, then, by elaborating a critical distance from the modernist nationalism conceived by other mid-century colonial intellectuals. Like Adorno, Benjamin, and other critical theorists of the Frankfurt school, Innis rejected the West's self-definition as free, rational, positively progressive, and universal in its values.[56] Like these contemporaries, he concluded that intellectual and artistic practice was responsible for the unmasking of this self-definition but that this critical mission was endangered by the market's domination of consciousness and by its corporate intrusion into the workings of democracy. "Our poets and painters are reduced to the status of sandwichmen," he complained; what he wanted was an "orderly revolt against commercialism."[57] How well this last phrase encapsulates the spirit of his time! The image uncannily echoes Quebec artists aligned with the Refus Global, who expressed their contempt for the 1950 spring salon of the Musée des Beaux-Arts by marching through the exhibition pointedly clad in sandwich boards.[58]

But Innis's polemics derived from a situation that also distinguished him from his international contemporaries. Unlike them, he found himself poised between two conflicting dispositions: the bleak, post-totalitarian, anti-scientistic, and post-enlightenment vision exemplified by Adorno's "negative dialectics," versus the more pragmatic, nation-building, culturalist modernity of his own milieu. Innis's emphasis on the space/time and centre/margin dialectic is his intellectual response to his dilemma. He calls for a phenomenological balance amongst differently "biased" media (rather than formal evolution through the purification of a single medium), which could through juxtaposition provide the balance eroded by monopolizing structures of communication. Ian Angus suggests that "this notion of balance is Innis' refor-

mulation of the idea of disinterestedness in traditional humanism. Though it is no longer suggested that one can 'rise above' the conflicts of social life, and judge them from an 'unbiased' perspective, it is argued that a balance of biases can allow a viewpoint which, in a sense, neutralises the biases of media."[59] This shifts the centre of gravity for reflexivity and critique (what Bourdieu and Angus both term "disinterestedness") away from the self-absorbed realm of modernist art, and relocates them in the social and material capabilities of diverse media. It offers a new means for evaluating political and cultural consequences of global strategies, ownership structures, and technical innovations, and for imagining and evaluating critical practices dedicated to a more emancipatory culture.

Innis's concept of space/time bias and critical balance gives us a language to talk about culture in both material and philosophical terms, a contribution that joins his work with that of Brecht, Williams, and Foucault. These theorists all examine the material production of culture and its complex imbrication with ideas, images, and the social formation. By identifying communications as a vehicle for the spatial and temporal spread of empires, Innis articulated an approach to cultural imperialism whose insights, like those of these others, have helped critics to see beyond the idealistic compulsions of the modernist paradigm. As we seek for more conscious and reflexive ways to co-inhabit this globe, Innis's insight into the modern imperialization of time and space may point us in as yet unforeseen directions. A critical and reflexive cultural politics cannot evade these issues as the art/technology/media matrix continues to evolve in the wake of modernism's demise.

NOTES

1 Recent studies include Stamps, *Unthinking Modernity*; Angus and Shoesmith, eds., Dependency/Space/Policy; Drache, introduction to Innis, Staples, *Markets and Cultural Change*; Berland, "Space at the Margins."

2 "The Bias of Communication" was first presented as a paper in 1949 and published as *The Bias of Communication*, University of Toronto Press, 1951, containing the essays "A Critical Review" (published in Innis, 1995, as "The Mechanization of Knowledge") and "A Plea for Time" (also in Innis, 1995). *Empire and Communications* was first published in 1950 (University of Toronto Press); it was republished in 1986 (introduced by David Godfrey), Press Porcepic, Victoria/Toronto.

3 The usual name for the Royal Commission on National Development in Arts, Letters and Sciences, appointed in 1949. Its report, referred to here as the Massey Report, appeared in 1951 – the same year as Innis's *The Bias of Communication*.

4 As Alison Beale put it, "The emphasis on legislation and institutions represents a constitutional history approach which is at odds with the political economy orientation often claimed by many researchers, and results in an overly-close parallel between the work of intellectuals concerned with policies, and a federal government in Canada which, until recently, was devoted to an image of itself as a provider of hardware, the common carrier" ("Harold Innis and Canadian Cultural Policy in the 1940s," 79). In other words, policy does not operate in a vacuum, but interacts with corporate actions, inter-governmental struggles and agreements, artistic and cultural formations, technological change, fiscal policies, etc. Cf. Colin Gordon, "Governmental Rationality," Burchell et al. (eds.), 36.

5 The influence of this historical climate on Innis's research on culture, technology and colonialism is taken up in J. Stamps, *Unthinking Modernity*; and J. Berland, "Space at the Margins." I attempt a fuller discussion of Canadians' fundamental ambivalence or split subjecthood in relation to American popular culture in "Locating Listening." Surveys over four decades show consistent approval for government support for Canadian culture. Broadcast ratings reveal the same proportion (70–75 per cent) watch or listen to American products.

6 CBC interview with Canadian composer Harry Somers, 17 March 1997. In 1948 Somers himself was focusing on music "as a medium in itself" rather than as "a sort of second hand medium for painting or literature" (Cherny, *Harry Somers*). But Somers was far more ambivalent on this subject than Boulez: in the same year (1948) Somers was writing music that evokes "the rugged, almost wild landscapes of northern Ontario" (liner notes, with thanks to Andra McCartney).

7 The theme of the "incomplete" identity as a motif in Canadian literary criticism is explored in Diane Theman's "Mental Treasures of the Land." The production of the incomplete citizen/subject in postmodern governmentality is the subject of Miller's *The Well-Tempered Self*.

8 The period begins in 1941 with the Kingston Conference of the new Federation of Canadian Artists (see *The Kingston Confernece Proceedings*) and ends in the 1960s, when McLuhan and his contemporaries devised a (post)modernism relevant to Canada's emergent modernity. Michael Bell's introduction to the *Kingston Conference Proceedings* offers a useful introduction to the historical context and philosophical orientation of this gathering of 150 artists, museum directors, art historians, and others, who met to discuss "the relationship of the artist to society" and the

impact of national and continental developments on that relationship. McLuhan's relationship to/impact on modernism is explained in Stamps, *Unthinking Modernity*; Kroker, "Technology and the Canadian Mind."

9 Quebec offers a different history. See, for instance, Ellenwood, 1992; Gerard Morisset, "Les arts dans la Province de Québec" in Canada, Royal Commission Studies.

10 These broad generalizations about English Canadian representations and beliefs are drawn from the the *Kingston Conference Proceedings*; *Report of the Royal Commission on National Development in the Arts, Letters and Sciences*, 1951; Leclerc, *The Crisis of Abstraction in Canada*; McInnes, *Canadian Art*.

11 Michel Foucault, "Omnes et singulatim: Towards a Critique of Political Reason," cited in Gordon, "Government Rationality," 10.

12 See *Royal Commission Studies: A Selection of Essays Prepared for the Royal Commission on National Development in the Arts, Letters and Sciences*, 1951; *Report of the Royal Commission on National Development in the Arts, Letters and Sciences*, 1951; Walter Whittaker, "The Canada Council for the Encouragement of the Arts, Humanities and Social Sciences." Paul Litt, *The Muses, the Masses and the Massey Commission*.

13 The historical connection between culture and national defence is explored by Kevin Dowler, "The Cultural Industries Policy Apparatus," in Dorland (ed.), *The Cultural Industries in Canada: Problems, Policies and Prospects*; and by J. Berland, "Culture, Politics and the Nation State," forthcoming in S. Joyce, *History of/As Cultural Studies*.

14 Litt, *The Muses, the Masses and the Massey Commission*, 17.

15 Compagnon, *The Five Paradoxes of Modernity*

16 The late 1950s are remembered for Diefenbaker's desision to quash the Avro Arrow, an innovative airplane prototype towards which American military-industrial interests were not favourably disposed. All prototypes and plans were destroyed.

17 Osborne, *The Politics of Time*, 21, 17.

18 Leclerc, *The Crisis of Abstraction in Canada*, 39. "In Canada, the repercussions of this article and the accompanying reproductions were widespread," she notes.

19 Leclerc, *The Crisis of Abstraction in Canada*, 38, 40.

20 Compagnon, *The Five Paradoxes of Modernity*, 144.

21 Cf. ibid., 51, and *passim*.

22 In the period 1945–1955 there seems to have been only one text relating art to evolution, or what Compagnon calls "genetic historicism," to gain attention from Canadian artists; this was Biederman's *Art As the Evolution of Knowledge*. Biederman was an American living in the Canadian Midwest who, Leclerc argues, influenced Molinari. The turning point for artists was Barnett Newman's influential visit to the artist's workshop in Emma Lake (Saskatchewan) in 1959 and Greenberg's in 1962 (Leclerc, *The Crisis of Abstraction*, 51).

23 Innis, "The Strategy of Culture."

24 See, for instance, McInnes (1950); his critical review of artists working in the 1940s does not emphasize innovation in form but rather reviews personal contributions (those of illustrators and designers as well as painters and sculptors) to the "development of art in Canada [which] has been interwoven with our struggle to achieve nationhood" (1950, 111). McInnes characteristically warns against excessive haste in the process, echoing Innis's warnings against haste in essays like "A Plea for Time" (1950, and *Staples, Markets, and Culture*, 1995).

26 Dexter, "Yes, Cultural Imperialism Too!" 158.

27 Leclerc remarks on their "amnesia"

regarding grants of $7.3 from the Carnegie Foundation and $11.8 million from the Rockefeller Foundation, which commonly consulted Innis as advisor in Canadian academic and cultural affairs (*The Crisis of Abstraction in Canada*, 79).

28 These are not so much "alternatives" as two sides of the same coin; as Osborne argues, "Both traditionalism and reaction are distinctively modern forces" (*The Politics of Time*, xii).

29 This displacement is the subject of my PhD thesis, "Cultural Re/Percussions," (1986) which is concerned specifically with music. McInnes's *Canadian Art* confirms the argument. McInnes discusses contemporary work in painting, sculpture, book illustration, graphic design, architecture, and political cartoons as though these forms of visual culture are equally deserving of aesthetic criticism and evaluation. Clearly the postwar formation and disciplinary practices of professional artistic organizations had not yet altered the perimeters of critical discussion. Similarly, McInnes does not employ the evolutionary language of early modernism to evaluate or valorize artists; in the 1940s that was more likely to be found in Quebec than in English Canada. I am indebted to Rosemary Donegan for advice and discussion on this subject.

30 Globerman, *Cultural Regulation in Canada*, 41. Globerman argues that this is a fallacious comment used to justify state intervention where open market regulation would be more effective.

31 National Arts Centre, "A Climate of Creativity," Ottawa, 1982, 6.

32 Pearson, *The State and the Visual Arts*, 43.

33 For a small but representative sample of Arnold critiques, see Thierry du Duve, "Back to the Future: The Sequel," in Berland, Straw, and Tomas, eds., *Theory Rules*; James Clifford, "On Collecting Art and Culture," Raymond Williams,

"Politics and Policies: The Case of the Arts Council," in Williams, *The Politics of Modernism*.

34 Clifford, "On Collecting Art and Culture," 64.

35 Calinescu's *Five Faces of Modernity*, Williams's *Politics of Modernism*, and Compagnon's *The Five Paradoxes of Modernity* all discuss modernism's complex relationship to cultural tradition.

36 Williams, *Politics of Modernism*, 147.

37 Ibid.

38 Dorland, 'Policing Culture," Pearson, *The State and the Visual Arts*, 81–2. Miller, in *The Well-Tempered Self*, offers a longer discussion of governmentality in cultural policy.

39 Bourdieu, "The Aristocracy of Culture," 234, *passim.*

40 Cited in ibid., 236.

41 Ibid., 234, 235.

42 Ibid., 237.

43 Williams, *The Politics of Modernism*, 145.

44 McLuhan, *The Medium Is the Message*, 68. "For McLuhan, a critical humanism, one which dealt with the 'central cultural tendencies' of the twentieth century, had to confront the technological experience in its role as environment, evolutionary principle, and as second nature itself" (Kroker, *Technology and the Canadian Mind*, 62). McLuhan's approach represents both a continuation (its emphasis on evolutionary form) and a reversal (its focus on the experience of technology) of the immediately preceding generation of Canadian modernists.

45 Foucault, *Language, Counter-Memory, Practice*, 200.

46 "Government," Foucault explains, "is defined as a right manner of disposing things so as to lead not to the form of the common good, as the jurists' texts would have said, but to an end which is 'convenient' for each of the things that are to be governed. This implies a plurality of specific aims" ("Governmentality," *The Foucault Effect*, 95).

47 Williams, *The Politics of Modernism*, 146–7.
48 Litt, *The Muses, the Masses and the Massey Commission*, 17, 19.
49 Innis, "Minerva's Owl," cited in Stamps, *Unthinking Modernity*, 93.
50 Hobsbawn, "Nationalism," 400.
51 Compagnon, *The Five Principles of Modernity*, xvi–xvii.
52 Cf. Kroker, *Technology and the Canadian Mind*, 118–23.
53 Innis, *A Strategy for Culture*, 2.
54 Beale "Harold Innis and Canadian Cultural Policy in the 1940s," 79.
55 Innis, *The Strategy of Culture*, 2, 18–19.
56 Stamps, *Unthinking Modernity*, 27–8.
57 Innis, *A Strategy for Culture*, 16, 13.
58 Ray Ellenwood, Introduction to Bourduas, *Refus Global*, 14.
59 Angus, "Orality in the Twilight of Humanism," 29.

BIBLIOGRAPHY

Angus, Ian. "Orality in the Twilight of Humanism: A Critique of the Communication Theory of Harold Innis." In Angus and Brian Shoesmith, eds., "Dependency/Space Policy: A Dialogue with Harold A. Innis." Special issue of *Continuum: Australian Journal of Media & Culture*. 7, no. 3 (1993): 16–42.

Beale, Alison. "Harold Innis and Canadian Cultural Policy in the 1940s." In Ian Angus and Brian Shoesmith, eds., "Dependency/Space/Policy: A Dialogue with Harold A. Innis." Special issue of *Continuum: Australian Journal of Media & Culture*. 7, no. 1 (1993): 75–90.

Berland, Jody. "Culture Re/Percussions: The Social Production of Music Broadcasting in Canada." PhD Thesis, York University 1986.

– "Locating Listening: Popular Music, Canadian Space, Technological Mediation." In David Matless et al., eds., *The Place of Music*. New York: Guilford Press, 1997.

– "Space at the Margins: Critical Theory and Colonial Spatiality after Innis," *Topia: Canadian Journal of Cultural Studies* 1, no. 1 (1997): 55–82.

– Will Straw, and David Tomas, eds, *Theory Rules: Art As Theory, Theory and Art*. Toronto: University of Toronto Press and YYZ Books, 1996.

Biederman, Charles. *Art As the Evolution of Knowledge*. Minnesota: n.p., 1948.

Borduas, Paul-Emile. *Refus Global*. Trans. Ray Ellenwood. Toronto: Exile Editions 1985.

Bourdieu, Pierre. "The Aristocracy of Culture." *Media, Culture and Society* 2, (1980): 225–54. Reprinted in Richard Collins, James Curran, Nicholas Garnham, Paddy Scannel, Philip Schlesinger, and Colin Sparks, eds., *Media, Culture and Society: A Critical Reader*. London: Sage Publications 1986.

Burchell, Graham, Colin Gordon, and
Peter Miller, eds. *The Foucault Effect:
Studies in Governmentality*. Chicago:
University of Chicago Press 1991.

Calinescu, Matei. *Five Faces of Modernity*.
Durham: Duke University Press 1987.

Canada. *Report of the Royal Commission on
National Development in the Arts,
Letters and Sciences*. Ottawa, Edmond
Cloutier: Printer to the King's Most
Excellent Majesty 1951.

Canada. *Royal Commission Studies: A
Selection of Essays Prepared for the
Royal Commission on National
Development in the Arts, Letters and
Sciences*. Ottawa: Edmond Cloutier,
Printer to the King's Most Excellent
Majesty 1951.

Clifford, James. "On Collecting Art and
Culture." In Simon During, ed., *The
Cultural Studies Reader*. London:
Routledge 1993.

Compagnon, Antoine. *The Five Paradoxes
of Modernity*. New York: Columbia
University Press 1994.

De Duve, Thierry. "Back to the Future:
The Sequel." In Jody Berland, Will
Straw, and David Tomas, eds., *Theory
Rules: Art As Theory, Theory and Art*.
Toronto: University of Toronto
Press/YYZ Books 1994.

Dexter, Gail. "Yes, Cultural Imperialism
Too!" In Ian Lumsden, ed., *Close the
49th Parallel*. Toronto: University of
Toronto Press 1970.

Dorland, Michael. "Policing Culture:
Canada, State Rationality, and the
Governmentalization of
Communication." (This volume.)

Dowler, Kevin. "The Cultural Industry
Policy Apparatus." In Michael
Dorland, ed., *The Cultural Industries
in Canada*. Toronto: James Lorimer
1996.

Ellenwood, Ray. *Egregore: A History of the
Montreal Automatist Movement*.
Toronto: Exile Editions 1992.

Fethering, Douglas, ed. *Documents in
Canadian Art*. Peterborough:
Broadview Press 1987.

Foucault, Michel. *Language, Counter-
Memory, Practice*. Donald Bouchard,
ed. Ithaca: Cornell University Press
1977.

Globerman, Steven. *Cultural Regulation in
Canada*. Montreal: Institute for
Research on Public Policy, 1983.

Innis, Harold. *The Bias of Communication*.
Toronto: University of Toronto Press
1951.

– *The Strategy of Culture*. Toronto:
University of Toronto Press 1952.

– *Staples, Markets, and Cultural Change*.
Selected Essays. Daniel Drache, ed.
Montreal & Kingston: McGill-Queen's
University Press 1995.

Joyce, S., ed. *History of/As Cultural Studies*.
New York: Routledge 1998.

The Kingston Conference Proceedings,
Kingston: Agnes Etherington Art
Centre, Queen's University 1991.

Kroker, Arthur. *Technology and the
Canadian Mind: Innis/McLuhan/
Grant*. Montreal: New World Books
1984.

Leclerc, Denise. *The Crisis of Abstraction in
Canada*. Ottawa: National Gallery of
Canada 1992.

Litt, Paul. *The Muses, the Masses and the
Massey Commission*. Toronto:
University of Toronto Press 1992.

McInnes, Grant. *Canadian Art*. Toronto:
University of Toronto Press 1950.

McLuhan, Marshall, and Quentin Fiore.
The Medium Is the Message. New York:
Simon and Schuster 1989.

Miller, Toby. *The Well-Tempered Self:
Citizenship, Culture, and the
Postmodern Subject*. Baltimore: Johns
Hopkins University Press 1993.

National Arts Centre. *A Climate of
Creativity*. Brief to the Federal Cultural
Policy Review Committee 1982.

Osborne, Peter. *The Politics of Time:
Modernity and Avant-Garde*. London:
Verso 1995.

Ostry, Bernard. *The Cultural Connection:
An Essay on Culture and Government
Policy in Canada*. Toronto: McClelland
and Stewart 1978.

Pearson, Nicholas. *The State and the Visual Arts. A Discussion of State Intervention in the Visual Arts in Britain, 1760–1981.* Milton Keynes: Open University Press 1982.

Stamps, Judith. *Unthinking Modernity: Innis, McLuhan, and the Frankfurt School.* Montreal & Kingston: McGill-Queen's University Press 1995.

Theman, Diane Lynne. "Mental Treasures of the Land: The Idea of Literary Resource Development in Nineteenth-Century English Canada." PhD Thesis, York University 1996.

Whittaker, Walter Leslie. "The Canada Council for the Encouragement of the Arts, Humanities and Social Sciences: Its Origins, Formations, Operation and Influence upon Theatre in Canada, 1957–1963." PhD Thesis, University of Michigan 1965.

Williams, Raymond. *The Politics of Modernism: Against the New Conformists.* London: Verso 1989.

Willis, Anne-Marie. *Illusions of Identity: The Art of Nation.* Sydney: Hale & Iremonger 1993.

Intersection

Ron Wakkary

DIE CUT

Plan detail in elevation for intersection. The drawing shows the placement of a one inch hole through a marble paneled wall and concrete.

ANCHOR
EXISTING MARBLE AND GRANITE PANELS
CONCRETE
CENTERLINE OF 1 DIA HOLE DRILLING AS PER LOCATION ON PLAN AND ELEVATION
HOLE

Anthony Camplens Architect

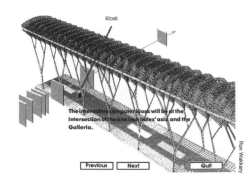

A still from the interactive computer program from Intersection.

Kiosk

The interactive computer kiosk will be at the intersection of the one inch holes' axis and the Galleria.

Previous Next Quit

Ron Wakkary

Intersection is the drilling of one inch holes through and the placing of a computer interactive program in the BCE Place complex in Toronto.

The BCE Place contains 2.4 million square feet of office space in two office towers: the Canada Trust and Bay Wellington towers. These buildings are joined by a 380 foot long and sixty storey tall, glass-roofed thoroughfare. These atria known as the *Galleria* and *Heritage Square* offer 125 000 square feet of retail space. **Intersection** will be near the Bay Street entrance of the *Galleria*. There will be approximately 20 one inch holes in a variety of materials (sheet rock, marble, glass, concrete, wood and metal). The one inch holes will be 60 inches above the floor, traversing

DIE CUT

approximately 360 feet along an axis that is perpendicular to the direction of the *Galleria*. The interactive computer program will be at the intersection of the one inch holes' axis and the *Galleria*. A small kiosk will house the *Macintosh Color Classic* or *LC575* computers that will run the program. The interactive computer program explains to the viewer the inconspicuous sculpture element and **Intersection's** relation to the BCE Place complex.

The BCE Place, in particular, Santiago Calatrava's *Galleria* is premised on sight. The *Galleria's* repetitious detail, homogenous materials and one point perspective render it flat. This increases the visual rush as it gives up its interior in a virtual instant. The view depicts a present of technological and economical ease against a fictional and idealized past. The corporate town square is not a new oxymoron but it reaches a new level of success here. The one inch holes of **Intersection** are based on the peephole. It is the scopophilic view as an alternative to the *Galleria* spectacle, where you must bend down or push up against the wall to see what you are not allowed to see.

This book version of **Intersection** is based on blindness not sight. There is no view of the *Galleria* from here. The DIE CUT instructions are for the printer to register and cut a one inch hole in six pages. These instructions are not to be seen by the reader. However, chances are the printer and editors will be blind to the instructions (for financial reasons) and make available to the readers something that they should not see.

Ron Wakkary
June 1994

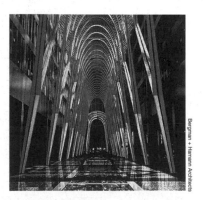

A computer generated image of the interior of the Galleria by Santiago Calatrava, BCE Place, Toronto. Bergman + Hamann Architects and Skidmore, Owings & Merrill Architects were the architects.

Bergman + Hamann Architects

Aesthetics in the Age of Global Markets

Monopolies of Censorship: A Postmodern Footnote to Innis

John Fekete

Postmodernism, Ethics, and Aesthetics in the Age of Global Markets

Thierry de Duve

The Old Age of Art and Money

Paul Mattick, Jr

Monopolies of Censorship:
A Postmodern Footnote to Innis

John Fekete

The hundredth anniversary of the birth of Harold Innis is celebrated in 1994 as a noteworthy occasion in Canada. Innis was surely one of the seminal Canadian thinkers, and not only in political economy where his work on staples began but also in the field of cultural history and theory where his inquiries on the technological staple economy of communications led him. Canada has a second Group of Seven, a collection of distinguished thinkers that includes, in addition to Innis, Marshall McLuhan, George Grant, Eric Havelock, Charles Cochrane, C.B. MacPherson, and Northrop Frye. Only Havelock is still alive, and only McLuhan and Frye have so far found places in such critical canons of cultural intelligence as the new *Johns Hopkins Guide to Literary Theory and Criticism*.[1] The pioneering intellectual achievements of these giants, however, in spite of relatively slow international recognition, continue today to ground a genuinely innovative Canadian intellectual discourse on culture and civilization. As we try to negotiate the many imposing transactions between postmodernism and the cultural legacy of modernity, these voices continue to resonate among other, more contemporary ones.

What links Innis's work at mid-century with ours at the threshold of the millennium are his profound meditation on the Canadian mixed economy and his profound insight into the patterns of cultural mutation enabled by changing technological biases. Innis was writing about the institutions of modernism, especially art and higher education, at the exact point where the Massey Commission signalled that the postwar reconstruction would see the state in the role of a friend to the arts and education against the pressures of a naked commercial economy. Accordingly, at this historical moment of governmental attacks on the public sector, cutbacks in support for galleries, moves to seize control of the internal culture of universities, and the new tide of censorship of the arts, what also separates Innis from us is the near-disintegration of the modernist covenant which had secured financial and legal supports – at arm's length, moreover – for the autonomous institutions of art and scholarship.

This collapse of a system of alliances around the values of elite culture, including the aristocratic values of noble cultivation and post-theological redemption, may link up at the macro level with the demotic influence of electronic and digital communications media and their environing power, including the postmodern decentralization of art and education into a range of non-canonical symbolic sites and exchanges. At the micro level, this collapse also links with a certain loss of confidence by artists and educators, and secondarily the public, in the *special status* of those institutions of creativity and learning to which Innis was dedicated with conviction, if not unproblematically. To him they seemed to be critical sites of resistance against the commercial onslaught of the American empire and therefore possible institutional sites for the recovery of a viable public sphere.[2]

To be sure, Innis, like George Grant after him, was looking at art and universities through the spectacles of Greece, and seeing as yet only early forms of that culture of simulation which is transforming symbolic activists such as ourselves into "lifeguards at the data pools."[3] But the Innis who could see brilliantly through the mask of the free press to the destruction of the freedom of speech that press freedom also entailed,[4] and who could watch the decline of censorship receding on the outgoing tides of privatizing technology,[5] is still singing to us siren-like from the rocks as the new tides of global communications once again bring censorship into the foreground of "a wired planet, burdened by information overload," to cite Marshall McLuhan.[6] But now the censors act precisely in the service of new demons, like Maxwell's famous Demon, tirelessly sorting, sorting information into the identity frames of tribal monopolies of knowledge and interpretation.

It is in Innis's spirit, with its recoil from the monopolistic pressures of fanaticism,[7] that I want to make my next few remarks about censorship and culture in the age of virtuality. I hope in this paper to offer some examples of a vigorous challenge by agencies of the state to those very institutions of art and education which for long have expected to be safe from such challenges, and to consider both the logic of such expectations of special-case security and the consequences of expectations frustrated. I want in particular to direct attention both to the disintegration of the modernist defensive shield around artistic and educational freedoms and to the contribution that postmodern artists and educators have themselves made to the de-institutionalization of modernism.

The academic year 1993–94 began for me with Canada Customs holding up at the u.s. border a work of literary art scheduled for my graduate course on interpretation – *The Man Sitting in the Corridor* by the internationally renowned Marguerite Duras – on the grounds that it was demeaning to women. These are the same people who hold up lesbian magazines on the grounds that the penis has been demeaned. In due course, after appeals and a great deal of bad press for Canada Customs, the book was released to the Trent University bookstore, but not before raising a lot of questions about the nature of the legal authority to interpret and prohibit.

In October the Ontario Ministry of Education and Training (which, following Orwell, it would be reasonable to call the Minitrain) issued its dystopian prescription for universities called *Framework Regarding Prevention of Harassment and Discrimination in Ontario Universities*. The notorious Butler decision of the Canadian Supreme Court,[8] which redefined the relations between harm and freedom of expression in connection with a criminal obscenity appeal concerned with "hard core" videotapes, had imported from the American feminist legal fringe the totalitarian notion that prevention of harm justifies bringing previously protected beliefs, attitudes, and predispositions into the orbit of legal intolerance: literally, that "the stronger the inference of a risk of harm, the lesser the likelihood of tolerance."[9] Now, in the wake of that decision, the fiction of a potential harm has become this Minitrain's formula for requiring all universities to comply immediately with its minimum policy expectations.

These expectations are spelled out in a nine-page document dedicated to a cultural razed-earth policy of "zero tolerance"[10] with respect to all of the university's employment and educational dealings. What emerges from the document is the absolute intolerance of anything that anyone might consider to be offensive, unwelcome, and inappropriate, including forms of expression such as graffiti, gestures, humour, signs, cartoons, and ordinary speech, as well as texts and educational discourse – all lumped into the same category as physical violence and sexual assault. This is a policy of cultural cleansing, where the Minitrain rolls on toward the therapeutic university and expects its censors – expects *us* as its censors – to plug up all the inevitable leaks in the rhetoricity of communication. Since the consistent application of such a policy would not only destroy the universities but also civil society, Trent faculty endorsed my statement "On Free Inquiry and Expression"[11] (figures 1 and 2) as a stand of resistance designed to protect the rights of students and faculty in this and future generations to speak freely to one another. This grass-roots initiative has spread to other universities and the "right to offend" has been finding its place on the Canadian cultural agenda as a historical novelty that has been compared to Martin Luther's far-reaching act of heresy.[12]

Finally, December brought news of the charges against artist Eli Langer for exhibiting his work at the Mercer Union, a small, private, artist-run art gallery in Toronto. Langer's thirty-five drawings and five paintings representing children engaged in sexual activity were the first artistic targets attacked under the Canadian federal government's new child pornography legislation, Bill C-128 – the same law that could hypothetically send a seventeen-year-old girl to prison for five to ten years for keeping a diary of her own sex life or sex fantasies.[13]

What these three events have in common, and in common also with the banal taxpayer fuss over the Newman and Rothko acquisitions at the National Gallery of Canada, is exactly that they all raise the question of the value of art: "what is it worth?"[14] Whether it is about art used in class, or art on public display, or the art of education, it seems that the censor's answer reaches back to the prior question: is it really art at all? Neither Kate Taylor, the *Globe and*

TRENT UNIVERSITY

December 1993 - January 1994

ON FREE INQUIRY AND EXPRESSION

We, whose names are attached below, have set forth the following public statement in order to contribute to the discussion and policy formulation currently under way at Trent with respect to issues of rights and freedoms.

Taking positive note that, according to the University's "Mission Statement," Trent's first goal is "to create a teaching, learning, research and living environment fundamentally committed to the promotion of free inquiry and expression";

Taking positive note, as well, of the affirmation of academic freedom in the Collective Agreement, as follows:

"The common good of society depends upon the search for knowledge and its free exposition. Academic freedom in universities is essential to both these purposes in the teaching function of the university as well as in its scholarship and research. Academic staff shall not be hindered or impeded in any way by the University or the Association from exercising their legal rights as citizens, nor shall they suffer any penalties because of their exercise of such legal rights. The parties agree that they will not infringe or abridge the academic freedom of any member of the academic community. Members of the academic community are entitled, regardless of prescribed doctrine, to freedom in carrying out research and in publishing the results thereof, freedom of teaching and of discussion, freedom to criticize the University and the Association, and freedom from institutional censorship. Academic freedom does not require neutrality on the part of the individual. Rather, academic freedom makes commitment possible. Academic freedom carries with it the duty to use that freedom in a manner consistent with the scholarly obligation to base research and teaching on an honest search for knowledge. The claim of academic freedom shall not excuse members from meeting the duties and responsibilities set forth [in the Terms and Conditions of Employment] provided that the allocation of such duties and responsibilities shall not conflict with principles of academic freedom."

Taking positive note, moreover, of an accelerating social project to identify and remove discriminatory barriers;

We hereby reaffirm our commitment to unrestricted academic freedom and freedom of expression and inquiry in the university community as the indispensable framework for the fulfilment of the University's mission and also as the best and most hopeful support for non-discriminatory multiculturalism and gender equality within the university milieu. Uninfringed and uncurtailed academic freedom in research, teaching, discussion, criticism, reading, writing, and publishing is the best underpinning for the work of the university and for its contribution to the social welfare of its members and to the broader good of society. It offers the most humane and effective pathway toward inclusiveness, because it includes the freedom to differ, the freedom to disagree, and the freedom to get things wrong now and then. More and better than any of the available alternatives, it protects diversity and equality in a complex social ecology. By contrast, censorship, and other

Figure 1: Trent University, December 1993–January 1994, "On Free Inquiry and Expression"

prohibitions on the freedom of expression, even if intended to promote harmony, are still forms of constraint that improperly limit the circulation of information and expression which are the lifeblood of higher education.

Without limiting the preceding, we affirm in particular the following:

1. We urge the University to lead, not in the restriction of free speech and academic freedom, but in its defense. Self-reforming and self-critical institutional discussion about social barriers to participation in the university's intellectual and cultural life, equitable employment, and access to social justice are recognized features of university life, and themselves depend on discursive freedom, which therefore should not be abridged in the process of discussion or as a result of it. The University should defend democratic freedoms, for itself and for others, especially those freedoms that are most vitally necessary to its own educational mission. The restriction of expression on account of its messages, ideas, subject matter, contents, or viewpoints, including restrictions on the free availability of reading materials, must be defined as unreasonable in a democratic university. The fundamental right to express any thought, belief, or opinion, free from censorship, is an indispensable precondition for building democratic politics, cultures, and intellectual formations, for promoting equality and multiculturalism in a complex milieu, and for articulating the self-fulfilment of associated individuals. In particular, content controls--including prescribed constraints on teaching, learning, and research, with respect to course and curricular contents and with respect to the freedom of students to develop intellectual autonomy--would fatally undercut the profound social commitment to a public system of higher education that is uninhibited, robust, and wide-open.

2. We defend, therefore, the right to certain types of speech and academic expression which, in fact, we do not condone, and in some cases deplore. This includes the right to offend one another. It includes the right to express--and the right of access to intellectual materials which express-- racially, ethnically, or sexually discriminatory ideas, opinions, or feelings, just as it includes the right to expressions that favour inequality of incomes or benefits. It also includes the right to make others uncomfortable, to injure, by expression, anyone's self-esteem, and to create, by expression, atmospheres in which some may not feel welcome or accepted. A general right not to be subjected to such expression would undermine the right to question cherished assumptions that may be important for someone's comfort, complacency, affiliations, or identifications, and would cripple intellectual inquiry. It includes, moreover, the right to use language in any traditional, quaint, or dated manner, because the regulation of such expression would both contravene the principle of free expression and also stifle legitimate debate on the proper relationship of language to social progress.

3. We accept, simultaneously, that the protection of these rights does not preclude the-circulation of any information, whether stimulated by a particular occasion or systematically authorized and directed as part of an informational or educational program, which aims to challenge, criticize, or condemn any of the sorts of expression covered above. Nor do we wish to preclude either discussion on the desirability, effectiveness, or appropriateness, of any sort of expression, or the option of individuals to confront, complain about, or demonstrate against someone's expressions without fear of academic or administrative reprisals.

NOTE: Three academic units (Cultural Studies, Mathematics, and Spanish) have adopted this statement as their policy since December 2, 1993. Other programs and departments are scheduled to discuss the statement in the near future. In addition, as of January 6, 1994, more than one third of Trent's full time faculty on site have personally signed the statement. This includes both senior and junior professors, male and female, from across the university, winners of teaching and research awards, chairs, former presidents and vice-presidents. For further information, please contact Prof. John Fekete, Cultural Studies. 705-748-1771. Fax: 705-748-1795. E-mail: jfekete@trentu.ca.

Figure 1: Trent University, December 1993–January 1994,

"On Free Inquiry and Expression"

Names of Trent Faculty and Librarians Attached to the Statement "On Free Inquiry and Expression," as of Jan.22, 1994

This is an ongoing, open list, mostly of full time on-site faculty--of whom more than 40% are found below. Any full or part time Trent faculty member or librarian who wishes to attach her/his name to the others is cordially invited to get in touch with John Fekete as soon as possible, at PRC, 748-1771, or email: jfekete@trentu.ca. This list is also available, and will be updated, on Trent University gopher, at Faculty Organizations/.

Professor G. D. Aitken, *M. L. & L. (Spanish)*
Professor R. G. Annett, *Chemistry*
Professor M. Arvin, *Economics*
Professor P. Bandyopadhyay, *Comp. Devel. St.*
Professor Z. Baross, *Cultural Studies*
Professor S. Bilaniuk, *Mathematics*
Professor F. A. Bleasdale, *Psychology*
Professor J. Bordo, *Cultural Studies*
Professor C. V. Boundas, *Philosophy*
Professor S. Brown, *English Literature*
Professor A. G. Brunger, *Geography*
Professor J. Buckman, *English Literature*
Professor J. Buttle, *Geography*
Professor R. D. Chambers, *English Literature*
Professor I. C. Chakravartty, *Mathematics*
Professor L.. Clark, *English Literature*
Professor I. G. Cogley, *Geography*
Professor D. C. A. Curtis, *Economics*
Professor P. C. Dawson, *Physics*
Professor R. J. Dellamora, *English Literature*
Professor V. de Zwaan, *Cultural Studies / Eng. Lit.*
Professor T. Drewes, *Economics*
Professor G. D. Eathorne, *English Literature*
Mr. S. R. Elliott, *Library*
Professor C. H. Ernest, *Psychology*
Professor D. Evans, *Env. & Res. St. / Watershed Ecosys*
Professor W. Evans, *Env. & Res. St. / Physics*
Professor J. A. Fekete, *Cultural Studies / English Lit.*
Professor C. I. Fewster, *M. L. & L. (German)*
Mr. K. Field, *Library*
Professor F. Garcia-Sanchez, *M. L. & L. (Spanish)*
Professor R. M. Garrido, *M. L. & L. (Spanish)*
Professor D. Glassco, *English Literature*
Professor S. Guy-Bray, *English Literature*
Professor M. Gunther, *Political Studies*
Professor G. F. Hamilton, *Mathematics*
Professor P. F. Healy, *Anthropology*
Professor H. S. Helmuth, *Anthropology*
Professor J. P. Henniger, *Mathematics*
Professor B. J. Hodgson, *Philosophy*
Professor D. Holdsworth, *Env. & Res. St.*
Professor V. Hollinger, *Cultural Studies*
Professor M. Horban, *M. L. & L. (French)*
Professor R. G. Johnson, *Physics*
Professor S. H. W. Kane, *Cultural Studies / English Lit.*

Professor S. L. Keefer, *English Literature*
Professor Emeritus D. Kettler, *Political Studies*
Professor K. H. Kinzl, *Classical Studies*
Professor P. Lafleur, *Geography*
Professor H. B. Lapointe, *M. L. & L. (French)*
Professor J.-P. Lapointe, *M. L. & L. (French)*
Professor E. G. Lewars, *Chemistry*
Professor D. G. Lowe, *Psychology*
Professor R. E. March, *Chemistry*
Professor C. D. Maxwell, *Biology*
Professor E. A. Maxwell, *Mathematics*
Professor C. McKenna-Neuman, *Geography*
Professor I. McLachlan, *Cultural Studies / English Lit.*
Professor W. Morrison, *Mathematics*
Professor T. N. Murphy, *Mathematics*
Professor R. M. Neumann, *Philosophy*
Professor Emeritus T. E. W. Nind, *Mathematics*
Professor E. Nol, *Biology*
Professor T. A. Noriega, *M. L. & L. (Spanish)*
Professor P. J. Northrop, *Computer Studies*
Professor F. Nutch, *Sociology*
Professor M. A. Peterman, *English Literature*
Professor Z. Pollock, *English Literature*
Professor R. Ponce-Hernandez, *Env. & Res. St. / Geog.*
Professor G. T. Reker, *Psychology*
Professor S. Regoczei, *Computer Studies*
Professor S. T. Robson, *History*
Professor P. Royle, *M. L. & L. (French)*
Professor I. M. Sandeman, *Biology*
Professor R. G. Setterington, *Psychology*
Professor D. L. Smith, *M. L. & L. (Spanish) / Cult. St.*
University Professor D. F. Theall, *Meth. / Cult. St. / En*
Professor Y. Thomas, *M. L. & L. (French)*
Professor J. Tinson, *Classical Studies*
Professor F. Treadwell, *M. L. & L. (French)*
Professor J. M. Treadwell, *English Literature*
Professor F. B. Tromly, *English Literature*
Professor J. M. Vastokas, *Anthropology*
Professor P. Watson, *Psychology*
Professor A. L. Wernick, *Cultural Studies*
Professor T. Whillans, *Env. & Res. St.*
Professor N. Whistler, *English Literature*
Dr. John A. Wiseman, *Library*
Professor P. T.-P. Wong, *Psychology*
Professor B. Zhou, *Mathematics*

Figure 2: Names of Trent faculty and librarians attached to the statement "On Free Inquiry and Expression," as of 22 January 1994

Mail art critic (in spite of what strikes me as her excessive praise for the "gorgeous" technical execution of Langer's work), nor the art police seem to have accepted Langer's work as art.[15] Bill C-128 provides an artistic exemption (which will now have to be a defence).[16] Although Canada's record of censorship is bad – James Joyce's *Ulysses* was not permitted to circulate until the year of Innis's death in 1952 – there has not been courtroom persecution of art under the obscenity laws for some years. In both the Customs Canada treatment of the Duras work and the Toronto police treatment of Langer, the shared element is that the censor's moral override simply bypassed the instituted and much fought for legal protections for art. The same override is now expected – should the Ontario Ministry of Education and Training's intervention succeed[17] – to expose the previously protected independence of universities to the moral certainties of its censors.

What is crucial to ask here is this: Who has the authority to decide what is to be protected under the rubric of "art" or "higher education?" In the words of Trent University's officials, protesting the customs decision on Duras, they rely on the authority of professors, not the censors, to decide whether a text is worth the special-case protection. The answer from the art institution is the same: What is art is properly decided by it alone. Keith Kelly, the national director of the Canadian Conference of the Arts, says: "If it's a professional artist working in a professional art institution, one can assume there is artistic merit."[18]

But who is "one," and on what basis is the special status claim to be made? In all these cases, the university and the other symbolic managers make the claim on the basis of the "seriousness" of the work – "A serious exploration of the human psyche," say the directors of the Mercer Union.[19] The identical defence of Duras is made by the university, as indeed the serious pursuit of knowledge has been the traditional basis for the corporate claim of academic freedom. And why not? Except that this high seriousness, in all its pedigree, is precisely the claim of high modernism, entrenched in the much-maligned Arnoldian traditions of canon formation on the principle of the highly serious cultivation of the best in culture. This is the founding claim for the institutional self-enclosure of the institutions of art and education, and of the economy of value that supports their special status. And the challenge to such a claim, or at least to the self-evidence of such a claim, is certainly an indication of the ongoing process of the de-institutionalization of modernism.

But this challenge also highlights a deep dilemma for the artistic and university communities. Militant postmodernist challenges to institutions of art and education erected on modernist legitimating principles have been the order of the day for nearly two decades, from *within* these institutions. The paradox is that the very success of these challenges has left the institutions of art and education more porous to social forces and relatively defenceless against moral and legal attacks from everyday culture. Martin Jay, for example, argues that the modernist claims have been hollowed out by recognition of their contingency.[20] Critical sociologists have contended that the arts are rooted in and help maintain the system of social distinction, in which they

function merely as cultural capital. This hollowing is supported by the relentless pressure from the avant-garde in the arts to reintegrate the arts and everyday life. The aim, to be sure, has always been to set up a one-way street wherein art would emancipate life. But the results are tending toward an unexpected symmetry, a two-way street at the very least, where the arts are in fact mobilized as designer principles in the retooling of promotional culture. Meanwhile the mores of industrial society invade and submerge the arts, washing away their protective shields.

As we know, both critical sociology and poststructural deconstruction have worked their way into the most secret recesses of the house of modernism, only to expose it as part and parcel of the architecture of the world. Both have offered to show, again and again, in education as in art, that truth and knowledge are tainted. The utopian promise of happiness from special cultivation is seen to be uncashable; the redemptive message of the privileged forms of exchange, that we should not settle for cheap happiness, is seen to be an illusory by-product of living on embezzled accounts. The very claim of seriousness has been brought under fatal attack. In the uniquely adversarial culture of capitalist societies – the only societies that have not, until recently, produced an apologetic culture that would defend the main institutions of the social formation – the claims of artistic seriousness have always been legitimated as criticisms of life. Now, they are revealed as nothing more, after all, than the missing culture of apologetics: high culture as the dominant culture, the ideological gatekeeper of privilege!

How, then, after all this porousness, can a defence based on modernist principles be re-employed to revive the dense protective shields – legal and financial – around higher education and the arts? Can we rely on self-conscious duplicity, on presenting to the external world on behalf of artistic and educational freedom arguments that are no longer credible, at least not in their naive forms, within the institutions of art and education? Some theorists of this dilemma[21] suggest trying something of this sort: perhaps a fake-modernist defence, which borrows the concept of "strategic essentialism" from feminist usage in order to propose that art and education are collective realms that *do* exist naturally, independent of mundane values and interests, and should be protected from subordination to damaging external forces. Or a fake-sociological defence, built on the tautology that if art continues to function successfully as cultural capital, then it remains rooted in social conditions and deserves to have its continued success protected. Or, finally, a fake free-speech-in-general defence, throwing the arts and education on the direct mercies of the community and its public sphere without any special-status claims, in the hope that the everyday normative arrangements will extend protection to the transgressive symbolic actions of previously protected networks of symbolic exchange.

I suspect that this is wishful thinking, doublethink. Neither artists nor educators can organize their public legitimating discourses in bad faith. This is difficult even in the short run. In the long run, the (postmodern) mission

statements and analytic frames produced and promoted by artists and academics cannot be radically at odds with their (modernist) justificatory arguments when under attack and close scrutiny. The public is not stupid. Nor is the censor likely to remain idle, precisely when the shifting of cultural boundaries brings urgency to new experiences of deviation.[22] The modernist economy can only be sustained in these terms if one continues to assume a permanent and increasingly deliberate conspiracy of elites linking the institutions of cultural capital, the art market, and the state. But that brings us full circle to the indications with which we began: that all this is in the process of unravelling. I will leave this paradox for now in this fruitful state of irresolution, as a problem for our urgent attention, which does not at the moment have any obvious solution. Let me turn to my final observations.

Innis was always clear about the dirty puritanical secret of Canadian cultural life. That we are about to have the benefits of another spasm of the heavy "hand of Puritanism"[23] would not have surprised him, and he would have seen in it a panic reaction to the invasion of the liberal body by the new biotechnologies of the cybernetic chronotope. Metaphors and metonyms for health, environment, gender, and race take the place of the idioms of class, and the politicization of the body emerges as the fulcrum of contemporary politics and morality, as new offshoots of the deep patterns organized by cultural technologies call for new modes and targets of attention.[24] The tribal monopolies of biopolitics organized around the issues suggested above seek to capture the state to advance their positional advantage, and they are also resignified by the state to advance powers of intervention against all the residual special-case exemptions from its influence. A paradox of the current situation of the institutions of art and education – long habituated to the largesse of arm's-length public support – is that their members may soon find surfing on the waves of the cultural market more promising than taking passage on the ship of state.

Having looked back to mid-century Massey and Innis and the modernist construction and evaluation of the patterns of information, and then having reviewed a paradox of our own transitional postmodernism as that modernist edifice deconstructs under the pressures of the *fin-de-millennial* recomposition of culture and economy, perhaps we may also turn our glance tentatively to the future, or at least to the "gigantic shadows which futurity casts upon the present" (to cite Shelley's *Defence of Poetry*). If we look speculatively ahead without too much sentimentality to a global economy of information, the current cottage industry of the intellectual producer can be expected to yield not to the recovery of the more glorious and flattering images of the modernist figurations of mental life but rather to a condition of full, if not elevated, employment in some twenty-first century cultural industry.

We may see what looks like a dystopian picture: artists and intellectuals in the roles of word processors, image managers, signal designers, system coders, and symbol analysts. In the universities, intellectuals may come to act like honest tellers at the information banks, counter clerks in the knowledge business.[25] In these guises, most are likely to find their roles as stage hands and bit

players on the virtual stage, processing and reprocessing the cultural archive and what Northrop Frye called the symbolic forms of human desire. The work to be performed will be the large work of the retrieval of the analog data of traditional culture, its images, values, and meanings, and then the transformation of these signs into digital commodities. In doing this, even as hired help for global corporate capital, however, the decanonized image managers will be actually storing up the collective memory now consigned to external storage in external brain cells. The processing work of maintenance and preservation, meanwhile, will amount simultaneously to the processing of the cultural worker by the consumer simulacra of technological society in its virtual phase.

McLuhan saw clearly that the exteriorization of the unconscious mind was the mark of the new era; we might say that the formation of exponentially augmented new memory-storage systems is an evolutionary leap beyond the ages of dependency on biological memory and the aid of transport-dependent inscriptions. The enhancement of broadcasting, with its space bias, and the enhancement of recording, with its accumulation of time, are both by-products of the electronic and digital technologies which, finally, are neither speech nor writing, and which reconfigure the effects of both those forms of linguistic expression.[26] Innis's "Footnote to the Massey Report"[27] outlined an epic mission for intellectuals and artists: to articulate their visions of significance and to transmit these "as an imperishable record to posterity."[28] As an answer to his plea for time, global capital based on microchips will make this recording a matter of daily practice.

As space and time are globalized in a manifold equilibrium, and as the explicit censorship of external memory perhaps comes to be regarded as akin to a surgical lobotomy, utopian questions of the kind that occupied both McLuhan and Innis will still remain to be asked anew. What can be done to assure that the artists and intellectuals who have left the special protections of the ivory towers have access to and presence in the control towers, and that the shapes of human community are not abandoned entirely to the biases of the technological process? In the speculative frame, as in time present, utopian answers to utopian questions cannot be guaranteed, and indeed may not be desirable, inasmuch as they may tend to mortgage the play of the future to the seductions of the present. At the same time, it may be that the decentring mechanisms of the impersonal market form, ever recycling the contents of modern culture, may offer the consolations of recognition to the cadres of modernist art and education, even once the privileges of special place have to yield to what is merely differential commodification for differential markets. This may be more than the state can or should be asked to underwrite on its own. Paradoxical as it may seem, re-raising the question of a self-reforming polity in this frame is also re-raising the question of culture and capital once more.

NOTES

1 According to the jacket, the *Guide* is "designed to serve as an international, encyclopedic guide to the important figures, schools, and movements" in an influential and expanding area of study, which includes such currents of thought and expression in the humanities and social sciences as postmodernism, feminism, new historicism, hermeneutics, cultural studies, deconstruction, and semiotics. It is an impressive work, especially as a snapshot of a consolidating moment in theory, which is why its gaps are as much worth noting as its actual offerings.

2 Innis saw art as "a buttress for talent against wealth" (*Idea File*, 16/2), and praised its "civilising effects" (ibid., 28/12) even while recognizing that the interest that democracies could be expected to take in (what he saw as) the elite arts was "niggardly" (ibid., 27/83). In a similar vein, Innis argued for the importance of universities as centres of openness that might be capable of resisting the various impulses toward the monopolistic closure of speech, expression, and thought – i.e., precisely as centres "where one has the right and duty not to make up one's mind" (ibid., app. A, 269). His commitment to the university for its potential to function as a place of expanding freedom, or as an open public sphere, is all the more significant in light of the many abuses of this potential that he describes in the *Idea File* and other texts – abuses from practical imperatives, restrictions of points of view, the flattening effects of democratization, the excessive pressures of religion, commerce, and finance, the menacing transgressions of university traditions by professional education, and generally the "inability to secure common ground" in the face of the kinds of communication, nationalism, and emphasis on regional civilization promoted by "machine industry" (ibid., 267–73).

Innis's critique of monopolies of knowledge and Michel Foucault's reworking of the Baconian tradition of linking power and knowledge both converge on the critical view of expertise and specialization, which among other things means, in an age of commodities, the dependence of non-specialists on external sources for their supply of knowledge. As Jim Carey notes (*Communication*, 169), "The new media centralize and monopolize civic knowledge and, as importantly, the techniques of knowing. People become 'consumers' of communication as they become consumers of everything else, and as consumers they stand dependent on centralized sources of supply." Innis placed his hopes, here as always, in the oral tradition, which would be harder to monopolize if supported vigorously in the universities, in the form of the unrestricted circulation of speech protected by academic freedom.

3 Luke, *Screens of Power: Ideology, Domination, and Resistance in the Informational Society*, 252.

4 Innis, *Changing Concepts of Time*, 65 and passim. One of Innis's most intriguing obsessions, developed in essay after essay of his *Changing Concepts of Time*, was his sense of discovery about the damaging effects of new media on creative thought. He was particularly hostile to the press, which he saw as the spearhead of the American commercial penetration of Canadian culture. His resistance to advertising in American magazines was clearly a forerunner of the nationalist protectionism with respect to Canadian cultural publications that has survived even the Free Trade agreements to some extent.

In "The Strategy of Culture," Innis writes (15): "The overwhelming pressure of mechanization evident in the newspaper and the magazine has led to the creation of vast monopolies of communication. Their entrenched positions involve continuous,

systematic, ruthless destruction of elements of permanence essential to cultural activity." Drawing on Upton Sinclair's *Money Writes!*, Innis argues that the guarantee of freedom of the press, underwritten by postal regulations, "meant an unrestricted operation of commercial forces and an impact of technology on communication tempered only by commercialism itself." And again in "Military Implications of the American Constitution" (38), he says: "The disequilibrium created by a press protected by the Bill of Rights had its effects in the Spanish American War, in the development of trial by newspaper, and in the hysteria after the First World War." And in "Roman Law and the British Empire" (65): "The effect of freedom of the press on the position of the citizen in Congress and in the courts has been disastrous … True freedom of speech has become a mockery." Innis notes that the effects of this on Canada have been "pernicious," and "evident in all the ramifications of Canadian life." See *Changing Concepts of Time*, "The Strategy of Culture: With Special Reference to Canadian Literature – A Footnote to the Massey Report" (19). Partly, he means that American advertising and commercial pressures create a new monopoly of American values and standards, which erode the European value traditions and the transatlantic connections that Innis prefers to promote. But also, in terms of his favourite themes, as he puts them in "The Press, a Neglected Factor in the Economic History of the Twentieth Century," linear, quantitative time comes to obscure qualitative differences and discontinuities, as advertisers place information before large numbers of people at the earliest moment, piggybacking on the hunger for news. In short, "Freedom of the press as guaranteed by the Bill of Rights in the United States has become the great bulwark of monopolies of time" (108).

5 From "The Strategy of Culture" (11): "Decline of the practice of reading aloud led to a decline in the importance of censorship. The individual was taken over by the printing industry and his interest developed in material not suited to general conversation." Mass culture is bringing renewed interest in censorship of all kinds, from the most blatant to the most subtle.

6 McLuhan, *Empire and Communications*, vii.

7 Innis's *The Bias of Communication* concludes with an appendix on "Adult Education and the Universities," which is an appeal to the ideal of the "open mind." He calls on universities "to produce a philosophical approach which will constantly question assumptions, constantly weaken the overwhelming tendency, reinforced by mechanization, to build up and accept dogma, and constantly attempt to destroy fanaticism" (210). It is in this release and focusing of mental energy that Innis finds the vitality of the universities' special contribution to society. Although the anti-monopolistic formulation here is typically modernist, it remains readily available to a postmodernist reformulation as well, in terms of providing support for diversity and difference – though not for the tribal pressures from "irreconcilable minorities" (of church, army, state, or other groups) that seek to achieve domination (*Idea File*, app. A, 272).

8 Supreme Court of Canada, *Donald Victor Butler v. Her Majesty the Queen*.

9 Supreme Court, 4.

10 The Ministry's *Framework* policy document opens, under the heading "Purposes," with the following: "The Government of Ontario has adopted a policy of zero tolerance of harassment and discrimination at Ontario's universities. This document provides the institutions with a framework that sets

out the elements for institutional policies" (1). A little further, under the heading "Policy Statement," the document provides the following gloss on the concept of zero tolerance: "The general goal of the policy should be zero tolerance, that is, harassment and discrimination as defined by the policy will not be tolerated by any university in its employment, educational, or business dealing" (3).

The "zero tolerance" concept appears to have originated in the Reagan presidency's war on drugs, and to have become since then a convenient political formula for expressing blanket disapproval of selected (and quite varied) targets. In the current situation, it was the Harassment Task Force of the Ontario Council of Regents that first proposed a zero tolerance policy to the government in May 1992, in its *Report on Harassment and Discrimination in Ontario Colleges of Applied Arts and Technology*. This report has remained the ministry's model of "best practices" (1). Apart from the sinister historical echoes of governments taking command of universities' "educational" dealings, the actual correlatives of "as defined by the policy" are sweeping definitions and examples of objectionable expression, resting on strictly subjective, complainant-based criteria, Draconian penalties for offences caught under the policy, and the clear risk of legal liability for institutions that fail to police their domains sufficiently effectively to "prevent" offences. In this respect, by removing or sharply curtailing institutional discretion, the policy encourages both prior restraint and subsequent sanctions.

11 Fekete, "On Free Inquiry and Expression," December 1993. At Trent, this statement was approved by five departments acting as a whole (Cultural Studies, English Literature, Mathematics, Spanish, and the graduate program in Methodologies for the

Study of Western History and Culture), as well as by 40 per cent of full-time faculty, acting as individual signatories. During the course of the 1993–94 academic year, the moral force of this grass-roots faculty initiative produced the retreat of the administration from the zero tolerance approach to policy (to which it had been publicly committed as late as December 1993), as well as wide faculty endorsement (through Faculty Council and the Trent University Faculty Association) of the position that any thought, opinion, belief, and expression protected *outside* the university by the Canadian Charter of Rights and Freedoms should not become subject to disciplinary measures *inside* the university. This position was then incorporated into a revision of Trent's own internal policies on harassment and discrimination, providing Trent with perhaps the best and most prinicipled balance on these issues in Ontario.

Outside Trent, the statement "On Free Inquiry and Expression" circulated widely in the first months of 1994 – at both universities (e.g., Carleton, Ottawa, Western, Queen's) and colleges (e.g., Humber and Algonquin). The McMaster University Faculty Association Executive unanimously endorsed the statement in February. It became the model for petitions and general arguments in a variety of places throughout Canada – in particular, because the statement addressed the contemporary issue of "offensive" expression directly and forthrightly. Since "offensive" expression is what is currently under attack, and since comfort is the current goal of reforming zeal, it has become crucial for the resistance to speak to these issues head on.

12 Robert Fulford, in his *Globe and Mail* column "Defending the Right to Be Offensive," writes: "At Trent University in Peterborough a group of professors recently signed a petition asking for the right to be offensive.

This may not be quite as earthshaking as the critique of Catholicism that Martin Luther pinned to a church door in 1517, but in education today it's equally heretical. The Trent professors have attacked the reigning belief that a university should provide a harmonious, friction-free environment ... The professors at Trent are true revolutionaries. Everyone who cares about education should take them seriously."

13 Bill C-128 was adopted in August 1992, in the dying days of the short-lived government of Prime Minister Kim Campbell. For over a decade, Canadian governments had drafted (without adopting) one over-broad and dangerous child pornography bill after another, on the urging of fringe groups and police agencies. In each instance, the wider cultural community of intellectuals, educators, librarians, artists, media agencies, and others had managed to persuade each government that the legislation was either unnecessary or badly drafted and more of a threat than a help to cultural life. Campbell's government was the first to show itself deaf to the expression of sane and prudential considerations. Bill C-128 is the first Canadian legislation in the domain of sexually explicit materials which goes after not only visual but also verbal representations, and not only production and distribution but also possession.

14 See Nicole Dubreuil's article in this volume (eds.).

15 Kate Taylor writes, in her original art review "Show Breaks Sex Taboo," which brought the exhibit to public attention, that Langer "is young and he can paint marvellously well. Maybe when he grows up he'll be an artist." She argues that Langer's depiction of the illegal sexuality of children is juvenile. In the same vein, censors usually argue that whatever attracts their censorious attention is not in fact art. Later, under pressure, Taylor ("Don't Shoot the Messenger ... or the Artist")

clarifies that her view is really that, though Langer "has a lot of professional maturing to do," in fact he is "innocent of producing pornography because his work has artistic merit." It is an intriguing and provocative dimension of this matter that, meanwhile, Langer, who began his own public self-defence by stressing his standing as an artist (see Taylor, "'I'm Not a Pornographer, Charged Artist Says'" (7)), and gained some support for that argument (see the *Globe and Mail* editorial "Art Is Its Own Defence" (13)), eventually began to shift over to a moral and utilitarian defence on the grounds that he was using his art to expose the evils of child abuse and to protest against children being victimized by incest and coercion.

16 At the same time, legal opinion suggests that Kate Taylor errs in law when she reports ("Child-Porn Law Used for the First Time") that the artistic-merit exemption or the educational-value defence shifts the burden of proof to the accused. Taylor makes the correction in "'I'm Not a Pornographer.'"

17 As a result of public protest by the Ontario faculty and derision in the media, as well as growing reticence on the part of university administrations in the face of such expressions, the ministry has effectively withdrawn from its 1 March compliance deadline. In a 9 February letter to universities and the media, Minister Dave Cooke clarified that the *Framework* policy was not legislation but also that it did nothing beyond spelling out the implications of the Ontario Human Rights Code. The first part of this tactical retreat relieved the pressure on universities in the short run; the second part introduced a threatening note into the long-term relations between the government and the cultural institutions of Ontario. It is also important to remember that the government has imposed the "zero tolerance" framework

policy on Ontario's twenty-three colleges of Applied Arts and Technology from 1 March 1994, just as scheduled.

18 Kate Taylor ("Child-Porn Law") cites Kelly's statement. Bronwyn Drainie takes both this position, and the *Globe and Mail* editorial ("Art Is Its Own Defence") to task ("How Can We Tell If 'Pornographic' Drawings Are Art?"), on the grounds that an exhibit cannot be considered self-evidently legitimate in every context. It may pass in the context of the art community's own elite traditions and standards of tolerance, but when reprocessed and distributed technologically, by mass media, for example, the different contextual impact calls for new kinds of legitimation arguments. It is not Drainie's specific examples that are most interesting here but rather the challenge made to the universality of the special-case defence for the arts and the challenge to the institution of art as the sole arbiter of the evaluation of the merits of works of art.

19 Brown, "But Is It Art?" 17.

20 Jay, "Force Fields: The Aesthetic Alibi," 17–18.

21 Ibid., 21–3.

22 Kai Erikson's study of seventeenth century "wayward puritans" shows convincingly that the persecution of heretical deviance is strongest and most unyieldingly irrational at the exact moments when cultural boundaries are destabilized and dislocated. The cultural revolution we call postmodernism, combined with *fin-de-siècle* anxieties and enthusiasms, shows every sign of producing the turbulent intolerances that one would expect on the basis of this kind of analysis.

23 Innis, *Essays in Canadian Economic History*, 385

24 This kind of recognition was always Innis's strong suit. His sense of structure and pattern, and his awareness of the power of media to alter the action of other cultural forms, was matched only by Marshall McLuhan, who had

more flair but less patience for detail. The question that Innis claimed to have learned from Ten Broeke, his philosophy professor at McMaster – "Why do we attend to the things to which we attend?" (*Idea File* 17/22) – remains a crucial corrective today to the cognitive superficiality of taking tribal politics and its self-evidence and self-importance at face value.

25 Luke, *Screens of Power*, 252–3.

26 Andrew Wernick provides a useful and clear-minded insight into the problems of employing, as both Innis and McLuhan did, "an over-condensed system of binaries" (144), and therefore conflating the distinctions between time/space, speech/writing, ear/eye. and recording/broadcasting, and, more generally, forms of (linguistic) expression and forms of storage and collective memory. While appreciating the stimulation offered by the communications idiom developed by Innis and McLuhan, Wernick nevertheless suggests the continuing need for "new styles of conceptual expression" (148).

27 Innis, *Concepts*, "Strategy of Culture."

28 Innis, *Concepts*, 3.

BIBLIOGRAPHY

"Art Is Its Own Defence." Editorial. *Globe and Mail,* 31 December 1993, A13.

Brown, Eleanor. "But Is It Art?" *Xtra,* 7 January 1994, 17.

Carey, James W. *Communication As Culture: Essays on Media and Society.* Boston: Unwin Hyman 1989.

Drainie, Bronwyn. "How Can We Tell If 'Pornographic' Drawings Are Art?" *Globe and Mail* 8, January 1994, C1.

Erikson, Kai T. *Wayward Puritans: A Study in the Sociology of Deviance.* New York: John Wiley & Sons 1966.

Fekete, John. "On Free Inquiry and Expression." Public Statement with Signatures. Trent University, Peterborough, ON 1993–94.

Fulford, Robert. "Defending the Right to Be Offensive." *Globe and Mail,* 2 February 1994, C1.

Innis, Harold A. *The Bias of Communication.* Toronto: University of Toronto Press 1951.

– *Changing Concepts of Time.* Toronto: University of Toronto Press 1952.

– *Essays in Canadian Economic History.* Ed. Mary Q. Innis. Toronto: University of Toronto Press 1956.

– *The Idea File of Harold Adams Innis.* Intro. and ed. William Christian. Toronto: University of Toronto Press 1980.

Jay, Martin. "Force Fields: The Aesthetic Alibi." *Salmagundi* (Winter 1992): 13–23.

Johns Hopkins Guide to Literary Theory and Criticism. Ed. Michael Groden and Martin Kreiswirth. Baltimore and London: Johns Hopkins University Press 1994.

Luke, Timothy W. *Screens of Power: Ideology, Domination, and Resistance in the Informational Society.* Urbana and Chicago: University of Illinois Press 1989.

McLuhan, Marshall. Foreword to *Empire and Communications,* by Harold A. Innis (1950). Rev. by Mary Q. Innis. Toronto: University of Toronto Press 1972.

Ontario. Ministry of Education and Training. *Framework Regarding Prevention of Harassment and Discrimination in Ontario Universities.* Toronto 1993.

Ontario. Ontario Council of Regents' Harassment Task Force. *Report on Harassment and Discrimination in Ontario Colleges of Applied Arts and Technology.* Toronto, May 1992.

Sinclair, Upton. *Money Writes! A Study of American Literature.* Long Beach, CA 1927.

Supreme Court of Canada. *Donald Victor Butler v. Her Majesty the Queen.* File no. 22191. Ottawa: Supreme Court of Canada 27 February 1992.

Taylor, Kate. "Child-Porn Law Used for the First Time." *Globe and Mail,* 22 December 1993, A5.

– "Don't Shoot the Messenger … or Arrest the Artist." *Globe and Mail,* 24 December 1993, C5.

– "'I'm Not a Pornographer,' Charged Artist Says." *Globe and Mail,* 23 December 1993, A7.

– "Show Breaks Sex Taboo." *Globe and Mail,* 14 December 1993.

Wernick, Andrew. "The Post-Innisian Significance of Innis." *Canadian Journal of Political and Social Theory 10,* no. 1–2 (1986): 128–50.

On Postmodernism, Ethics, and Aesthetics in the Age of Global Markets

Thierry de Duve

I would like to offer a few remarks in reaction to some of the assumptions contained in the introduction to the workshop Postmodernism, Ethics, and Aesthetics in the Age of Global Markets.[1] Therein I read: "Traditionally, aesthetics and ethics have looked for universal values as the justification and foundation of aesthetic and ethical judgment. Postmodernism arises from the conditions in which aesthetic and ethical values are local and plural rather than universal and essential." This statement, in my opinion, contains some truth and a lot of misunderstandings.

Such a link between ethics and aesthetics around the issue of universality is a dated one: it would not have occurred, in philosophy, in religion or elsewhere, before the Enlightenment, i.e., modernity. So, I assume that the tradition referred to is the modern tradition, a tradition that "postmodernism" is supposed to have challenged or invalidated. Leaving ethics more or less aside, I shall concentrate on the frequently used target of Kant's *Critique of Judgment* as best embodying "traditional aesthetics."

Even though, on the one hand, the empirical evidence in favour of the recognition of very widely shared (I don't say universal) aesthetic qualities (I don't say values) in the long run overwhelms the evidence to the contrary, it is one thing to notice that fact empirically and another to maintain (or to recuse) that aesthetic judgments are actually universal.

Aesthetic judgments are not, have never been, and never will be universal. Nor do they have universal values as their justification or foundation. But all aesthetic judgments have a built-in claim to universal validity (as can be seen from the grammatical construction of sentences such as "this is beautiful" used to express feelings which would otherwise better be expressed by "I like this"). On the one hand, both the fact of aesthetic disagreement and the freedom to disagree are undeniable (even should the utterance of one's disagreement be socially repressed); on the other hand, the claim to universal validity of aesthetic judgments is justified (as claim, not as universal validity).

This apparent contradiction has been once and for all laid out by Kant as the "antinomy of taste." Kant solved the antinomy not by concluding (as is too often believed) that there are universal aesthetic values, nor even that there exists a faculty of aesthetic judgment shared by all human beings, but that such a faculty (a *sensus communis*) ought to be supposed in everyone, in order to account at once for the claim to the universal validity of aesthetic judgments and for the right to disagree. This is why the faculty of taste is said to be transcendental, which simply means that it can't be proven but that it nevertheless ought to be supposed, necessarily (or, in more Kantian terms, that the *sensus communis* is a mere idea of reason and not a concept of the understanding).

I don't see why "postmodernism" would change the structure of aesthetic judgment, which, I repeat, Kant has seen more clearly than anyone before or since. Which is why I approve of the workshop presentation's next sentence (with reservations as to the word "understanding"): "Nevertheless, the tradition of aesthetics and ethics continues to provide the central concepts and categories which define our experience of the good and the beautiful, and aesthetic and ethical judgment continues to search for stable forms of understanding within a deeply plural culture and society."

It is true that Kantian aesthetics have been challenged on other counts, not by "postmodernism," however, but by subsequent developments within modern science and philosophy alike. The target should not be Kant's *Critique of Judgment* but his "transcendental aesthetics," that is, the epistemological belief in time and space as a priori forms of sensibility. Reflecting (or accompanying, or anticipating) the scientific and philosophical critique of the Kantian concepts of time and space, modern (not postmodern) art indeed casts doubt on their universality, showing them to be, instead, heavily culture-bound. This, in turn, makes the existence of a universally shared *sensus communis* even more remote a possibility than it was in Kant's time, and thus, even more of an idea of reason. Perhaps it should be said that, in the absence of a humanistic belief system (which certainly has collapsed), the transcendental postulate of a common ability to feel is much less an epistemological requirement than an ethical one. To put it bluntly: it is perhaps not true that we feel the same (about art or morals) across cultural boundaries, but *we ought to*. Which brings me to a few remarks regarding "postmodernism."

The text presenting the workshop assumes that our "postmodern" culture (as opposed to modern culture, I suppose) is one of "global pluralism rather than universalism." I understand "universalism" to carry an innuendo (absent from my use of "universality" above) alluding to the ethnocentric (phallocentric, logocentric, etc.) pretention of white, male, heterosexual westerners to adequately represent the species. I agree of course that this pretention should be curtailed, but whether it can be ascribed to modernism as a whole (if that was intended) is questionable. As to "global pluralism," I cannot help but read between the lines of this oxymoron and sense in it the fear that our western culture at this point in history is threatened by two, in fact, contradictory phenomena. On the one hand, there is "global pluralism" (the emphasis being on

"global"), which is sameness all over under multinational capitalism (call it the McDonald's culture), and on the other, there is "global pluralism" (the emphasis being on "pluralism"), that is, the manic search for differences (gender- and sex-based, ethnically based, religiously based, class-based, community-based, and so on), as an antidote.

A further assumption is that these bases constitute a variety of separate "communities," each with its own set of aesthetic and ethical values (helter-skelter examples: if you are a fundamentalist Muslim, the laws of a democratic state don't apply to you; in order to qualify as a judge of Australian aboriginal painting, you need to be an Australian aboriginal yourself; gay art speaks primarily to gay people, etc.). Whether this should be seen as a fact, as a wish, or as a threat is of course open to debate. I personally tend to see it as a threat and, inasmuch as the threat is already a fact, I tend to read as wishful thinking the sentence from the presentation text that says, "the central concepts of aesthetics and ethics have become plural without becoming merely relativist or idiosyncratic." Relativism is endemic, and when the claim to the universality of aesthetic judgment (which is to aesthetics what Kant's categorical imperative is to ethics, and thus the contrary of the pretention to the universalism of values) is relinquished, we are left with, at best, commercial competition among cultural values and, at worst, ethnic warfare. Meanwhile, a gathering of idiosyncracies is not enough to constitute a community, and generalized relativism is nihilism (as Nietzsche saw clearly a hundred years ago).

Moreover, speaking of wishful thinking, the very word "postmodernism" strikes me as carrying a lot of it. Time doesn't cut itself into slices spontaneously, and it is usually up to historians, when they retroactively take stock of a major rift in the continuity of the historical fabric, to invent names that periodize history. Not so with "postmodernism," however. It is most of the time uttered prospectively by people who obviously don't want to be modern any longer, and who use the word as a disclaimer. Ironically, they fall back onto the worst modernist ideology: the desire to burn one's bridges, the longing for the *tabula rasa*. Hence the wishful thinking.

On the other hand, for the very same reason that time doesn't cut itself into slices spontaneously, once a periodizing name has been uttered (and the name "postmodernism" has been around for quite a while, now) history is periodized *de facto*, if only nominally. To the historian, such names act as the injunction to reinterpret the period which they close. Taking their clue from the symptomatic fact that the word "postmodernism" has appeared as a disclaimer, historians should ask what went wrong with modernity that warrants the current disenchantment, and then, whether or not postmodernism (as a style or an attitude or a cultural phenomenon, this time) is the adequate way to resist this disenchantment.

Postscript

The text above was written a few months before the conference, in Paris, where the issue of pluralism, whose other, more up-to-date name is multicul-

turalism, is not as burning as it is in North America. The problems are the same, and with the Front National, the right-wing party led by Jean-Marie Le Pen, drawing more than 13 per cent of the votes, the threat is perhaps more acute. But what is foreign to the French scene is, on the one hand, the fractioning of the political world into special-interest groups which define themselves in terms of "identity," and on the other, the over-sensitivity of the academic world to the phenomenon known as "political correctness." For Europeans (and the French especially), the Nation is an idea, and so is Europe, so is mankind, so are universals in general. It is therefore astonishing to a European mind to see every call on universals systematically attacked by "politically correct" North American intellectuals, whether in the name of postmodernism or multiculturalism. Perhaps this attack is due in part to a philosophical tradition rooted in empiricism and pragmatism, and in part to the (now collapsing) faith in the melting pot. (But then, Canada was never so much of a melting pot as the United States; why do its intellectuals seem so fascinated by the current trends south of the forty-ninth parallel?)

Seen from Paris, the presentation text for the panel I was on smacked of this fascination. I could not help but respond the way I did, because I could simply not work with the assumptions it contained. Re-reading my paper in the aftermath of the conference, I realize that some of my concerns with the dangers attached to the relinquishing of universals in favour of a variety of separate "communities," each with its own set of aesthetic and ethical values, were somewhat prophetic. Among other examples of the breakdown of "global pluralism" into fetishized "rights to differences," I had imagined this one: if you are a fundamentalist Muslim, the laws of a democratic state don't apply to you. Well, while we were debating in Toronto, a woman judge from Montreal, Judge Verreault, sentenced a man to twenty-three months of jail for having sodomized his nine-year-old stepdaughter for two years in a row. Facing an outburst of indignation in light of such a mild verdict, the judge claimed that, the virginity of the little girl having been preserved, the crime was not as bad as rape. Pressed with even more protests, she then admitted that, the man being Arab, she gave him attenuating circumstances on the ground that sodomy was allegedly a more acceptable sexual practice in the Arab world than in the western world. Disgusting and frightening! When the most ignoble sexist and religious prejudices are being reinforced by the perhaps well-intentioned scruples stemming from multiculturalism, the law is no longer the same for everyone. I already hear "critical" voices from the intellectual community crow: "But the law was never the same for everyone!" There is enough cause for distress in this story; please spare me the additional distress of seeing my fellow intellectuals surrender, and let me find solace in the fact that the most vehement protests against Judge Verrault's explanations came from the Canadian Arab community.

NOTES

1 This paper responds to the introduction to the workshop Postmodernism, Ethics, and Aesthetics in the Age of Global Markets, part of the Art and Money conference organized by Shelley Hornstein, Jody Berland, and Gary Wihl (see the introduction to this volume).

The Old Age of Art and Money

Paul Mattick, Jr

Art and money have both made appearances in many types of society other than capitalism, the one that has given them their currently definitive forms. Or rather, phenomena involving features of the practices now called art and money are to be found in various modes of social life, though without other features essential to their roles in that in which we live. Classical writers already railed at the corruption engendered by the love of money, including its deleterious effects on poetry. Yet until the last few hundred years money was not a true universal equivalent in commodity exchange (since labour-power hardly existed as a commodity) and played only the most rudimentary role as capital. "Art" was largely restricted to the sense of craft or skill; only towards the end of the eighteenth century would the modern system of the arts be brought into existence.

The quickening of commerce in the Renaissance, and the development of a mode of production centred on the expansion of value, brought a great springtime romance between art and money. Poets, musicians, and visual artists produced to the account of merchants and bankers as well as popes and princes. By the eighteenth century, however, elements of conflict appeared anew in this relationship (so that Mme d'Epinay could write in 1771 of Fragonard, "He is wasting his time and his talent: he is earning money").[1] Diderot's salon criticism, for instance, represented the opposition between the emerging social principle of capital and earlier aristocratic ideals in the form of a fear that the arts would degenerate due to the very increase in wealth that ought to make a flourishing of culture possible. With the turn of the century, however, art came generally to seem a redeemer of wealth, providing not just a beautiful home but also a spiritual refuge for hard-working capital. (We must note, by the way, the complexity of the gendering of art suggested here: while the artist was definitely typed as male, the art object tended to be female.)

As in any legitimate relationship, in this one the state played an appropriate role. The first museums were created out of princely and royal collections

at the end of the eighteenth century, as important signifiers of national power and dignity, and as institutions for the improvement of the taste of the vulgar whose presence, within the development of "modernity," had to be acknowledged. In the United States, no sooner did the new unified capitalist power feel its rapidly growing strength after the Civil War than a group of businessmen from New York met in Paris to call for the founding of an art museum, to demonstrate their equality with the ruling classes of Europe. To varying degrees and in different ways, states have encouraged private collecting, provided institutions for the training of artists, and subsidized theatres and concert halls.

Like some other marriages, this one combined genuine affection, dependency, resentment, and mutual suspicion. It was, after all, in a society dedicated like no other in history to commerce that art's spiritual virtue was associated with its (conceptual) distance from money-making. From the artist's side of it, art marked superiority to the condition of wage labour that is the lot of the mass of humankind in bourgeois society. It was thus defined – Kant's aesthetic is the classical locus – as "free," ruled only by the internal compulsions of its creator. Like other modern modes of freedom, the artist's was a specific application of the ideal of *laissez-faire*, representing the replacement of work to the order of a patron, characteristic of pre-modern arts, by work for an anonymous market. Given the actual mechanics of markets, it is no wonder that the companion myth to freedom of expression was bohemian poverty. Making a virtue of necessity, engagement in a profession that yields riches or even adequate payment only to a small minority suggested an aristocratic disdain for trade and so a mode of life superior to that of the businessman.

The other side of this coin was the rising above mere money-grubbing of the art-loving businessman (on occasion represented by his wife or daughter). The worship of art came to express the claim of capitalist society's highest orders to transcend the confines of commerce as worthy inheritors of the aristocratic culture of the past. As the manufacturers and financiers of Europe and America bought estates and took up fox hunting, so they filled their houses with old furniture, old masters, or the art of their own moment. The golden age of this love may be represented by Joseph C. Choate's words, spoken at the opening of the Metropolitan Museum of Art's new building in Central Park in 1890: he urged New York's millionaires

> to convert pork into porcelain, grain and produce into priceless pottery, the rude ores of commerce into sculptured marble, and railroad shares and mining stocks – things which perish without the using, and which in the next financial panic shall surely shrivel like parched scrolls – into the glorified canvas of the world's masters … ours is the higher ambition to convert your useless gold into things of living beauty that shall be a joy to a whole people for a thousand years.[2]

In reality, of course, the dependence of living beauty on far-from-useless gold disciplined even the collecting and philanthropic giving of art, and

accounted for the mixed attitude of admiration and scorn with which the wealthy regarded artists.

Clement Greenberg drew attention to a twentieth-century version of this conflicted romance when in 1939 he wrote of the avant-garde's relation to "an elite among the ruling class of that society from which it assumed itself to be cut off, but to which it has always remained attached by an umbilical cord of gold."[3] Given the opposition of fascism and Stalinism to the modernism he favoured, and the lack of interest displayed in it by art-buying Americans, Greenberg believed that only socialism – the abolition of a society devoted to the expanded reproduction of money – could keep culture alive. He failed to appreciate that the upper classes would soon embrace the avant-garde with enthusiasm, and that modernism would become the official art of progressive capitalism.[4]

With the victory of American modernism after the Second World War and the movement of contemporary art to the centre of the aesthetic stage, art could be seen as a distillation of those characteristics that make an individual, company, or nation successful: daring, innovation, sensitivity to emerging needs still unknown to those who would recognize them at the moment of their satisfaction.[5] The most consistent attempts to contest capital's ownership of the avant-garde – I am thinking, for instance, of works such as Hans Haacke's documentation of Peter Ludwig's industrial and artistic holdings – are absorbed without difficulty by the art system, even if one or another institution within it balks (as when the Guggenheim refused to show Haacke's *Shapolsky et al. Manhattan Real Estate Holdings* of 1971). That modernist (including "postmodernist") art can function as a sign of class can be seen in the way it can be mobilized to quasi-populist effect by the American religious right in its struggles for political and social power.

Such phenomena as these attest to the presence of elements disturbing the embrace of culture and commerce as these partners move into older age. Not only has art from the start provided a field for the representation of conflictual relations within bourgeois society; in addition, its meaning has been affected by the development of that society. With its world-historical success, capitalism has lost much of its earlier bad conscience and sense of inferiority to earlier social orders. Thus art could function more freely not just as a signifier of wealth but as a means to its expansion. In the nineteenth century, as we saw, art was defined as an embodiment of higher values than those of the marketplace, a model of meaning and purpose transcending the commercial everyday. At the present time this conception of art, while still in force, is seemingly on the decline. A striking manifestation of this is the tendency in the work of artists, critics, historians, and collectors to accept, with whatever irony, the coexistence of the commercial character of art with its aspiration to transcendence, or even the former's dominance over the latter.

Andy Warhol is, of course, the pre-eminent example of an artist who has made the commodity character of art central to his artistic practice. One could mention, as interesting variations on this theme, J.S.G. Boggs and Haim

Steinbach, who have specialized, respectively, in the money and commodity poles of value circulation. The recent explosion of studies of art markets by sociologists, art historians, and economists is part of the same phenomenon, as is the growing influence of Pierre Bourdieu's studies of cultural production, emphasizing the relation between aesthetic and market value and making central use of the concept of "cultural capital."

The taking up by institutions of state and academy of artistic production and consumption and in particular of the avant-garde area within it (this publication presents an example worth pondering), together with the enormous and rapid expansion of the market for art, have eroded the earlier conception of art as founded on the transcendence of the social division of labour achieved by the heroic, creative individual. Art is today, at least in practice, more clearly subordinated to the nexus of corporate and state institutions that govern all other social domains. This is not necessarily bad for artists, or anyone else who seeks to find in the debris generated by capitalist civilization materials for the construction of future meanings. It is always helpful to know where one stands.

With the collapse of pseudo-socialism, now transformed retrospectively into a preparatory stage for the continuing globalization of capitalism, the domain of money seems wider and more secure than ever before. At the same time the crisis of the party-state system has functionally been an element of a far greater crisis of the capital-state system. It is no doubt overly optimistic to speak of the "old age" of money, suggesting as this does an incipient demise of bourgeois class society. But beyond the certainty that this form of society can no more endure indefinitely than any earlier one, the present moment, combining economic decline with multiple looming ecological disasters, finds us at the brink of a period of catastrophe that might again make thoughts of alternative social orders thinkable.

It is this situation that has produced the debilitation of ideology experienced as "postmodernism" – the loss of confidence in progress in every social domain. While art, along with politics, science, and the self, continues as a basic category for the conceptualization of social activity, it is undeniably implicated in the general decline. (This can perhaps be seen in its present-day eclipse as a prime object of faith by religion, for which it once seemingly promised to be a substitute.) In their old age, art and money have found not the peace and security that only forty years ago seemed their due, but anxiety, disappointment, and doubt, that bluster and self-assurance can only temporarily allay.

NOTES

1 Quoted in Etienne Jollet, "'Il gagne de l'argent': L'artiste et l'argent au xviiie siècle," in *Le commerce de l'art*, L.B. Dorléac, ed., 129. In addition to this interesting article, see P. Mattick, Jr, "Art and Money," in Mattick, ed., *Eighteenth-Century Aesthetics and the Reconstruction of Art*, 152–77, and Becq, "Artistes et marché," in Bonnet, ed., *La Carmagnole des Muses*, 81–95.

2 Quoted in Tomkins, *Merchants and Masterpieces*, 23–4.

3 C. Greenberg, "Avant-Garde and Kitsch," in *Art and Culture*, 8.

4 For two accounts of early stages of this development, see Webers's *Patron Saints*, a study of modernist patronage in the United States during the 1930s; and Allen's *The Romance of Commerce and Culture*, on the alliance between modernism and the American corporate elite.

5 To cite one among many expressions of this thought, Hamish Maxwell spoke for the sponsor of the great 1989 exhibition of Picasso and Braque's cubism at the Museum of Modern Art with the reflection that "Philip Morris is pleased to help present this tribute to the enduring value of creativity, experimentation, and innovation, qualities that we think are as important to business as they are to the arts. For whether the year is 1908 or 1989, in a rapidly changing world, not to take risks is the greatest risk of all" (Rubin, *Picasso and Braque: Pioneering Cubism*, 5).

BIBLIOGRAPHY

Allen, James Sloan. *The Romance of Commerce and Culture*. Chicago: Chicago University Press 1983.

Becq, Annie. "Artistes et marché." In *La carmagnole des muses*, ed. Jean-Claude Bonnet. Paris: Armand Colin.

Greenberg, C. "Avant-Garde and Kitsch." *Art and Culture*. Boston: Beacon 1961.

Jollet, Etienne. "'Il gagne de L'argent': l'artiste et l'argent au xviiie siècle." In *Le commerce de l'art*, ed. L.B. Dorléac. Paris: La Manufacture 1992.

Mattick, P., Jr. "Art and Money." In *Eighteenth-Century Aesthetics and the Reconstruction of Art*, ed. P. Mattick. New York: Cambridge University Press 1993.

Rubin, William. *Picasso and Braque: Pioneering Cubism*. New York: Museum of Modern Art 1989.

Tomkins, C. *Merchants and Masterpieces*. New York: Dutton 1973.

Webers, Nicholas Fox. *Patron Saints*. New York: Knopf 1992.

Art Money Madness: With Origins in Mind

Cheryl Sourkes

MIND emerges etymologically from a range of word experiences including love, understanding, mentioning, remembering, fearing, warning, forgetting and significantly, madness. The ancient Greek word Menos carries the multiple connotations of mind, spirit, intention and force. And while Mnasthai means to remember, Mainesthai translates as to rave. These associations shaped MIND and spawned her three daughters, Mania, the eldest and most feared, Memory, the middle, charged with holding things together, and Money, the youngest and most indulged.

When times are worst MIND moves into disorder, distraction, dissociation and madness. It's here we find Mania, and her descendant Mainas, known to English speakers as The Maenads, the nymph participants found at Dionysian, orgiastic rites. The Maenads are related in turn to Mantis, the visionary, as well as to Manatee, the oracle. Mania carries a strong connection to The Furies or Erinyes as well. These otherworldly avengers with their snaky hair were so feared, people hesitated to use their name in conversation lest they call down unwanted attention. Instead The Furies were referred to euphemistically as The Eumenides, or Gracious Ones.

Memory draws elaborate patterns in MIND. These powerful structures eventually mold the substance of language itself. But Mnesis, Amnesia or Forgetfulness is a totally inseparable companion of Memory. MIND ponders and sorts through experience with Remembering and Forgetting present in equal measure. The ancient Greeks believed the Goddess of Memory, Mnemosune spent nine nights with Zeus, and that this liaison produced The Three Muses. Actually Zeus' claim to fatherhood is a late one. Hesiod calls The Muses the daughters of Mother Earth and Air. Regardless of their paternity, The Muses are our great benefactors. They grant the gifts of inspiration, prophecy and healing. In early representations they are depicted as three Mountain Goddesses in their orgiastic aspect. Later on these elusive patrons transform into Nine Muses: Calliope, epic poetry and eloquence, Euterpe, music and lyric poetry, Erato, love poetry, Polyhymnia, oratory or sacred poetry, Clio, history, Melpomene, tragedy, Thalia, comedy, Terpsichore, choral song and dance, and Urania, astronomy. This multiplying takes place in the spirit of the Tripartite Goddess – she who personifies the three ages of woman.

When Mnemosune was adopted by the Romans, she and Juno were collapsed into a single entity who was called Moneta, The Warner. The Romans embraced coinage a millennium after it had been invented by the Babylonians. The value of coins was guaranteed by the followers of the Deity whose image was stamped on its face. In Rome minting took place at the round temple dedicated to Juno. It was her portrait that was printed on their silver coins. These coins became known popularly as Moneta. Moneta travelled through French into English, where it transformed into the word, Money.

Those wild girls, The Maenads, are known to party along the perimeter of MIND. Memory sometimes turns up at these occasions with her daughters, The Muses, and lets them run free. At times Money comes by as well. During bad periods Money is afraid of The Muses. She imagines that they are giving her the judgmental stare of the Furies. The Muses in turn are afraid that Money will forget the value of Memory, and paralyse their projects. When anxious times come around, Memory consorts with Madness. Anxiety, anxietat from anxius, itself from angere, to cause pain. Cf anger. Anger. Inadequacy. See equal. Adaequare, to render truly level or equal, whence adequacy. Equal and adequate. Art, Money and Madness, our necessary consorts, forever trailing their deeply tangled origins in MIND.

Marketing Culture and the Politics of Value

Ideas without Work/Work without Ideas: Reflections on Work, Value and the Volk

Bruce Barber

In his *Bias of Communication* Harold Innis quotes the early French economist Riqueti, Compte de Mirabeau (1749–81), who wrote: "The two greatest inventions of the human mind are writing and money – the common language of intelligence, and the common language of self-interest."[1]

This privileging, in Mirabeau, and as we shall see, in Innis, of the inventions of the mind as distinct from the articulations of the body, provoked me to reflect upon a similar elision in the title of this conference, "Art and Money: What Is It Worth?" The absent element, neglected by philosophers and economists both, is *work*. In this paper, the "index of power" – my bias, if you will, is *work* and its *value*, specifically as this pertains to the production and reproduction of culture. I agree with Roald Pahl that "Work is [fast] becoming the key personal, social and political issue of the remaining years of the twentieth century,"[2] and I believe that we should take every opportunity to acknowledge and discuss this dominant feature of life (figure 3).

It is significant that Marx and Marxism are accorded little attention in Innis's books *Empire and Communications* and *Bias of Communication*. His two citations, in *Empire and Communications*, the first for Marxism, and the second for Marx himself,[3] are glosses in what Marshall McLuhan has identified as Innis's purposeful "cinematic montage-like figure/ground style of writing."[4] I say purposeful here, because McLuhan imbricates his own famous aphorism "the medium is the message" on to the former's work, declaring that Innis's "psychogenetic" montage style mirrors the very hot process of communication itself. But for Innis, the figure(s) and ground(s), to give this binarism a postmodern inflexion, are less symptomatic of the conditions of communication, about which Innis had much to say, than of the "entropic imperatives" established in the temporo-spatial paradigms of modernism which he derived from reading Veblen, Lewis, and others.

Another way of distinguishing between the two is to say that where McLuhan's conflation of the medium and message presumes a certain apodic-

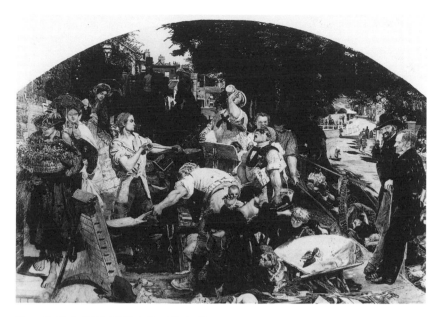

Figure 3: *Work*, 1852–1863, by Ford Madox Brown

ticity – self-evidence as its primary bias – Innis's communications bias is somewhat stochastic – regular, exponential, yet subject to random variability which is, in the final analysis, entropic. Empires are superseded because they either lose control of or exhaust their limited resources; the hegemony of a certain form of communication is contested when its system and the medium itself (as a staple) is too widely distributed to be maintained by a singular set of controls, and its value therefore, is evacuated, lost. In somewhat vulgar terms, this is Innis's thesis: success begets fatigue, fatigue beckons breakdown and ... failure.

As an astute critic of the increasing expansion and monopolization of knowledge, Innis argued that "intense cultural activity is inevitably followed by fatigue." Cultural decline and exhaustion are quintessentially modernist ideas, played out throughout the ninteenth and twentieth centuries by many writers who, in their urge to give definition to a somewhat formless historical process, decorated their exhaustion theses with tropes that likened cultural production to some kind of elaborate mating game, with the satiation of desire, detumescence, and exhaustion providing the primary goal(s). Like Levi-Strauss's sanguine dissatisfaction with hot modernist culture(s) issuing forth various technological and cultural vanguards, Innis's problems with western civilization are broadly symptomatic of what he believes implicity to be a failure of models of capitalist appropriation and modernization. However, in his Spenglerian (and Schweitzerian) profile of decline, he neglects to accommodate the labour process itself, interpreting historical development in strictly economic terms as the control over limited resources, a means/ends

rationality which frames everything in terms of control and dependency, power and powerlessness. Accordingly, this does not allow him to acknowledge that a produced culture can also register various kinds of responses to power beyond subordination, including forms of resistance and accommodation.

I believe the central problem with Innis's cultural theory is where to locate work and what values to assign it. When he employs the ear and eye as metaphors[5] to emphasize the supercession of oral forms of communication by print technology, he implicitly acknowledges that the model of empire and development is entropic. By contrast, a critique of the ocular or language-based model for the monopoly of communication must privilege the labour process, and would therefore emphasize the employment of the hand, or more precisely all the senses, as these become engaged in the work process. Privileging any part of the body must ensure the recognition of the important social and economic relationships into which it is inserted.

Innis's evident lack of interest in Marxism, while not unusual for the time (especially for a Keynesian), would not be worthy of examining closely but for the fact that his work often alludes to areas of theory about which Marx had much to say. For example, in a somewhat difficult passage in *Capital*, Marx argues that "all commodities, as values, are objectified human labour, and therefore in themselves commensurable, their values can be communally measured in one and the same specific commodity, and this commodity can be converted into the common measure of their values, that is into money, money as a measure of value is the necessary form of appearance of the measure of value which is imminent in commodities, namely labour time."[6]

Perhaps Innis skips over Marx because he does not have to deal with the troubling issue of value in productive and unproductive labour, which Marx confronts in numerous examples including the tailor and the piano builder.[7] Marx negotiates which values to assign the owner of the means of production, the distributor of the staple materials – wood, ivory, iron – compared to those assigned to the labour of the designer and builder of the piano, as distinct from the author of the piano scores, as compared to the pianist. How do we assign value here? Innis would privilege the originary materials and their owners, by extension the empire designers and builders, the technocrats and dynasts. And of course capitalism, the free enterprise system, had the answer to all of these silly questions of value: *what the market will bear!* Value becomes relative, provisional. It can be assigned and reassigned *ad infinitum.*

Innis's economic emphasis upon the staple as the primary unit of value within historical development can be compared with the American critic Harold Rosenberg's late modernist reflection on the art commodity as the primary index of value within the development of the history of art. Like Innis, Rosenberg had a jaundiced view of modernity and distrusted avant-gardes. To both men avant-gardes were not only curious institutions formed by self-serving, self-segregating power, or would-be power elites, but also thoroughly anachronistic. Today's avant-gardes are no longer antagonistic to the ideologies of the ruling classes nor are they actively critical in relation to the prevailing conditions of the status quo

in art production. They are no longer "revolutionary," if we accept this as an extension of Poggioli's (1975) against/antagonist/activist description of avant-garde behaviour simply because they are absorbed, co-opted/appropriated by the market, an awaiting, knowledgeable, fashion conscious, and "vanguard" public ready to popularize, and thus, proverbially, nip their avant-gardism in the bud. In Innis's terms they are superseded by the cultural monopoly, the very business of which is supersession.[8]

Perhaps Rosenberg's foresight of the impending demise of any postmodern avant-garde allowed him to attempt to construct one for himself. In a 1974 issue of *Partisan Review* he wrote:

> In the postmodern period, art is anthropology. The basic model is folk art, with or without professional training. Modernism is inherently polemical; it advocates the present. By its very nature it generates vanguards; that is, representatives of the future who issue orders to those lagging behind that they must catch up. In postmodernism the present sinks back into the past. As for the future, it will be another CBS evening sign-off: 'That's how it is ... (folks!)' Put simply, the idea of postmodernism is that the time has come for all radical thinking and activity denoted by the word modernism to come to a halt. Henceforth, to keep striving to advance in any direction will be taken as a sign of backwardness.[9]

Like Innis's anachronistic promotion of orality in a time of ocular (logocentric) supremacy, it seemed reasonable, although Rosenberg did not apply the principle until a few years later, that several great leaps backward could amount to one great leap forward. In a 1975 essay reviewing the Whitney Museum's Bicentennial exhibition, The Flowering of American Folk Art, 1776–1876, he elaborated his stand on a postmodernist "art as anthropology" and simultaneously revealed his partisan and avant-garde intentions:

> In the past folk art existed as a manifestation of social hierarchy; folk painting and sculpture were low class accompaniments of respect inspiring creations, analogous to the comic rustics in serious dramas. To the old academic regime the folk were culturally identical with savages, strangers from below instead of from outside. The label for both was "barbarian" with its dual connotation of innocence (the noble savage) and ineptitude. Now the arts of all classes and castes are intermixed (even those of the intellectual avant-garde) and are undergoing assimilation into a global aesthetic that already comprises the arts of formerly alien cultures, high and low. Apparently history has decreed that what was once anthropology shall now be art and what was once in ethnological and folk museums, from American Indian and Eskimo art to scrimshaw carvings – shall now be lodged in the (high) art museum. By a process seemingly irreversible, one-time cultural outsiders and undersiders are being lifted into visibility. This movement may well turn out to be one of the most radical art accomplishments of the twentieth century.[10]

VOLUME 1 NUMBER 2 FEBRUARY 1970

Art-Language

Edited by Terry Atkinson, David Bainbridge,
Michael Baldwin, Harold Hurrell
American Editor Joseph Kosuth

CONTENTS

Art-Language is published three times a year by
Art & Language Press 26 West End, Chipping Norton, Oxon.,
England, to which address all mss and letters should be sent.

Price 12s.6d. UK, $2.50 USA All rights reserved
Reprinted 1972 by W.H.Sharpe (Printers) Ltd., 83-87 Cambridge Street, Coventry

Figure 4: *Art-Language* 1, no. 2, February 1970

With this ideologically loaded statement, one that we are able to recognize as prophetic of some of the great cultural debates (primitivism, appropriation, globalization) of the 1980s and 1990s, Rosenberg developed some arguments with which to criticise cultural strategies advanced by the Anglo-American group Art-Language[11] (figure 4). He argued that the reversal from "ideas without work," a classic polemic against conceptual art, to a "work without ideas," supposedly exemplified by folk art (figure 5) was a natural, logically consistent, and historically inevitable step to be made in the late twentieth century "evolution" of art production. His inversion implied an "epistemological break." The appropriation (although he did not equate it as such) of "low culture" forms by "high culture" would allow the formation of another vanguard, thus reinforcing the closure of the modernist telos and inaugurating a new ideology, postmodernism, which he was happy to confirm, "may well turn out to be one of the most radical accomplishments of the twentieth century." In company with Innis's valorization of Greek oral culture, Rosenberg suggested that folk art's "freedom from an evolution of forms" would make it particularly suitable for the rejuvenation of a high culture sensitive to the conundrum precipitated by an overuse of technology and the pre-eminence accorded modernist rejuventations of the Kantian critical imperative.

But work without ideas? The move from conceptual art's putatively radical and materially subversive practice, notwithstanding market successes in some instances, to a softer yet still "socially conscious" and apparently critical position did seem an attractive proposition for those caught in the post-conceptualist *tabula rasa* which had advocated, at its most extreme, the total renunciation of the institutionality of art practice, conventional aesthetic value, and the commodity form itself, toward the formation of a politically operative and engaged praxis. Rosenberg's thinking at this time placed him close to debates beginning to be articulated by those waving the banners of communications and cultural studies, feminism and neo-Marxism, which placed emphasis on the "new ethicality" confirmed by a post-structuralist emphasis on the provisionality of meaning, difference, and the recognition of power differentials in the arenas of culture.

A number of key feminist texts of the 1970s focused upon the inequities of the institutional power structures within the art world which privileged the work of male artists at the expense of women. Rozsika Parker and Griselda Pollock in their provocative *Old Mistresses: Women, Art and Ideology* (1981) argued convincingly for the thorough critical revision of art history. They demonstrated that stereotypical attitudes about women as artists developed on the basis of their identification with "conceptually weak" craft as opposed to more complex, theory-laden and critical art practice. The result was that men were seen as endowed with genius while women were fortunate merely to have acquired taste. Parker and Pollock quote the French critic Leon Legrange to illustrate their point: "Male genius has nothing to fear from female taste. Let men of genius conceive of great architectural projects, monumental sculpture, and elevated forms of painting. In a word let men busy themselves with all

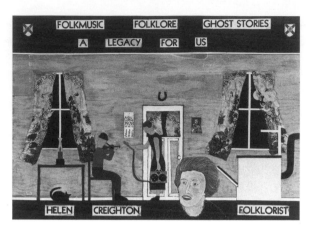

Figure 5: Helen Creighton: A Legacy for Us, 1985, by Eric Walker

that has to do with great art. Let women occupy themselves with those types of art they have always preferred, such as pastels, portraits or miniatures."[12]

While Innis, Rosenberg, and others remained untouched for the most part by these critical debates, they were wholly cognisant of the new shifts in discourse that focused away from the old philosophical chestnuts of modernism to new ones inventoried under "relations of power."

The confirmation of creativity as pleasurable and hence valued work, which underlay Rosenberg's arguments, invokes a labour process dialectic of need/work/enjoyment where conception and execution are an indivisible aspect of labour in its primary and non-alienated state. Yet for Rosenberg the conflation of work/pleasure is less sociological than stereotypical, deriving probably from his populist understanding of the inherent, self-satisfying pleasures of (creative and procreative) work as distinct from potentially alienated (dissatisfying) labour within a structured political economy. His strategically a-contextual emphasis upon the surface values which he accords work/creation, as distinct from work/production, represents work *qua* work, by, in, and for itself. This is similar to the way women's domestic work was not accorded economic value(s) when compared to wage labour and the expenditure of human energy (in any masculine form) from the classical economists Adam Smith and Ricardo through to Marx, Engels, and beyond. For Rosenberg, this strategic "oversight" was a necessary reduction in order for him to sustain his polemic against Art-Language, producers of *ideas without work,* and the implied, *art without value.* The quasi-anthropological gloss he placed upon work, particularly his affirmation of the unfettered labour of the *Volk,* suggested that some kind of ultimate transcendental pleasure controlled by and for the subject – the individual creator/worker – was embedded in the work process. Art/creativity and work are conflated in such a fashion as to suggest that they are *independent* of any true understanding of the social (and his-

torical) relations involved in any labour activity.[13] Rosenberg's collapsing of high and low culture, outside and inside, East and West, into some kind of Innis monopoly or McLuhanist "global aesthetic" further negates the intricate dynamics of the social and cultural examination of creative labour, freezing it – as Innis had frozen cultural activity as a whole into some kind of reified and ultimately value-free form – as an expression or symbolic representation of obdurate power.

Like Innis's reductive and valorizing profile of Greek society, Rosenberg's description of the work of the folk as ethical, rewarding, self-fulfilling, self-sufficent, and independent was marginalized from external economic contexts that would tie it to conventional economic models, such as those operating within the international art market. The implication that labour has meaning in social and economic terms is only there by way of its reflection in the negative. The critique is against thinking, particularly the "thinking" that does not display the material evidence: the valued product that becomes the potential *commodity* of this process. Rosenberg is careful to distance himself from the solecism that would exclude the process of thinking from work altogether. His essay alludes to Weber's conception of the work ethic, yet does nothing to articulate or explain it.[14] Had he recognized explicitly the potential commodity status of both "ideas without work and work without ideas," his text would have achieved greater explanatory power and perhaps transcended the ironic/cynical tone which he had adopted. For, at their best, his arguments draw attention to a number of critical questions pertaining to work that still exist within Marxist and neo-Marxist theory, ironically the same range of questions contained in many Art-Language texts that Rosenberg wished to exclude from art practice, criticism, and perhaps even art history itself.[15]

One important issue revolves around his insistence on the "free" (unfettered) labour of the folk, which by extension could be applied to all social groupings, classes, and class fractions marginalized by monopoly capitalist organization. This begins to confront the critique of the essentialist implications of Marx and Engel's equation of work and pleasure in its pre-capitalist and hence non-alienated state, which for Rosenberg, Innis, and many other writers paraphrasing variously from Marx's classic formulations of the early 1840s,[16] is embodied in the work of "outsiders and undersiders" – women, the folk, pre-colonial ethnic communities, the early Greeks, and in some instances, the "enlightened" artist figure. These groups are those "barbarians" who have been elevated to insider status.

This touches on an important aspect of those debates about the theory of value, "the return of the repressed," which some postmodernist discourse has admitted recently through the back door.[17] The acknowledgment of the polyvalent conditions for the reception and experiencing of pleasure continues to problematize theories of work which had previously assumed a certain mechanical status under the power of certain wage labour models, including Marxist formulations of productive and non-productive labour. The notions that associate the primordiality of pleasure gained from satisfying one's needs

– whether these be providing shelter, protection for one's children, feeding oneself, or painting a picture – have for some time, rightly, provided difficulty for theorists, particularly those working within the Marxist aesthetic tradition. The Marxist aesthetician Vazquez, for instance, reduces the satisfaction of needs to an essential creative process: "Work is the expression of the fundamental condition of human freedom and its significance lies only in its relationship to human needs."[18]

For Marx, however, *homo faber* is a category that has been determined *historically*, and is not merely, as his critics and some of his followers have interpreted, a condition of human *nature*, but rather of human distance *from* nature. For Vazquez the issue of creative labour presents no problem. For him there is no essential difference between labour/work and creative activity as indices of the human essence: "The similarity between art and labour thus lies in their shared relationship to the human essence; that is, they are both creative activities by means of which man produces objects that express him, that speak for and about him. Therefore, there is no opposition between art and work."[19]

And yet the status of labour, once it gets beyond the simple ontological satisfaction of material needs and into the realm of the social and ideologically informed desires, does raise some gritty epistemological questions. I can flag a few of the keywords that invariably cause difficulty in the consigning of value. In the text from which the above quote was taken, Vazquez has used the words "create," "creator," and "creativity" in a number of ways that undermine the clarity of many of his arguments. Notwithstanding his criticism (after Marx) of the Hegelians, he still has difficulty surrendering the metaphysical senses that are derived from late eighteenth-century (Kantian) aesthetic theory. Words like "taste," "judgment," "ideal," "genius," "essence" remain part of his discursive field. He therefore continues to mystify creativity in art, making of it something not quite here and now, an originary human condition that (after Derrida) has the stain of transcendence/metaphysics upon it. Yet for Vazquez, the resolution of creativity is secured because it now becomes available to everybody, not the sole responsibility of the specialist – the male artist as creative magus or *alter deus*.[20] The epistemological complexity of the terms, as these have developed historically, seems to elude him. The erasure of difference between art and work may be realized abstractly with a concept of an autonomous subject. However, as soon as the description moves beyond or relativizes the notion of such autonomy, the erasure of difference itself becomes suspect. That is, as soon as the social reality of the meanings of work and creativity in their *institutional* contexts are investigated, ideology becomes manifest, and moreover, the language used to describe the conditions of either difference or similarity becomes suspect. And since the feminist critique of language from the late 1960s and before, it is not easy to let the "language of the patriarchy" go by without attaching at least a few parentheses. If *homo faber* is not yet offered along with its mate *femina faber*, we should be able to signal the identity crisis which the entrenchment of one "system" presents at the expense of the alternative. And while we can still presume the predomi-

nance of work as an origin category of the human condition, we can also renegotiate its terms of reference with the other *homo* categories such as *ludens, politicus,* and *economicus* which are its natural heirs.

The work ethic is not closely associated with the origin debates touched upon above. It does, however, represent one aspect of the status of work that has relevance to issues raised earlier in this essay and may be briefly discussed here. Taken to its logical conclusion by Rosenberg, the work ethic in fact may have indicted the Art-Language group more thoroughly than given support to the unwieldy notion of a "global aesthetic" or a new vanguard, for it is within Weber's conception that the participation of the folk in their own subordination is most clearly represented. After the Reformation, and with increasing religious secularization, the emphasis on work as an ethical and rewarding activity in all its material and metaphysical aspects was introduced by the Protestant church to reinforce its own power, a "counter-offensive" in the face of increasing agnosticism and the conflicting ideologies represented in the exploitative and other determining relations of early capitalism. As Weber argues, the Protestant work ethic became a means of keeping the general populace subservient and ignorant of their exploitation by the ruling classes. This was effected by the church and emerging state apparatus (laws, education) through their condemnation of idleness (non-work), and by attaching to work notions subordinating its economic values to its spiritual ones. Had the economic value of work been privileged instead, it would have led wage labourers to question more thoroughly, and at a much earlier time, their subordinate position in the labour process, to challenge more directly the owners of the means of production, the actual or potential exploiters of their labour. If work was not intrinsically pleasurable and creative, it was made so through the imposition of various ideological accents which revealed that its opposite, non-work, was both physically and metaphysically dangerous. The paternalistic authoritarianism of the church controlled the ideological structures, simply, the *meanings* of work within society, using the valuation of work, hard work, or idleness as a measure of an individual's worth on earth, in life, and ultimately, on the Day of Judgment. With increasing modernization in all areas of social life, the metaphysical ascriptions for work became subordinated to those emphasizing material and economic values. For (labour) time to become money (time is money), the power of the church had to be revoked.

As is the case with women, it is highly debatable whether the folk, the peasantry, were ever free (essential) producers satisfying their needs in a creative, self-enhancing, non-alienating, and hence pleasurable way. Beyond the broadly epistemological questions and the arguments attaching to the (relative) autonomy of the subject, the social-economic conditions of labour begin to demonstrate their own power and "logic." Some powerful ideas – we could usefully, if provisionally, attach the notion of tropes – remain.

The folk artist, the embodiment of the Greek artisan, peasant, noble savage, and medieval artist archetypes, is one that has surfaced often throughout art history, and its symbolic use in the reconstruction and reproduction of ide-

ologies central to the maintenance of the high art status quo should not be dismissed.[21] The image of the folk, (and) the quintessential proletarian (undersider or outsider) artist, has exercised a peculiar fascination for artists who wish to distance themselves from the bourgeoisification and institutionalization of art practice. In his impressive study on Mannerism,[22] Arnold Hauser has demonstrated that from the late sixteenth century through to the present, the resurgence of interest in folk art has usually coincided with, and more often preceded, mannered tendencies in art production, especially in those artists sensitive to their own alienation and/or the demise or exhaustion of the high culture[23] issues of the day. He argues that the estrangement of high culture artists from their culture gives rise to mannered tendencies in their art work. And in an attempt to alleviate the problems of dissociation or cognitive tension, they move to the less dynamic forms of folk art for their intrinsic freshness, spontaneity, and stylistic continuity. The high culture artists identify with, or appropriate, the *image* of the folk artist as one who is socially integrated, and at one with nature, both the non-polluted/rural environment and their own "internal nature." Here in the folk artist is the primordial and essential condition of creativity, untainted by the conditions and pressures of economics, politics, history. With its inert yet ostensibly "vital" character, to paraphrase Rosenberg, folk art would appeal to the high culture artists alienated by the pressures to innovate, the discontinuous acts, high problem construction, and the solving of conditions that their institutionalized role has accorded them.[24] Perhaps the same is true of academic intellectuals in their pursuit of an ideal institution, system, or society.

With this assumption, does it necessarily follow that the move by high culture intellectuals and avant-garde artists towards the work of low culture artists supports the assertion that postmodern art and art discourse is now anthropology?[25] And is avant-gardism itself dead? No: Rosenberg, in company with many other twentieth century critics from Apollinaire onward, has in fact contributed to its health, advancing, as he writes, modernism's "inherently polemical" character.

Folk art, like mannerism, exhibits its own form of stylistic dynamism. It only appears to be unchanging and inert. These are simplifications, generalities at best. Both art historical and anthropological investigations confirm that folk art, in common with high culture, is tied to specific periods, times, and communities. Rosenberg merely alluded to the existence of folk arts' "other characteristics" for fear of destroying his central argument that this movement (making outsider/undersider art more visible) might become one of the most radical accomplishments of the twentieth century.

It could be stated generally that a prime determinant of the process of theorizing is the search for something more fundamental and truthful or scientifically verifiable. In its quintessentially vulgar, rhetorical, and interrogative forms, theorizing implies the quest for the something "other." The theories associated with modernist avant-gardes, as these have developed over the past century and a half, have exhibited the same implicit tendency, the search for

the "absent condition" that would establish, confirm, construct the primordial condition of human essence, human nature, the true meaning of creativity, the standard of genius, correct judgment in matters of taste, absolute beauty, freedom, or even the subject presently under discussion – the pleasure dialectic of need/work/enjoyment circumscribed as "creation."

For the anti-technological/socialistically inclined soft-primitives Rosenberg and Innis, regression (looking back) is not necessarily an undesirable element of progressive modernist thinking. From their (modernist) allusion of the present sinking into the past, which Rosenberg suggests is postmodernist, we can theorize a position every bit as polemical as "modernism's advocacy of the present." Postmodernism's appropriation of low culture to the high cultural (avant-garde) position may not last for long, according to Rosenberg; it will become quickly popularised and thus lose one of its essential vanguard features -"newness," the keeping up with avant-garde progressions (fashions) which "normalise the modern as a period that can be left behind."[26]

Rosenberg has grossly over-emphasized his proposition that folk art is work without ideas. This has the same absurd connotations as a conceptual art that consists of ideas without work. Perhaps Innis's insistence on Greek "oral culture" is similarly suspect. We can take it further: the same generalities may be rendered suspect if we attach them to essentialist notions of work independent of social context, or theories that are divorced from notions/ideas of practice. In each case the absent other signals the process, the justification for theoretical activity that confirms the inter-textual condition of the proposals themselves. The reification of work in the separation of work/with and work/without ideas is the basic problem here – at least as much as the romantic idealization of the *Volk* as the People.

The expropriation of works of "low culture art" and the advocation that new vanguards be constructed from their principal characteristics could only become a radical art accomplishment of the twentieth century with the powerful assistance of a high culture critic like Rosenberg and others like him.[27] And he has fallen, like those members of the "old regime" whom he criticizes, into the trap of treating the work of the *Volk* – the undersiders, outsiders, plebeians (proto-proletarians?), women – in a paternalistic manner as subordinate agents in the process of cultural legitimation. The exercising of this (masculine) power reproduces the hegemony of ruling class culture(s). The institutional demonstration of this power *in extenso* has footnoted the demise of the culture and artifacts of "alien cultures" for the past two hundred years and will possibly hasten the demise of important cultures within our own society. As Innis sanguinely remarked, "Each civilization has its own methods of suicide."[28] And if it can somehow approximate the condition of an avant-garde for a while to serve and secure the artistic, intellectual, and pecuniary interests of high culture elites ... then, "that's how it is (folks)." But perhaps our work about art, art about work, work about work, could have different ends in view.

NOTES

1 Innis, *Bias of Communication*, 8.
2 Pahl, *On Work*, 1.
3 Innis, *Empire and Communications*, 56, 166.
4 McLuhan, foreword to *Empire and Communications*, vi. The passage reads: "Toward the end of *Empire and Communications* Innis speeds up his sequence of figure ground flashes almost to that of a cinematic montage. This acceleration corresponds to the sense of urgency that he felt as one involved in understanding the present."
5 "The Treaty of Versailles recognised the impact of printing by accepting the principle of the rights of self-determination, and destroyed large political organisations such as the Austrian empire. Communication based on the eye in terms of printing and photography had developed a monopoly which threatened to destroy western civilization first in war and then in peace. This monopoly emphasised individualism, and in turn instability and created illusions in catchwords such as democracy, freedom of the press, and freedom of speech" (ibid., 80–1).
6 Marx, *Capital*, bk. 1, 188.
7 Marx, *Grundrisse*, 305. The passage reads: "Is it not crazy, asks Mr Senior, that the piano maker is a *productive worker*, although obviously the piano would be absurd without the piano player? But this is exactly the case. The piano maker reproduces *capital*; the pianist only exchanges his labour for revenue. But doesn't the pianist produce music and satisfy our musical ear, does he not even to a certain extent produce the latter? He does indeed: his labour produces something: but that does not make it *productive labour* in the economic sense; no more than the labour of the madman who produces delusions is productive. *Labour becomes productive only by producing its opposite.*"
8 *Empire and Communications*, chapters 4 and 5.
9 Rosenberg, "Art and Politics," 384.
10 Rosenberg, "The Peaceable Kingdom," 292–3, emphasis added.
11 These appeared in the February 1974 issue of *Artforum*.
12 Parker and Pollock, *Old Mistresses*, 13 (original: Legrange, Leon, "Du rang des femmes dans l'art," *Gazette des Beaux-Arts* 1860).
13 For a useful introduction to the sociological study of art and its associated literature, see Wolff, *The Social Production of Art*.
14 Weber, *Economy and Society*.
15 See the journal *Art-Language*, 1968–1978.
16 See Marx's *The Economic and Philosophical Manuscripts of 1844*, Lawrence and Wishart, 1959, and *Capital: A Critique of Political Economy*.
17 Fekete, *Life after Postmodernism: Essays on Value and Culture*.
18 Vazquez, *Art and Society*, 61.
19 Ibid., 63.
20 "Other God."
21 See Pelles, *Art, Artists and Society: Origins of a Modern Dilemma; Painting in France and England 1750–1850*, and Wittkower, *Born under Saturn: The Genesis and Character of Artists from Antiquity to the French Revolution*.
22 Hauser, *Mannerism*.
23 Or the subculture avant-garde within high culture.
24 See Hauser, "Alienation As the Key to Mannerism."
25 Other instances of the conjunction between art and anthropology exist in examples of art criticism from this period. See Lippard, *Overlay*. The erasure of difference between the disciplines is a function of a complex range of debates that occurred during the 1960s which stressed the interdependence of intellectual inquiry and the cross-disciplinary nature of theory. The substitution of one discipline for another, art as anthropology, art as philosophy, and art and politics, became the rhetorical condition of

other conditions of epistemological proximity implied by other connectives such as and or after (Kosuth, *Art after Philosophy*).

26 Rosenberg, "Art and Politics," 384.

27 See Crow, "Modernism and Mass Culture in the Visual Arts."

28 Innis, *Bias of Communication*, 141.

BIBLIOGRAPHY

Burger, Peter. *Theory of the Avant-Garde.* Trans. Michael Shaw. Minneapolis: University of Minnesota Press 1980.

Crow, Thomas. "Modernism and Mass Culture in the Visual Arts." In *Modernism and Modernity*, ed. B. Buchloh, B. Guilbaut, and D. Solkin. Halifax: NSCAD Press 1983.

Fekete, John. *Life after Postmodernism: Essays on Value and Culture.* Montreal: New World Perspectives 1987.

Hauser, Arnold. *Mannerism.* New York: Knopf 1965.

– "Alienation As the Key to Mannerism." In *Marxism and Art*, ed. Beryl Lang and Forrest Williams. New York: McKay and Co. 1972.

Hess, Thomas B., and Elizabeth Baker. *Art and Sexual Politics: Why Have There Been No Great Women Artists?* New York: Collier Macmillan 1973.

Innis, Harold A. *Bias of Communication.* Toronto: University of Toronto Press 1951.

– *Empire and Communications.* Revised by Mary Q. Innis with foreword by Marshall McLuhan. Toronto: University of Toronto Press 1972.

Lippard, Lucy. *Overlay.* New York: Beacon Press 1983.

Marx, Karl. *Capital*, Bk 1. Trans. Ben Fowkes, introduction by Ernest Mandel. New York: Vintage 1977.

– *Grundrisse: Foundations of the Critique of Political Economy* (Rough Draft). Trans. Martin Nicolaus. Harmondsworth: Penguin Books 1973.

Pahl, R., ed. *On Work: Historical, Comparative, and Theoretical Approaches.* London: Basil Blackwell 1988.

Parker, R., and G. Pollock. *Old Mistresses: Women, Art and Ideology.* London: Routledge 1981.

Pelles, Geraldine. *Art, Artists and Society: Origins of a Modern Dilemma; Painting in France and England, 1750–1850.* Englewood Cliffs: Prentice Hall 1963.

Rosenberg, Harold. "Art and Politics (from the Notebook)." *Partisan Review* 41 (1974): 378–84.
– "The Peaceable Kingdom: American Folk Art." In *Art on the Edge: Creators and Situations.* New York: Macmillan 1975.
Vazquez, A. *Art and Society: Essays in Marxist Aesthetics.* New York: Monthly Review Press 1973.
Weber, Max. *Economy and Society.* 2 vols. Ed. G. Roth and C. Wittich. New York: Bedminster Press 1968.
Wittkower, Rudolph, and Margot. *Born under Saturn: The Genesis and Character of Artists from Antiquity to the French Revolution.* New York: Wittenborn 1960.
Wolff, Janet. *The Social Production of Art.* London: Macmillan 1981.

The Cost of the Sublime:
The *Voice of Fire* Controversy

Nicole Dubreuil

The Scholar and the Broker

The remarks that follow were triggered by my experience on a panel of "experts" chosen to discuss *Voice of Fire*, the controversial Barnett Newman painting (figure 6) bought by the National Gallery of Canada. Held in the fall of 1990,[1] about one year after the infamous purchase that made the headlines and unexpectedly got a whole country thinking and talking about contemporary art,[2] the event was called "Other Voices." It must have somehow been intended to add a serious note to a debate that had, more often than not, at least from an academic point of view, sent out frivolous overtones. Besides curator Brydon Smith, there were four of us, artist Robert Murray and art historians and professors John O'Brian, Serge Guilbaut, and myself, trying to demonstrate to a somewhat reluctant audience that the painting *Voice of Fire* was aesthetically significant and/or historically important.

My own argument was based on Newman's special position and relevance within the development of modernist art. He had come at a moment when painting was still a leading and demanding medium, trying to convey subject matter of the highest kind while depriving itself of all the traditional means of representation. In fact, it was this very sacrifice, intended to rid the work of down-to-earth particulars, that was a testimony to the artist's ambitions. Combining a gigantic format, a confronting structural scheme, and a suggestive title,[3] Newman aimed at creating a situation where the spectator was called to enquire about the very meaning of art and of human destiny. It was tightrope metaphysics, I was willing to concede, more easily conveyed in a controlled environment like that of the museum where high ceiling, white walls, and subdued atmosphere concurred with the painting's intentionality. That meaning, obviously, must have been lost in the visual hurly-burly of the United States pavilion at Montreal Expo 67, where the work was initially shown.

Serge Guilbaut invoked this context to take a more critical stance and to literally reverse the argument. *Voice of Fire*, tied to an ideologically charged

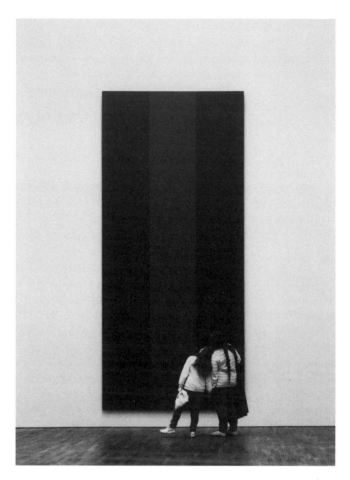

Figure 6: *Voice of Fire*

event like an international exhibition, was more a monument to American imperialism and to phallocentrism than an exercise in soul-searching through aesthetics. The museum, because of the aseptic nature of its presentation practice, could not but fail to reflect upon this historical determination. But the painting still bore testimony to the political climate of a recent past and was valuable as such. Brydon Smith showed X-ray photographs of *Voice of Fire*, cleverly hinting at the material complexity of the work. As for Robert Murray, who alluded to his apprenticeship in sculpture with Newman, he was living proof of both the man's mastery and his influence on Canadian artists. We were all well prepared, full of convictions, and moderately defensive: John O'Brian had reminded everyone in his introductory remarks how often contemporary art practice had recently come under attack.

Despite the seriousness of our arguments, I was left with the nagging

impression that we had not been able to reach that part of the public concerned mainly with one big question, the one that had started the *Voice of Fire* controversy in the first place: Was the painting worth the $1.76 million it had cost the taxpayers? We, the advocates of symbolic values, felt somehow disconnected from the social and economic mechanisms responsible for that other set of values that determines market price and good business deals, and answers to such volatile and influenceable criteria as supply and demand. That demand can include the whimsy of any rich crackpot willing to bid outrageous sums of money for kicks, prestige, greed, and – why not? – passion, to acquire some picture representing "a bunch of limp posies" (*Vancouver Sun*, 2 April 1990) painted by a dead, mad artist.[4] There were, as I was later to find out in the Newman file, a few examples of those volatile criteria in the *Voice of Fire* transaction, including (and notice the wide range of arguments involved here) the relative smallness of Newman's total oeuvre,[5] the exchange rate for American and Canadian currency at the time of purchase,[6] the recent and long-awaited increase in the National Gallery's annual acquisition budget,[7] the sudden availability of a space huge enough to house a two-storey-high panel that happened to be also available[8] and, last but not least, the personal attachment of the artist's widow to Canada[9] and the special fondness of curator Brydon Smith for a certain type of art emanating from the New York School.[10] Yes, there was a strange world out there in which we, the scholars, had no part. Or did we? The numerous opponents to *Voice of Fire*, who by the way were convinced that the painting was not worth a nickel, seemed to lump us together as members of the art clique,[11] as if we were part of the same conspiracy to rip them off and live at their expense. After all, we were providing the labels[12] that were somewhere translated into hard cash.

I knew I was never going to resolve that dilemma. I knew also that I could not stop being a believer in some kind of social significance for modern art in general and for Barnett Newman's works in particular (if only for the trivial reason, and here the taxpayers' suspicion is grounded, that it makes my life meaningful in so many ways, including financially). So it may have been partly to ease my conscience and partly to clarify the misunderstanding between *Voice of Fire* and the people of Canada that I put aside my usual learned readings to enter opinion territory; I opened the painting's dossier in the archives of the National Gallery. The many folders constituting the Newman file, containing nearly a thousand pages of newspaper clippings and radio and television transcripts, are probably the thickest set of documents ever to gather dust on the museum's shelves. (Not far from it, the Rothko file was starting to inflate when I was there, but my feeling was that it wouldn't become more than an inch thick: remakes and sequels rarely retain the flavour of original scandals!) Having completed the reading and classification of this huge amount of information, I found a series of topics that are all pertinent to the attribution of artistic value (trying to answer the questions of how, how much, by whom it is established and communicated). I extract the following, which seemed especially relevant to a debate on *Art and Money*.

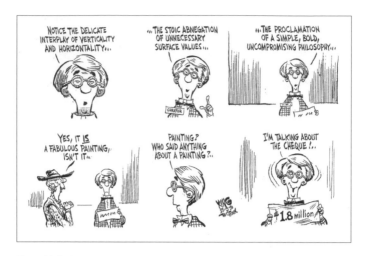

Figure 7: Caricature, Allan King, 1990

Oh Say, Can You See ...

"What was the gallery thinking of, spending a fortune, in lean times, on a trio of tall stripes?" (*Saskatoon Star Phoenix*, 17 March 1990). "Everybody's trying to figure out how two simple strips could cost 1.8 million" (CBC/CBOT, *The Journal*, 10 April 1990); "Striped panel costs almost two million" (*Red Deer Advocate*, 13 March 1990).

Leave it to the media: they have learned how to channel maximum information in minimum space. Those compressed and clashing sentences, running through the Newman file like a protest slogan, point to the main value problem concerning this painting: it offers too little for too much (figure 7). It does actually seem to present such a paucity of visual information that it is possible to describe it – "do away with it" would be more appropriate – in a scandalously short formula: "If anyone ... missed hearing about this supposed masterpiece, let me first describe it to you. I won't take long"(*Sudbury Star*, 4 April 1990). It doesn't take long, indeed, to point to "a red stripe against a blue background" (*Saturday Star*, Toronto, 17 March 1990); or to "a blue stripe, a red stripe and another blue stripe" (*Hamilton Spectator*, 26 December 1990). The colour scheme can be easily qualified by a simple set of terms: "painted in brilliant red ... with two bright blue stripes" (*St John's Evening Telegram*, Newfoundland, 16 March 1990); "The centre one would be red, and either side of that would be a blue-ish, purple-ish color" (CBC/CBO, *As It Happens*, 16 March 1990); "a red stripe down the centre of a background of deep blue" (CBC/CBOT, 21 March 1990); "a deep red vertical stripe on a blue background" (*Lincoln Post Express*, 14 March 1990).

Someone of the older generation, educated like myself in the heyday of formalist abstraction and criticism, may have already picked up on a few discrepancies and misapprehensions in the above quotes, where cadmium and

ultramarine pigments keep shifting in hue and intensity. Such readers may have also noticed that an in-depth reading (i.e. in terms of figure-ground relationship) of *Voice of Fire* does not have the same implications as a lateral scanning of its surface (the Newman file, in fact, offers many instances of both options). These readers may also be aware that such paintings usually contain more than meets the untrained eye[13] and may not be surprised to learn that Newman actually painted the blue over the red in order to create a meaningful visual ambivalence.[14] Try this argument on the lay-persons who are already convinced that *Voice of Fire* "has nothing on it but a few blobs of paint" (*North Bay Weekend Nugget*, 24 March 1990) to offer,[15] and their reply is ready: "We culturally deprived are to ponder such profound issues as whether the red column is pushing against the blue or vice versa? Spare me" (cfra, *Network Commentary*, 29 March 1990).[16] With the exception of a few holdovers for whom the terms "impressionist" (*North Bay Weekend Nugget*, 17 March 1990) or "*futuriste*" (*Journal de Québec*, 17 March 1990) still stand for the whole scandalous enterprise of modernism, and a few *cognoscenti* interested in Newman's position within the New York branch of expressionism, most of the commentators, anticipating the unfolding of history and responding to the apparently simplistic structure of the work, seem to agree that the artist belonged to the minimalist school: "It is perfectly representative of minimalist abstract art whose aim is to give nothing to the viewer and to demand that the viewer do all the work" (*Etobicoke Guardian*, Oakdale, 16 May 1990).

An Honest Day's Work

Work is, indeed, a sensitive and pervasive issue in the Newman file. The perceived scarcity of visual information corresponds to the much-commented-on perceived lack in artistic ability, making *Voice of Fire* totally unworthy of its price tag. The most-often quoted and paraphrased judgment in the controversy must have been by mp Felix Holtmann, the pig farmer then in charge of the Commons Standing Committee on Communication, Culture and Citizenship: "It looks like two cans of paint and two rollers and about 10 minutes would do the trick" (*Edmonton Journal*, 17 May 1990). This aspect of the Newman controversy has already been treated intelligently by Thierry de Duve,[17] mainly through the case study of John Czupriniak, the Nepean resident, owner of a plant nursery and house painter by trade, who received a lot of exposure for his copy of the Newman.

Let's consider briefly the general treatment given to the question of work, including the perception of worker, workmanship, and working tools in the debate on *Voice of Fire*. Painting pictures is not simply a *métier*, artists have claimed since the Renaissance when they left the working structure of the medieval guild and started viewing their practice as a liberal art. As soon as inspiration became an important defining element in their activity, they ran the risk of being treated like hopeless procrastinators and frauds.[18] Things have only worsened with the modern period, which has increased the irrelevancy of

the craft aspect of the profession to the point of annihilating it.

But the general public is still keen on recognizing merit and legitimizing value by the craftsman's standards, where cost and quality of materials, time of execution, and manual competence ensure the probity of the trade. As one commentator put it: "craftsmanship in art, or vice-versa, is a question the philosophers can debate; but I am very much afraid that successful modern artists ... include a lot who were too lazy to learn their craft, or failed in the attempt" (*North Bay Weekend Nugget*, 24 March 1990).

According to the craftsman's criterion, there is no chance in the world that *Voice of Fire* could fetch $1.76 million. Flat areas of colours and straight lines don't require the services of even the house painter: they belong to the domain of hobbies and home improvement chores. They suggest the cellar and the shed and regular trips to the hardware store with the family car and piling plywood sheets in the back of the pickup. The following reaction is typical of a whole set of preconceptions: "Now granted, I know precious little about art ... Nor am I an artist. But I did learn back in elementary school how to paint between straight lines and my brother-in-law has just enough experience to build a huge frame and nail canvass (sic) to it. I also have an empty garage and a free weekend coming up ... we'll build, er, pardon me, create a replacement even bigger, better and brighter" (*Regina Leader Post*, 10 March 1990). With the proper tools and supplies, a steady hand is no longer needed to execute a masterpiece, though some may still fail in the task, like this Barnett Newman con artist who, as one giggling couple was to find out in front of the picture, "couldn't even keep inside the lines" (*Ottawa Citizen*, 5 June 1990).

Enter the too-familiar remark about everybody's kid could do it[19] (and some have, sending their own version of *Voice of Fire* to the National Gallery or to their MP to prove their parents' point). Even Czuprinyak, who took his copy-job of the Newman very seriously, made this nostalgic remark: "I should have started that when I was at least ten years old. I would have been a multi-millionaire by now" (CBC/CBOT, *The National*, 21 March 1990). As for working time, which may vary from a real full day to a fictitious and highly symbolic ten minutes, it spells "short" when the key word is "million." "It was no trouble at all. Waiting for the paint to dry was the biggest thing" (*Edmonton Journal*, 14 March 1990), said this self-called "average Edmontonian" who even used a brush, like the painter, contrary to the widespread fantasy that *Voice of Fire* belongs to the "roller school." Renaissance theorists would have referred to the search for a higher *cosa mentale*, those deep moments of reflection an artist spent, between actual working hours, searching for ways to give the most significant form to an important subject. Since this argument did not always convince the patron paying the bill back then, there is not much hope that it can achieve anything today. Ask this columnist, who has been told there was time-consuming effort involved in conceiving *Voice of Fire*: "One gallery apologist said the artist probably thought about this thing for two years before putting roller to canvas. Scary, eh? Someone out there spent two years of his life thinking about a red stripe" (*Winnipeg Sun*, 26 March 1990).

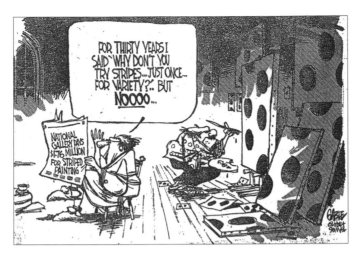

Figure 8: Cartoon, Brian Gable, 1990

(De)sign

At least the Renaissance artist had recognizable motifs to testify to both the skill and the thinking involved in the art. It has been often and rightfully pointed out that abstraction, especially abstraction of the radical, end-of-the-line sort developed by Barnett Newman, is largely responsible for public outrage at the price of his work: "I would wager that if ... the National Gallery had spent this much money on a superior example of a representational painting, there would not have been any of this cafuffle" (CBC Radio Calgary, *Home Stretch*, 11 April 1990). The following comment seems to encourage that conviction in a tongue-in-cheek way: "If it doesn't look like some flowers or a nice country landscape, the hell with it, it's not going to hang on the walls of this home" (*Barrie Examiner*, 15 March 1990). Such expressions as the painting "portrays," "features," or "depicts" colour stripes recur, revealing that a picture is supposed to look like somebody or something being or doing something. If not, then what we may be left with is just ... design[20] (figure 8). This commentator, parodying Newman's project, seems to agree: "Is the painting so expensive because artist Newman spent so much time fretting over just the right combination of colors for his statement? 'Should I use green or yellow?', he must have agonized ... 'Should the stripe run vertically or horizontally? Or maybe I should use polka dots.' As a master artist, he probably suffered several breakdowns before setting on the final design" (*North Bay Weekend Nugget*, 24 March 1990). The main function of design appears in this case to be an ancillary one: an un-meaningful pattern whose task is to enhance, to decorate objects. In a way, that is what some of the painting's copies were doing, resting against a fence in front of the barn door[21] or the porch, or stretched on a rooftop[22] for the enjoyment of those driving by. MP Holtmann, who admitted he would not hang *Voice of Fire* in his parliamentary office, came to the hear-

ings of the Culture Committee wearing a tie that he described as an exact replica of the original Newman (a nasty reporter claims that Brydon Smith was wearing a scarf of that same pattern too when he was summoned to appear before the committee but that he got rid of it when he saw Holtmann flashing his tie before the cameras (*Ottawa Citizen*, 11 April 1990).

The striped pattern, then, becomes that visual decorative scheme in the world of experience the painting resembles (which brings us back to representation in a strange distorted way). Once you start playing that game, there is no limit to the type of objects you can refer to, from wallpaper, bedspreads, and sheets, to toothpaste and radio-station cars.[23] Obviously the museum officials were also thinking adornment when they insisted that *Voice of Fire* was so exhilarating and so well suited to their new, sunlit gallery space.[24] To which they received the somewhat deserved reply: " ... We could have been exhilarated at a fraction of the cost if someone with a steady hand had purchased a few cans of blue and red acrylic from Canadian Tire and copied the work directly onto the gallery wall where this object now hangs" (*Globe and Mail*, 16 March 1990). No wonder they were also asked how they knew the painting was not exhibited upside down or if it could be hung horizontally in a room with a lower ceiling. (These are not fictitious issues: it took a reversed logo on a pair of jeans to make someone realize that the photograph of *Voice of Fire* on the museum's publicity leaflet had been flipped over.) Designs applied to objects in the world, of course, offer more than exhilarating decoration: they can also be useful and make you feel comfortable, like the T-shirts silkscreened with the *Voice of Fire* motif by Ontario artist Bob Beland or a more profane sofa, sold at discount price and described as "A true work of art covered in buttersoft Italian leather, available in 12 colors – not just 2!"[25] Design as decoration can, of course, be worth money, providing it happens to be highly original. Well, *Voice of Fire* does not qualify by those standards: the striped ties and bedspreads were around long before it appeared.

Sublime Stripes

Of course, designs can also be deeply "sign/ificant" – and perhaps they can recover something of the old Italian concept of *disegno*[26] – as they start acting on their own, like ciphers of sorts. "You have to have both – esthetic pleasure and meaning – otherwise you're talking wallpaper" (*Winnipeg Sun*, 8 April 1990). Critic Joseph Masheck probably had that in mind when, elaborating a few decades ago on "The Carpet Paradigm,"[27] he tried to demonstrate that the whole endeavour of modernist painting was to subsume the design into the sign. That the quest for meaningful signs motivated artists of Newman's generation to push the deconstruction of traditional painting to its limits, in order to bring the viewer in contact with the sublime, is a recognized historical fact, testimony to one of the last utopian moments of modernism. That the confrontation with *Voice of Fire* could provide real historical viewers like the people of Canada with such bliss is another story altogether.

First, the *Voice of Fire* known to Canadians was largely a mediated image, processed through the printed press or the TV screen, reduced in size and in chromatic effectiveness – sign without the revelation of anything but a simplistic design in search of its meaning. Was it because the litigious painting happened to be stationed in Ottawa, or because at a time of budget cuts angry taxpayers wanted to make its purchase a national issue, or because veterans thought they were not getting their fair share of the social pie? The more frequent allusions to a possible meaning of *Voice of Fire* referred to flags (flag for a Banana republic), emblems (Ottawa city coat of arms, without the arms), and military paraphernalia (Grenadier watch strap, RCMP trousers). They represent signs whose ultimate meanings remain unknown, incomplete, and in the end trivial – unless they turn out to symbolize all our collective irritants, like the opposition between Tories and Liberals or the distinction between French blue blood and good old English red blood (*Toronto Star*, 21 April 1990).[28] Even for many visitors to the gallery, who went out of curiosity or expecting a revealing encounter with the work, the sign appeared to have remained mute and its most performing aesthetic asset, the sheer size of the piece, seemed to be a pure shock tactic and a fallacious excuse for its huge price: "Sure, this particular piece of art, and I use the term incorrectly, is 5.4 metres high, but what does that prove? A pole vaulter may be impressed by that height, but the only thing it shows the rest of us is that Newman could paint evenly for about six yards" (*North Bay Weekend Nugget*, 24 March 1990). Or, "Unfortunately nobody's likely to glide down a rope from the skylight to steal it. This baby is big enough to roof a house" (*Winnipeg Sun*, 26 March 1990).

Negative reactions to the prose of the gallery officials trying to emphasize the seriousness of the painting also indicate that this sign was not operating properly: "Shirley Thompson ... gave us a perfect example of this art-babble when she was asked to justify the purchase of the infamous stripes: 'It's the distillation of a man's thought ... it takes you out of yourself ... '. Are we to imagine that maybe she travels the world looking for simple things that take her 'out of herself' – and that she then puts down a cool million when she is thus transported?" (*Halifax Chronicle-Herald*, 17 May 1990). "Smith 'described' *Voice of Fire* as 'a phenomenal painting in which our sensory experience of the work is stripped of all other associations, and through which the emphatic qualities of purely colored form are able to flood our consciousness with a sublime sense of awe and tranquility.' Feeling a little stunned? Hey, Brydon Smith was just warming up" (*Montreal Gazette*, 17 April 1990). Unless one accepts the fact that provocation per se is the hallmark of authenticity in art,[29] one is tempted to consider any explanatory rhetoric concerning *Voice of Fire* a smokescreen preventing the lay person from realizing the obvious: the emperor has no clothes.[30] The thickest smokescreen was perceived to be the very title of the painting which, in Newman's usual practice, is loaded with connotations and intended to create a productive tension with the painted form. Since neither the "voice" nor the "fire" could be seen in the work, its title was submitted to ample mockery: *Voice of Ire*, *Voice of the Confused*, *Voice*

of Stupidity, Voice of Amazement, Voice of Laughter, Voice of the Disillusioned, etc., among which an ominous *Voiceless* summed up, for a vast majority, the failure of the real *Voice of Fire* to communicate anything significant.

People's Money, People's Art

It was becoming clearer to me why the aesthetic values we were advocating on the National Gallery's panel were largely intangible to the people expressing their frustrations in the Newman file. Indeed, the situation was so extreme that even the historical arguments invoked to assert the painting's value did not seem to carry much weight, even if the line of defence seemed spread out on solid grounds. Declared "one of the three most seminal American painters of the post–Second World War period" (*Winnipeg Free Press*, 14 April 1990) and "a major figure in 20th century art" (CBC/CBOT, *The Journal*, 16 March 1990), Newman had works "hanging as celebrated additions to the collections of the great Museums of western culture, including ones in New York, London, Paris, Berlin, Zurich and Washington" (*Ottawa Citizen*, 24 March 1990). Retrospective exhibitions of his oeuvre had been held and his reputation had reached as far as Japan (*La Presse*, Montreal, 20 March 1990). Besides the artist's impeccable credentials, his moral support and his style of painting proved to have been highly influential on Canadian artists of reputation from Saskatchewan (he conducted a famous workshop at Emma Lake in 1959[31]) to Quebec (he is reported to have visited the Montreal Plasticiens in 1969[32]). And it was for an important international event held in this country, Expo 67, that he had executed the impressive *Voice of Fire*. For those in favour of the acquisition, the reappearance of the painting on the National Gallery's walls amounted to no less than a long-overdue return home. Unfortunately, the feeling was not shared by the larger community.

"Number one, I don't think the painter was that well known; two he's American, and three, he's dead" (*Vancouver Province*, 18 March 1990). To give MP Felix Holtmann the right of reply amounts to simplifying a rather complex issue and playing into the hands of someone who has been described as an astute publicity-seeking politician,[33] even though his stubborn resistance to any positive argument concerning Barnett Newman and his painting seems to offer a compendium of all the public whining about the purchase. His outburst as a representative of the people does indicate how difficult it can be to debate the status of art in a democracy. The political and economic system under which we presently live was, indeed, very much at the heart of the *Voice of Fire* controversy. The following argument from a chronicler is enlightening and worth quoting at length: "In the bad old days before democracy, peasants were worked to the bone and taxed out of their shoes so that aristocrats could overeat, dress funny — and sponsor artists and musicians. If some uppity peasant complained that he never got to hear a cantata or sit for a portrait, a kindly aristocrat would explain that the bootless bumpkin couldn't possibly appreciate art, then have him flogged. An unkind aristocrat would skip the

explanation. Thankfully, we've done away with aristocrats. The average Canadian is now taxed out of his shoes so that bureaucrats can sponsor artists and musicians" (*Vancouver Province*, 26 March 1996). The danger of being chastised no longer present (except, of course, on a symbolic level), the workaday citizen now feels free to speak up and manifest some discontent.

It was perhaps because the gallery ill-advisedly announced the acquisition on March 7, in the wake of a penny-pinching federal budget and under the threat of an impending GST, that the public became acutely aware of being directly involved in the *Voice of Fire* purchase.[34] In terms of actual cost by citizen, the amount may not have been much (rough estimates ranged from less than 6 cents to 13 cents at most), but the principle remained: people had paid for something they did not want. While idealist modernist painters like Barnett Newman dreamed of a universal audience for their work (and it was this very idealism that kept them from the particulars of figurative painting), it is not clear what kind of art would satisfy a democratic community in search of consensus. If long-celebrated geniuses like Michelangelo, whose works, by the way, are no more available than they are affordable to the taxpayers of the world, are occasionally mentioned as capable of creating unanimity, what appears more obvious is that the quest for common taste is more likely to lead to ... common art: "The problem, of course, is one person's art is another's garbage, and for many people, the best art is what most closely resembles reality. That means the best art is the stuff sold in shopping mall art sales and features black velvet bullfighters and Elvis Presley busts" (*North Bay Weekend Nugget*, 24 March 1990).[35]

As for the very high-brow *Voice of Fire*, at the cost of $600,000 a stripe, it obviously did not belong to any kind of popular art. That may explain why a defence strategy had to be concocted to convince people they had not been cheated out of their tax money. Hence the conversion of the painting into an asset: "We're not really spending money, we're transforming it into a work of art" (*Edmonton Journal*, 14 March 1990). This line of argument led to stating that the Newman was, in fact, a real bargain, even a steal, when compared to the amount paid for other paintings by the same artist on the open market. As Shirley Thompson told a reporter: "You know, Japanese museums would kill for it" (Q-101 FM, *Insight*, 7 March 1990). With the fever that had been infecting the art market for some years and pushed prices sky-high, *Voice of Fire* had probably already increased its value to $3 million. And this was not even taking into account some fringe benefits, like the promise made by Annalee Newman to give another of her husband's paintings to the gallery, or the profits gathered from the record number of visitors attracted to the Ottawa museum by the publicity. That type of message must have been heard by the taxpayers, whose main preoccupation became the anticipated returns from the sale. Was the United States at all interested in getting it back? Were the Japanese still eager to buy this name? To convert *Voice of Fire* into money again would prove the museum was right in its evaluation and maybe make a nice profit to buy more of more reassuring art. Besides, it would dispel one

last source of uneasiness about Newman and his painting: "As for the price, yes, it's a bit suspect, especially since the painting was produced for the American Pavillion at Expo 67 ... and the artist was probably paid a large amount for it then" (*Etobicoke Guardian*, 1 May 1990).

Social Body

The money problem leads to toying with questions of decision making and social priorities.[36] The general public is rather distrustful of its politicians' taste[37] and cautious for reasons of principle: "Governments make political judgments. They look at the choices and pick up the one that will make the fewest enemies. They pick the alternative that takes provincial, regional, ethnic and religious sensibilities into account" (*Ottawa Citizen*, 24 March 1990).[38] Politicians can use art issues as clever diversions when facing public discontent. They have also proven to be spendthrifts, wasting the people's money on all kinds of dubious investments like costly war armaments and nude dancer nightclubs. Better keep the politicians, then, in the role of watchdogs over that necessary evil of any advanced modern society: the specialist.

For some reason difficult to explain,[39] people seem less tolerant of their art experts than of any other kind of higher government clerk empowered to spend their money: "Everyone's aware of the space program – but no one expects the whole world to know the formula for rocket fuel. And those who DO know it don't get branded elitist" (*Vancouver Province*, 1 April 1990). "Elitist" becomes a key word in the *Voice of Fire* controversy. What seems to be a cause for grief is less a problem of class discrimination based on "hard" capital (even if some complain that they cannot afford the airfare to Ottawa or even the museum's entrance fee to see "their" new painting) than an effect of social distinction grounded on "soft" cultural capital. The Newman file presents a social body conscious of the deep cleavage separating the dilettantes from the philistines, the snobs from the slobs, the artsy set from the plebs:[40] "On one hand, there's the art world. Aloof, hostile and inarticulate, it refuses to justify the purchase or is unable to do so. Then on the other hand, there's the rest of the world. Resentful, ungenerous and equally inarticulate, it refuses to understand or even try" (*Toronto Star*, 13 May 1990). Feigned ingenuousness was becoming the weapon of counter-attack: "What sort of person must I become to experience true art? What is it I must do to share the feelings of those who like it? Do I need more education, better income, friends in higher places, more etiquette, less socializing with minorities, art classes?" (*Fredericton Gleaner*, 17 April 1990). To calm the hostilities, Newman himself had to be presented as an everyday kind of guy, fond of baseball and vodka, capable of discussing art with a cab driver and dragging him into a local gallery (*Windsor Star*, 28 April 1990). The logical economic conclusion to this social cleavage was to be expected: if only a very small clique of connoisseurs has symbolic access to the Newman, then let it pay for it, through private purchase or through an art lottery. After all, art is not an essential service (*Toronto Star*, 5 May 1990).

In fact, a social body has sore parts that hurt on occasion or chronically and need to be given attention. The Newman file reveals a lot of pain among starving Canadian artists who did not think they got their rightful share of public support while scandalous sums of money were spent on an American: "What happens to Canadian artists when they can't function financially? They take other jobs to support and feed themselves until they can afford to paint or sculpt themselves back into poverty. You will not find a more dedicated group of people than Canadian artists. They have subsidized Canadian culture and have enriched Canadian life without any real expectation of financial reward" (*Comox District Free Press*, Courtenay, B.C., 16 March 1990). Nor have they received due recognition in the museum's collection: "A 'national' gallery of art that has yet to purchase a single painting by such an important Canadian artist as Charles Pachter – widely known for his Flag and Queen on Moose paintings – has no right whatsoever earmarking such immense sums for paintings by foreign artists like Newman who are 'spent forces'" (*Toronto Star*, 14 March 1990). These artists come in pressure groups or as individuals, from the large metropolitan centres or from God-forsaken regions, to complain about the gallery spending more than two-thirds of its annual budget on a single, non-Canadian work. There ensues a battle of figures about how many local artists (ten at $180,000?, one hundred at $1,800?) could be fruitfully supported by dividing up the $1.8 million. Enter the museum's officials, explaining that since the payment of *Voice of Fire* had been spread over a three-year period, there was still a considerable and fixed portion of the gallery's subsidies allotted to buy Canadian art, and that a national museum is not supposed to show exclusively local production but has to present it in a meaningful art historical context.

Self-declared starving artists did not, however, constitute the more sensitive zone of the social body (taxpayers were quick to consider them spoiled children who should learn how to support themselves instead of always relying on help from the state). But how can art, any kind of art, take priority over so many more pressing social needs like real poverty and sickness? "My suggestion is to have prints made of this costly work of art, placing them in the hundreds of soup kitchens, food banks, school lunchrooms where hungry children are fed; place them in the research labs for heart, kidney, diabetes, multiple sclerosis, cystic fibrosis, burn units, and so on, where they will be the 'distillation of man's thought and how it may take them out of themselves' to find cures" (*Regina Leader Post*, 24 March 1990). What can one answer to that except by an equally desperate act of faith in some kind of spiritual necessity for art, a faith that is totally akin to Newman's attitude towards his own painting. On a more profane level, among the urgent social causes evoked in the Newman file, one often quoted concerned cuts in government funding of battered women's shelters just at the time of the *Voice of Fire* controversy. Of course, it may have been chosen because it was, indeed, a serious issue. But one suspects it was also singled out because its "cultural sensitiveness" made it "news," catchy news relayed by that nervous system of the social body called

the mass media. The Newman "scandal" was also largely a media affair, lending itself to short cuts and strong contrasts, with ready-made heroes/villains like MP Holtmann and ongoing episodes as the government was pushing its examination from committee to committee. The painting and its title were endless sources of punchy lines and puns: "Fire the Curators," "A Lot of Stripe for the Money," "A Divisive Issue," and so on.

Academia, the Soft Spot ...

Finishing my extensive reading of the Newman file, I realize that the long hours spent compiling reasons for public discontent may have given some insight into a real problem facing the art community, but they have provided little in terms of solutions. There may have been some "juicy" material in the thick pile of documents I gathered from the museum's archives; yet the type of objections unfolding through nearly one thousand pages had to be anticipated. The dilemma, indeed, remains intact. We, the participants in the National Gallery panel, had already rehearsed the best arguments available for the circumstances and perhaps convinced a few people that we mean serious business when we consider aesthetic value and historical significance. Dragged outside of that cloistered realm where modern art has entrenched itself from its inception, as a specialized practice severed from any clear social function and involvement, its advocates risk sounding like hopeless utopists, dreaming that with more tax money (see the irony?) visual illiteracy could be overcome and Newman's desire for universal communication through art realized at last. Alternatively, they must start playing cynics and ostentatiously ignore the ignorant.

It is worth noting that when the art community feels summoned and somewhat threatened by public discontent, it cannot easily organize its own defence according to any *esprit de corps*, divided as it is by conflicting interests. We have already seen that Canadian artists had mixed feelings about the purchase, and great expectations as well as strong frustrations concerning their own institutional recognition. Scholars meet with the same difficulties, the dividing line opposing, in the present case, the modernists and the traditionalists. Academia has always been a territory of fierce individualism and heavy competition, making a regrouping of forces nearly impossible. Besides, the kind of work that scholars do takes time, and the rhythm imposed by newspaper publication does not correspond to their ways and customs (nor does it offer the necessary space for their lengthy elucidations). Neither does their type of prose suit journalism, and the argument goes for the most radical among them who have relinquished aesthetics for cultural politics and a critique of artistic ideology. The general public expressing its discontent in the Newman file would not be any keener on subsidizing an abstruse deconstruction of social discourses than in paying for an "overpriced acrylic." Even politics may add to the relative impotency of the artistic milieu to embark upon serious reflection when facing a crisis like the one brought about by the

Voice of Fire controversy. In Quebec, for example, many took it for granted that the Newman scandal concerned exclusively English Canada (true, according to the comparative volume of documents published in both languages) where abstract art, a latecomer on the scene, had never had a Borduas to confer on it outstanding cultural and social value. This "innocent" view was to be challenged at the very beginning of the Rothko controversy when the same attacks on senseless, easy decorative art were voiced in the francophone media. Yet, in spite of all its domestic quarrels, the art community could not but feel deeply challenged by the public outburst over the purchase of the Newman painting. It was reminded in a very pressing way that its practice was deeply tied to a social position, and a precarious one at that, especially in a period of economic uncertainty.

NOTES

1 The papers delivered at this panel and the discussion that followed have been published in *Voices of Fire: Art, Rage, Power, and the State* (Bruce Barber, Serge Ouibout, and John O'Brian, eds., University of Toronto Press, 1996).

2 To the director of the National Gallery, Dr Shirley Thompson, this seemed to have created a rather unusual situation: "We're delighted by the lively nature of the debate, by the way. We're talking about art, we're talking about Canadian artists, we're talking about Canada's role within the international community of contemporary art. It's a great debate" (CBO *Morning*, 11 April 1990).

NB: All radio and television interviews referred to in this article are quoted from MTT [Media Tapes and Transcripts] Ltd., Ottawa.

3 Brydon Smith had found written testimony tending to prove that the expression "Voice of Fire" might have carried anarchist connotations. He too inquired about the question of subject matter in the work of Newman.

4 Everyone will have recognized the $53.8 million transaction, conducted at Sotheby's in 1987, that marked the acquisition by Australian businessman Alan Bond of van Gogh's *Irises*.

5 The argument was brought up occasionally in the newspapers: "The law of supply and demand certainly supports the price paid for Newman's work. He completed only 125 paintings in his lifetime, which makes each example a rare and precious commodity" (*Saskatoon Star Phoenix*, 10 March 1990). On top of that, it may just be the tallest work in this rather small oeuvre, since only four or five paintings (some are willing to go up to twelve) reach the size of *Voice of Fire*. The significant fact that Newman is a "dead" contemporary artist has triggered unexpected ironic comments: "How do we go about creating added value in a provincial art market? Being dead, as Newman is, helps" (*Toronto Star*, 31 March 1990). "Perhaps the National Gallery thought that since Newman is dead, they can afford to pay any astronomical price for his painting, since the chance of him cashing the cheque are fairly slim" (*North Bay Weekend Nugget*, 24 March 1990).

6 "We picked up about $80,000.00 just through the exchange," Brydon Smith was happy to announce, commenting

on the time gap between the decision to acquire the work and the actual moment of purchase (CBC/CBO, *Morningside*, 15 March 1990).

7 It had just risen from $1.5 to $3 million a year.

8 The completion of a new building for the gallery had of course a lot to do with the decision, both on financial and on aesthetic grounds: "Their budget for acquisitions had been held back during the time of capital expense ... So there is some catch-up they have to do at this point, that's for sure" (CBC Newsworld, *This Country*, 9 April 1990). "It was in 1986 when I [Brydon Smith] was project director for the new building. I was over in the Gallery ... the concrete had been poured, and I was sitting in a room with no walls, a large space, and this painting just came into my mind as something that would look absolutely magnificent in that space. I reasoned that it probably was still available because of its extreme height" (CBC/CBO, *Morningside*, 15 March 1990).

9 Annalee Newman is reported as having declared: "I felt [Canada] was the right place for the painting. I kept the price low because I wanted [Canada] to have it" (*Ottawa Citizen*, 24 March 1990).

10 "Someone at the gallery has a fetish for Newmans because they already have two of them" (CBC/CBOT, *Midday*, 9 March 1990).

11 "Certain curators, collectors, and idolatrous art critics have helped contribute to Newman's cultural canonization" (*Toronto Star*, 31 March 1990).

12 On that topic, one should read Alsop, "Art into Money": "In the art-into-merchandise transformation, moreover, art history, which supplies the art market's labels, is just as important as art collecting, which supplies art market's customers."

13 As this commentator puts it, "Abstract painting doesn't translate well to prose at the best of times" (*Cape Breton Post*, 2 April 1990), and Barnett Newman's pursuit of the purely visual at the expense of the literary narrative in painting exacerbates this condition.

14 "You [the *Financial Post*] described the painting as a 'single red stripe against a blue background.' Have I missed something in this controversy? I have been under the impression that the painting was two deep blue stripes against a red background" (*Financial Post*, 20 April 1990).

15 We are not simply dealing here with a lack of visual competence. Obviously some of the people expressing their anger have not seen the work, not even in reproduction. Most have only been exposed to newspaper photographs, possibly to photographs of copies, like John Czupryniak's much publicized *Voice of the Taxpayer*. A few confront this situation with a real seriousness: "I have studied photos of it very carefully to try to comprehend what would make it worth that much, but I just can't see it. I must be stupid" (*Fredericton Gleaner*, 3 April 1990).

16 This other comment is aimed at "the authoritative History of Modern Art [which] speaks of the tangible tensions between the color surface and the 'line' which seems to be a structural opening and closing ... The difference between a line and a 'line' is to be about $1.8 million" (*Saskatoon Star Phoenix*, 10 March 1990).

17 de Duve, "Vox Ignis, Vox Populi," 35–8.

18 On the new status of the Renaissance artist see Wittkower, *Born under Saturn*, especially the sub-chapter on "Creative Idleness."

19 The age of the child, of course, would not matter since what counts is the connotation of facility and lack of competence pertaining to "kid's stuff." In the Newman file, we regress from grade-school hallways to kindergarten classes, which prepare us for other familiar regressions leading to the

monkey and the donkey.

20 "Are you sure there isn't something under that's covered up?" says this onlooker when *Voice of Fire II*, a fictitious replica of the Newman painting, is brought by truck to a gallery, implying that design cannot be enough in a work of art (CTV/CJOH, *Newsline*, 18 April 1990). Amazingly, the pure visual enjoyment that some people expect from painting may not be that different from design consumption: "Being a successful artist myself, I do believe that I am qualified to express regret for this extravagant expenditure on an article of questionable merit. Abstract art, when well done, can be very pleasant viewing. This particular example does nothing for my senses" (*Ottawa Citizen*, 15 March 1990).

21 The repeated references to the barn, and barn door (it was used again when the National Gallery bought the Rothko) would certainly require more attention than it can receive here. Was it triggered by the fact that John Czupriniak's copy was described as towering near a "weathered barn" (CBC/CBO, *Local News*, 16 March 1990)? Or by the rectangular shape of the painting's support? Or by the fact that honest, no-nonsense Canadians like to picture themselves as country folks?

22 An allusion to Ron Sajack, Fredericton's "rooftop" artist who painted his own version of the Newman picture on a friend's roof: "We did it all out of a desire to put a smile and a happy face on residents of Fredericton and a number of tourists … People have been telling me how really nice it is, and how it helps to take their minds off problems" (*Fredericton Gleaner*, 14 August 1990).

23 All the examples enumerated here are taken from the Newman file.

24 From the decision, taken on the construction site (see note 8), to buy this particular Newman to the public relations strategies of the National Gallery,

a special emphasis was indeed put on the harmonious relationship of building and painting. The critics were quick to catch on: "The gallery's remarks have been … unhelpful in explaining why the painting is worth the expenditure. Smith's own comments made the painting appear chiefly an extension of the gallery architecture" (*Globe and Mail*, 30 March 1990). This may explain the special kind of humour used by this chronicler in discussing a possible de-accession of the painting: "That just won't do. You can't send back a $1.8 million painting with a note saying: 'On getting it home, we found it doesn't match our slip covers and are returning it herewith. Regards'" (*Vancouver Sun*, 2 April 1990).

25 Taken from a photocopy in the Newman file (origin unknown).

26 A term in which "drawing" and "concept" coalesce.

27 Masheck, "The Carpet Paradigm."

28 Once in a while someone may try to make sense of this very situation, i.e., of the fact that *Voice of Fire* is possibly a reminder that we are surrounded with signs of a kind not alien to the painting's scheme: "It is strange indeed when an image of stripes hanging on a gallery wall causes such an uproar, yet does not effect a second thought when seen in other contexts. I am referring to the restrained pinstripes and the bold, flashy stripes of fashion, the order-imposing lines of our road system, and the patriotic stripes of the flags of many of the world's nations" (*Toronto Star*, 14 April 1990).

29 Some have used the argument in defence of the painting: "It's over a quarter of a century old and it still has that power to provoke, to challenge. And that's part of a work of art" (*St John's Evening Telegram*, 16 March 1990). But most, starting with MP Holtmann, see the situation differently: "We're spending in excess of a billion dollars on culture in this country, and

we're doing that not to bring about a bad mood to Canadians" (CBC/CBO, *Morningside,* 5 April 1990). "It's provoked a lot of people, but I suspect it has angered a lot more than it has provoked. It has provoked them to anger" (CBC/CBOT, *Midday,* 11 April 1990).

30 "I would like to suggest that the obviously highly intellectual and extremely knowledgeable connoisseurs of great works who have chosen *Voice of Fire* for our National Gallery should perhaps read the fairytale *The Emperor's New Clothes* ... Frankly, I think that the gallery wall which displays this 'masterpiece' is just as naked as was the Emperor in the fairytale" (*Toronto Star,* 21 March 1990).

31 Says artist Robert Murray, "He gave us a sense of what the importance of being an artist was all about, regardless of what else one had to do to make a living, of making your work your first commitment" (CBC/CBOT, *The Journal,* 10 April 1990).

32 The names of Molinari and Yves Gaucher, and Tousignant, who painted an *Hommage à Barnett Newman,* are mentioned.

33 "He likes to play his image of the rural rube, the hick pig farmer just to enrage the Ottawa cultural community" (*Hill Times,* 17 May 1990).

34 "It is all too easy for the critics to say that this represents the blood of the average taxpayer who is footing the bill for this painting, so I shall avoid this metaphor" (*Toronto Star,* 21 April 1990).

35 Allusions to paintings on velvet recur, in the Newman file, as if they were to embody the very paradigm of popular and democratic art.

36 The *Voice of Fire* controversy was already becoming pedagogical material, being used as a case study for future public administrators (SRC/CBOF, *Bonjour,* 16 November 1990).

37 The culture committee of the Commons gave such performances

that it was called an oxymoron by a sardonic chronicler (*Sudbury Star,* 14 April 1990).

38 A politician's museum could be an amusing alternative to mainstream art history institutions; but one doubts if it would make any critical sense.

39 Here are a few speculations about this state of affairs: visual literacy is thought to be given by nature, and art worthy of the name, easily readable. Contrary to science, art is not a serious priority and belongs to the domain of leisure; hence the right of everyone to enjoy it without constraint.

40 Like the head opposed to the working hands? The answer is not clear. Foreheads have been known to sweat under physical strain.

BIBLIOGRAPHY

Joseph Alsop. "Art into Money." *New York Review of Books* 33, no. 12 (17 July 1986): 42.

de Duve, Thierry. "Vox Ignis, Vox Populi." *Parachute* 60 (October, November, December 1990): 35–8.

Mascheck, Joseph. "The Carpet Paradigm: Critical Prolegomena to a Theory of Flatness." *Arts Magazine* (September 1976): 82–110.

Wittkower, Rudolph, and Margot Wittkower. *Born under Saturn.* New York: Norton 1969.

Colville and Patton:
Two Paradigms of Value

Mark A. Cheetham

To help think through issues of art and money, let us consider briefly recent work by two artists whose artistic and entrepreneurial interactions with their ideal publics are very different: Alex Colville and Andy Patton. I want to suggest that their respective attitudes about this public and its ability to buy art very much configure the sorts of work they do. I'd also like to entertain the idea that these attitudes are only in part personal or volitional; for Patton, Colville, and the rest of us, what we might deem "institutional" forces and expectations in part shape the attitudes that shape the art. More specifically, the commercial gallery system in Toronto, in which both artists participate, demands that the work have exchange value. What constitutes that value, and what is exchanged, nonetheless differs in the case of these two artists. Despite surprising points of contact, they have developed divergent aesthetics and different ideologies of art.

It is well known that Colville styles himself as a business person rather than being hypocritical enough to pretend he's a starving artist.[1] Existentialist painter and thinker that he is, Colville sees his success as the result of self-fashioning: "You are what you decide you should be," he has claimed. "Things are sort of wide open. You can decide you're going to appear to be and live like a plumber's helper, or you can decide you're going to live like someone who is vice-president of a bank" (personal interview). Colville thinks the former course – that of the plumber's helper – is the route chosen by most artists; he sees himself as a banker of art, and indeed he encourages the use of his work for calendars, book covers, and even bank promotions.[2] He believes in free will. As he once put it rather graphically, "if you don't like Detroit, get out of Detroit, I would say. People should exercise their wills in these terms more fully perhaps than they do."[3] He has done so, and with great success. He feels sorry for those less fortunate in their career choices, partly because he saw his father – a Scottish immigrant – change jobs frequently when he came to Canada and become dissatisfied with his job as a steelworker. Colville has

sought security in class mobility. "I know this sounds vain," he confides, "but I think of myself as a sort of self-appointed aristocrat" (personal interview). He has that bearing and charm, perhaps even a touch of *noblesse oblige*.

Colville is proud of his business acumen and actively defends his recent decision to have several of his best-known images photographically reproduced and sold for relatively low prices (around $300 each, a fraction of the going price for one of his drawings, let alone a serigraph or painting). *To Prince Edward Island* appears again in this context, in a edition of 950 with 100 artist's proofs, hand signed, with "a document of authenticity" (as the promotional material states) accompanying each reproduction. So close to the look of the original painting are these prints that even the example sent to prospective buyers carries a "sample" label to discourage counterfeiting (figure 9). "Some people are shocked that I've allowed these reproductions to be made," Colville says, "but of course I've been wanting people to reproduce my paintings for decades" (personal interview). David Burnett, of the Drabinsky & Friedland Galleries in Toronto, suggests that the controversy in the artistic community over this move away from the sacred trust of an artist's signature on "original" work hasn't been so intense. He reports that most of the responses he has had have been from other prominent artists inquiring about reproducing their work this way in order to find buyers (personal interview). On the other hand, Mira Godard, Colville's former Toronto dealer, stands on principle and says that Colville should never have allowed this commercialization of his art (personal interview). We are in interesting territory here, since Godard – one of Canada's most experienced and financially successful art dealers – is of course in the art business, yet draws the line at photo-reproduced prints. On the one hand, then, for some the "value" of Colville's work is reduced by its mass reproduction. At the same time, Colville himself clearly sees no diminution in the integrity of his work and he sees a new market for its sale. His move to reproduction, then, reveals much about what art is for him and how it should function in society.

In fact, Colville is quite happy to have an issue made out of his allegedly damaging commercial interests. "I occasionally get letters sadly reproving me for having allowed my work to be reproduced," he reported recently. "My reply is that I do not live off government grants ... and so I like to *earn* money" (letter). He views his independent attitude as part of a larger question about the status and self-image of the artist, about the plumber's helper versus the banker. He argues that "it is widely assumed that the artist, as 'rebel,' 'non-conformist,' 'outsider,' etc., is a member of a kind of underground proletariate who is 'kept' by government agencies ... , [whereas] I consider myself a self-appointed member of the upper class" (letter). Echoing the often-heard position of George Woodcock and others that the state should have nothing to do with the financial support of the arts, Colville elaborates the notion that the artist must be fiercely independent. For him, this means making his work popular in subject – and now, cheaper.

Colville waited to have prints of his work made partly because the technology capable of achieving the quality he demands has only recently become

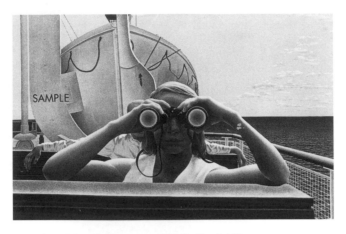

Figure 9: *To Prince Edward Island*, 1965, by Alex Colville

available. (He now employs the Toronto firm Herzig Sommerville.) But the real barrier for this practice, I think, is the attitude, widespread among the *cognoscenti* of art, that popular means bad. For example, John Bentley Mays, in his provocatively titled review of Colville's 1983 retrospective – "Colville's Importance Exaggerated" – claims that "Colville's art is worthy of inclusion in a small, didactic group show of realists from Canada's Atlantic region, nothing more … *its widespread popularity and potential as a crowd-pleaser apart*."4 Colville has consistently claimed that he wants his art to be accessible and available to the widest possible audience, and he knows that relatively few will ever see his paintings, even in museums. He wants people to think about his images, not just spend money. By marketing photographic reproductions, he has underlined the specific sort of fungibility he thinks art should have: that is, the aesthetic and ethical value that he sees in his work must be "exchangeable." There are for him two central aspects to this exchangeability: first, people must be able to, as it were, exchange ideas with the artist by understanding his realist images. Colville wants communication, preferably with "ordinary" citizens rather than artists and art experts. Secondly, thanks to the new prints, more people are able to exchange dollars for the aesthetic values of his images. Both parties receive a certain security from the transaction: Colville is financially comfortable and can therefore do without government support. He can be an aristocrat. Those who own his work can demonstrate their understanding and taste in art.

Would I be right in saying that Andy Patton's version of the values of exchange are the inverse of Alex Colville's? Much of Patton's recent work is almost inaccessible in a physical sense. To take the most dramatic example that involves the art/money theme, in Grand Valley Silo (figure 10), he has converted a building that at one time stored goods to be sold into a site for aesthetic contemplation and perhaps for challenging received opinion not only

Figure 10: *Grand Valley Silo*, 1993, by Andy Patton

about the "value" of the deep blue colour with which he has coated the inner walls of the structure but also about the monetary exchange value of art. Where Colville's new prints can be seen to exchange the aesthetic for currency in a straightforward way, Patton's often-uninvited incursions with paint or wallpaper transform money-making places into ones with "only" aesthetic value as their primary quality. This work of Patton's is both too big and too remote to have direct financial value. And I think we have to ask what – if any – sort of "communication" he envisions for these almost environmental gestures. No doubt some people will seek the pieces out, and others will happen upon them, but his strategy is to work away from the public in all senses. Yet as performance – the painting of the silo interior is dangerous and takes a long time – as concept, and as perceptual entity, each of these pieces of course has value, a conceptual exchangeability in the contemporary art scene – just not monetary value. I am suggesting that the very remoteness of this work gives it a certain intellectual cachet because the intellectual is often opposed to the economic. Where Colville tries with his prints to make his work more exchangeable in all senses, Patton challenges the ideas of communication, meaning, and monetary value.

Having noted the contrasts between Colville's and Patton's attitudes, I don't want to paint these artists into opposite corners. There are surprising points of contact. For example, both focus on and rate highly the labour-intensive aspects of their art[5] – though this might be the limit of their similarity as painters – and both are passionately interested in the art of the early Renaissance in Italy. Colville has often acknowledged that the precision and order of his work is in part inspired by the paintings of Piero della Francesca in particular, and Patton so admires religious fresco cycles from this period that he painted his own self-consciously belated versions in an abandoned monastery near Winnipeg.

Yet I have a hunch that Patton and Colville are interested in rather different Quattrocento art and for disparate reasons that take us back to the questions of fungibility. Colville sees himself as part of art history, as an inheritor – a son – of the mysterious directness of artists like Piero. Patton thinks historically and sees value in preserving traditions, but to me he seems most concerned with the "experience" of a fresco cycle in the present, not in its contextual meanings and messages or in how it communicates technically and formally. Colville insists on another sort of communication, on the directness of an audience "getting" his images. He works with traditional subject matter in a conventional realist style. Because these choices make his work both comprehensible and, now, financially available to a relatively wide audience, one wonders if he prefers early easel paintings because of their similarly ready exchangeability. Patton, by contrast, whether in his own work or in his travels, typically goes to the site rather than bringing a look or an image forward temporally as Colville – an admirer of Malraux's notion of the "museum without walls" – does. Where Colville's works successfully update the static profundity of Quattrocento art, Patton's quasi-religious transformations of formerly "productive" buildings can remind us of the remoteness of many Italian Renaissance cycles. Because he traces his realism to these Italian sources, Colville in a way makes this style financially viable in the late twentieth century. Patton, with his interest in immovable fresco cycles, leaves the past to itself but recreates a similarly invaluable – even sublime – remoteness in the present.

I suggested earlier that the differences in attitude and practice I'm pointing to might be more than merely personal and not entirely volitional, despite what Colville says about making choices. Both a psychoanalytic and institutional reading of the contrasts I have sketched would bring us to places other than that envisioned by the self-directing, intentional self. Colville is deeply and proudly conservative, and his conservatism in art makes his work popular and thus gives it value with a more "general" art-loving public. We need to ask if this conservatism isn't a deep-level recognition of what values will provide the financial security that the Colvilles missed during and after the Depression. Patton's gesture in making some of his work inaccessible gives it value with a very different art audience (one that normally disdains Colville), but it is the value of the sublime as the ineffable. There seems to me to be a contrast between a mercantile interest in art as communication with Colville versus Patton's monastic and I think romantic search for extra-linguistic value that cannot be exchanged for something other than a higher version of itself.

But what of institutional encouragements? My suggestion is that we think about the gallery systems here, specifically about the differences between high-profile, often international commercial galleries – like Marlborough Fine Art, "the General Motors of the art-dealing world," as Colville puts it (personal interview), and the gallery that handled his work from 1967 to 1985 – and equally prominent but substantially different commercial galleries like Toronto's S.L. Simpson Gallery – where Patton used to show – or the Linda Genereux Gallery where he exhibited until its recent demise. Though all these

institutions sell the work of their artists, the latter two are in a sense hybrids, existing somewhere between the artist-run spaces in which their member artists are often active and the traditional commercial galleries. Making art that can and will sell is crucial in the latter context. Hence Colville needs to make both serigraphs and photographic prints for the Drabinsky & Friedland Galleries. But the Linda Genereux Gallery – especially as a new enterprise in Toronto – needed the intellectual capital supplied by an artist like Andy Patton, in part because its audience was generally geared to more avant-garde production. Of course he couldn't exhibit the work we've been looking at in their space, but a piece like *Silo* nonetheless added value to the smaller blue paintings that he recently exhibited in the gallery. Unlike a gallery such as Marlborough Fine Art or perhaps Mira Godard, Genereux's could "afford" to show Patton's work because of the respect given him as an intellectual and a painter. This patina came off on other gallery artists, and even though Patton himself felt that his recently exhibited paintings might actually seem diminished if the viewer knew about the silo work, it was equally likely that the smaller paintings gained a certain resonance because of their remote relative. No one escapes value, evaluation, or the exchanges they entail, but this claim only serves to accentuate the differences between the economies of Alex Colville and Andy Patton.

NOTES

1 For a detailed discussion of Colville and his art, see Cheetham, *Alex Colville: The Observer Observed.*

2 I want to thank Johanne Lamoureux for bringing the latter instance to my attention.

3 Cheetham, "The World, the Work, and the Artist: Colville and the Community of Vision," 59.

4 *Globe and Mail,* 23 July 1983, E 13. Emphasis added.

5 I would like to acknowledge that it was Bruce Barber's paper on "work" at the Art and Money workshop that led me to make this connection.

BIBLIOGRAPHY

Burnett, David. Personal interview. 17 December 1992.

Cheetham, Mark A. *Alex Colville: The Observer Observed.* Toronto: ECW Press 1994.

– "The World, the Work, and the Artist: Colville and the Communality of Vision." *RACAR* 15, 1 (1988): 58–63.

Colville, Alex. Letter to the author. 14 January 1994.

– Personal interview. 9 November 1992.

Godard, Mira. Personal interview. 14 October 1992.

"Whiffs of Balsam, Pine, and Spruce"[1]: Art Museums and the Production of a Canadian Aesthetic

Anne Whitelaw

> Not all the pioneering in Canada has been done in her forests and plains by any means. The growth of the fine arts from the days of the earliest topographical draughtsmen and water colourists ... to our own day, when a vigorous and national school of painting is springing up, has been no less heroic and deserving of epics and monuments than the work of her explorers and her statesmen.[2]

Culture has long been the pivotal point around which the contestation of national identity has occurred in Canada. Poised between two major political and cultural powers, politicians and members of the cultural elite have attempted since Confederation to stem perceived encroachments on the nation's autonomy by controlling the import of cultural goods, and by subsidizing local production.[3] As the legislators see it, a strong centralized support of Canadian culture remains the foremost tool in the construction of a Canadian national identity: a tool which has proven useful historically in bringing together the remote regions of the Canadian political landscape, but which has also served as an important mechanism in "acculturating" immigrant cultures and assigning them a place within the Canadian mosaic. National institutions of culture – the National Film Board, the CBC, the National Museums – function in different ways to ascribe a coherence to, as well as to contain, a diverse set of practices and traditions that may be characterized as "Canadian," advancing a single unified national culture that would effect a (unified) national identity.

Although the repository of *high* culture, a realm traditionally associated with universal values that transcend national boundaries, the National Gallery of Canada also figures as an important marker of national culture. This importance goes beyond the gallery's legislated status as a national institution, with a mandate from the federal government to promote Canadian identity. The gallery's fostering of national culture is made visible in the exhibition of its

permanent collection, and specifically through the display of the work of Canadian artists. It is through this display that a coherent narrative of Canadian art is constructed, a narrative organized around the contribution of Canadian artistic practice to the nation's growing realization of its status as an autonomous state. Inscribed in the display of Canadian art in the National Gallery's permanent collection, then, is Canada's emergent sense of itself as a nation.

Although the gallery's exhibition of Canadian art is organized as a chronicle of artistic development in Canada, it is motivated by a quest for a specifically Canadian aesthetic vocabulary: an artistic language that would reflect Canada's distinct identity and signal its separateness from the former colonial power.[4] For many historians, this distinct Canadian aesthetic took shape in the work of the Group of Seven, a collective of artists working out of Toronto who, from their first exhibition in 1920, foregrounded a new style in painting that broke with the European picturesque style of their predecessors and set the agenda for the development of Canadian art. The Group's almost exclusive use of the landscape as subject matter contributed to their status as Canada's "national school." This essay, however, is not concerned with the nationalism of individual works of art. Rather, it examines the exhibition of works in the permanent collection of the National Gallery, and the production through this display of narratives of nation-ness. As I will argue, the gallery has organized this artistic chronology around particular conceptions of "Canadian" art and "Canadian" identity, conceptions that are seen to be epitomized in the paintings of the Group of Seven (and Tom Thomson)[5] during their most cohesive years as a group.[6]

Lawren Harris, J.E.H. MacDonald, Arthur Lismer, A.Y. Jackson, Fred Varley, Frank Carmichael, and Frank Johnston came together through a common dissatisfaction with the state of Canadian art and a desire to "paint Canada." On a formal level, these artists broke with the aesthetic conventions of their time, the European-derived romantic and picturesque landscape tradition found in the works of the preceding generation of Canadian painters, preferring the stylized lines of Art Nouveau design and the brilliant colour of the Fauves. As the artists matured, they developed an increasing interest in the use of broad, simplified forms and shapes to represent the massive wilderness of northern Ontario, perhaps most evident in the later work of Lawren Harris (figure 11). In this, the artists have often been regarded as Canada's first modernists: for breaking with prior artistic conventions in Canada, and for introducing abstraction on a wide scale. The principal claim to artistic distinctness of the Group of Seven, however, is their treatment of the Canadian landscape, and the belief that their paintings alone captured the essence of the Canadian spirit. As J.E.H. MacDonald wrote in the *New Statesman* in 1919:

> The Canadian Spirit in art prefers the raw youthful homeliness of Canada to the overblown beauty of the recognized art countries. It aims to fill its landscape with the clear Canadian sunshine and the open air, following faithfully all seasons and aspects and it would make its treatment of them broad and rich

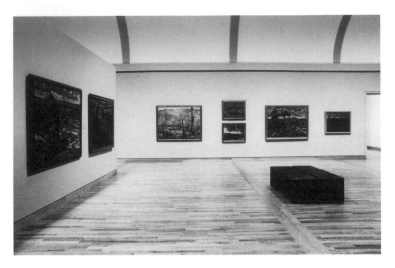

Figure 11: Installation view of paintings by the Group of Seven

attempting to convey the sense of rough dignity and generosity which the nature of the country suggests. Let the reader go if he will [to the exhibition] and feel in the pictures the Canadian spirit in art, striving through sincere expression for a self-determination which will enable our people to make their necessary and fitting contribution to the common art treasures of the world.[7]

It is this legacy of the Group of Seven, their preoccupation with the landscape as artistic subject matter and as a philosophy of Canadian distinctness, that has provided coherent material around which a narrative of national identity has been articulated. The centrality of the land figures in other media such as film and literature,[8] but in the years following the First World War, it was the paintings of the Group that produced the visual vocabulary and conception of territory around which nationhood could be articulated. As British critics' favourable reaction to the work exhibited at the British Empire Exhibition in 1924 testifies, this portrayal of the landscape was seen not only as constitutive of Canada but as the first art form that celebrated Canada's emerging sense of nation-ness:

> Canada reveals herself in colours all her own, colours in which the environment of Nature plays no insignificant part. She has mixed her colours with her restless unrestrained energy, her uncontrolled forces. We feel as we look at these pictures, the rush of the mighty winds as they sweep the prairies, the swirl and roar of the swollen river torrents, and the awful silent majesty of her snows. And such is Canada's art – the "pourings out" of men and women whose souls reflect the expansiveness of their wide horizons, who dream their dreams, "and express themselves in form and colour" upon the canvas.[9]

As the above passage suggests, the success of the Group's paintings in Britain was due in large part to the way in which the artists' choice and treatment of subject matter was seen to embody contemporary images of Canada's national character. This also accounts for their later popularity in Canada, and the relative ease with which such paintings of northern Ontario and Quebec functioned to represent the nation both in Canada and abroad. As Benedict Anderson has argued in *Imagined Communities*, the nation is produced less through the defining of territorial boundaries than through the collective imaginings of its inhabitants. Anderson thereby moves the emphasis from an essentialist notion of national identity as something one is born into to a fluid conception of nationhood as a sense of belonging, organized around shifting signifiers that resonate in the experience of a nation's populace. As such, nations are to be distinguished not by their falsity or their genuineness but by the way in which they are imagined. Cultural artifacts, institutions, landmarks, and geographical elements play a central role in the representation of the nation and constitute some of the mechanisms through which an affective relationship between it and its inhabitants is produced. The museum is one such mechanism which makes the nation visible. Through the ascription of symbolic value on certain objects placed on public display, the museum produces a narrative of nationhood within which a national public can inscribe itself. There is thus in the museum's display an attempt to build on the affective relationship of the individual citizen with the nation, isolating those objects that resonate on a national level, obscuring elements that provide conflict. The museum produces a discourse of nation-ness that frames individual objects in terms of collective memory through appeals to a common heritage and shared national values.[10] Through their location in an overarching narrative of national artistic production, objects are mobilized to provide viewers with a sense that they are members of a national public, and that they are participating in a collective endeavour that has meaning beyond the individual experience.

In Canada, the recent construction of two major museum buildings in the capital – to house the Canadian Museum of Civilization and the National Gallery – testifies to the centrality of cultural institutions in the articulation of national identity. The National Gallery was established by the nation's first governor general, the Marquis de Lorne, in 1880, little more than a decade after the founding of a Canadian state to unify Upper and Lower Canada. Both the National Gallery and the newly instituted Royal Canadian Academy of Arts[11] were seen by the governor general and other members of Canada's cultural elite as essential tools in the encouragement of a distinctly Canadian cultural tradition. The promotion of a visual symbolic that was "native" to Canada was seen as a mechanism that would differentiate Canada as much from the United States as from Great Britain, as well as bring together under the aegis of a single institution the cultural products of Canada's disparate regions.[12]

Under the terms of the first National Gallery of Canada Act of 1913, the gallery's primary function was educational: its mandate was "the encouragement and cultivation of correct artistic taste and Canadian public interest in

the fine arts, the promotion of the interests of art, in general, in Canada."[13] The belief in the civilizing powers of high art was central to the formation of many art museums in the New World at the turn of the century,[14] and over the years the National Gallery has actively sought to acquire important works from Europe and the United States in order to present a complete art historical survey.[15] Nevertheless, the work of Canadian artists remains a central component of the gallery's collection, and its quest for a truly Canadian high art tradition has resulted in its promotion of Canadian artists at home and abroad. This position was stated as far back as 1912 by director Eric Brown:

> There is no doubt that Canada has growing along with her material prosperity a strong and virile art which only needs to be fostered and encouraged in order to become a great factor in her growth as a nation. No country can be a great nation until it has a great art ... [H]owever, ... the encouragement of our national art in its broadest and best sense is not achieved by the exclusive purchase of Canadian works of art. The purpose of our National Art Gallery is mainly educative, and as a knowledge and understanding of art is only to be gained by the comparison of one work of art with another, so for this comparison to lead always to higher ideals and understanding we must have in addition to our own Canadian pictures the best examples we can afford of the world's artistic achievements by which we may judge the merit and progress of our own efforts. It is on these lines that the purchase of works for the National Gallery is proceeding.[16]

As a national institution, in addition to acquisition policies the gallery has had (and continues to have) a commitment to making its works accessible to the entire population of Canada through a program of circulating exhibitions and educational material. There is then in the National Gallery's own policies and internal structure a continuing belief in the centrality of its role in building a national culture, through the presentation of a largely European cultural heritage and through the collection of works by living Canadian artists.

This commitment to a nationalist project, however, is not simply an internal motivation. As one of four national museums in Canada,[17] the National Gallery has a mandate from the federal government, outlined in the 1990 Museums Act, to "preserv[e] and promot[e] the heritage of Canada and all its peoples throughout Canada and abroad, and [to] contribut[e] to the collective memory and sense of identity of all Canadians."[18] In recent years, as was particularly apparent in evidence submitted to the Standing Committee on Communications and Culture of the Federal Government in 1991,[19] the National Gallery has stood by this belief in the importance of a national culture, and the centrality of its role in maintaining that culture. To quote from the gallery's submission to the committee: "As one of the government's national cultural agencies, we will strive as always to make visible to all Canadians the supremely important part artists play in creating our national identity, our 'Canadianness'."[20]

The art museum's assigned role in the production of a national culture is not specific to Canada, despite our chronic nationalist malaise. Since its inception as a public institution at the end of the eighteenth century in France, the art museum has functioned as a monument to the nation. As Carol Duncan and Alan Wallach have described in "The Universal Survey Museum," it functions, both physically through its architecture and symbolically through the display of accumulated objects, as a marker of the state's power. Through the chronological exhibition of a representative selection of works from the history of art that culminates with the greatest achievements of the nation's artists, the art museum serves both as the storehouse of "official" western culture and as a monument to the artistic production of the nation itself. As Duncan and Wallach thus argue, it is through the orchestrated narrative[21] of displayed artifacts in the museum that the state can make visible its adherence to the highest values of western civilization, while simultaneously positioning itself as the rightful inheritor of those values through the works of the nation's greatest artists. In more general terms, the aesthetic ideology at work in the art museum is one that operates along a modernist notion of art as embodying universal, transcendental values, while at the same time highlighting the production of the nation's artists as emblematic of those universal values.[22]

The permanent display in the Canadian galleries of the National Gallery provides a linear chronology of Canadian artistic production from the late seventeenth century to the 1960s. Traditional in scope and intent, it provides a trajectory of great moments in Canadian art organized around a selection of major artistic movements – for example, the Group of Seven, Painters Eleven, the Automatistes and the Plasticiens. As in most "survey" museums throughout the western world, the traditional art historical view of the history of art as a linear stylistic trajectory is present in the gallery's display of the permanent collection.[23] This view of the history of art as a progressive artistic development culminating in abstraction is reinforced in the physical layout of the rooms that house the collection of Canadian artworks. The major moments or instances of works that do not fit into the larger teleological narrative of "Canadian art" are situated in the smaller theme rooms, adjacent to the main rooms, and therefore outside the main exhibition trajectory. One of the most important motivations in this stylistic progression is the development of abstraction, first seen in the stylized landscapes of the Group of Seven, and reaching its apogee in the very disparate work of the Plasticiens and the Painters Eleven in the 1950s and '60s. The rise of artistic modernism, as it is traced through the trajectory of the permanent collection, signals the abandonment of European-derived realist art forms, and Canada's move towards entry into a universal aesthetic avant-garde. This full participation in the international art world can perhaps best be seen in the shift in the gallery's organization of its permanent collection: from a strictly Canadian history of art up to the 1960s, to the integration of the work of Canadian and international artists in the contemporary galleries.

This stylistic separation of works into those that form the main history

and those works that are outside this history must also, however, be seen as part of the larger project of both the National Gallery and the Canadian art historical establishment: namely, the development of an authentically Canadian aesthetic. This quest for a distinctly Canadian artistic vocabulary was the original impetus behind the creation of both the Royal Canadian Academy and the National Gallery, under the assumption that the development of such an aesthetic – and the establishment of a wholly Canadian art movement – would translate into visual terms the affective experience of nationhood. This distinct Canadian aesthetic was seemingly only achieved with the Group of Seven, whose exploration of the Canadian landscape – though that landscape only reflected a small portion of Canadian territory – was seen by both the artists themselves and by posterity as "a direct and unaffected mode of painting derived from an experience of the Canadian land that all Canadians, if they would only look about themselves, would have to acknowledge as being true and worthwhile."[24]

The articulation of national identity with the land, however, did not originate with the Group of Seven. Although for many these artists more closely approximated the rough wilderness that was Canada than the picturesque images produced by their predecessors, the work of earlier artists – from Cornelius Krieghoff's paintings of habitants and coureurs des bois in the nineteenth century and Paul Kane's voyages west to capture the "vanishing Indian," to the romanticized paintings of Lucius O'Brien and Horatio Walker – also took as their subject matter the distinctive elements of the Canadian landscape. These early depictions, however, were poetic and idealized visions of the land, virtually indistinguishable from the picturesque and romantic European paintings avidly collected in Montreal and in Toronto. They nonetheless point to the importance of the landscape in any artistic articulation of national identity in Canada. Art historians have repeatedly attempted to explain Canadian artists' preoccupation with painting the land. Notes Dennis Reid, "A number of theories have been advanced to explain this 'landscape' fact in Canadian painting, as also in our literature and music. They usually involve the identification of the essentially individualistic, introspective nature of the Canadian psyche, and the consequent need to see oneself in a one-to-one relationship with nature in all its magnitude."[25] Others see the preponderance of images of the land throughout Canadian art as a mechanism for domesticating what was for early settlers a harsh and difficult landscape, or even as an incentive for European emigration to Canada[26] on the part of late-nineteenth century nationalists (who asked artists to paint pictures with no snow).[27]

The identification of topographical characteristics with national identity, however, went beyond works of art. The rhetoric of many Canadian nationalists in the decades after Confederation sought to establish a close association between Canada's northern location and racial superiority. As Carl Berger has shown, many early nationalists believed that Canada's strength lay in its geographical location and climatic conditions, arguing that the cold climate had fostered the development of a strong and pure race already equipped with an

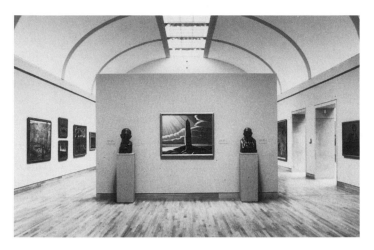

Figure 12: The Canadian galleries with Lawren Harris's *North Shore Lake Superior,*
1926, in foreground

ingrained sense of freedom and the capacity for self-governance.[28] In their
arguments for the strong correlation between climate and racial character,
these early nationalist tracts manifested in varying degrees a kind of social
Darwinism. The more moderate version saw the Canadian climate as con-
ducive to the production of certain characteristics desirable in a free and
democratic country. The second, more extreme argument maintained that the
climate functioned as a process of natural selection, and that races indigenous
to cold climes were inherently superior to those of warmer areas. This belief
was often "proved" in the migration northwards of the human species as it
evolved, and in the greater wealth of countries of the North compared with
the underdeveloped nations of the South.[29]

In these characteristics of strength, perseverance, and the capacity for
self-governance, Canadians were likened to the peoples of Scandinavia and
Germany, Britain and northern France: all northern "races" and all seen as the
direct ancestors of English and French Canadians. Canada's racial affinity with
Britain lay in sharp contrast to the perceived differences between Canada and
the United States, a country whose Anglo-Saxon heritage, in the minds of
advocates of the more extreme position, was being diluted by an influx of
immigrants from warmer climes, races who were inherently lazy and less gov-
ernable than those individuals of superior northern heritage[30] (figure 12).

Although most Canadians did not take up the extreme views of these post-
Confederation nationalists, the landscape, and in particular the mythic North,
constituted an important element in the popular imaging of the nation.
Members of the Group of Seven recognized the affinity between northern
landscapes and popular conceptions of Canada at the same time as they aban-
doned the picturesque conventions of European landscape painting, a shift

which has been chronicled in the Group's mythology as an "awakening" to the essential character of Canada, "the spirit of our native land."[31] The Group's belief in the superior qualities of the northern climate and the importance of developing an artistic practice that captured the essence of the land were the fundamental elements that banded them together as a group, and which endeared them to promoters of a "national feeling."[32] For these artists, the flourishing of Canadian art was only possible once the artistic conventions of Europe lost their dominance. And a truly Canadian art form could only occur out of a spiritual engagement with the environment, an engagement which in the formative years of the Group took place in the Canadian Shield. In an essay in *The Canadian Theosophist*, Lawren Harris describes the impact of the North on the Canadian artist, a description in which can be found echoes of early nationalists' theories of dominant northern races:

> We are in the fringe of the great North and its living Whiteness, its loneliness and replenishment, its resignations and release, its call and answer, its cleansing rhythms. It seems that the top of the continent is a source of spiritual flow that will ever shed clarity into the growing race of America, and we Canadians, being closest to this source seem destined to produce an art somewhat different from our Southern fellows – an art more spacious, of a greater living quiet, perhaps of a more certain conviction of eternal values. We were not placed between the Southern teeming of men and the ample replenishing North for nothing.[33]

The centrality of the Canadian Shield in the work of the Group of Seven is consonant with the exalted position of this small area of central Canada within the national symbolic. It is to the Canadian Shield that writers and artists refer when they speak of "the North,"[34] but the contingent nature of this conception underscores the constructed nature of national identity, and the function of narrative in experiences of nationhood. The centrality of the Canadian Shield, and in particular of Algonquin Park, in the visual vocabulary of the Group of Seven highlights the particular origins and interests of Canada's political and cultural elite. The broad success enjoyed by the Group, and the active patronage of the National Gallery, cannot be seen apart from the fact that Group members painted largely what Toronto's wealthy art patrons saw outside the windows of their cottages in the Muskokas. This is made abundantly clear in the National Gallery's inclusion in the Canadian galleries of the murals painted by J.E.H. MacDonald and Arthur Lismer for Dr James MacCallum's cottage on Georgian Bay.

The Group of Seven's status as Canada's "national school" is reflected in their prominent location within the permanent display of Canadian art. They are accorded several large rooms in the northernmost corner of the Canadian galleries, and are positioned, quite literally, as a turning point in the developmental history of Canadian art. With the European-derived work of the early settler artists and of the Academicians behind them, they point towards the

flourishing of Canadian art in the abstract works of the Automatistes and other high modernists. This pivotal position in the development of a specifically Canadian aesthetic, as well as their established status as the first modernists, underscores the Group of Seven's fundamental importance in the display of Canadian art in the National Gallery and its narrative of national identity. Given the consonance of the goals of the Group and the National Gallery – in particular the fostering of a Canadian aesthetic tradition – it is not surprising to see a strong element of cooperation between them, especially in later years when some of the Group of Seven were sent on Gallery-sponsored lecture tours of Canada in an effort to bring the narrative of Canadian art to a broad public. As Dennis Reid has commented, "to a large degree the struggles of the Group became the struggles of the Gallery."[35]

This close relationship and the common goal to produce a distinct Canadian aesthetic is exemplified in the protracted debate between members of the Canadian Academy and members and admirers of the Group of Seven over the National Gallery's strong support of the work of the Group.[36] The debate was occasioned by the gallery's commitment to acquire and exhibit both in Canada and abroad the works of the "modernist" Group of Seven, at the perceived expense of the traditionalist members of the Academy (who had, moreover, founded the gallery in 1880). The fundamental issue in the debate centred around which aesthetic tradition best embodied the "Canadian genius," i.e., which work was more "Canadian." This contest over representation, over which aesthetic – traditional or modernist – would best represent the nature of Canadian art, not only in the National Gallery but in the eyes of the art world, constitutes a formative moment in the history of the gallery, and of Canadian art history. The debate was a public one, with calls for the gallery's director, Eric Brown, to be "controlled" by Parliament,[37] and with articles from both sides published regularly in newspapers across the country. The National Gallery felt vindicated, however, by British critics' high praise for the works of the Group of Seven on display at the British Empire Exhibition in 1924, with particular attention paid to the artists' ability to capture the Canadian spirit in their depiction of the landscape. This positive critical reception began the process which established the centrality of the Group of Seven in the Canadian national symbolic and in Canadian art history. The debates that continue to rage over whether the gallery's collection is representative of artistic production in Canada often a powerful statement about the contested territory of national cultural production and the role of the National Gallery in determining and legitimizing that territory.[38]

In its display the permanent collection presents in material form the moments of progress and development chronicled by Canadian art history. This narrative, like the museum, presents the viewer with a series of artworks that have been divorced from their original setting and exist in a timeless void. "Everything takes place in the museum in some eternal contemporaneity; all diachrony, all difference, all multivocality is enframed in synchronicity," Donald Prezioso has observed.[39] More importantly, such objects are subject to

the infinite manipulation of historical narratives and to the temporal organization determined by those narratives. As Preziosi has argued, the purpose of art history is to organize data and objects, to get them to "stay" and "lie orderly"[40] – in other words, to submit to the organizing narrative that will give these objects meaning according to their position within the broader system. In the case of Canadian art history, that system is more often than not the articulation of a distinctly Canadian aesthetic: one that would differentiate our cultural production from that of other nations. And harnessed to this quest for artistic distinctness is the search for a broader cultural identity that could serve as an overarching principle in the definition of a unified national identity.

Most visible in the permanent display of Canadian art, then, is the apparent solidity of the trajectory: more than anywhere else in the museum, this exhibit signifies History, a nation's connection to its past. This is the "shared cultural heritage" outlined in promotional literature and exhibition introductions, and most clearly stated in evidence submitted by the gallery's director, Shirley Thomson, to the Standing Committee on Communications and Culture in 1991. It is worth quoting this submission at length:

> We believe that the National Gallery of Canada in bringing together the best works of artists through time and across the country makes visible both what we hold and value in common and the rich diversity of our viewpoints and traditions. As one form of cultural expression, the visual arts serve as a record of who and where and how we were. Today that record is part of our common heritage, an expression of our national identity in the landscape, peaceful or rugged, majestic or humble, and in the faces of the settlers, ecclesiastics, homesteaders, *coureurs des bois*, soldiers and native people who have preceded us. These images powerfully evoke Canada. The compelling Joseph Brant, the serene Soeur Saint-Alphonse, the enduring jack pine, the mystic totem pole – these images are familiar and common to all of us. By collecting, showing, touring, borrowing and lending the works of say William Berczy, Alphonse Plamondon, Tom Thomson, Emily Carr and many more, the gallery as a federal cultural agency makes a vital and direct contribution to Canadians' sense of themselves. We provide the essential links from coast to coast, from one Canadian to another, and from all Canadians to their visual arts heritage.[41]

What this statement reveals is that the trajectory of Canadian art on permanent display in the National Gallery presents a particular narrative of Canadian nationhood. First Nations peoples are included only as the subjects of representation, and not as cultural producers. Where they are mentioned elsewhere in the gallery's submission it is in relation to the Canadian Museum of Civilization – a more "anthropological" museum – or, together with the works of "ethnic" artists, as part of the intriguing diversity of Canada's statistical make-up. What Shirley Thomson's statement does suggest, however, is the solidity of the art historical narrative reproduced in the gallery and its powerful evocations of a unified affective relationship with the "masterpieces"

of Canadian art – the jack pine, Emily Carr's images of totem poles, and the coureurs des bois – images that are "familiar to all of us."

These appeals to a common sensibility, to a shared vision, are part of the museum's construction of a unified and homogeneous "national" public: an assumed self-recognition that is built into the display of objects, suggestive of a sense of appurtenance, a belonging, a "we." Through the permanent collection's appeal to the public to identify with the objects ordered for display, there is an inherent inscription of the viewing subject within the national narrative. The assumption is that by subscribing to the display of power/knowledge in the museum, the viewer is acquiescing to the proposed narrative of nationhood. This construction of a unified subject in the museum is mirrored in the way in which the nation continually attempts to construct a unified national population, usually around cultural symbols seen to be invested with meaning for an entire nation. In other words, underscoring appeals to nationalism is the belief that there is such a thing as "a" (single) "common heritage" that will have meaning across boundaries of race, class, sexuality, and generation.

Within Benedict Anderson's characterization of the nation as an imagined community lies the fundamentally important assumption that the experience of nationhood is largely subjective: that the communities imagined in the minds of the nation's inhabitants are not undifferentiated across time and geography. In the nationalist rhetoric of the National Gallery, the permanent collection displays a progressive development of Canadian art, a particular vision of Canada as seen through the eyes of its foremost artists, but positioned as embodying the national values of a shared or common heritage of a diverse population. However, what is in effect presented as emblematic of a nation's cultural identity is the hegemonic narrative of national art production found in Canadian art history and forming the basis of the National Gallery's permanent display of Canadian art.

In positioning the Group of Seven as a formative moment in the history of Canada and its aesthetic production, this essay has traced the emergence of the modern as a significant moment in the constitution of Canadian identity. As Canada's first aesthetic modernists, the Group of Seven established a mode of painting in Canada that was formally distinct from the work that preceded it and which served, in the years following the First World War, to reinforce Canada's efforts to establish itself as a distinct and autonomous nation. In foregrounding a new, distinct aesthetic style, the Group was seen to epitomize the foundation of the modern nation. The pivotal role that the Group played in the trajectory of Canadian art is based not only on the formal properties of their work but on the belief that these works represent Canada's "true" image of itself, in a way unequalled by any other artist or group of artists.

In the rhetoric of nationalism articulated in the National Gallery, the continued popularity of the paintings of the Group is seen as evidence of the centrality of these works in the affective relationship between individual and nation. This relationship is seen to reside in the artists' ability to capture the essential nature of the Canadian landscape, a landscape that is assumed to

embody all the characteristics of Canadian identity, and therefore to have great meaning for all Canadians. As a result of their perceived importance within the context of a narrative of Canadian art history, as well as in the emergence of Canadian national autonomy, these paintings of the Canadian landscape occupy a central position in the narrative of national identity on display in the National Gallery of Canada, and form the basis for the gallery's and Canadian art history's quest for a truly "Canadian" aesthetic.

NOTES

This essay was written prior to Charles Hill's 1995 exhibition *The Group of Seven: Art for a Nation.* For a more detailed analysis of the exhibitionary practices of the National Gallery, please see my "Exhibiting Canada: Articulations of National Identity at the National Gallery of Canada," PhD Thesis, Concordia University, Department of Communication Studies, 1995.

1 This quote is taken from Housser's celebratory history of the Group of Seven, *A Canadian Art Movement: The Story of the Group of Seven*, 49.

2 Foreword, *A Portfolio of Pictures from the Canadian Section of Fine Arts; British Empire Exhibition*, London, 1924.

3 In 1951, in a report that has largely shaped the form of Canadian cultural legislation, the Massey Commission emphasized the essential role played by cultural institutions in the maintenance and promotion of a distinctly Canadian cultural identity. The fundamental role of these institutions was to restrict the flow of cultural commodities from the United States and thereby their influence on Canadian life, while at the same time providing centralized sites for the production of distinctly Canadian works of art and culture. In the wake of recent debates over national identity, the policies put forward in the Massey Commission Report continue to resonate in more

recent documents produced by the federal government, particularly as Canada's political and cultural autonomy is seen to be under threat from the U.S. (for example, with the Canada-U.S. Free Trade agreements and NAFTA). A recent example is the 1992 Report of the Standing Committee on Communications and Culture drafted in preparation for the Charlottetown Constitutional Accord, *The Ties That Bind*, a document which in its support of the continued protection of national culture through support of centralized federal institutions reiterates many of the recommendations put forward by the Massey Commission.

4 This quest for a distinct Canadian aesthetic can also be found in art historical survey texts on Canadian art.

5 Although Tom Thomson died in 1917 (appropriately while sketching in Algonquin Park) before the official formation of the Group of Seven, he painted and sketched with them often, and is credited in Canadian art history as being a major influence on the works of the Group.

6 This is roughly delimited as 1920–26. May 1920 marks the date of the Group's first official exhibition at the Art Museum of Toronto; 1926 signals the moment at which individual members began to strike out on their own, and the Group lost its cohesiveness. It is also the date of publication of F.B. Housser's paean to the Group, *A Canadian Art Movement*. The Group

did not formally disband until 1933, although their last exhibition was in 1931. See Harper for a brief chronology of the Group's activities, and Reid for a detailed analysis of their lives and works.

7 Housser, *A Canadian Art Movement,* 143–4.

8 See, for example, Peter Morris's *Embattled Shadows* for references to early Canadian filmmaking, and Margaret Atwood's *Survival* for the theme of the land in Canadian prose and poetry.

9 J.M. Millman, quoted in Harper, *Painting in Canada,* 288.

10 Annie E. Coombes describes this process as follows: "Through transformations in marketing and policy, the museum has become both a vital component in the reclaiming and defining of a concept of collective memory on the local level and, on the national level, an opportune site for the reconstituting of certain cultural icons as part of a common "heritage" – a "heritage" often produced as a spectacle of essentialist national identity with the museum frequently serving as the site of the nostalgic manufacture of a consensual past in the lived reality of a deeply divided present" ("Inventing the 'Postcolonial,'" 41).

11 An early function of the National Gallery was to serve as the depository for the diploma works of members of the Royal Academy; hence the Academy's stake in the evolution of the gallery's acquisition policies.

12 Tooby, "Orienting the True North," 18.

13 National Gallery of Canada Act, 1913.

14 See Michael J. Ettema, "History Museums and the Culture of Materialism."

15 This rhetoric was recently used by the gallery to justify the expense of purchasing Barnett Newman's *Voice of Fire* and Mark Rothko's *No. 16.*

16 Cited in Charles Hill, "The National Gallery, A National Art, Critical Judgement and the State," 70–1.

17 The other three national museums are the Canadian Museum of Civilization (includes the Canadian War Museum), the National Museum of Natural Sciences, and the National Museum of Science and Technology (includes the National Aviation Museum), all located in the Ottawa area.

18 Bill C-12.

19 The evidence submitted by the National Gallery was in the context of *Culture and Communications: The Ties That Bind,* a document on national identity and unity drafted by the Standing Committee on Communications and Culture in preparation for the Charlottetown Accord, which was signed by representatives of all ten provinces, the two territories, and the Assembly of First Nations in August 1992. It was subsequently put to a national referendum and was rejected by Canadian voters.

20 Government of Canada, "Evidence Submitted to the Standing Committee," 6.

21 Following anthropologist Victor Turner's research, Duncan and Wallach describe this as a process in which citizens enact a symbolic ritual that reinforces the state's ideological position. Although this essay is very useful in unpacking the physical and symbolic mechanisms through which the museum constructs meaning, I would rather see the visitor's activity in the museum as a process of reading, thereby suggesting an active engagement with the material objects on display, rather than the passive following of an ideological script as Duncan and Wallach seem to suggest.

22 Duncan and Wallach trace out their argument through analyses of the Louvre and the Metropolitan Museum of Art in New York. Both these institutions are more properly "universal survey" museums because their collections begin with the works of the ancient world (Egypt, Greece) and cover all major periods of art, ending

with important works from their nations' artists. Although the National Gallery of Canada does not have the wealth of objects of the Louvre or the Metropolitan, similar concerns with providing a complete "history of art" govern the organization of the works on display.

23 Douglas Crimp has discussed the legacy of Hegel's aesthetic philosophy in the discourse of traditional art history. The view of the history of artistic production as a linear development from the functionalist to the wholly spiritual was taken from Hegel and adapted to a notion of art history as stylistic succession. This linear and evolutionary conception of the history of art underscores the organization of the traditional museum (and as Crimp argues, is evident in the design of the prototypical art gallery the Berlin Altes Museum) and can also be found in contemporary art, specifically, Alfred Barr's schematic outline of the genealogy of modern art in the catalogue for the 1936 MOMA exhibition, *Cubism and Abstract Art* (Douglas Crimp, "The Postmodern Museum"in *On the Museum's Ruins*).

24 Reid, *The Group of Seven*, 13–14.

25 Ibid., 15.

26 Osborne, "The Iconography of Nationhood," 164.

27 Requests for depictions of Canada without snow were also made to the directors of the early CPR films; see Peter Morris, *Embattled Shadows*.

28 Berger, *The True North*, 15.

29 Ibid., 19.

30 Ibid., 14.

31 Early in his chronicle of the Group, Housser writes: "The story is unique in the history of art. It is not, however, so much the story of an art movement as the dawn of a consciousness of a national environment which to-day [1926] is taking a most definite form in the life of the nation" (*A Canadian Art Movement*, 32).

32 W. Stewart Wallace wrote of the Group of Seven in 1927: "The work of this group has attracted international attention, mainly because of its strong native character. It tends at times to the crude and bizarre; but at its best it is instinct with the feeling of Canada's 'great open spaces,' from which indeed in draws its inspiration" (*The Growth of Canadian National Feeling*, 77).

33 L. Harris, *Revelation of Art*, 86.

34 Cole Harris has characterized Canadian nationalism as an "incantation to the north" with "the north" equalled to the Canadian Shield. "The Canadian or Precambrian Shield is as central in Canadian history as it is to Canadian geography, and to all understanding of Canada ... And this alternate penetration of the wilderness and return to civilization is the basic rhythm of Canadian life, and it forms the basic elements of Canadian character" (William Morton, *The Canadian Identity* [1961] quoted in Harris, "The Myth of the Land in Canadian Nationalism," 28).

35 Reid, *The Group of Seven*, 11.

36 Charles Hill provides a detailed analysis of this debate in his essay "The National Gallery, a National Art, Critical Judgement and the State."

37 Charles Hill cites from the *Vancouver Sun* that J.A. Radford demanded in 1932 that "parliament ... find out what is wrong and ... correct the error" (Hill, ibid., 65).

38 Debates have occurred in recent years over the lack of contemporary art by First Nations artists on display in the gallery, and the gallery's lack of attention at various times to francophone artists from Quebec (as in the *Songs of Experience* exhibition of 1986) or to artists from the Maritimes (*Canadian Biennial of Contemporary Art*, 1989).

39 D. Preziosi, *Rethinking Art History*, 69.

40 Ibid., 61.

41 Government of Canada, *Evidence Submitted to the Standing Committee on Communications and Culture*, 6.

BIBLIOGRAPHY

Anderson, Benedict. *Imagined Communities: Reflections on the Origin and the Spread of Nationalism.* Rev. ed. London and New York: Verso 1991.

Atwood, Margaret. *Survival.* Toronto: Anansi Press 1972.

Berger, Carl. "The True North Strong and Free." In *Nationalism in Canada,* ed. Peter Russell. Toronto: McGraw Hill 1966.

Coombes, Annie E. "Inventing the 'Postcolonial': Hybridity and Constituency in Contemporary Collecting." *New Formations* 18 (Winter 1992): 39–52.

Crimp, Douglas. *On the Museum's Ruins.* Cambridge, MA: MIT Press 1993.

Duncan, Carol, and Alan Wallach. "The Universal Survey Museum." *Art History* 3, no. 4 (December 1980): 448–69.

Ettema, Michael J. "History Museums and the Culture of Materialism." In *Past Meets Present: Essays about Historic Interpretation and Public Audiences,* ed. Jo Blatti. Washington and London: Smithsonian Institution Press 1987.

Government of Canada. *Culture and Communications: The Ties That Bind.* Report of the Standing Committee on Communications and Culture, April 1992.

– *Evidence Submitted to the Standing Committee on Communications and Culture* 5 (3 October 1991).

Harper, John Russell. *Painting in Canada: A History.* 2nd ed. Toronto: University of Toronto Press 1977.

Harris, Cole. "The Myth of the Land in Canadian Nationalism." In *Nationalism in Canada,* ed. Peter Russell. Toronto: McGraw-Hill 1966.

Harris, Lawren. "Revelation of Art in Canada." *The Canadian Theosophist* 7, no. 5 (July 1926): 85–8.

Hill, Charles. "The National Gallery, a National Art, Critical Judgement and the State." In *The True North: Canadian Landscape Painting 1896–1939,* ed. Michael Tooby. London: Barbican Art Gallery 1991.

Housser, F.B. *A Canadian Art Movement: The Story of the Group of Seven.* Toronto: Macmillan Company of Canada 1926.

Morris, Peter. *Embattled Shadows: A History of Canadian Cinema 1895–1939.* Montreal: McGill-Queen's University Press 1978.

Osborne, Brian. "The Iconography of Nationhood in Canadian Art." In *The Iconography of Landscape,* ed. Denis Cosgrove and Stephen Daniels. Cambridge: Cambridge University Press 1988.

A Portfolio of Pictures from the Canadian Section of Fine Arts; British Empire Exhibition. London 1924.

Preziosi, Donald. *Rethinking Art History: Meditations on a Coy Science.* New Haven and London: Yale University Press 1989.

Reid, Dennis. *The Group of Seven.* Ottawa: National Gallery of Canada 1970.

Stacey, Robert. "The Myth – and – Truth of the True North." In *The True North: Canadian Landscape Painting 1896–1939,* ed. Michael Tooby. London: Barbican Art Gallery 1991.

Tooby, Michael. "Orienting the True North." In *The True North: Canadian Landscape Painting 1896–1939,* ed. Michael Tooby. London: Barbican Art Gallery 1991.

Wallace, W. Stewart. *The Growth of Canadian National Feeling.* Toronto: Macmillan Company of Canada, 1927.

*Please deposit fifty cents and
take card from slot below*

Michael Buckland

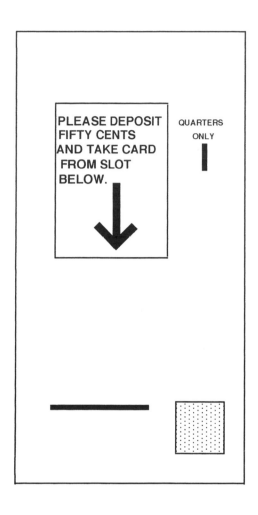

Culture and the State

Policying Culture: Canada, State Rationality, and the Governmentalization of Communication

Michael Dorland

Le trésor de la langue: Visual Arts and State Policy in Québec

Johanne Lamoureux

Policing Culture: Canada, State Rationality, and the Governmentalization of Communication

Michael Dorland

The administration of culture has become a big beautiful machine. Only the mind in the machine is missing.[1]

One of Harold Innis's most profound insights into the nature of Canadian cultural development appears in the 1947 text "The Church in Canada:" "Students of cultural development in Canada have failed to realize the extent to which religion in English-speaking Canada has been influenced indirectly by the traditions of the Gallican Church. Nor do we appreciate the significance of the political background of the France of Colbert and Louis XIV. State and Church under an absolute monarchy in France was state and church under an absolute monarchy in New France."[2]

Innis is writing in his usual bivariate obscurity; thus, his point is at least as political as it might be theological. For what the absolute state and the church here share is a common form of organization: more exactly, of bureaucratic rationality. "It was this [ratio of] bureaucracy," Innis continues, crucially, "which enabled the British to govern New France and which enabled Canadians through governmental activity to develop their natural resources by construction of canals, railways, hydro-electric power facilities, and other undertakings."[3]

As Innis notes, this is to give to Canada's distinctive absence of a revolutionary (or Enlightenment) tradition its full cultural significance: the bureaucratic rationality of the Canadian state has its roots in an unbroken continuum reaching back to the early modern emergence of the European absolutist state (if not before that, to the separatist Gallican crisis of church organization of the late thirteenth century). What follows attempts to draw out some of the metapolitical implications for contemporary Canadian cultural policy of Innis's remarkable, and still vastly under-appreciated, observation.

Police Theory

The nature of early modern bureaucratic rationality particularly preoccupied Michel Foucault in the late 1970s, and that task has since been continued in the work of his students in Britain, France, and Italy,[4] exploring the complex zone of research Foucault had come to term "governmentality." For Foucault, here following Friedrich Meinecke's great study,[5] what distinguished the early modern state (sixteenth century) was the emergence of a form of rationality particular to itself: *Raison d'état.* Called by the seventeenth-century German academic statist Hermann Conring "the polar star of modern politics," *raison d'état* is the first form of governmental rationality as an autonomous rationality. As historian Etienne Thuau has written, it is a form of reason "born of the calculation and ruse of men," which makes of the state "a knowing machine, a work of reason." The state ceases to be derived from the divine order of the universe and is henceforth subject to its own particular necessities.[6] In the international system of states that took shape in late sixteenth-century Europe, *raison d'état*, in effect, bifurcates into two distinct "logics": an external form governing relations between states, or what German political theorists would term "*Politik*," and an *internal* form that would govern relations between the state and its "subjects" – though it would be more accurate, if more unwieldy here, to say relations between the state and its knowing arts of exercising power within a field of intervention crystallizing in a concept of "economy." In Foucault's words, "To govern a state will therefore mean to ... set up an economy at the level of the entire state, which means exercising towards its inhabitants, and the wealth and behaviour of each and all, a form of surveillance and control" that German administrative thought would designate by the term "Polizei"; in English the word "policy" is an accurate, if vague, equivalent.[7] If police theory (or policy science) developed in its most systematized form in the numerous seventeenth-century German principalities grappling with the problems of governance, it would also come to constitute a substantial pan-European body of literature – "*une immense littérature circulant dans la plupart des pays européens de l'époque*"[8] – and increasingly disseminated throughout the seventeenth and eighteenth centuries (resurfacing in American sociological scholarship of the early twentieth century in the writings of Albion Small). Police theory, then, was the theoretical distillation of reflection "formed by the institutions, processes, analyses ... the calculations and tactics that allow the exercise of this very specific albeit complex form of power, which has as its target population, as its principal form of knowledge political economy, and its essential technical means apparatuses of security."[9]

As such, within the wider Foucauldian theorization of governmentality, it would be the outstanding manifestation of early modern rationality, internal to the workings of the state.

Pastoral Power

Foucault's most encompassing reflection on the history of governmentality was his 1979 lecture "Omnes et Singulatim." Increasingly convinced that state rationality had both centralizing and individualizing dynamics, he traced the roots of the latter back to theocratic antiquity, notably the Hebrews. In Foucault's account, the outstanding Hebrew contribution to political thought would be the metaphorization of both the divinity and kingship in the figure of the shepherd, or what Foucault calls the pastoral modality of power: "the strange technology of power treating men as a flock led by a handful of pastors," establishing for governance a complex and paradoxical series of political relationships.[10] On the other hand, the pastoral metaphor was largely absent from Greek and Roman thought. The singular exception was Plato (in *The Critias, The Republic,* and *The Laws*) – though in Plato the pastoral function was less a political one than provisionally assigned to the helping professions (the doctor, the farmer, the gymnast, and the teacher) for specific and temporary ends (healing, feeding, entertainment, learning). In turn, Christian patrology would effectuate a curious synthesis of elements of both the Platonic and the Hebrew pastoral traditions, in the former case by transforming a means into a permanent condition of the dependence of the flock upon the pastors, and in the latter case by shifting the initially unilateral responsibility of the shepherd for his flock into a complex circuit of total obedience, self-knowledge, and confession in a calculus of moral deficits that weighed as heavily upon the pastor as upon the flock, if not more so. Finally, in the medieval context, the Christianization of pastoral power became not only urbanized but, as a complex technology, presupposed a certain level of culture, as much on the part of the pastors as for the flock.

With the early modern emergence of *raison d'état* and, within the state, the theory of police, pastoral power becomes secularized; that is, it is no longer based upon a legalistic conception of justice (divine or natural) but instead becomes rational on the basis of a logic proper to itself. The function of a rational, pastoral politics is to guarantee that there be "communication" between humans. As Foucault states it, "As a form of rational intervention exercising political power over men, the role of politics is to grant them something more than mere existence; and, in so doing, to give the state a little more power. This is achieved by the control of "communication"; that is, the common activities of individuals (labour, production, exchange, comforts)."[11]

In eighteenth-century France, Burchell observes in his commentary on Foucault, urbanization and police are almost synonymous. One formulation of the objective of police was that of organizing the entire royal territory like one great city. Public space, bridges, roads, and rivers are prominent among the objects of police attention: "This physical infrastructure of connection and mobility is seen by police theorist Jean Domat as the means whereby the policed city can function as a place of assembly and *communication,* a term whose meaning embraces all the processes of human intercourse, exchange, circulation and cohabitation within a governed population."[12]

In the light of the Foucauldian theory of governmentality, then, the implications of Innis's identification of the continuum between the absolutist or police state of the seventeenth century and the Canadian state of the nineteenth and twentieth centuries in its establishment of a communications infrastructure (not to speak of its role in the economy generally) becomes more sharply focused. Indeed, Innis's repeated insistence that Canadian governmentality was fundamentally European is clarified by the history of police theory, perhaps in an unexpected new light. For example, it allows us to better grasp Northrop Frye's equally perceptive observation that English-Canadian society, as long as it remained predominantly rural society – at least until the 1940s, in demographic terms – is particularly distinguished by the inarticulate forms of communication: "It is in the inarticulate part of communication, railways and bridges and canals and highways that Canada, one of whose symbols is the taciturn beaver, has shown its real strength."[13] However, Frye's observation needs also be contrasted with the diametrically opposite, if paradoxical, thesis of Gilles Paquet and Jean-Pierre Wallot that French-speaking "Canada never developed anything but limited identities, but that paradoxically these limited identities, rather than reducing 'national' communicative competence, may have improved it."[14]

Precisely because of its absolutist origins, Canadian governmentality, as Innis's life work demonstrated, is intimately implicated with the history of communication – but in the police sense of the term: as the strategies and tactics of apparatuses of security targeting populations.

Policing Culture

However, the aims of the early modern state were still implicated with ethical, religious, and political considerations (just as, for example, contemporary Canadian politics remain far more entangled with religious, ethnic, and linguistic considerations than with class). To the extent that accumulation was not yet an end in itself, the aims of the state derived from a conception of innate human sociability. Thus, the ruler could conceive of himself as the prudent manager of a large-scale household modelled on the classical *oikos*. In this still-limited sense, economic action was the prerogative of the state, and economic order flowed from the prudent direction of such action.

In this conception, however, the individual subject had no independent initiative, nor interests potentially or autonomously productive of order. As the historian Keith Tribe states, "Humanity confronts the state as "population," a subject mass to be regulated, enhanced and supervised."[15] As a result, the concepts of society and polity are synonymous: one cannot exist without the other, and they are as such conceptually indistinguishable. It would not be a great leap to the assumption that social order was owed *uniquely* to governing activity, and that the proper concern of government was "the happiness" of a population. As an innately social being, a creature of wants and needs – involving commerce, broadly understood as spanning the range from narrow

economic activity to culture – the human being could attain happiness by the proper administration of these needs, which could only be assured by good government ("*gute Polizei*"). Thus, the primary tasks of the ruler were to ensure (1) the numerical sufficiency of the population, (2) that it was provided with the institutions necessary for its subsistence (such as academies and entertainments), (3) the regulation of prices, (4) the proper punishment of crime, (5) the prevention of disease, and similar social policies.[16] The policying of society implies infinite, ever-extending networks of regulation. The French police theorist Delamare, in his early eighteenth century Compendium, would delimit eleven fields of policy regulation within a state: (1) religion, (2) morality, (3) health, (4) supplies, (5) roads, bridges, highways, public buildings, (6) public security, (7) the liberal arts and the sciences, (8) commerce, (9) manufactures, (10) domestics and convicts, and (11) the poor.[17] As Foucault put it, "police oversees everything that regulates society (social relations) … It is life itself that is the object of police: in whatever is indispensible, useful and superfluous. It is the responsibility of police to make it possible for men to survive, to live and improve themselves."[18] Tribe observes, "Unlike a legal order which defines transgressions and prescribes punishments, *Polizei* remained a prescriptive model of social order."[19]

If I've drawn such attention to classical police theory, it is because I am suggesting that the distinguishing logics of Canadian cultural policy are far more profoundly sedimented with such early modern policy characteristics than has been generally recognized. I would like to emphasize that in its practices, in the logics that articulate them, in its fundamental ordinariness, the administration of culture in the Canadian context has been the creation of an historically deeply rooted bureaucratic rationality – but I can only do so here either theoretically or by historical analogy.

As a result, the fit between the above and the contemporary Canadian policy context can only be highly general. This is particularly due to the fact that the academic study of contemporary Canadian cultural institutions, policies, and personnel remains largely a scholarly no man's land (except to some extent in Quebec). It will thus have to suffice to indicate several general problems of the contemporary context that a police theory approach may begin to shed light on.

From the above it should at least be clearer that for the police state, the realm of the cultural was inherently a seminal dimension of the pastoral technologies of "good government." The context of policy intervention was urban, and the nature of regulation was prescriptive, not legalistic; it presupposed a still empty, or identityless "subject," though strictly speaking there are no subjects at all. In aligning these characteristics with the contemporary Canadian context, it will have to be left to other researchers to more satisfactorily explain why, given a shared political culture, all former British white dominions would be afflicted to varying degrees – until the 1960s – with what the Australians so aptly called "the cultural cringe." My guess, based on Frye, is

that this has a lot to do with the predominantly rural basis of these societies until well into the twentieth century.

Even so, it remains that such national cultural institutions as Canada has established, beginning with the National Museum (1842), have been created by what the critic Robert Fulford recently called "the political and bureaucratic class."[20] One need only mention in illustration the Marquis of Lorne for the nineteenth century and Vincent Massey for the twentieth. But is this to say that the political and bureaucratic class itself has had a distinctive cultural ideal; or has there been a sociologically identifiable cultural fraction to this class? Or, on the other hand, is there a separate, subordinate, cultural subset to the political and bureaucratic class? And if so, what ties (of kinship, education, ideology) connect it to the political and bureaucratic class? What have been the beliefs, the reading habits, the intellectual and imaginative categories of the bureaucrats of Canadian culture? There is a massive indistinction here – a conflation of polity and culture – that cries out for empirical investigation.

The Foucauldian theory of governmentality suggests that the relationship between the political and bureaucratic class, the security of the state, and the targeting of the population forms an intimate triangulation. One might think here of the physical emplacement of the headquarters of the Canadian Broadcasting Corporation in Ottawa, with the Canadian Security Establishment on its left and National Revenue on its right, for a particularly glaring spatial representation of state power. But what, if anything, does this tell us specifically of the CBC itself?

The discourses on Canadian culture, particularly in the domain of broadcasting policy, have been historically constituted, as Marc Raboy[21] has impressively demonstrated, by "discourses of the state" – but who and what exactly, beyond its political masters, is the state here? A further difficulty is that the normative order regulating Canadian cultural discourse and practices remains significantly alegal (with the singular exception of broadcasting). If there are laws that govern the establishment of specific state cultural agencies (e.g., the National Film Board, the Canadian Film Development Corporation, the Canada Council), the cultural sphere as a whole remains a jumble of overlapping jurisdictions, in which – and perhaps as a result – primarily administrative norms and practices prevail – because there are no other norms. As Fortier and Schafer observe in their brief history of federal cultural policies: "le développement des politiques et des activités fédérales dans le domaine des arts et de la culture étaient tributaires … de leur importance sur le plan politique," until the mid-1970s rise of a specifically economic rationality applied to culture, in Fortier and Shafer's account, often by artist lobby organizations such as the Canadian Conference of the Arts.[22] Finally, the much-touted exemption of the Canadian cultural industries from international treaties like the FTA and NAFTA only further increases their legal ambiguity and the resulting latitude of their political direction.

If, as these examples suggest, one can broadly point to some traits of the "statist" rationality that impinges upon the sector in a general manner, what

the precise sociological, ideological, and manpower contours of this rationality consist in are clouded in anonymity. And whatever else it may be, the "current crisis" of cultural policy in the Canadian context is also a crisis of the very state rationality that has sustained the growth of the sector since the 1950s.

The Limits of Police Theory

Classical police theory founded in the course of the transition to an international, capitalist market economy as the realm of the economic achieved greater differentiation as of the late eighteenth century, and the study of national wealth increasingly demarcated civil society from the state. As a result, the study of economic processes became the study of the self-regulation of civil society.[23] The cataclysmic enormity of the transition to a market economy hardly needs restating here,[24] except perhaps in those dimensions foregrounded by recent British neo-Foucauldians: notably, the work in aesthetic history of Peter de Bolla.[25]

Simplifying considerably, the transition to an economy of generalized exchange is accompanied by conjunctural transformations in the realms of subjectivity, aesthetics, and their discursive articulation. Thus, if the period of the Seven Years' War (1756–63) sees, as de Bolla argues with many qualifications, the appearance of the autonomous subject, that subjectivity appears in complex relationship both to a discourse on the national debt and on sublimity in aesthetic theory.[26] The implosion of the ground of wealth (in landed property) by exchange liberates logics of displacement across categories of data, with aesthetic ramifications. It becomes possible, for instance, for there to be "an aesthetics of mercantilism,"[27] the theory of international trade of the early modern police state. Significantly, neomercantilist frameworks would be used into the 1970s to explain the vagaries of Canadian economic development.[28] Further, the eclectic documentary realism so prevalent in Canadian art practices can be traced back to the aesthetics of mercantilism. At the same time, this would be an aesthetic in which international circulation prevailed firmly over local knowledge, devaluing the latter except for its more exotic form.

The point is this: historically speaking, the scale of economic transformation need not be inhibitive to aesthetic transformation – quite the contrary. But, for the policy state, negotiating such transformations is more difficult: the technologies of pastoral power have created a deep dependency of the flock upon the pastorate. Put differently, what has been happening in the Canadian context since the mid to late 1970s and increasingly as of the 1980s has been an *inversion* – interestingly, the Mexican word for the neo-modernization of their economy – of the logic of state rationality *away* from internal, prescriptive policy to the external, and more legalistic, forms of inter-state rationality. For a country with Canada's backward linkages (a statist culture, small domestic markets, under-capitalization of a cultural infrastructure dependent on subsidy – in short, a weak civil society in its indifferentiation of the political and the economic), this is extremely painful.

While there is among academic analysts some agreement that the contemporary globalization of markets necessitates rethinking the "traditional" interventions of the state in culture, is calling for the increased democratization of access to culture an appropriate strategy? Whatever else might be understood by democratization these days,[29] one of its dimensions would have to be the democratization of markets themselves.[30] But this would first entail, as John Keane has observed, rethinking the concept of civil society as an alternative venue for participation in the public sphere not mediated either by the state or the market.[31] At the very least, this would mean a better historical grasp of the emergence of the concept of civil society in comparative national contexts.

If all industrialized societies have historically experienced complex tensions between the spheres of economy and culture, the Canadian context offers particular articulations of these tensions. Without going quite so far as Ostry who claimed that "the cultural issue in Canada is more complex and requires more attention as a continuing political problem [!] than is the case in other countries,"[32] I have tried to provide a perspective above where such an endeavour might prove pertinent: because the policy state does not facilitate but, on the contrary, *blocks* the emergence of civil society. In this perspective, as Roger de la Garde has suggested,[33] one might look again at the Canadian discourses on identity as experimental forms of "currency" (nodes of sociability) attempting to establish a civil economy of symbolic exchange. Such an approach would make it possible to better understand the various shifting grammars that come into play in the transition to commodity exchange in the political economy of culture. One would thus have to re-examine Paquet and Wallot's thesis that the historical Canadian community of the eighteenth century, if it communicated less, may have communicated better. But all this calls for painstaking, detailed work in archives that are disgraces of neglect.

More simply for now, to recur to Innis, one might just begin with the recognition that much of the discourse on the Canadian cultural policy context has taken the form of what he called "panic literature rather than exhaustive studies of the field as a whole."[34] But it is precisely those exhaustive studies that are required. And until these are produced, or their skeletons unearthed from the archives of the state, we cannot even begin to say, as Innis could, "I am sufficiently humble in the face of the extreme complexity of my subject to know ... that I am not competent to understand the problem much less to propose solutions."[35]

NOTES

1 Ostry, *The Cultural Connection: An Essay on Culture and Government Policy in Canada*, 175.
2 Innis, *Essays in Canadian Economic History*, 384.
3 Ibid.
4 Burchell, Gordon, and Miller, eds., *The Foucault Effect*.
5 Meinecke, *Machiavellism: The Doctrine of Raison d'État and Its Place in Modern History*.
6 Burchell et al., *The Foucault Effect*, 9; Thuau, *Raison d'état et pensée politique à l'époque de Richelieu*, 9.
7 Foucault, "Governmentality," in Burchell et al., 92.
8 Foucault, "Omnes et singulatim," 29.
9 Foucault, "Governmentality," in Burchell et al., 102.
10 Foucault, "Omnes et singulatim," 11.
11 Ibid., 29.
12 Burchell et al., *The Foucault Effect*, 20, original emphasis.
13 Frye, *The Bush Garden*, 222, emphasis added.
14 Paquet and Wallot, "Nouvelle France/Québec/Canada: A World of Limited Identities," 96.
15 Tribe, *Governing Economy*, 27–9.
16 Ibid., 29–33.
17 Foucault, "Omnes et singulatim," 30.
18 Ibid., 31.
19 Tribe, *Governing Economy*, 31.
20 Fulford, *The Arts Tonight*.
21 Raboy, *Missed Opportunities*.
22 Fortier and Schafer, *Historique des politiques fédérales dans le domaine des arts au Canada, 1944–1988*, 52.
23 Smith, *The Wealth of Nations*, bks. 1–3.
24 Polanyi, *The Great Transformation*; Marx, *Capital*; Taussig, *The Devil and Commodity Fetishism in South America*.
25 de Bolla, *The Discourse of the Sublime*.
26 Ibid., 6–7.
27 Bunn, "The Aesthetics of British Mercantilism," 303–21.
28 Levitt, *Silent Surrender: The Multinational Corporation in Canada*.
29 Mouffe, *Dimensions of Radical Democracy: Pluralism, Citizenship, Community*.
30 Raboy et al., *Le développement culturel dans un contexte d'économie ouverte*, 1.
31 Keane, *Civil Society and the State*.
32 Ostry, *The Cultural Connection*, 27.
33 Personal communication.
34 Innis, *Essays in Canadian Economic History*, 89.
35 Ibid., 78.

BIBLIOGRAPHY

Bunn, James H. "The Aesthetics of British Mercantilism." *New Literary History* 11 (1980): *303–21*.

Burchell, Graham, Collin Gordon, and Peter Miller, eds. *The Foucault Effect: Studies in Governmentality.* Chicago: University of Chicago Press 1991.

de Bolla, Peter. *The Discourse of the Sublime: Readings in History, Aesthetics and the Subject.* Oxford: Basil Blackwell 1989.

Fortier, André, and Paul Schafer. *Historique des politiques fédérales dans le domaine des arts au Canada, 1944–1988.* Ottawa: Conférence canadienne des arts 1989.

Foucault, Michel. "Governmentality (1978)." In Burchell et al., 1991.

– "Omnes et singulatim: Towards a Critique of 'Political Reason.'" In *The Tanner Lectures of Human Values,* vol. 2 Sterling McMurrin, ed. New York: Cambridge University Press 1979.

Frye, Northrop. *The Bush Garden: Essays on the Canadian Imagination.* Toronto: Anansi 1971.

Fulford, Robert. *The Arts Tonight.* CBC-FM Radio, 22 October 1993.

Innis, H.A. *Essays in Canadian Economic History.* Ed. Mary Q. Innis. Toronto: University of Toronto Press 1956.

Keane, John, ed. *Civil Society and the State: New European Perspectives.* London: Verso 1988.

Levitt, Kari. *Silent Surrender: The Multinational Corporation in Canada.* Toronto: Macmillan 1970.

Marx, Karl. *Capital.* New York: International Publishers 1967 [1867].

Meinecke, Friedrich. *Machiavellism: The Doctrine of Raison d'État and Its Place in Modern History.* London: Routledge 1957.

Mouffe, Chantal. *Dimensions of Radical Democracy: Pluralism, Citizenship, Community.* London: Verso 1992.

Ostry, Bernard. *The Cultural Connection: An Essay on Culture and Government Policy in Canada.* Toronto: McClelland & Stewart 1978.

Paquet, Gilles, and Jean-Pierre Wallot. "Nouvelle France/Québec/Canada: A World of Limited Identities." In *Colonial Identity in the Atlantic World, 1500–1800,* ed. Nicholas Canny and Anthony Pagden, 95–114. Princeton: Princeton University Press 1987.

Polanyi, Karl. *The Great Transformation.* New York: Rinehart 1994.

Raboy, Marc. *Missed Opportunities: The Story of Canada's Broadcasting Policy.* Montreal/Kingston: McGill-Queen's University Press 1990.

Raboy, Marc, Ivan Bernier, Florian Sauvageau, and Dave Atkinson. *Le développement culturel dans un contexte d'économie ouverte: Un enjeu démocratique.* Rapport présenté au Conseil de recherches en sciences humaines du Canada at au Ministère des communications du Canada 1993.

Smith, Adam. *The Wealth of Nations,* bks. 1–3. 1776; reprint London: Penguin 1986.

Taussig, Michael. *The Devil and Commodity Fetishism in South America.* Chapel Hill: University of North Carolina Press 1981.

Thuau, Etienne. *Raison d'état et pensée politique à l'époque de Richelieu.* Paris: Colin 1966.

Tribe, Keith. *Governing Economy: The Reformation of German Economic Discourse 1750–1840.* Cambridge: Cambridge University Press 1988.

Le trésor de la langue: Visual Arts and State Policy in Québec

Johanne Lamoureux

I would like to draw your attention to an ironic twist of my presentation on the theme of money and art.[1] I choose to inscribe the economic dimension of my text within the field of linguistics, for the Saussurean coloration of the formula[2] offers a perfect and concise metaphor. It encompasses both a concern with the accumulation of riches (it plays on the "thesaurus") and the site of my current research on the hegemony of language in the fashioning of Québec discourse(s) of identity and its impact on the production and reception of the visual arts.

The title of this paper is doubly appropriated. It was previously borrowed by the experimental musician René Lussier,[3] in a work paradoxically dealing with "*lalangue*," as Lacan used to say,[4] through a compilation and a monumentalization of street-talk (*parole*). Given its thematization of wandering, of begging for directions or getting lost, and given the way it is structured as a survey of the historical highlights of the Québec sovereignist movement, Lussier's archival work clearly situated the construction of Québec identity under the paradigms of time and language (*Je me souviens*), rather than under those of a more McLuhanian narrative of identity based upon space and technology (*Ad mari usque ad mare*).[5] In none of these narratives will we find the redeeming balance between time and space for which Innis seemed to have longed. Bell Canada advertisement campaigns made that difference almost tangible when they invented "the long distance feeling" for their English-speaking clientele while coining "*gens de parole*" as their French trademark. Lussier's production was also extremely interesting in its putting forward of the problematic dimension of orality in Québec, for it is not only language but spoken language that caters to the specular quest of the Québécois.[6] Once more we have an implicit opposition to the central "aurality" of the McLuhanian narrative of Canadian identity.

Obviously also, in its reference to Saussure, my titling strategy alludes to and operates within the context of the enduring opposition, polarization, and

division of competences that were cast upon the two official languages of Canada for a good part of its history. This duality traditionally identified English as the language of money and French as that of culture (in nineteenth century Québec literature or in Sunday sermons, for example) even if French was by then already becoming less and less the *lingua franca* of culture. Yet what matters for what I am trying to establish here is not so much that French should or should not be confined to the status of a language of cultural matters (the past thirty years in Québec have modified that situation). I am more concerned with the way a definition of culture by the state (whereby culture becomes fundable) can be too narrowly constructed as the only master key to a narrative of identity. My position is that the visual arts in Québec have embodied and do embody an alternate narrative, one that challenges the enchanting mirror-image of mother tongue (implicitly opposed, of course, to a more spatial fatherland).

Let me present a programmatic overview of the consequences of the above-mentioned circular notion (culture as French as culture) for the future funding and for the present practice of the visual arts in Québec.[7]

A reading of the *Rapport Arpin* (1991), which outlines the latest cultural policy of Québec, suggests that culture is no longer merely equated with language. (Even the report's table of contents has an interesting slip: the section on language is not even listed.) The following quotation (in my own approximate translation) constitutes the report's main statement on the articulation of language and culture:

> If culture is a more encompassing reality than language, the latter is a central element of cultural life: first, because language expresses that culture – let's think in particular of the writing of novels, theatre, poetry, songwriting and film, radio and television, these last two then considered as means of expression; secondly, because language carries in its words the memory and the trace of the cultural past of a society, to learn the language is to domesticate a code, of course, but it is also to become part of a culture … This as such indicates the place of language in any cultural policy. Given the particular context of the French language in North America, everything must be done, through support of all kinds, to contribute to the valorization of this language and to ensure its presence and its influence on an international level through the quality and prestige of the works it expresses.[8]

This excerpt unfolds many revealing aspects in need of further development, including an instrumental conception of language and a presentation of language as the privileged connection of culture to the past – but these are not the points I want to explore. I would rather call attention to the exemplary and seemingly candid enumeration of media that Arpin introduces.

Independent of what governmental policies have tried to convey about art and culture in Québec, it remains undeniable that art involving language, be it the written word or (more to the point for Québec's cultural context) the

spoken word, the word as voiced, has generated cultural practices more likely to be popular and recognized (in the most polysemic understanding of the term, as both situated and valued). And this is so because, even when the content of those works does not openly address the issue of Québec identity, the works as such nevertheless invite an allegorical or even symbolic reading of that issue. For even when there is no such reading supported by the narrative, the very medium exacerbates a sense of self-recognition in a large public aware of itself as an audible minority/majority. Songwriters, novelists, playwrights, poets and, more recently, stand-up comics have been embraced – some of them engulfed, even – by a collective claim of the public and by the value openly granted to their work in relation to the construction of a narrative of identity. Arpin is clear on culture as a vocal mirror-image. He writes: "The Québécois artists speak, name, call to and illustrate Québec: they give it a face."[9]

Arpin's visual-arts metaphor is both telling and deceiving. Producing Québec as a name plus a face, Québec artists are viewed as portraitists of some sort, and as committed, be it deliberately or not, to an endeavour of collective self-portraiture. Yet what happens when the sought-for face, portrait, mirror-image has to be a voice or a word, a certain way of speaking the word? What does it mean for artists whose medium is not language? A full response to that question would require at least a three-fold answer, one that would study how the works of visual artists are affected by that belief, how it shapes their relation to Québec cultural institutions, and how it colours their reception outside of their immediate circle of peers.

Of course I will not be able to provide answers to these issues here. Certainly, a lengthier investigation of those avenues would ask that one keep in mind how the founding moment of Québec's pictorial modernity – that is, the Refus Global of 1948 – coincided with a clearly formulated refusal of any kind of literary and nationalist agenda and with a quite characteristic internationalist craving. That refusal of extra-pictorial connotations led Borduas and his friends to reiterate often the impossibility of an interface between painting and language. It reminds us of Matisse's emblematic and paradoxical statement: "*Qui veut se donner à la peinture doit commencer par se couper la langue.*"[10]

In a more synchronic analysis, one would also have to relate the somehow perilous situation of the visual arts in Québec to the broader context of current art, and especially the visual-arts bashing in western societies, a situation partly brought about by the new awareness that taxpayers have of themselves as unwilling sponsors of grants and art purchases. What is extremely revealing of Québec's cultural credo, however, is that when visual artists are under vicious attacks from the media, no intellectual or cultural producer from any other field ever speaks up to protest.[11] Some highly respected *indépendantistes* figures like Pierre Bourgault or Gaston Miron have even fuelled the controversy against contemporary art. It is as if somehow visual artists were, from the very start, breaching the implicit contract of identity now formulated by the official policy.

A traumatic consultation with artists, triggered by the Arpin Report's

release, gave birth to a new Conseil des Arts. It appeared that Québec artists, whatever their specific field of cultural production, wanted a Canada Council for the Arts. For the first time many cultural producers, under the leading voice of playwright René-Daniel Dubois, publicly expressed their resentment of the fact that Québec cultural institutions had for years made them feel guilty because they were asking for money from the (federal) Canada Council as well as from the provincial Ministère des Affaires Culturelles. They declared that they would no longer tolerate being seen as disloyal Québécois and cultural traitors, and held as cultural hostages to the political agenda of cultural specificity when no economic measures were ever taken to actualize this discourse. Some even uttered loud and clear what had only previously been whispered: artists felt that the Canada Council showed more interest, more concern, and more respect for their practices and for the daily conditions of their reality as artists (in the way it designed programs, hired agents, set deadlines, or awarded grants).

As a result of that polemic, the Québec minister declined, for the time being, to claim sole competence in the field of culture and announced the creation of a Conseil des Arts du Québec. This new council was, however, to have a twist alien to its federal model: it would not enjoy the same political autonomy but would answer to the new Ministère de la Culture and would receive from it its general directions. The euphoria was dimmed by that last condition. Yet, as Lise Bissonnette, editor of *Le Devoir*, has argued, the Canada Council is paying a high price for its autonomy from the political realm, and the Canadian government has put in place its own parallel structure to exert some control over cultural production.[12] For even before the Canada Council had to implement the drastic cuts of 1993, its expected budget increases had been denied for nearly a decade, while during the same time the federal Department of Communications had seen its budget inflated and had fully sponsored its own vision of fundable culture in Canada, often acting as a kind of "Mega-Department of Propaganda."

To this day, the only main direction indicated by the minister of Culture has been to set a focus on creation, with the promise of funding injections, rather than to invest in bureaucracy and building maintenance. As such it does not mean much, and only offers a benign, predictable statement in a time of recession.

From that point, many avenues are opened that would call for further examination of that antinomy of visual and spoken languages in Québec and for a continuing analysis of the textual production of governmental agencies on art and culture. These axes should also be completed with an attentive reading of the complex critical reception that the artworks themselves have generated: symptomatic motifs would emerge, like that of an internationalist fantasy or that of visual practices anchored in the postmodernity of a critically exalted hybridity of languages (the interdisciplinarity of two media). Then an even more important task would have to be carried out: that of looking at individual works, or at a series of works by a given artist, to explore the pos-

sible configuration of singular obsessions with language(s) from the point of view of visuality.

For example, Rober Racine has worked for a decade on *Le Parc de la langue française* or *Pages-Miroir*. Yet up to 1991, no critic had ever pointed out, even in the most remote fashion, the relevance of inscribing these works in the context of the linguistic situation in Québec; Racine could still be seen by Canadian art critics as an artist of the '80s, still tied to the non-referential semiotic plays of the conceptual scene of the '70s. In *Pages-Miroir: "A"* (figure 13), Racine opens the French dictionary, the *Robert*, a homonymic pun playing on his own first name – and illuminates the double fold like an ancient manuscript by highlighting certain passages of the definitions. More significantly, the entry for each word has been almost surgically excised. Behind the missing word, a mirror has been set. The beholder is left with a glimpse of reflection and a definition without a signifier. Racine himself refers to this series as expressing the anxiety of being unable "to find the word" you need. We find in this project one of the leading statements of what I suspect could encompass a much larger segment, although still a partial one, of visual production in Québec. It is a segment I choose to designate as the aphasic paradigm and I have further explored as the curator of an exhibition at the Fine Arts Gallery of the University of British Columbia.

Finally, I would suggest that the critical discourse on art in Québec must begin to commit itself to the construction of small narratives that would allow certain bodies of works from different artists to resonate with one another and to make sense as timely and precarious series. Traditionally in Québec art historical discourse has been split between the formalist-semiotic approach (that excels in the reading of singular works) and the sociological approach (that studies the institutional conditions of possibilities for art practices). Meanwhile, museums (not parallel galleries) have mostly failed to gather works that could be read as a small and signifying segment, thus inviting not a reading of one work, a reading around the work, but rather a reading between works. These institutions remain committed to monographic shows or blockbuster exhibitions listing famous names or presentations of art that are articulated by outmoded criteria for the narrative construction of art production – among them the monographic retrospective, the generational gathering, and the exploration of a single medium. Or, sometimes, they simply propose a theme too broadly formulated to generate any engaging storytelling, or any sense of local stakes.

I conclude with a brief example of such an exhibition narrative, as it had to be dug out of the nomenclature of artistic champions. When in May 1992 the Musée d'art contemporain de Montréal re-opened at its new location downtown, it did so with an international exhibition called *Pour la suite du monde*. Many artists from Québec had been included in the selection. Yet no critic, and certainly not the curators, seemed to have noticed the sub-text revolving around the mouth and the voice that nearly half of the Québec artists of the exhibition had inserted in its itinerary.

Figure 13: *Page-Miroir "A,"* 1982, by Rober Racine

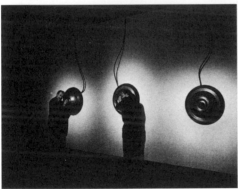

Figure 14: *Artiste en conversation jour d'audience*, 1992,
by Gilbert Boyer

Inside the museum, the corridor introducing the viewer to the exhibition
rooms included Gilbert Boyer's huge breast-like ringbells (figure 14). One had
to press the "nipple" in order to listen to the artist's whispered complaint
about artistic identity. The closing piece of the show was Barbara Steinman's
Signs, a set of emergency exit light-boxes that spelled "Silence," a word that
functions bilingually (figure 15). The artist had distributed them on a curved
wall facing the only window of the exhibition space. Certainly, at one level,
among many others of course, this installation signified its indexation of the

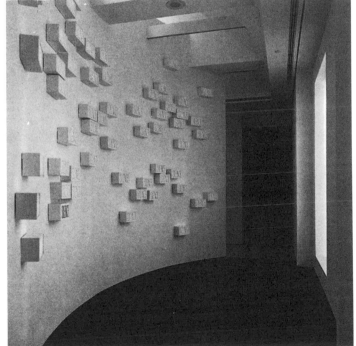

Figure 15: *Sign (Signes)*, 1992, by Barbara Steinman

Figure 16: *La voie lactée*, 1992 by Geneviève Cadieux

indoor/outdoor criteria that was the basis of the language sign legislation in Québec. Steinman questioned the language law as it was meant to act as national self-portraiture, the rationale behind the exclusivity of French signs in the windows being the necessity of asserting "*le visage* linguistique du Québec," that is, language as a visual fact.

On the roof of the museum, Geneviève Cadieux's giant lightbox of her mother's mouth offered perhaps the most telling clue to this modest narrative. Entitled *La voie lactée*, not just *the milky way*, since between "*voie*" (way) and "*voie*" (voice) it rang with an inevitable *double entendre*, invoking the mother's voice if not the mother-tongue (figure 16). All these works, read together, contest the triumphalist and hegemonic definition of culture as verbal language; yet in their alternate narratives they reveal the hold this hegemony has in their cultural milieu of production. Often, as they unfold a visual narrative of troubled speech and blissful orality, they claim their right to *infancy*, not in any derogatory sense but, as the etymology goes, as a right to a culture also expressed by others than those who know how to speak.

NOTES

1 "Art and Money, or What Is It Worth?" Interdisciplinary Workshop/Conference, Harold Innis Centenary Celebration, 14–15 January 1994. (See introduction to this volume.)

2 "La langue est le trésor déposé par la parole dans les sujets appartenant à une même communauté." Quoted in Barthes, "Éléments de sémiologie," *L'aventure sémiologique*, 22. For a comparison between Saussure's linguistics and monetary economy, see also in the same collection of essays, "Saussure, le signe, la démocratie," *221–6*.

3 Lussier, *Le trésor de la langue*.

4 "Lalangue sert à toutes autres choses qu'à la communication. C'est ce que l'expérience de l'inconscient nous a montré, en tant qu'il est fait de lalangue, cette lalangue dont vous savez assez que je l'écris en un mot, pour désigner ce qui est notre affaire à chacun, lalangue dite maternelle, et pas pour rien dite ainsi." Lacan, *Le Séminaire*, 126.

5 Innis, "A Plea for Time," *The Bias of Communication*, 61–91. See also Kroker's analysis of Innis's claim that in "Western civilization, a stable society is dependent on an appreciation of a proper balance between the concepts of space (territory) and time (duration)." Kroker suggests that "all of Innis' writings might be interpreted as a recovery of time, of historical remembrance against the monopolies of space ... imposed by technological society" ("Technological Realism: Harold Innis' Empire of Communication," *Technology and the Canadian Mind*, 92).

6 Cambron, "L'importance de l'oralité," *Une société, un récit. Discours culturel au Québec (1967–1976)*, 101–24.

7 On the construction of Québec's gendering within the representation of the visual arts scene in Canada, see my essay, "French Kiss from a No Man's Land: Translating the Art of Québec," 48–54.

8 Arpin, *Une politique de la culture et des arts*, 44–5.

9 Ibid., 73.

10 Matisse, *Écrits et propos sur l'art* ["Whomever chooses to be a painter must begin by cutting one's tongue (langue)": eds.], 235.

11 One could read as the most recent example of such a vicious attack Chartrand, "L'art est-il malade?", 72–8.

12 Bissonnette, "La culture du soupçon," 14.

BIBLIOGRPAHY

Arpin, Roland. *Une politique de la culture et des arts*. Québec: Gouvernement du Québec 1991.

Barthes, R. *L'aventure sémiologique*. Paris, Seuil 1985.

Bissonnette, Lise. "La culture du soupçon." *Le Devoir* (30 novembre 1992): 14.

Cambron, Micheline. *Une société, un récit. Discours culturel au Québec (1967–1976)*. Montréal: L'Hexagone 1989.

Chartrand, Luc. "L'art est-il malade?" *L'Actualité* (15 octobre 1993): 72–8.

Innis, Harold. *The Bias of Communication*. Toronto: University of Toronto Press 1951.

Kroker, Arthur. *Technology and the Canadian Mind*. Montréal: New World Perspectives 1984.

Lacan, Jacques. "Lalangue sert à toutes autres choses qu'à la communication. C'est ce que l'expérience de l'inconscient nous a montré, en tant qu'il est fait de lalangue, cette lalangue dont vous savez assez que je l'écris en un mot, pour désigner ce qui est notre affaire à chacun, lalangue dite maternelle, et pas pour rien dite ainsi." *Le Séminaire*, livre 20, "Encore," Paris, Seuil (1975): 126.

Lamoureux, Johanne. "French Kiss from a No Man's Land: Translating the Art of Québec." *Artsmagazine* (February 1991): 48–54.

Lussier, R. *Le trésor de la langue*. Ambiances magnétiques (AMO15-CD), Société Radio-Canada 1989.

Matisse, Henri. *Écrits et propos sur l'art*. Paris: Hermann 1972.

Speculation (Blue Chip, Red Dot)

Janice Gurney

MIDLAND WALWYN
PAST PERFORMANCE

Midland Walwyn Past Performance

JANICE GURNEY
PAST PERFORMANCE

Janice Gurney Past Performance

Technology, Globalization, and Cultural Identity

Learning the New Information Order
Janine Marchessault

The Crisis of Naming in Canadian Film Studies
Brenda Longfellow

Learning the New Information Order

Janine Marchessault

New communications media and particularly technologies of information transmission and retrieval such as the merging of televisions, telephones, and computers are redefining the countenance of knowledge and entertainment. Central concerns regarding new telephonic media are access and participation or in the liberal democratic rendition, equality and freedom. In North America, the economic development and political deregulation of new media technologies are being framed by the liberal ideal of global community. Such an ideal, frequently evoked by governments to justify policy decisions, seems driven more by multinatioanl capital than by hopes for transcultural understanding.

Indeed, the conflation of democracy and industry is nowhere more apparent than around current discourses of access. Derived from the functional rationality of progress in economics and science, access is reduced to choice. AT&T's promotional video *Connections: AT&T Vision of the Future* (1993) is a good example of the way access means choice in the new media environment. AT&T's vision of the future promises pay-per-view television ("Have you ever watched the movie you wanted to, when the minute you wanted to?"); electronic interactive classrooms ("learned special things from faraway places – where does jazz come from?"); and videophones ("tucked your baby in from a phone booth? YOU WILL!"). Just in case YOU were worried about the effects that these new compound media might have on social stratification and the political economy of culture, a woman guides a visitor down the corridors of a high school: "I'd like to show you something." Sitting in a circle, teenage students peer into laptops at their computer-generated teachers beamed in from the educational centre in Washington, D.C. An interactive geography class unfolds differently for each of them, "giving that special help when and where it is needed." A map of North America carries the user-friendly caption "Our Ecosystem" as the AT&T guide underlines something that, given the ethnic make-up of the class, was presumably already apparent: "Not all the children in this

neighbourhood get that kind of attention at home." A spinning globe marks the end of the lesson as the camera zooms in on the perfect prototype of the New Information Order, Mother Earth. More generally, the scene encompasses the utopian image of globalization where class is transcended through technology, difference is recognized and accommodated, and a new technological class is founded on equal access to a multicultural curriculum.

Technology as feminine, mass culture as enlightenment, interactivity as democratic – these symbolic juxtapositions that promise to break down the boundaries between people and between places are familiar. Any new technology will invariably be invested with utopian or dystopian meanings. Nevertheless, it is worth exploring some of these meanings in more detail for what they reveal about the difficulties that new media technologies present for cultural analysis. This is especially important in Canada where so much cultural policy around communications industries and institutions has been informed by Marshall McLuhan's formalist legacy. My aim here is to consider access in a dialectical fashion – focusing on the commodified version of information access described above (AT&T's vision) and on the real possibilities for political community being enabled by new communication technologies.

The modern idea of education is bound up with a radical democratic project born of the Enlightenment. For H.A. Innis writing in Canada in the 1940s and '50s, this project was being threatened by the mechanization of learning. In his (1947) report on adult education he would observe: "Education has been largely concerned with conservation of knowledge, and in turn becomes extremely conservative ... This tendency towards conservatism has been enhanced by the mechanization of communication in print, radio, film."[1] Even before computers entered the classroom, Innis ascertained that instructional technologies could be used to produce "useless knowledge of useful facts." The emphasis on factual information and classification rather than ideas – "abstract ideas are less susceptible to treatment by mechanical devices" – was symptomatic of both an obsession with and loss of history. According to Innis, education and information were becoming identical.[2] With the merging of state and university, and the concomitant "mechanization of knowledge," pedagogy was being made to conform to the increasingly instrumental (i.e., market driven) concerns of the university, emphasizing vocational training and specialism over the stimulation of thought.[3] While the university was expanding its student body, changing curricula, and adding courses, Innis believed this to be less a matter of goodwill than of economics. Universities should strive to foreground the relation between power and knowledge, to produce "open minds" able to "question assumptions."[4] Thus, while he held that the university should be "available to the largest possible number," he also maintained: "Adult education, appealing to large numbers with limited training, can be disentangled with difficulty from the advertising of large organizations concerned with the development of goodwill."

There is, of course, more than a hint of elitism in Innis's understanding of

Canada's "limited intellectual resources," in his view that universities, having taken on the monopolistic character of the media, were following "the pattern of advertising," lowering academic standards to "reach lower levels of intelligence."⁵ Innis's ideas around the "information industries," like Adorno and Horkheimer's "culture industry," are informed by "the dialectic of enlightenment," by an underlying tension between mass culture and modernism, or centre and margin. This tension enables Innis to clearly discern the ramifications of the mechanization of knowledge: the merging of education and marketing, and the privileging of facts over concepts in learning.

With this in mind, I want to turn to a persistent image in the marketing of new technologies, the trope described by Andreas Huyssen of "mass culture as woman." Huyssen traces this nineteenth-century mystification across a wide spectrum of writings where he finds the figure of woman consistently called upon to signal both the democratic ideals of cultural modernization and the debasement of high culture.⁶ Either way, Huyssen notes, the feminine is invariably inscribed in the technological. This juncture of the feminine and the technological is not so much about cultural production as it is about reproduction and transmission.

AT&T's promotional video *Vision of the Future* provides a good illustration of this problematic. Here, women are either mothers using new communications technology (Ma Bell is the original network model here) or they are themselves technologies to be used. That is, new technologies are feminized by virtue of the women, children, and racial minorities who use them or else they are feminine by nature. In AT&T's electronic classroom, featured at least three times throughout the video, computer-generated teachers, played by women and black men, are replacing the mother and the absent father. Indeed, the circle of students in the classroom reproduces that tried and true picture of consumer harmony, stability, and democracy, the family circle. The image, the characteristic family posed in semi-circle around a particular technology, invokes a sense of domestic sanctity, warding off the centrifugal social forces of modernity while accommodating its technologies.⁷ Moreover, within this configuration, emphasis on the feminine, the domestic, and the private serves to deflect the more public institutional economies that define modern communications. For as Judith Williamson asserts, "one of the most important aspects of images of 'femininity' in mass culture is not what they reveal, but what they conceal. If 'woman' means home, love, and sex, what 'woman' doesn't mean, in general, is currency, work, class and politics."⁸

AT&T's "vision" flattens the realm of class and politics by stressing cultural diversity. Across a variety of spaces designed for the consumption and the circulation of commodities – the middle-class home, the airport, the shopping mall, the school – the autonomous expression of consumer freedom is seen to equalize and efface difference along with the political economies that shape it. The distance-learning of the electronic classroom presents both a highly personalized and yet centralized communication system, a centre-without-margins, to use McLuhan's expression, as students are connected to Washington,

D.C., while working at their own pace. The electronic class can claim all the attributes of the mythological family and the nation, assuring personal freedom, equality, active democratic participation and, at the same time, the guarantee of social cohesion.

"Have you ever ... YOU WILL." The AT&T campaign is clever because it combines two things: the promise of a better future and the idea that the technological will is the consumer's alone. The multinational corporation appears merely to provide a public service, of which education with its invocation of democratic ideals is the most estimable. Thus, an earlier functionalist model of the mass media is reversed in the new interactive environment by transforming the passive viewer into an active agent. Who is being addressed by AT&T's promotional campaign: you or me? It is anyone who can pay the price. But the personalized and psychological mode of address does not reflect the reality of capital's uneven development; rather, it replicates atomized forms of media distribution, calling out to citizens individually but in the same way – a perfect illustration of difference as sameness. The more important question is who is doing the asking and the answering. Who is setting the very limits of interactivity and its future? It is, in all probability, not us.

Nevertheless, we must take care not to revert to a functionalism that would posit the user as that empty receptacle programmed into action by the multinational corporation. For in actuality new forms of interaction and agency are being enabled by the new media environments that AT&T promises to control.

John Tomlinson has underlined that the globalization we are currently experiencing is distinct from earlier forms of imperialism. In the context of the spread of cultural modernity, a language that emphasizes cultural domination and imposition is no longer entirely appropriate. Tomlinson maintains that globalization is far less coherent or culturally directed than imperialism: "For all that is ambiguous between economic and political senses, the idea of imperialism contains, at least, the notion of a purposeful project: the intended spread of a social system from one centre of power across the globe. The idea of 'globalization' suggests interconnection and interdependency of all global areas which happens in a far less purposeful way ... and which functions to weaken all nation states – including the economically powerful ones – the imperialist powers of a previous era."[9]

Taking his lead from Raymond Williams, Tomlinson distinguishes between cultural and economic imperialism.[10] While earlier forms of empire were directed by political and cultural interests that worked in tandem to define a social mission (i.e., colonization/civilization), the processes of globalization that distinguish multinational capitalism are driven by the interests of the market alone. This distinction enables us to think about cultural practices and new global cultures in ways that do not simply reduce them to ownership or capitalist ideology. In this way we move beyond the binary opposition of modernism and mass culture that informed Innis's distrust of instructional

technologies. Instead of the notion that mass culture is simply a uniform product imposed on passive consumers, a space is opened for contradictory forms of empowerment, production and consumption. This is not to say that the centre-margin relation so central to Innis's analysis of power is no longer relevant but rather that such a model is useful for analysing economic rather than cultural configurations of domination. What is interesting is not that centres of power have ceased to exist but that they, along with the margins, are shifting in unpredictable ways.

For many, the Internet embodies the contradictory status of global cultural modernity. As a web of computer networks, the Internet allows communication between users with no centralized source or power controlling access and circulation. Centralized communication and authority are replaced by a web – a plurality of networks – of centrifugal informational forces. The Internet was, in fact, designed to cope with the collapse of a central authority. It emerged in the early 1970s as an experimental network created by the U.S. Defense Department to support weapons research. This research concerned the construction of networks that could withstand partial outages, as in the case of a nuclear attack, and continue to function. The idea behind the Internet is that any portion of the network can disappear, and messages will still circulate between computers. Contrived to survive an attack on its centre, it is an information system that cannot be dislocated precisely because its centre is not located. In its incarnation as a military technology, this decentralization of intelligence was merely structural and was intended to lay the foundations for an even more sophisticated information infrastructure.[11] However, at present the Internet cannot be controlled or monitored in any coherent manner. The source of a transmission, technology, or service is blurred across national, regional and institutional boundaries, across public and private spaces, within the decentred economy of the user.

Indeed, McLuhan's belief that electronic forms of global communication would both connect and differentiate cultures appears apt:

> Since electric energy is independent of the place or kind of work-operation, it creates patterns of decentralism and diversity in the work to be done. This is a logic that appears plainly enough in the difference between firelight and electric light, for example. Persons grouped around a fire or candle for warmth or light are less able to pursue independent thoughts, or even tasks, than people supplied with electric light. In the same way, the social and educational patterns latent in automation are those of self-employment and artistic autonomy.[12]

Against the centre-margin relation stressed by Innis, McLuhan's centre-without-margins is a cultural rather than an economic model. It has proved useful for describing new and highly creative forms of decentralized communicaton, new forms of community and resistance that characterize global cultures. McLuhan maintained that computers would support the expression of difference, breaking down national borders while fostering interfaces and flows

between cultures. Moreover, he believed that the new electric media would support innovative interdisciplinary knowledges. In the early 1950s he set up the newsletter *Network* at the University of Toronto for the expressed purpose of by-passing the specialization of academic disciplines and publishing, creating conversations between different fields of study and thinkers. Inspired by the vast "intellectual landscape" that characterized Innis's work on empire and communications,[13] *Network* not only anticipated the interdisciplinary field of communication studies as it would develop in Canada but also the role played by the Internet in decentralizing communication.

But since McLuhan privileges the cultural in his thinking, the centre-without-margins model can tell us nothing of the economic structures that support the new technologies, cultures, and knowledges he describes. His concept of the global village collapses the global into the local, making it impossible to discern relations of power of any kind. This is why his media theories have always been more attractive to corporations like AT&T than to cultural theorists and activists.

A relation between communication and place might allow us to link the spatial models devised by Innis and McLuhan. An emphasis on "positionality," as Stuart Hall has argued, forces us to comprehend that "everyone speaks from positions within the global distribution of power."[14] Calling for a "politics of mobility and access," Doreen Massey has suggested that a "global sense of place" might provide a starting point for analysing the concept of the global village. According to Massey, that phenomenon many have called an experience of "time-space-compression" is one that is not unified and universal; rather, it is an experience that needs to be located in terms of "the power-geometry of time-space-compression":

> For different social groups, and different individuals are placed in very distinct ways in relation to these flows and interconnections. This point concerns not merely the issue of who moves and who doesn't, although that is an important element of it; it is also about power in relation to the flows and the movement. Different social groups have distinct relationships to this anyway-differentiated mobility; some are more in charge of it than others; some initiate flows and movement, others don't; some are more on the receiving end of it than others; some are effectively imprisoned by it.[15]

By insisting on the global network of relations that define the local as local, "a global sense of place" recognizes that an experience of place is inflected by who we are. Mobility and access need to be specified and differentiated in a more "socially imaginative way." Unlike the global village, Massey's concept of place is not static. In its interactions with wider geographical contexts, places are always processes; boundaries between places, as between space and time, are never clearly demarcated. Place in its global sense, then, allows us to locate ourselves differently within a network of changing social relations.

In the new information environment that is redefining our sense and experience of place, discourses of access and participation will need to take into account the different meanings of access both within countries and between them. Access must be considered in terms of material (rather than virtual) realities, in terms of the actual technologies, computer services, and kinds of information that are available. The recent mergings of cable and telephone companies across North America may soon severely curtail the heterogenous interactions on the Internet. Paving the way for the new "information home supermarket," many companies plan to provide over five hundred channels as well as myriad information and entertainment services.

More than ever, Innis's emphasis on the political economy of communication is absolutely essential. His work provides us with the materialist tools needed to see through the technological infrastructure so central to Canada's nation-state existence. The centre-margin model, rather than being an outmoded reflection of simpler times as McLuhan alleged, might serve to guide us through and to locate the complex power geometries of global networks, the relations, as Massey puts it, between place and space. This emphasis will enable us to confront some of the essential questions that are currently arising out of the information environment: questions not only about access – who is being given access to information, at what cost, and for what purposes – but also about the government policies that are shaping access.

Canada's desire, paradoxically nationalist, to be part of the global information environment by acquiring communications hardware has historically elided questions of the local and led us to be on the receiving end of culture. Statements by former chief broadcasting regulator Keith Spicer concerning Canadian Radio-television and Telecommunications Commission (CRTC) controls over the influx of American product via the information superhighway reflect this history: "Canadian-content rules are gradually withering away ... We can't keep the Americans out. What we can do is offer much better Canadian shows."[16] If we have learned anything from the CRTC's relationship with the cable companies in the 1970s and '80s, it is that we cannot rely upon the government to ensure the exhibition of indigenous cultural production. The sad erosion of public-access television in Canada was facilitated by the unregulated power that cable owners and managers were able to exert over the parameters of "quality" programming.[17] The sense of resignation in Spicer's comments reflects the technological determinism at the heart of the superhighway metaphor. It is an image built on the separation of the local and the global; it invokes the inevitability of a culture outside of space and time.

In "A Plea for Time," Innis suggests that we need to escape "on the one hand from our obsession with the moment and on the other hand from our obsession with history." We need to find a "balance between the demands of time and space."[18] Despite AT&T's rhetoric of access, the geographies of the new information environments will intensify class divisions. Even at this early stage it is apparent that many schools already suffering financial cut-backs will not have access to the latest information technologies. Yet those institutions

which do gain access will need to consider seriously how to use them, how to make them contribute to the new forms of interdisciplinary knowledge, rather than reproducing what Innis feared most about the mechanization of knowledge, "useless knowledge of useful facts."

NOTES

1 H.A. Innis, "Adult Education and Universities," *The Bias of Communication*, 204.

2 Ibid., 205.

3 Ibid., 208.

4 Ibid., 210.

5 Ibid., 213.

6 Andreas Huyssen, "Mass Culture as Woman: Modernism's Other," in *Studies in Entertainment*, ed. Tania Modleski, 189–200.

7 Cf. Lynn Spigel, "Television in the Family Circle: The Popular Reception of a New Medium," in *Logics of Television: Essays in Cultural Criticism*, ed. Patricia Mellencamp, 75–80; Roland Marchand, *Advertising the American Dream: Making Way for Modernity, 1920–1940*, 248.

8 Judith Williamson, "Woman Is an Island: Femininity and Colonization," in *Studies in Entertainment*, 103.

9 John Tomlinson, *Cultural Imperialism*, 175.

10 Raymond Williams, *Keywords*, 160.

11 Cf. Ed Krol, *The Whole Internet: User's Guide & Catalogue*.

12 Marshall McLuhan, *Understanding Media: The Extensions of Man*, 359.

13 Philip Marchand, *Marshall McLuhan: The Medium Is the Messenger*, 114.

14 Stuart Hall, "The Meaning of New Times," in *New Times: The Changing Face of Politics in the 1990s*, ed. Stuart Hall and Martin Jacques, 133.

15 Doreen Massey, "Power-Geometry and Progressive Sense of Place," in *Mapping the Futures: Local Cultures, Global Change*, ed. Jon Bird et al., 61.

16 Ian Austen, "Canadian-Content Rules Are Doomed," *Montreal Gazette*, 19 January 1994, C8.

17 Cf. Robert Babe, *Telecommunications in Canada: Technology, Industry and Government*.

18 Innis, "A Plea for Time," *The Bias of Communication*, 90.

BIBLIOGRAPHY

Austen, Ian. "Canadian-Content Rules Are Doomed." *Montreal Gazette* (January 19, 1994): C8.

Babe, Robert. *Telecommunications in Canada: Technology, Industry and Government.* Toronto: University of Toronto 1990.

Doane, Mary Ann. *Body/Politics: Women and the Discourses of Science.* Eds. Jocobus, Mary, Evelyn Fox Keller and Sally Shuttleworth. New York: Routledge 1990.

Felski, Rita. *Beyond Feminist Aesthetics.* Cambridge: Harvard University Press 1989.

Hall, Stuart, and Martin Jacques, eds. *New Times: The Changing Face of Politics in the 1990s.* London: Verso 1990.

Huyssen, Andreas. "Mass Culture as Woman: Modernism's Other." *Studies in Entertainment.* Ed. Modleski, Tania. Bloomington and Indianapolis: Indiana University Press 1986.

Innis, Harold A. *The Bias of Communication.* Toronto: University of Toronto Press 1951.

Krol, Ed. *The Whole Internet: User's Guide & Catalogue.* Sebastopol, California: O'Reilly & Associates, Inc. 1993.

Marchand, Roland. *Advertising the American Dream: Making Way for Modernity 1920–1940.* Berkeley: University of California Press 1985.

Massey, Doreen. "Power-Geometry and a Progressive Sense of Place." *Mapping the Futures: Local Cultures, Global Change.* Ed. Bird, Jon, et al. London and New York: Routledge 1985.

McLuhan, Marshall. *Understanding Media: The Extensions of Man.* Toronto: McGraw Hill 1964.

Stix, Gary. "Domesticating Cyberspace." *Scientific American* (August 1993): 85–92.

Spigel, Lynn. "Television in the Family Circle: The Popular Reception of a New Medium." *Logics of Television: Essays in Cultural Criticism.* Ed. Mellencamp, Patricia. Bloomington and Indianapolis: Indiana University Press 1990.

Tomlinson, John. *Cultural Imperialism.* Baltimore: The Johns Hopkins University Press 1991.

West, Cornel. "Beyond Eurocentrism and Multiculturalism." *Public* 10 (1994): 10–19.

Williams, Raymond. *Keywords.* London: Fontana 1983.

Williamson, Judith. "Woman Is an Island: Femininity and Colonization." *Studies in Entertainment.* Ed. Modleski, Tania. Bloomington and Indianapolis: Indiana University Press 1986.

This Is Your Messiah Speaking

Vera Frenkel

The following text (The Place, the Work, the Dilemma)
accompanied a group of installations, videotapes, and
performances originally mounted in Toronto, Newcastle,
and London in 1990 and 1991, tracing the collusive
relation between messianism, romance, and consumerism.
This cycle of work culminated in the videotape, "This Is
Your Messiah Speaking" and a related public intervention
in the form of a computer animation for the Piccadilly
Circus Spectacolor Board, an electronic billboard in the
centre of the most expensive shopping district in London.

Gill Sans, the typeface used by the artist, was
originally designed by Eric Gill in Scotland in the 1930s
and was chosen as a fitting vehicle for a text written in
and on the experience of northernness encountered during
the making of the work.

Catalogue text and photo-collages from *This Is Your
Messiah Speaking* by Vera Frenkel are taken from the
two-channel video installation, Newcastle Polytechnic,
1990, documented by Isaac Applebaum for *Queues,
Rendezvous, Questioning the Public*, 1994, and published
here courtesy the Walter Phillips Gallery, Banff, Alberta.

The Place, The Work, The Dilemma
Vera Frenkel

"She wonders what one does with memories in a brand-new life."

Alice Walker, In Love and Trouble 1967

The delicately-shaded line between genuine regional culture and parochialism is of interest to any artist or traveller, perhaps especially a Canadian, given our losses, our youth, our invisibility and our big, chauvinist neighbour. That this might be a charged issue also in Newcastle upon Tyne was one of my main reasons for accepting the invitation from Newcastle Polytechnic to live and work here for a time and to make an installation in the Squires Foyer.

But then I didn't need much persuading. Newcastle is a place about which I'd been curious since my Leeds childhood — that dreaming time that now seems a field of idyllic memories — from which I was wrenched at the age of eleven. ("But I don't *want* to live in a logging camp!" I protested in my pain and ignorance, having "done" Canada in Social Studies at Cowper Street School and learned to make little log cabins in art class.)

My father, a furrier, hoped in Canada to make a living and to suffer less the rheumatism and chilblains that marked for him the Yorkshire winters. (Given my schoolgirl notions, Montreal's bilingual sophistication and immense, stylish sprawl across her vast evergreen-lined river came as a shock. Schools then, and not only the family hearth, could be seed-beds of stereotyping and custodians of received ideas.)

Now, here, a return, filled with wondering at the path not taken, informed by the feeling that had life continued undisrupted there's a good chance that Newcastle Polytechnic might have become my training-ground, perhaps even my employer. Certainly an institutional nemesis of some sort — as indeed it has turned out to be.

At this writing, and for reasons that will become unimportant in time, the means have not been made available to realize the work I was invited to make. I remain hopeful, but in the meantime, as an indication of what-might-have-been am drawing together some visual and textual elements that combine a first response to Newcastle with issues that have informed my recent work generally. It turns out, perhaps not so coincidentally, that the issues converge. More about that later. For the moment, I'm that Leeds lass returned to a region of the world that was, for me, between the ages of 10 months and eleven years, formative. The colour, scale, temperature and speech-cadence, very different but still related to the Yorkshire accent that I find the most heart-warming in the world, takes me by surprise and catches my throat, spelling home. A kind of home. More mythic, perhaps, than real, one might say. True enough except that there are few things more real than the mythic when one is its helpless guest.

The work I'd hoped to do is one thing, the residence another. My early wondering about Newcastle evolves into the everyday needs of quickly making a working life possible, as I learn, bit by bit, some things about this clanging, feisty city. A Moëbius-strip experience, this, returning with colleagues from another life to discover both this life and myself quite similar and quite changed.

I find my child self ill-at-ease in the presence of what seems the governing nostalgia of some visitors to this place, including, I have to say, two or three of my colleagues; a longing for "the genuine Newcastle experience" that moves predominantly towards a romance of the

artisanal and the proletarian. Working class craft skills are the envy of any initiate into less direct forms of work, including (or perhaps especially) artists. It's the romance part I find difficult. For me this sort of one-sided pastoral fantasy of an earlier era can lead too readily to the mutual depersonalization and sad skepticism of tourism. We've all witnessed the collusive relationship in which locals knowingly package themselves and visitors clumsily oversimplify. The determinants here are stage-craft, surrogacy, simulation.

The tiny tot I was, trained by older children to call out, "Any gum, chum?" to the lanky Canadian and U.S. soldiers stationed in Leeds after the war, emerges out of time past to remind me how it felt to be construed as quaint, to be patronized by the very sprawl, drawl and (pre-Korea, pre-Vietnam) innocence of the North Americans. I remember their unwitting smugness even as they admired our Yorkshire place names and dialect and, blustering to hide their homesickness, reeled unsteadily along our pitted pavements after yet another pub crawl having given up on figuring out the £.s.d. and overspent.

And I see on the faces around me now, and hear in the music of the speech that same reticence, that closing-in and away from the too easy-going stranger that was once my own response, until slowly trust is built. Coming upon this now from the other direction, I experience both startling warmth and empathy, and also forms of reserve ranging from truculence to superciliousness, and I remind myself of how it was then and how I must seem now. As my mother might say: you can't dance at two weddings at the same time. But in fact that's what I'm doing.

We think in Canada that we *are* the North. Some of us more so than others, but Northernness and dispersal serve as the twin fulcra of Canadian consciousness. Our artists, composers, writers, give us a notion of ourselves as Northern with all that that implies of the dark, the chill and the warm, the intrepid. But I'd say to any friends at home:

you haven't known North until you've tasted it in Newcastle, where things Southern are made to seem like tinted papier-maché and birds twittering. Feydeau, not Strindberg. Webs, not bonds; whereas one feels here the depth of loyalties that aren't just invented out of expedience, of allegiances carried public and proud.

But that, too, is changing.

When every third person you meet asks if you like the shopping you begin to pay attention. Newcastle, unlike many other ravaged centres where the expectations of a generation have been betrayed, has been unusually effective in restoring morale and shifting its bases of exchange. Shopping, not shipbuilding or mining, is the local industry now as evidenced in the frequent tour buses filled with shoppers from Scotland and Norway as well as from the surrounding catchment area, all moving towards that total, explicit fusion of tourism, shopping and theme-park twelve minutes by shuttlebus from the Earl Grey Monument that is the Metro Centre, the largest shopping mall I've ever seen.

Very sophisticated businessmen and their hireling artists and designers, developing Church lands and paying reduced taxes have produced a phenomenon that, far from "genuine" in the sense sought by visitors and citizens alike, is a realm of pure artifice.

Inside the Mall, past its Roman Forum and its Mediterranean Village, is its English Antiques village, complete with scarlet telephone booth and pillar box, bridge and stream, Olde Worlde Shoppes and imitation gas-lamps, and a white-bearded figure on a plinth with a recorded voice booming out the joys of Metro Centre Shopping. This fibreglass reincarnation of the artisanal suggests that Simon Hoggart writing in the Sunday *Observer* on August 12th is utterly right to be excoriatingly ironic vis-à-vis such attempts to market the soul of a nation. His example is a "Press Release from Hell" referring to the announcement by Wayfarer Inns of "a new

marketing ploy" designed to persuade more visitors from overseas to stay in their hotels. They intend to harness "folk power," which means appointing pub regulars as "ambassadors for Britain," at a cost of a free pint for every foreign guest talked to for at least half an hour. "Unlike normal ambassadors who are sent abroad to lie for their country," continues Hoggart, "these will stay at home and get pissed for theirs." The conversation is expected to be "folksy" and "country" in flavour. Visitors must be shown how to play dominoes and darts, taught a number of local dialect words; the local chap must reminisce back to the "good old days," be willing to be photographed, et cetera. The scheme, writes Gossart, is already in operation ... part of the continuing attempt to turn the entire country into a theme park: *Englandland*, as the *National Lampoon* calls it.*

The Metro Centre makes the Wayfarers Inn backstage marketing effort, insidious as it is, seem subtle. It goes a step further and turns the folksy into open parody (or is it slightly less sinister in being visible?). There, lost and meandering visitors, disoriented for lack of daylight, are drawn to the essence of it all: Metroland, a noisy, fluorescent, (and to me terrifying) fun fair in the heart of the shopping mall. (I saw no one smiling there among the hundreds of queuers and riders. This fun was serious.)

The deal made in all this is a tough one, the price to be paid still unclear: keep the region alive economically by turning all experience, life itself, into spectacle. Provide enough exotica, knee-jerk entertainment, fake palm trees and noise and the whole family will want to stay and stay and stay and shop and shop and shop. Shopping as rescue, as fantasy, as economic necessity, as appeasement, diversion, totemism. Shopping as tourism, adventure, ritual, the Metro Centre threatening to replace the weather as the universal topic of conversation among strangers. In this

*Many thanks to Tony Bryant for pointing out this article to me on my recent visit to Leeds where my preoccupation with the elision between the genuine and the surrogate spilled over.

season of epidemic proliferations of rabbits, wasps, cockroaches and political crises, the streams of shoppers daring the roller coaster, the sound of target practice guns; excruciatingly loud music, whining vehicles and rippling lights seem expressive of a larger dilemma.

Shopping as diversion, as dreaming, as trance-state. Eat-me displays both culinary (the Body Shop people should know better than to use fresh fruit or ice cream sundaes in their window displays as "chic" marketing ploys) and sexual, share public consciousness with the Salvation Army Emergency Unit; truck, trumpeters and touts cheerfully oompah-ing along, shaking coin-canisters at consumers and nobody minding (or realizing) that they haven't seen daylight or breathed fresh air for eight hours.

The hermetic, underwater feel of the shopping centre reminded me of an aspect of the former Playboy Mansion (now Hefner Hall, part of the Chicago Art Institute). When I lived there as artist in residence, working on a performance event for the ballroom ("Trust Me, It's Bliss: The Hugh Hefner/Richard Wagner Connection" 1987) I discovered Hefner's policy of covering all the windows with black-out blinds so that inmates wouldn't know day from night. Disorientation was programmed in order to encourage disinhibition to roam free, the body shifted from the rhythms of its diurnal clock. Similarly, and much more elaborately, the Metro Centre, with its Metroland hub. Simulation is all. The hammer and the forge (central, it seems, to the history of the region and to the heart of the Polytechnic art programme) couldn't be further away. It's no accident that pornography and tourism, twin distillates of artifice and fragmentation, are two major multinational industries devoted to severing us from our senses. Simulation does "market well."

Other sounds haunt my stay as well, but differently: I'm less aware of the look of the city and its bridges and pubs, its public baths and libraries, its proximity to the coast, or even its absorbing history — though I've

passed over and through some of each of these — but the sound of it envelops me. Flocks of seagulls inland at dusk; the screech of buses as they knife around corners; the thunk-thunk of pop music everywhere, raw or Muzaked — trains, wind and roar — coming into an empty subway station, and then their skreek of metal on metal; heroic toilet-flushing and tap-shrieking in our Albion House digs that could drown out Niagara; the ring of poles hitting the pavement as the Sunday market-stalls are dismantled; the slap and pummel sounds of the massages given in the Turkish Bath; the bell announcing last call at The Ship, the pub under Byker Bridge.

Talk of the threat of war informs and trivializes our every immediate difficulty. My colleagues now begin their long work-days poring over newspapers in the upstairs flat where we eat at night. The daily cries of the city blend with its fun-fair screams to produce a kind of darkness despite the magically long days.

But what's this? Can it be possible that the shopper is less manipulable than the theme-park meisters have imagined? On the marble slab next to the steam room, I ask a question based on things I have heard. "Aye," the masseuse answers, "I *have* heard that said," and looks both pleased and upset. Yes, she says slowly, it's said that people go out there to shop, but not to buy, if you see what I mean. They're just looking, really. The hoaxer hoaxed? Where everything else is simulated: aha! *simulated shopping!*

But, if it's true that people look but don't buy, the dilemma becomes what that will mean for the region. What if the thing fails? What will happen then? Think about it. Is there any reasonable alternative? It's at moments like this that unreasonable alternatives begin to seem attractive.

There are many ways of experiencing a place and it rarely is the planned

itinerary that offers the richest journey. The work aspect of my stay has been difficult, even painful at times — it would be foolish to pretend otherwise. But if a measure of one's life is the impact on it of people and places along the way, I can say that I've left part of my heart here somewhere in the Polytechnic.

Regarding the interim piece I'm now making: I have for some years been interested in cargo-cult practices in particular, and attributions of false meaning in general, among which I include any Messianic rescue fantasy. Developing out from that area, I have done work that traces the deep-rooted, if clandestine, connections between romance, consumerism and fundamentalism, and — to return to my starting thought — have remained curious regarding the relation between what is eagerly viewed as a genuine cultural expression and the presence of its surrogate, and how these meet and change places.

These concerns came together in a 1987 shopping mall video-wall work for Public Access in Canada; and in 1988 in an I.C.A. London commission for the unrealized exhibition, "Exoticism: a Figure for Emergencies"; and in "Mad for Bliss," 1989, an 80-minute multidisciplinary performance presented at the Music Gallery in Toronto, from which I drew the text on shopping which follows these notes and which formed the uncanny seed of my work in Newcastle:

"This Is Your Messiah Speaking"

And, that afternoon at the Shopping Centre,
He said, (Devil that he was),
He said, that very afternoon
at the Shopping Centre,
"This is your Saviour speaking,"
"The Best in the Business."
"Welcome!" he said,
"Shop around. Look sharp. Be smart.
And I'll tell you a story,
A true story" (he said)
"About a people" (he said)
"Who didn't shop around.
Listen carefully."

*

And He, their leader, He said, (he said),
Devil that he was,
"Take off your clothes."
They listened carefully.
And they took off all their clothes (he said).
Then, naked in the tireless palm of fate,
(Still listening; still listening carefully),
They burned all their belongings and
Waited
By the shore
For redemption,
For a thousand years of peace;
for the Millennium.

*

THEY WAITED, AND AS THEY WAITED,
IT GREW COLD. IT GREW DARK.
IN THE COLD, DARK WILDERNESS
THEY WAITED FOR PEACE AND PLENTY.
AND, AS THEY WAITED, MADE SHRINES
OUT OF WEAPONS OF WAR.

*

"YOU CAN SEE FROM THIS, OF COURSE,"
(HE CONTINUED),
"HOW CRUCIAL IT IS
TO CHOOSE THE MESSIAH
WITH THE RIGHT CREDENTIALS."

WE LISTENED CAREFULLY.
"REMEMBER," (HE WENT ON), "I'M YOUR HEALER,
AND YOUR JOY.
I KNOW YOU,
AND WHAT YOU NEED.

"I KNOW (FOR EXAMPLE) THAT PEOPLE MUST SHOP
FOR THE RIGHT MESSIAH AT THE RIGHT PRICE.
WHERE REDEEMERS ARE CONCERNED,
COMPARE GUARANTEES.
ASK YOURSELF; IS THIS REALLY THE MESSIAH SPEAKING?
THE REAL MESSIAH SPEAKING?
ASK YOURSELF (HE SAID),
'IS THIS REALLY THE BEST VALUE FOR MY MONEY?'
"SHOP AROUND," HE SAID
"SEE FOR YOURSELF," HE SAID.
"I'LL BE WAITING."

*

AND, SHORTLY AFTERWARD
IN THE HEART OF THE SOUL OF THE CORE
OF THE SHOPPING CENTRE, SLOW AND CLEAR,
THESE ARE THE WORDS THAT WERE HEARD:
— IN THE ELEVATORS, THE SNACK BARS, THE WASHROOMS, THE
BANK AND THE BOUTIQUES —
THESE ARE THE WORDS THAT WERE HEARD:—

THIS IS YOUR MESSIAH SPEAKING.

THIS IS YOUR MESSIAH SPEAKING,
INSTRUCTING YOU TO SHOP.

DON'T WORRY.

NO ONE WILL FORCE YOU TO DO ANYTHING
YOU DON'T WANT TO DO.
NO ONE WILL EVER FORCE YOU TO DO ANYTHING
YOU DON'T WANT TO DO.

THERE'S NO RUSH (HE SAID).
BUT DO SHOP AROUND (HE SAID).
SHOP, THAT'S RIGHT.
OH, SHOP, SHOP AROUND ...

SHOP, I TELL YOU.

SHOP, HE SAID,
OR SOMEONE WILL SHOP FOR YOU!

The Place, The Work, The Dilemma

Epilogue

The standing question of deep-rooted continuity versus binding, sometimes bitter, parochialism remains, of course, unresolved. However, the specific issues raised by the marketing of shopping as theme-park in Newcastle and its region turn out to be of more than local importance. The Metroland phenomenon suggests not only the possible conduct of commerce anywhere during an economic shift, but also the way business is often done and people treated in the contemporary art world.

Along with its marketing experts and packaging procedures, Artworld is its own fantasyland — Investment Acres to your right; Transcendence Farm to your left; Nostalgia Nook next to Realist Row down the middle.

The "9 From Newcastle/9 From Toronto" exchange was conceived, among other things, as an antidote to and haven from such mainstream art business — artist-teachers on two continents sharing work, and in the case of the Canadians, actual studio practice, with each other. There is much to be said about the host institution preparing for such an exchange, and how things might sensibly be organized for everyone's mutual benefit, but at the moment I want only to mention two equal and unqualified sources of pleasure: on the one hand, the good company of my York University colleagues, whose work, talk, delicious cooking, support and laughter offered a very special climate in which to be during what for me has been an exercise in discontinuity; and, on the other hand, the gifted people who have made possible the work I was *enfin* allowed to do.

I can't say well enough about the kind expertise and humane insight of Mike Gallon and the steady encouragement and good humour of Mik Ayre; the flinty, ironic brilliance of Jonathan Lane; the impeccable skill and way with words of Keith Gascoine; and the privilege of working with John Adams, about whom I'd learned some time ago as a well-loved teacher and whose excellent work as an artist I had occasion to admire recently in London. (Special thanks are due as well to Shaun Allen, of Absolute Design, who spent much time of his own sorting out together with John Adams the college's computer animation equipment problems.) The angels of the office, Kathryn Limbert and Freda Churchill, and Stephanie Batty in the gallery, deserve very special mention for keeping communication alive in an institutional setting where this is vital, especially for strangers far from home, struggling to make art worthy of the vision that prompted their unlikely presence here.

It's a vision that suggests that there's a way of being an artist that is modest, generous, and non-competitive. And that's what this exchange hoped to make possible. I'm especially grateful to Michael Davey who initiated the project and saw it realized by dint of endless untiring efforts, and to Fred Gaysek, our resident writer, editor, witness, whose integrating presence I shall miss the next time I'm obliged to work alone.

It seems always to come down to the wisdom of particular people, doesn't it? It's too easy for visitors to be seen as tourists, to be treated with the contempt reserved for tourists (as artists are so often even at home). But whenever that happens, we are made thereby part of a shopping ethos.

In our relationships here we have escaped some of the standard notions which Canadians encounter in Britain ("We'll be folkloric if you'll be rich and sentimental," or, "We'll play mother-country if you'll play infant colonial," or, "You Americans….")

Imperialism dies hard. It can get into the bones of even the nicest people. And if the underlying terms of an exchange are seen as essentially touristic, that is, expedient and depersonalizing — the way Metroland designers prepare us to become — then indeed what might emerge would have more to do with shopping than with exchange based on mutual empathy and respect. Fortunately, artists can't be packaged as readily as exhibitions. We're too rough around the edges. We've seen before, and have survived, many a honey-tongued "developer" working our talent and energies to his or her own purpose. But the project itself has its imperatives, as does the city we're working in, and those in Newcastle at every level, British or Canadian, who respected and aided that working/living process, and moved beyond received ideas, whether taught in school, at home, or via theme-parks everywhere, are to be cherished.

Vera Frenkel

Draft Notes
August 1990
Newcastle upon Tyne

This Is Your Messiah Speaking

Production Credits

VIDEO
Text, Voice-over, Direction: Vera Frenkel
A.S.L. Signer: Norah Kennedy
Camera: Michael Balser
Editing: John Adams, Vera Frenkel
Technical Consultant: Mike Gallon

WALL-WORKS
Stills from Monitor, B/W Printing, Colour Documentation: Jonathan Lane
Screen Printing: Keith Gascoine
Frame Construction: Robbie Carr
Typesetting: Fred Gaysek

GALLERY INSTALLATION
Construction Team:
Mike Ayre
Robbie Carr
Mike Gallon
Jonathan Lane

PRODUCTION ASSISTANCE
Kim Halliday
Graham Kennedy

Piccadilly Circus Spectacolor Board:
Realized with the assistance of the Artangel Trust and the Maiden
Company animation programme, London

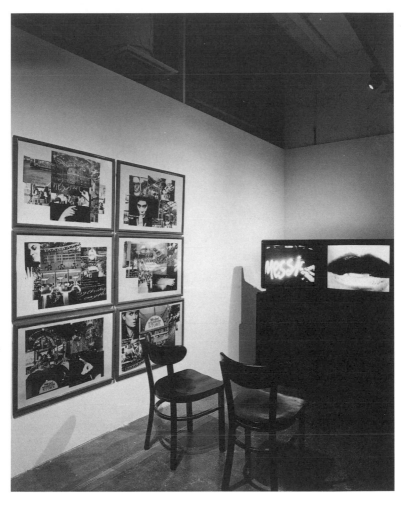

This Is Your Messiah Speaking, 2-camera installation view,
Toronto, 1993

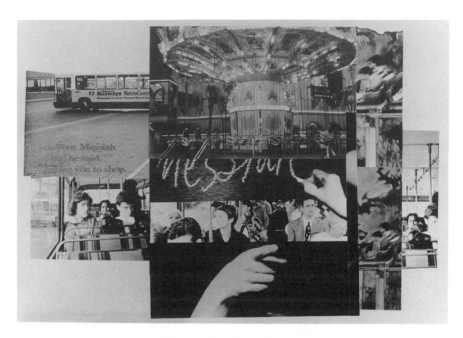

"This is your Messiah speaking, instructing you to shop"

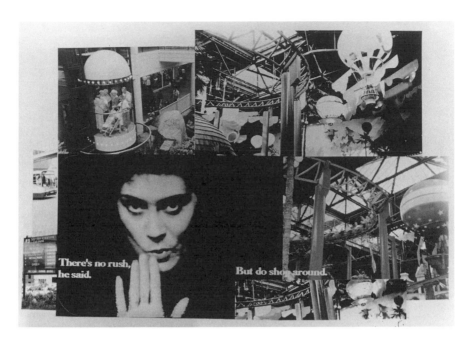

"There's no rush; but do shop around"

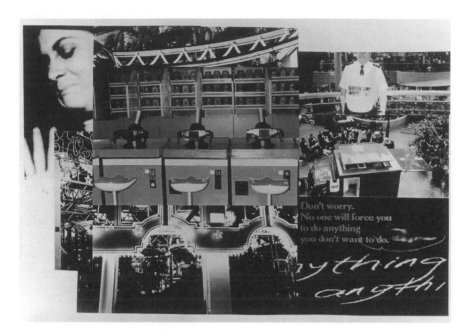

"Don't worry, no one will force you to do anything you don't
want to do"

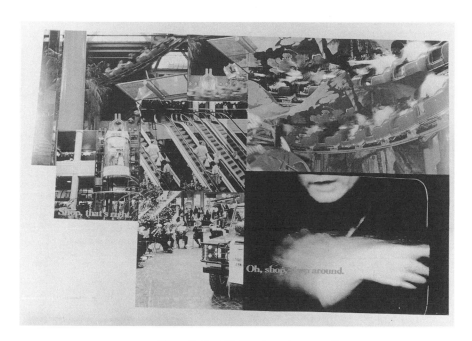

"Shop, that's right. Oh, shop, shop around"

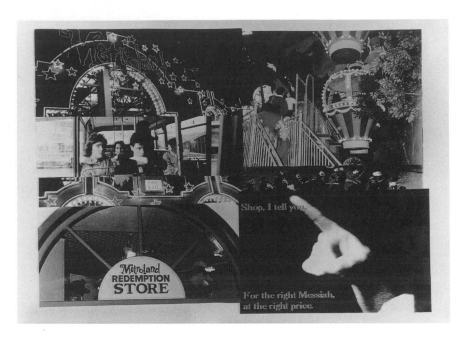

"Shop, I tell you, for the right Messiah at the right price"

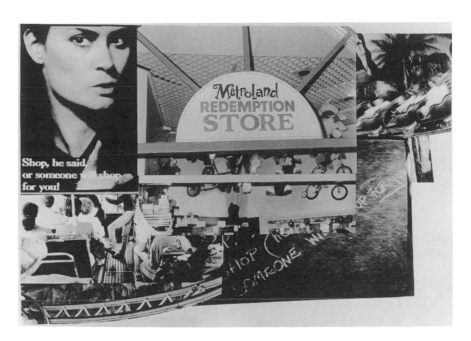

"Shop, he said, or someone will shop for you"

The Crisis of Naming in Canadian Film Studies

Brenda Longfellow

[handwritten marginalia: Cultural identity; national cinema; National identity important before cinema; Inherent cultures within or community + an individual?]

Canadian film studies (and for reasons of space and clarity, I address only the English Canadian variant) from its inception up to very recently,[1] has been forged around certain common assumptions concerning cultural identity and national cinema, particularly the notion that the former precedes and produces the latter. This assumption is perhaps most concisely articulated by Robert Fothergill in his much-quoted (1972) article, "Coward, Bully or Clown: The Dream Life of a Younger Brother": "If elements of a distinct consciousness (English or French) have indeed been engendered by the emotional and historical experience of being Canadian, then the imagination of writers and directors will have inherited it to some degree. It will lead them to project themselves into a certain range of experience, and to ignore whole other areas altogether."[2]

These assumptions include the idea that cultural identity is constituted isomorphically on a collective (macro) level and an individual (micro) level, that experience (historical, existential, and physical, such as the brutalities of the landscape) engenders a "distinct consciousness," and that cultural production and technologies *reflect* pre-existing cultural perspectives, deep patterns, and traditions of here (wherever here might be).

Within a very broad trajectory that begins with the first and crucial mappings of Canadian cinema by Peter Harcourt and Piers Handling and continues through the "Cinema We Need Debate" in 1984, Canadian film studies is based on the assumption of a fully articulated, homogeneous national culture and identity.[3] While the specific qualities associated with this identity (modern or postmodern, urban or pastoral, colonial or post-colonial) are rendered as fair subject for debate, the a priori existence of an identity that marks and defines all national subjects is not. As Christine Ramsey recently pointed out, this has produced a dominant interpretative strategy within Canadian film studies in which the individual film is read as a *metaphoric* (as opposed to metonymic) expression of national identity.[4] Each text, in other

words, is read as an expressive instance of a whole, a repeated version of the same constant identity.

What I would like to do here is to visit briefly various discursive sites and film texts to show how this formulation of national identity has been radically problematized by contemporary developments that include the pressures of globalization, technological transformation, the over-determinations of broadcasting and film policy, and changing ethnic and racial demographics.

One of the problems with any centring discourse of national identity in this country is its failure to sufficiently distinguish itself from state versions of the same. In Canada the official national discourse of the state is always transparently ideological, an empty sign tainted by political intentionality with little power to interpellate anyone.

Historically dominated by colonial powers and internally colonized by centre/periphery inequalities of wealth and resources, the centre in Canada, as Linda Hutcheon (among others) has observed, is always de-centred, "always elsewhere."[5] National identity is always articulated *against* the centre (always elsewhere and in some respects fully imaginary) and mediated through regional, ethnic, and linguistic identificatory priorities. Every time a political formation emerges with claims to unilaterally represent a collectivity (such as Quebec nationalism), other (excluded) voices emerge to contest that representation. This is nowhere more evident than in Quebec where an increasingly bureaucratized and conservative nationalism has been met by the intensifying militancy of the native rights movement. In this instance, two competing claims for nationhood clash around issues of sovereignty and state power, demonstrating once more that the centre in Canadian political discourse is always shifting or collapsing.

While the state has a weak ideological role to play in the articulation of national identity, its historic mission has been to provide a thin line of defence against the continentalist pressures of the marketplace through the construction (or deconstruction as the case may be, given the last ten years of conservative fiscal policies) of federal infrastructure (the Canadian Broadcasting Corporation, National Film Board, Telefilm Canada) and regulatory bodies (CRTC). The irony, however, is that while these cultural apparati have secured a certain level of production of national cinema, they have failed stupendously to ensure the continued and distinct presence of this cinema within the public sphere. With the exception of national film festivals, art house screenings, and the week or so run that Canadian features get in the theatrical market, the elaboration of Canadian cinema as a distinctly marked vehicle for dialogue with an audience has indeed been lost.

The figures are familiar: 97 per cent of screen time is monopolized by the majors, and scarcely 3 per cent is devoted to Canadian films, a phenomenon that is so idiosyncratic and such a telling harbinger of the potential fate of national cinemas everywhere that it has produced the generic term "Canadianization" to refer to the marginalization of a national cinema in its own country. Theatrical runs are now nothing more than advance publicity

for the video release in which Canadian films are shelved under the foreign film section in our local video stores.

While the battle for theatrical distribution and exhibition in this country is irrevocably lost by the absence of political will at the federal level, which has consistently backed down in the face of a powerful Hollywood lobby, its loss is also complexly bound up with technological developments that are profoundly transforming the conditions of cinematic reception and viewing internationally.

As Miriam Hansen has asked, how valid is that honoured association of cinema and cultural identity when the exhibition and reception of cinema is increasingly displaced from the realm of the public to the domestic realm of television? If that association was contingent on the auratic experience of cinema – the darkened theatre, voyeuristic viewing conditions, aural surround of theatre acoustics, and wide screen impact of images – what happens to the interpellation of the national subject when *Kamouroska* or *The Decline of the American Empire* is shrunk to the size of your television set, randomly viewed while channel-hopping, and intercut with advertisements for American cars or detergent? Clearly, television, by virtue of its distinct system of delivery, provides no guarantee of a national subject-spectator sutured into a fixed model of identity. Today's televisual spectator is rather transnational, coasting through a sea of American product broken only intermittently by a Canadian program which, all too frequently, arrives "disguised" – without clear markers of national origin.

From a broader perspective, however, national identity in Canada is also contested by that process which contemporary political theory has termed globalization. Globalization is the shorthand evoked to refer to the threat to cultural sovereignty posed by new information and communications technologies whose intensifying reconstruction of everyday life is transforming the relationship between the concrete territorial space of nation and the boundarylessness of global image systems. For most globalization theorists, the supranational spread of corporate empires and global reach of new technologies and media culture has been read as signalling the obsolescence of the nation and the dissolution of discrete and parochial forms of identification and belonging. The case of Canada, however, poses a stubborn retort. In Canada, globalization can hardly be considered a startlingly new phenomenon, given the long history of American domination of our theatres and television screens, and the even longer history of colonial ownership and control of our major economic resources. What is curious and perhaps anomalous in Canada, however, is that against this backdrop of increasing "global" rationalization of our economy and culture, issues of national identity have lost none of their resonance and seductions (and not only for dyed-in-the-wool cultural nationalists).

In the rest of this paper I would like to examine three symptomatic films, *Black Robe*, *I Love a Man in Uniform*, and *Calendar*, whose economic conditions of production, institutional sites, modes of address, and discrete discur-

sive worlds represent three very different responses to the exigencies and realities of globalization within the Canadian context.

Black Robe

> Forgetting, I would even say historical error,
> is essential to the creation of a nation...
> ERNEST RENAN, 1882[6]

From its inception, *Black Robe* was represented by the publicity machine at Alliance Releasing (the largest production and distribution house in Canada) as a milestone in Canadian film production, both because of its production budget (unrivalled at that point at $12 million), and by its epic pretensions (three months of shooting in the dead of winter with an international cast and crew). *Black Robe* also had the highest promotion budget of any Canadian film ($2 million), and this fact too was circulated as part of the publicity surrounding the film. For several months in 1991 and 1992, the image of priestly Lothaire Bluteau in the midst of a wild Canadian landscape (with smaller native figures in the background) filled full-page ads in major dailies, television trailers, billboards, and bus stops. At the opening night gala of the Festival of Festivals in 1991, *Black Robe* was an *event*.

Canada is no stranger to co-productions, as Manjunath Pendakur points out in his book *Canadian Dreams and American Control*.[7] In an era of escalating film costs (or so goes the logic of the co-production deal), no individual national cinema can hope to compete with the astronomical budgets of recent Hollywood spectacles. According to Pendakur, "Coproduction is the principal mechanism used by film and television producers to pool capital and labor from around the world and gain market access globally. Given the uncertainties of access to capital and markets compounded by the relatively small domestic market, Canadian producers [look] outside the country to compete in the international financing game of feature film production."[8]

The attraction (to the moneyed backers) is that co-productions spread the financial risk among many different producers while allowing "the merchants of culture," as Pendakur puts it, "to make 'world-class' films acceptable to global audiences and survive as an industry."[9] While the national cinema, as Canadian film studies has traditionally defined it, is auteurist and director driven, the co-production is driven by the "deal" and by producers. As Jean-Pierre Lefebvre observes, "It's cinema as business."[10]

The particular deal struck on *Black Robe* was only made possible through a formal international treaty between Canada and Australia, signed because of the direct intervention of the director of Alliance Releasing, Robert Lantos. According to Lantos, "We pursued, lobbied, and pressured both governments to get it signed and we got a good co-operation from Canada's Department of Communication."[11]

Filmed on location in the Lac St Jean/Saguenay region of Quebec with

post-production carried out in Sydney, Australia, the production itself makes an ironic commentary on the exigencies of postcolonialism. Here are two ex-British colonies collaborating to produce a film about French colonialism with a subtext that addresses their shared history of genocide against aboriginal peoples. Directed by the Australian director Bruce Beresford, one of the most mainstream of Australian directors (known for liberal social-purpose films such as *Breaker Morant* and *Driving Miss Daisy*) and written by one of Canada's most respected writers, Brian Moore, the film's cultural capital credentials are impeccable. It is a project lauded for its courage and stamped with integrity and moral earnestness.

Much of the hype surrounding the film focused on its historical authenticity, highlighting the number of native consultants, the degree of meticulous research into native decor, costume, and cultural mores. Ward Churchill quotes Herbert Pinter, *Black Robe*'s art director, on the minute detailing of the set design:

> Pinter fashioned rectangular shovels out of birch bark, used shoulder bones of a moose for another digging implement, bound stone axes with spruce roots, knitted ropes of fibre and used cedar bark (obtained free from a merchant in Vancouver, but costing $37,000 in transport) to build the outer walls of the huts ... in the Huron village scene at the end of the film, Pinter created a strikingly authentic little chapel, lit only by candles waxed onto stones that are wedged into the fork of stag antlers.[12]

In every instance the producers endeavoured to distinguish the film from the romantic idealism of *Dances with Wolves* (a constant pre-text in this case) and from the sorry history of native stereotyping and caricature that characterizes Hollywood films.

This persistent avowal of historical accuracy and realism, however, seemed precisely designed as a retaliatory retort to a native movement increasingly mobilized around issues of cultural appropriation and misrepresentation. Ironically, the stand-off at Kanehsatake occurred precisely when the film crew was shooting in northern Quebec, and that uncanny simultaneity would determine both the film's reception and its marketing.

What is also uncanny is the fact that in a film that so prides itself on its historic authenticity all the French characters speak unaccented English. While English is of course the language of the global marketplace, this curious elision of linguistic difference, at least for the national spectator in Canada and Quebec, seems like a blatant endeavour to homogenize history. The French "fact" and the long history of nationalist movements in Quebec from the defeat of Montcalm on is simply folded into a generalized *English* history of Canada.

Where linguistic difference is allowed to flourish, however, is in the speech of the native actors. They alone are subtitled as they speak in their allegedly authentic tongues. Yet, according to Ward Churchill, in a fascinating critique

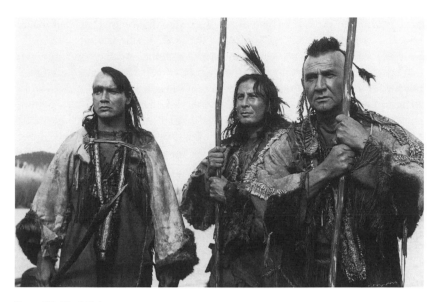

Figure 17: *Black Robe*

of the film published in *Z*, "the Cree verbiage uttered throughout the movie was *not* the language spoken by *any* of the Indians to whom it is attributed."[13]

A great deal of the contradiction surrounding the representation of native people in the film has to do with what Bill Marshall has identified (in another context) as the "gap between the enunciation of the moment in time of the narration (the relationship between narrator and implied reader/viewer) and the enoncé of the events being narrated."[14] What this gap implies is that the process of representing history (no matter how allegedly authentic its sources) is always overdetermined by the ideological perspectives and available narrative structures of the present. This "transtemporality," as Marshall puts it, the "to-ing and fro-ing between temporal periods and cultural/political epochs," is most evident in *Black Robe* in its contemporary liberal appreciation of the rights of native people to their own culture and spirituality. The "nowness" of the telling, however, frequently interrupts the illusion of historic diegesis with a knowing wink at the spectator, as in the scene where Chomina (August Schellenberg) admonishes his wife (Tantoo Cardinal) that they are in trouble because *her* daughter lusted after the Frenchman. As if they were in a Flintstone cartoon, Cardinal responds with the weary and atemporal insight of any mother of a teenaged daughter, "What do you mean *my* daughter? She's your daughter too."

This knowingness of the present imbues the narrative with its sense of destiny and fatality, a sense supported diegetically by the black-and-white visions that Father Laforgue and Chomina have of their own doomed lives. Within the liberal perspective of the film, all are victims of a tragic encounter pre-

ordained by the religious fervour of the Jesuits and by the ferociousness of the Iroquois who, unlike the Algonquin and the Huron, refuse to succumb.

As Ward Churchill encapsulates the film's moral message, "we find not good guys or bad guys, not right or wrong, but rather 'well-meaning but ultimately devastating' European invaders doing various things to a native population which, through its own imperfections and 'mystical' obstinacy, participates fully in bringing its eventual fate upon itself."[15] The European genocide of the native populations of North America is thus neatly elided and displaced onto the "warlike" Iroquois. In this particular national narrative, no blame need be assigned.

While the narrative provides the pretext for a revisionary articulation of the historic relations between European colonization and aboriginal peoples, what the film really appears to be selling is an auratic experience of the Canadian landscape. Shot in Cinemascope with Dolby sound, the film sets out to preserve a classical experience of cinema, a film you *really must* see in the theatre. Not since the early CPR films, used to lure immigrants to the country, has the landscape been so exploited as a commodified and exportable signifier of "Canada." Endlessly repeated sequence shots feature the "majesty" of the Canadian landscape: the mist rising on an early morning lake, the vivid colours of autumn, the starkness of the snow-covered hills of the Lac St Jean region. Several shots feature bird's-eye (god's-eye?) shots of the characters dwarfed by the landscape, as a welling symphonic score underlines the transcendental quality of the vision. This is a very familiar exportable image, steeped in that particular ideological fix where Canada comes to stand in as a synedoche for nature, unmediated by urban blight, class struggle, or political difference, a virginal fantasy untrammelled by contemporary environmental catastrophe.

If what the film sells to an international spectator is this fantasy of auratic contact with nature and exotic aboriginals, its address to a spectator located in Canada takes a slightly different turn. In the beginning of the film the landscape is anchored and named by a superimposed title: Quebec, North America. Here the landscape acts as the unsullied pre-text of the coming nation, Canada. As spectators – French, English, and aboriginal – we are sutured into place as national subjects through the recognition of our shared atavistic experience of the landscape. Within this homogenizing spectacle, real historical and political differences are ultimately mediated and secondarized.

The appropriation of landscape as the principal mediator of national identity has long been a maxim of nationalist discourse within Canada. According to Homi Bhabha, however, this prioritization of landscape is always embedded within a regressive and conservative discourse of nation: "The recurrent metaphor of landscape as the inscape of national identity emphasizes the quality of light, the question of social visibility, the power of the eye to naturalize the rhetoric of national affiliation and its forms of collective expression."[16] Such a discourse is regressive precisely because it relies on a specular constitution of the nation with its claim that meaning and identity are inherent in an

image and not in social and historical discourses. This is not to say that landscape does not play its role in the definition of social belonging. But the experience of landscape does not occur in a transcendental void: it is mediated by prior cultural expectations and social discourses. And it is precisely the differences in the cultural meaning assigned to nature and landscape that distinguish the historical experience of aboriginal people, French, and English.

For the global spectator of *Black Robe*, however, the landscape functions to totalize the national narrative as one singular experience of a sad but nonetheless inevitable national destiny. In this narrative, the real political effects of European colonization in North America are repressed as history becomes myth and difference is usurped into pathos.

I Love a Man in Uniform

We are all playing at being American.
JOHN CAUGHIE

I Love a Man in Uniform externalizes the market pressures that drive *Black Robe* in a supremely ironic metacommentary on the tragic effects of "global" television on national identities. It tells the story of Henry, a repressed bank clerk and aspiring actor. When Henry is cast as Flanagan, a tough cop on a generic American cop show called *Crimewave*, he takes method acting to new heights. Purchasing a gun and walkie-talkie, he begins patrolling the streets in his cop uniform and wanders into an underworld of Asian drug dealers and corrupt cops. Gradually the distinction between the "real world" and the imaginary universe of *Crimewave* begins to dissolve for Henry. He becomes Flanagan, locked within the violent world view of the character he is playing, with deadly results.

In *I Love a Man in Uniform*, American popular culture is represented not as something external or foreign but as a deeply internalized facet of our national psyche. This is the film's affront to that nationalist discourse which defines Canadian identity in opposition to American. Within this discourse, one of the cherished differences has been our pride in being a country of law and order, where the tight governmental grip on immigration and settlement and our contemporary gun control regulations ensures that Canada would never fall into the frontier lawlessness of the American experience. In *I Love a Man in Uniform*, this difference vanishes in an escalating pace of anonymous urban violence which begins with the shooting of a cop in the opening scene and continues through to Henry's grotesque and aestheticized suicide at the film's end.

As the single most homogenizing cultural force in this country, American culture is (to paraphrase David Morley and Kevin Robins) "[Canada's] alter ego, an exaggerated reflection of what [Canada] fears it will become, or perhaps what [Canada] already is."[17] This is precisely what the film enacts in its narrative movement and performance. For it is not simply Henry's transmo-

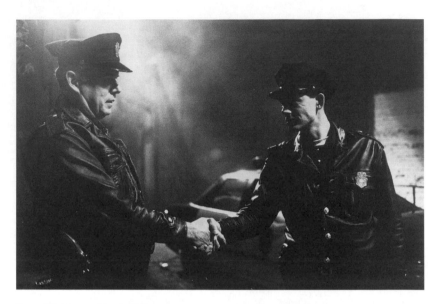

Figure 18: *I Love a Man in Uniform*

grification from mealy-mouthed bank clerk to American-styled vigilante which is at issue: it is the social vision articulated by the film, which comes to increasingly coincide with the paranoid world view of American television. As the director informs us: "In this film, the camera expresses Henry's perception of every situation ... The reality of the film is no more or less than Henry's reality, and we had to be true to that. The character motivates the camera, the cutting, everything."[18]

Within Henry's blurred perspective, the merging of narrative frames occurs on several levels. Visually, the clichéd rain-drenched streets and blue lighting design of the *Crimewave* series are matched in the framing narrative where the streets of Toronto (although never named as such) take on a similar chiaroscuro menace. In one sequence, obviously quoting *Taxi Driver*, Henry cruises the red light district of the city, stopping to watch a hooker and her pimp, as muted neon lights flicker across his windshield. Here the clichéd signifier of urban moral decay eradicates the particularities of place. Toronto becomes New York becomes Los Angeles becomes Hong Kong. At the level of the narrative, the pimps, scumbags, hookers, and petty criminals who populate the ritualized storylines of the cop show also begin showing up with increasing frequency in Henry's world as if it is his desire itself that calls them forth.

As spectators, however, we are not sutured into Henry's warped point of view. Rather, his paranoic vision of urban catastrophe and rampant criminality is observed at an ironic distance as an all-too-telling symptom, a worst-case scenario of what would happen if one's only source of information about the world were derived from *America's Most Wanted*.

Irony, as Linda Hutcheon has observed, is a dominant mode of (postmodern) consciousness with a particularly strong and resonant tradition in Canada, obsessed as it still is with deciphering an identity against a heritage of colonial domination. Irony, she writes, "allows speakers to address and at the same time slyly confront an 'official' discourse, that is, to work within a dominant tradition but also to challenge it – without being utterly co-opted by it."[19]

In *I Love a Man in Uniform* the irony stems from the parodic repetition of the cultural psychosis of the American cop show, appropriating its tropes and visual clichés, its cast of caricatures and violently Manichean vision of reality without ever finally surrendering to this vision. This kind of appropriation is very close to what John Caughie refers to as "playing at being American," a particular mode of reception he identifies within those margins and peripheries of the American cultural empire.

According to Caughie, watching American television in the Spanish Pyrennees (or Canada or anywhere else on the globe but America itself) produces a kind of doubled consciousness, an ironic knowingness "which may escape the obedience of interpellation or cultural colonialism and may offer a way of thinking subjectivity free of subjection. It gives a way of thinking identities as plays of cognition and miscognition, which can account for the pleasures of playing at being, for example, American, without the paternalistic disapproval that goes with the assumption that it is bad for the natives."[20]

Playing at being American is obviously very different than the ontological fixity of *being* American, and it is precisely in that margin of play that *I Love a Man in Uniform* installs itself. As fast-paced, slick, seamless, and dark as its American "origins," the film proffers the seductions of generic identification while slyly confronting the vacuousness, the sexism, and the racism that fuel prime-time pleasures.

In the end the progressive potential of the film depends on the ability of the spectator to read the doubleness and irony of the text. Playing at being American, as some of us have learned through the tortured history of cinema and broadcasting in this country, carries its own risks. The danger, of course, lies in the very close line the film skates between irony and cynicism. Appropriating the gestures and world view of the "American," the film's margin of critique and critical distance can be easily construed as amoral detachment and opportunism. In *I Love a Man in Uniform*, the dissolution of a Canadian "real" into American simulacra alerts us to the danger of permanent cultural assimilation.

Calendar

Our contemporary thought seems to be a thought of exile, a thought hiding behind nostalgia for a recent past, a thought speaking from spaces and cultures that no longer exist and were dead before the death of the long nineteenth century.

V.Y. MUDIMBE, Introduction to *Nations, Identities, Cultures*[21]

One of the most telling critics of conventional globalization theory, Arjun Appadurai, has argued that such a theory cannot be contained solely in an analysis of the transnational capital and the spread of American media culture worldwide. There is a third factor, he notes: the global transmigrations of people in which globalization takes the form of "a multitude of deterritorialized globalist-localisms that operate above and below the nation state."[22] Nations in this contemporary epoch are now increasingly made up of refugees, immigrants, and diasporic populations whose heterogeneity defies any possibility of conjuring up the nation as defined by a singular linguistic or ethnic origin – an enduring impossibility in Canada given its inherent ethnic plurality and diversity.

Atom Egoyan's *Calendar*, more than any recent Canadian film, addresses the challenges to cultural belonging and identity produced by the evolving ethnoscapes of the latter part of the twentieth century. *Calendar* is his most personal and intimate film, made in co-production with ZDF, the German national broadcast system which has long been a beacon of enlightened and innovative programming associated with the productions of Europe's leading art cinema directors (Wenders, Fassbinder, Akerman, Sanders). Produced for the extraordinarily modest budget of $100,000, the film is a model of what creative international co-production endeavours might look like when not simply driven by the deal.

In *Calendar*, narrative desire circulates around the longing for a homeland which is never finally realized, either in the "old" country, Armenia, or in the new, Canada. In Armenia to produce a calendar, a photographer (played by Egoyan himself) chooses a series of church ruins as iconic signifiers of Armenia. As he meticulously frames and composes, waiting until the light is just right, the images as seen through his lens are empty and flat, clichéd versions of the old country devoid of living history or meaning.[23]

The sites only become imbued with a living sense of history through the stories relayed by a local "informant" who guides the photographer and his wife (Arsinée Khanjian) through the mesmerizing beauty of the Armenian countryside. Locked behind the lens of his camera, the photographer remains off-screen, "present" only through the sound of his voice or through a thumb carelessly smudging the camera lens. For him Armenia is simply an economic proposition, and the church scenes provide an easily commodified and tourist version of ethnicity and culture. He doesn't speak the language and in this first section of the film is isolated both formally and diegetically by never appearing on screen. His is a disembodied voice and a dislocated body present only in the trace of his gaze through the camera.

His nostalgia for a homeland, however, comes to be complexly bound up with his desire for his increasingly estranged wife. In the first movement of the film she functions to mediate between her husband and the local guide. As their journey continues, however, she merges more and more with her surroundings, singing, drinking, and speaking Armenian with the locals. Imperceptibly, her loyalty begins to shift, and she allies herself with Armenia and with the guide.

Figure 19: *Calendar*

In the end, the estrangement of the photographer and his wife is produced by their radically different senses of national belonging. For him Armenia is just a job, but for her it signifies homeland, motherland, the place where she would want to raise her children. This discourse of maternalism is very close to a classically conservative ethnic nationalism where the mother is represented as the vessel of the nation, the matrix of national being, the inspirational muse of national heroics. Certainly, in the deeply sensual presence of the wife in the film, there is a romantic association made between the feminine, birth, spirit, and homeland.

Before accusing Egoyan of sexism, however, we should note that much of the observation of the wife is mediated through the photographer's hi 8 tourist footage. It is this footage that signals the inscription of the photographer's desire, as his hand-held video traces longingly over her body, spies on her as she increasingly ignores him, and watches her as she slowly begins to inhabit this other space, the imaginary homeland of Armenia. For Egoyan this mediated relationship comes to substitute for any real emotional attachment. Within its blurred and grainy aspects, she becomes a fantasized projection of his desire, so that the film's acute sense of nostalgia, of melancholy and loss, is bound up with the doubled disappearance of the wife and the loss, of a unitary sense of national belonging.

As the photographer returns to Canada to nurse his betrayal, the sunny golden hues and lush, wide open vistas that characterized the representation of Armenia yield to the cold, claustrophobic interiors of the photographer's apartment. In this half of the film, the representational strategies are reversed. Here the photographer's body is fully present, and it is the wife who is disembodied, rendered as an off-screen voice and as a video image, replayed by the photographer who sits naked before his television, masturbating to his sense of loss.

Additionally, he attempts to displace and compulsively re-enact that repetition of loss through a series of staged encounters with women from various ethnic and racial backgrounds. In these encounters, organic cultural belonging is represented as the exclusive province of the "other," the woman who, in each case, leaves the tortured courtship ritual of the dining room to place a phone call to another. Whispering passionate messages in their mother tongues, the women's conversations speak to the possibility of deep emotional intimacy through a shared cultural and linguistic tradition. This is diasporic subjectivity at its most humorous. Egoyan is supremely ironic in these sequences and supremely aware of the way in which fantasies of national belonging are all too often relayed through the perverse desires of a male subject for whom the body of the woman acts as mirror and anchor to identity. In *Calendar* it is the excess of these bodies, heavily coded for their marks of femininity and otherness, which renders ethnic identity as a performance. In the end, all security of place and belonging remains out of reach for the male subject who is left, the quintessential postmodern subject, with only his loss and his melancholy.

I would suggest that this remarkable film asks us the question that has guided the writing of this essay: What are we to make of national identity in the latter part of the twentieth century?[24] While one response to this question has been a particularly virulent strain of ethnic nationalism which is transforming Eastern Europe, Rwanda, and other hot spots, there is equally a reconstitution of forces in the West in which traditional notions of home, belonging, and identity are being radically challenged. Perhaps the hope for Canada is that its sense of national belonging could evolve (thanks to the native rights movement, vocal new immigrant politics, feminism, the gay and lesbian movement) into an idea of political citizenship and respect for differ-

ence. Perhaps too in that irrefutable diversity lies the possibility of recasting national identity as a place between Old and New Worlds, a place of transnational, transsexual, and transcultural movement, a negotiation between spaces of difference.

NOTES

1 Vol. 2, no. 2–3 of *The Canadian Journal of Film Studies/ Revue canadienne d'etudes cinématographiques* includes several critical revisions of this tradition. Peter Harcourt's "Canada: An Unfinished Text?" and Christine Ramsey's "Canadian Narrative Cinema from the Margins" are of particular note.

2 Fothergill, Robert, "Coward, Bully or Clown," 234–50.

3 When, for example, Elder sets out to define the Cinema We Need, he does so through a vitriolic attack on new narrative, for him a bastardized version of the uncorrupted purity of experimental cinema. I don't want to get into the details of Elder's position, which argues in highly metaphysical terms for a kind of purist, experimental cinema of perception. I only want to mention it because even here, with the attempt to construct a counter canon with the experimental films of Snow, Chambers, and (belatedly) Wieland, the critical vocabulary remains couched in terms of essence, universality, and purity.

4 Christine Ramsey, "Canadian Narrative Cinema from the Margins."

5 Linda Hutcheon, *The Canadian Postmodern: A Study of Contemporary English-Canadian Fiction*, 4.

6 Ernest Renan, *What Is a Nation?*, trans. Wanda Romer Taylor.

7 Manjunath Pendakur, *Canadian Dreams and American Control*, 7.

8 Ibid., 194.

9 Ibid.

10 As quoted by Pendakur, 194.

11 Quoted by Ward Churchill, "And

They Did It Like Dogs in the Dirt," *Z* (December 1992): 21.

12 Churchill, ibid.

13 Ibid.

14 Bill Marshall, "Gender, Narrative and National Identity in *Les Filles de Caleb*," *Canadian Journal of Film Studies/Revue canadienne d'études cinématographiques* no. 2–3 (1993): 55.

15 Churchill, 22.

16 Homi Bhabha, *Nation and Narration*, 295.

17 David Morley and Kevin Robins, "Spaces of Identity: Communications Technologies and the Reconfiguration of Europe," *Screen* 34, no. 1 (Spring 1993): 18.

18 Production notes, David Wellington, *I Love a Man in Uniform*, Alliance Releasing Press Package.

19 Linda Hutcheon, *As Canadian As ... Possible ... under the Circumstances!*, 4.

20 John Caughie, "Playing at Being American: Games and Tactics," in *Logics of Television*, 54.

21 V.Y. Mudimbe, Introduction, to *Nations, Identities, Cultures. Special Issue of The South Atlantic Quarterly* 94, no. 4 (Fall 1995): 983.

22 Arjun Appadurai, *Modernity at Large*, 41.

23 Ironically, too, the harsh political reality of the contemporary civil war between the Armenian and Azerbaijhan communities never intrudes into the detached observance of the photographer's gaze.

24 Egoyan's film seems to correspond to the insight of Akhil Gupta and James Ferguson that "as actual places and localities become ever more blurred

and indeterminate, *ideas* of culturally and ethnically distinct places become perhaps even more salient. It is here that it becomes most visible how imagined communities come to be attached to imagined places, as displaced peoples cluster around remembered or imagined homelands, places or communities in a world that seems increasingly to deny such firm territorialized anchors in their actuality." *Cultural Anthropology* 7, no. 1 (February 1992): 10.

BIBLIOGRAPHY

Appadurai, Arjun. *Modernity at Large: Cultural Dimensions of Globalization.* Minneapolis: University of Minneapolis 1996.

Bhabha, Homi. "DissemiNation: Time, Narrative and the Margins of the Modern Nation." In *Nation and Narration*, ed. Homi Bhabha. New York: Routledge 1990.

Caughie, John. "Playing at Being American: Games and Tactics." In *Logics of Television*, ed. Patrica Mellencamp. Bloomington: Indiana University Press 1990.

Churchill, Ward. "And They Did It Like Dogs in the Dirt." *Z* (December 1992): 20–4.

Elder, Bruce. "The Cinema We Need." *Canadian Forum* (February 1985): 12–14.

Feldman, Seth. "The Silent Subject of Canadian Cinema." In *Words and Moving Images*, ed. William C. Wees and Michael Dorland. Montreal: Mediatexte 1984.

Fothergill, Robert. "Coward, Bully, or Clown: The Dream-Life of a Younger Brother." In *Canadian Film Reader*, ed. S. Feldman and J. Nelson. Toronto: Peter Martin Associates 1977.

Gupta, Akhil, and James Ferguson. "Beyond Culture: Space, Identity and the Politics of Difference." *Cultural Anthropology* 7, no. 1 (February 1992): 6–23.

Hansen, Miriam. "Early Cinema, Late Cinema: Permutations of the Public Sphere." *Screen* 34, no. 1 (Spring 1993): 197–210.

Harcourt, Peter. "Canada: An Unfinished Text?" *Canadian Journal of Film Studies/ Revue canadienne d'etudes cintemato-graphiques* 2, no. 2–3 (1993): 5–26.

Higson, Andrew. "The Concept of National Cinema." *Screen* 34, no. 3 (Autumn 1993): 36–46.

Hutcheon, Linda. *The Canadian Postmodern: A Study of Contemporary English-Canadian Fiction.* Toronto: Oxford University Press 1988.

Hutcheon, Linda. *As Canadian As ...
Possible ... under the Circumstances!*
Toronto: ECW Press/York University
1990.

Marshall, Bill. "Gender, Narrative and
National Identity in *Les Filles de
Caleb.*" *Canadian Journal of Film
Studies/Revue canadienne d'etudes cine-
matographiques* 2, no. 2–3 (1993): 55–65.

Morley, David, and Kevin Robins. "Spaces
of Identity: Communications
Technologies and the Reconfiguration
of Europe." *Screen* 34, no. 1 (Spring
1993): 10–34.

Pendakur, Manjunath. *Canadian Dreams
and American Control.* Detroit: Wayne
State University Press 1990.

Ramsay, Christine. "Canadian Narrative
Cinema from the Margins: 'The
Nation' and Masculinity in *Goin'
Down the Road.*" *Canadian Journal of
Film Studies/Revue canadienne d'etudes
cinematographiques* 2, no. 2–3 (1993):
27–50.

Thoughts to Close

The Shape of Time and the Value of Art

Shelley Hornstein

The Shape of Time and the Value of Art

Shelley Hornstein

The *Antiques Roadshow* is an engaging television series produced for the BBC that evaluates, with the assistance of antiques experts from major international auction houses, items purchased at auction for a fraction of their current market worth. Or, the experts will evaluate an object unearthed from a forgotten corner of the attic of a recently deceased great aunt, and more often than not, it unfolds that the piece featured is not a worthless piece of furniture or curio but actually a rare example of a Chippendale sideboard or the work of an artist no scholar had previously recognized as worthy of notice. Usually the owner expresses boundless glee and the home viewing audience is encouraged that something can come from nothing.

What is the process of determining the value of art in western society and what steps must be taken to reveal the mechanics of the operation? The manner in which we value art calls up the ways in which – and the locations where – we continue to measure what art is worth, for as the *Antiques Roadshow* demonstrates weekly, we never have and never will let go of an opportunity to do so. I propose to mark this collection of reflections on capital culture in artworks and literary pieces with a fusion of time and space, and to do so means re-discovering art's location within western culture – that is, both on a temporal and spatial level – to ensure that the criteria we use be challenged at all times.

History, or the recording of events in time, is a discipline lately being challenged by scholars because for those who read or do history certain questions emerge regarding the ways history has actually been recorded. What are the means by which we examine events, and do they contribute to limiting some of our observations? Surely history is not dead, as some have declared. Simply, its limitation is due in part to the erosion, through the nineteenth and twentieth centuries in particular, of a consideration of the spatial component of social production. The love affair with history in the nineteenth century seen through the richness of a temporal optic, as Michel Foucault has suggested,

left behind an integration of space, or at least a space that was configured broadly and not exclusively by politics and nations. In other words, the strength of historical materialism and temporal relevance succeeded in subordinating a spatial critique.[1] Therefore, to suggest such a subordination necessitates looking closer at the idea of national identity, on the one hand, but more interestingly, necessitates the stretch to the visual arts in particular, of the idea of nation and its relationship to canons and values. Why are these terms, used here to think about art, pooled together in any sort of meaningful way? Moreover, how are these terms considered in light of time and space?

Heinrich Wölfflin's ground-breaking thesis on the development of style, published in 1920, stated clearly that its aim was "to set up standards by which the historical transformations (and the national types) can be more exactly defined."[2] While it is simple enough today to dismiss Wölfflin's often outspoken racist methodology, his model for analysing the evolution of style infuses much of the formalist analysis of art in this century. Let me continue to lead you to make the connections between his specific form of art history and valuation of art, and the idea to link to the terms "nation," and "canon." Here is another quote from Wölfflin to demonstrate the point:

> As the great cross-sections in time yield no quite unified picture, just because the basic visual attitude varies, of its very nature, in the different races, so we must reconcile ourselves to the fact that within the same people – ethnographically united or not – different types of imagination constantly appear side by side. Even in Italy this disunion exists, but it comes most clearly to light in Germany. Grünewald is a different imaginative type from Dürer, although they are contemporaries. But we cannot say that that destroys the significance of the development in time: seen from a longer range, these two types re-unite in a common style, i.e. we at once recognise the elements which unite the two as representatives of their generation ... Even the most original talent cannot proceed beyond certain limits which are fixed for it by the date of its birth. Not everything is possible at all times, and certain thoughts can only be thought at certain stages of the development.[3]

Time here is a critical element. Space, for Wölfflin and scores of cultural critics, historians, and theorists who shaped his thought and followed his lead, was a term that was far from plotted abstractly.[4] Rather, space implied a politically bound, national configuration of geography that was also responsible, however narrowly defined, for constituting ethnographic and racial boundaries, and what he called the "permanent differences of national types." Wölfflin, among others, has indisputably contributed to the content of our art historical and cultural canons by suggesting and delimiting our selection of objects worthy of critical investigation.[5] Necessarily, a developmental and evolutionary scheme of recording the past has given western culture specifically an art historical framework and subsequently our concepts of value. While time and history are fundamental considerations of cultural critique, I am

arguing for a reinsertion of spatial geography into the relationship, but this time reworked outside the parameters of a strictly political and highly limiting conception of the state. How does a new spatial hermeneutic change the way we look at art and reconfigure the space Wölfflin once conceived?

During the previous century, space was treated as "the dead, the fixed, the undialectical, the immobile."[6] Today, and in contrast to working with last century's model of geo-political nation-states as such, a new concept of spatial integration brings into play (with time) an ability to connect points laterally in tandem with much of what social theory has to offer rather than in a strictly linear accounting of culture, and it is this distinction I am after. Such a reassertion of space is not, as Soja has demonstrated, a simplistic, essentially Cartesian cartography and empirical exercise but instead an "ontological struggle to restore the meaningful existential spatiality of being and human consciousness, to compose a social ontology in which space matters from the very beginning."[7] The approach to space radically alters the way in which we traditionally explore it to include multi-dimensional explorations of communities, settlements, and the human subject; in short, this reconsideration of space is an attempt to identify human subjects in a formative geography.[8]

For those of us living or working from a base that looks at western art, meaning has been moulded by canonical texts. These texts no doubt establish a scale of appreciation, a ranking system or critical inquiry commonly understood as a system of value. Value, therefore, is inextricably tied to the term canon. I don't dispute that a canon, or the core of authoritative examples of what best represents a discipline, is an almost inadvertent necessity that is not fixed and incapable of change but is very much organic in that it increases and decreases according to expert decisions. What I am challenging is the means by which a canon *evolves* (that is, its pattern of embetterment through time [progress]), however elastic the boundaries, because this time-developed organic process has governed the criteria of what "we" as a (expert) collective, deem worthwhile. Eventually those (ranked) objects can form the canon of art, the cultural heritage, the national voice. It is a canon that is highly respected, often challenged but rarely dismissed. The canon, in short, as a collection of ideas and objects forming the core of cultural production and practice, doubles as the collective image or the representation of a nation. It follows then that the canon can be seen to symbolize the nation by serving as a model that moulds it both concurrently and thereafter.[9]

When reconsidering the role of canons in art and visual culture generally, certain critical observations emerge. Canons operate in tandem with the development of a national purpose so that the value we attribute to an object and, by corollary, the objects that we value (and thereby deem worthy of enlisting in the canon), are bound to a national vision. Consider the project of national purpose or "nation-building." As I mentioned above, it can be said that this applies to spaces with strict geo-political boundaries. But if we think about the project of national purpose, it can be argued that the very same process can be adapted to include local communities not bound necessarily by

such borders. (Here I am thinking of like-minded interest groups say, on the Internet listservs, where subject matter or focus ties together groups of individuals around topics such as urbanism, the Rolling Stones, Princess Diana, feminism and art history, aesthetics, technology and art, modernism, science and the body, etc.) Although the shift occurs from geographic nation to communities usually unbounded by geographic and political ties, still, the attachment to the "collective" and the implicit rejection of the "other" creates a group that retains and builds a history, which accumulates – however unwittingly – a material culture or cultural authority. What is ideally required (and I stress *ideally*) is that collectivities remain unbounded and fluid at all times with only our own body to guide us. This means that the idea of a canon – representing a nation and its vision – can shift from closure to openness continually to disturb, relocate, dislocate, or even contaminate considerations of (steadfast, trustworthy, and reliable) value.[10] Part of the need to signal this ideal is to hope for an assurance that fixed definitions of culture are questioned always.

Again, Soja comments on the importance of shaking up the linear registration of time in order to allow for lateral and multi-dimensional connections to be made. His objective "is to spatialize the historical narrative, to attach to *durée* an enduring critical human geography."[11] Time and history have held the privileged position of modernist thought in a sequentially recounted narrative.[12] This essay points out the pitfalls of a historical narrative bound exclusively to its linear telling, trapped by the paradox of verbal (sequential) language. I will show how a position of apparent closure that seemed impossible to escape came into full view for those of us who held onto a definition of culture within a politicized site formed within an almost exclusively time-based historical consciousness. In so doing, I hope to show how rewarding the project of a new spatial logic can be.

Markers of National Security

Western culture has been fashioned into an culture of object worship and loyalty. Objects produced are "labelled" with varying measures of value. That value is never the same thing to all people. Hence, the market value of a work of art may or may not be equivalent to its value within the canon of art history. The parameters of value are fluid: they are modified, stretched, flipped, and reduced by means of explosure through critiques. Each time the parameters of value are discussed, value itself changes. Ironically, this measure – inconsistent as it may be – offers a sense of security to an individual or community, however restricted and shaped by time that art object is. Furthermore, the manner in which art is valued fluctuates within a range of acceptance within that culture. For this, the materialism of the object is everything: it is the tangible evidence of a nation or collectivity. It is the visual proof that an event, an historical moment, *took place* and is therefore part of the collection of revered objects that *represent* a nation, that create its historical narrative and national memory.[13] "Modern memory," as Pierre Nora states, "is, above all,

archival. It relies entirely on the materiality of the trace, the immediacy of the recording, the visibility of the image."[14]

Long recognized as part of popular practice and socio-political relations, historical artifacts (including objects labelled "high," "low," or other) or cultural representations are sometimes and even very often taken to mean representations of a nation. "A cultural heritage is a more enduring foundation for national prestige than political power or commercial gain," says Copland in Innis's *Strategy of Culture*.[15] (Art) objects and the supporting literature about those objects are considered and ranked by specialists and the public through various educational and museological and media institutions. Still, much art is never recorded into that historical, canonical account, as feminist scholarship, among others, has gloriously demonstrated. What are the boundaries of "national" culture, and where are they set? If, as we have seen above, the canon is a collection of objects that shape and are shaped by national beliefs and objectives, then objects that do not conform to these guidelines must settle elsewhere or disappear from view. They are outside the historical boundaries of shared beliefs and therefore not markers of national heritage. Surely this reveals the weaknesses of a system that appreciates and values the products (and producers) of a nation dependent on a geographic and political model (the nation-state): the site where a market economy always ensures the status quo of art, an idea of self and nation, and the reliability of a canon as image of that nation?

However, what is left outside the canon remains to be assessed as well. Art that does not convey shared values is now being counted, even aggressively so. Witness, for example, the number of books that attempt to "redress" the balance of representation particularly in viewing objects produced in the western world. Better still, there are now titles that seek out new themes or approaches in order to challenge the totalizing, consuming ability to collapse local communities, even national frontiers, to yield to an expansive, indistinguishable world where pluralism and multi-layered forms of spatial representation have been denied. As a result of this move, the backlash takes the form of a perceived (covert) threat, a sort of digging in of the heels to champion the erasure of boundaries by supra-national bodies. International pressure is sometimes so omnipotent that at the other extreme we can witness a reassertion of (geo-political) national values. Daniel Drache and Robert Boyer, among others, describe this backlash as one of the pitfalls often attributed to globalization since it can fuel multiple counteractions from grass-roots and nationalist bodies.[16]

Let me point out some critiques of nationalism that are essentially critiques of the exclusive geo-political model of a nation. This is a model that typically refers to an infrangible country or a people with more or less unified histories, goals, or beliefs and values. Yet in view of the fact that this model erases difference by attempting to convey a sense (often fictive and damaging) of cultural and racial hegemony (and here we can return to Wölfflin's theory of national art), how can a nation-state really be cohesive when it is without the slightest

evidence of difference – even if that nation, like the United States, claims to stand for a "melting pot" of *unified* differences? Where is the nation of this ideal model when its *other*, an-*other*, represents all, both subject and object?

Homi Bhabha explains nationalism as a "progressive metaphor of social cohesion, the *many as one*." Modern nations buy into it, he continues, since it facilitates a promotion of a "holism of culture and community" where gender, race, or class are considered "expressive" social totalities. In short, *many as one* is a dictum expressing a national vision.[17] Similarly, Frantz Fanon speaks of national discourses that tend to create historical institutions of the state – a body politic. And with that homogeneous concept of centred and cultural sameness is a nostalgic whimpering, a yearning, for the "true" image of the past that almost forbids a present: "The present of the people's history ... is a practice that destroys the constant principles of the national culture that attempt to hark back to a 'true' nation state, which is often represented in the reified forms of realism and stereotype."[18] Bhabha asks whether spatiality can really convey a sense of nation any longer. Spatiality, in this uni-dimensional sense, is for Bhabha linked specifically to a historical model of narrative (i.e., linear) "space" and, as he argues, challenges the metaphor of landscape which serves as a substantive narrative for national identity.

The example of regionalism in French art is worth noting. At first blush it may seem that regionalism operates outside geo-politicized nationalist rhetoric. Its history in France reveals that it stressed the physical land as the indicator of national identity with an emphasis on historical nostalgia, French peasant life, and a rejection of anything modern, urban, and international. Yet regionalism emerged during the French Revolution, supported by the Girondists, and flip-flopped between left and right wing political sympathizers. So passionate a claim was it to rediscover one's roots, so to speak, in the (tangible, physical) soil that it eventually found its way into the restoration guide-books in the 1920s.[19] Critics such as André Salmon singled out Metzinger, Gleizes, and Fauconnier as cubists devoted to "naturalism" and Zingg and Charlot as artists who would carry the future of French art. Yet this sort of mystical attachment to the boundaries laid out "naturally" by the physical demarcations of the land flew in the face of the International Style, modernism, and other contemporaneous movements sweeping Europe in the first two decades of the twentieth century. France was not then a homogeneous representation of regionalism, just as it was not of modernism.[20]

The infrangibility of a nation-state and the narratives that thread together its history and thus identity, its values and production, is in the process of re-examination. With multiplying local interests and increased diversity in racial, ethnic, and sexual communities, the notion of the unifying, all-encompassing nation-state is less and less sustainable. Bhabha instead offers a model that "resists the transparent linear equivalence of event and idea that historicism proposes; the model provides a perspective on the disjunctive forms of representation that a traditional historical materialism presents to us that signify a people, a nation or a national culture."[21] Bhabha continues: "It is in the emergence of the interstices

– the overlap and displacement of domains of difference – that the intersubjective and collective experiences of *nationness,* community interest, or cultural value are negotiated. How are subjects formed 'in-between,' or in excess of, the sum of the 'parts' of difference (usually intoned as race/class/gender, etc.)? How do strategies of representation or empowerment come to be formulated in the competing claims of communities where, despite shared histories of deprivation and discrimination, the exchange of values, meanings and priorities may not always be collaborative and dialogical, but may be profoundly antagonistic, conflictual and even incommensurable?"[22]

Curiously, Bhabha introduces this model under the guise of a new "temporality" which may, on the surface, seem at odds with my support of a Soja-inspired spatial hermeneutic. Indeed Bhabha and Soja are actually arguing for the same thing: that is, a desire to invoke an epistemological shift from the exclusively historical and temporal model to one that values subtle interplay and simultaneity of multiple readings (of a map, for example). This is what Soja calls the recomposition of the "territory of the historical imagination through a critical spatialization." When Bhabha refers to subjects created in the interstitial spaces, he is sharing a basic theoretical premise with Soja. Both are arguing for a conscious shift from a temporal hegemony as laid out in the nineteenth century to a new kind of temporal appreciation that even Foucault had announced. Foucault's term "heterotopia" collapses time and history into a lived space and is capable of "juxtaposing in a single real place several spaces, several sites that are in themselves incompatible."[23] Perhaps Bhabha's most penetrating response to traditional temporal and historical models for reckoning with cultural representation is his critique of the narratives we have all come to accept in our definitions of a nation: that the linking in a linear manner of historical events is what has become "an apparatus of symbolic power ... [that] ... produces a continual slippage of categories, like sexuality, class affiliation, territorial paranoia, or 'cultural difference' in the act of writing the nation."[24]

The concept of informing the time of modernity after Soja or Bhabha, among others, must be considered quite seriously in order to challenge the idea of certain progress formulated in the nineteenth century (by Hegel and Marx, to name but two). Together these concepts call out to the model of time and ultimately duration, and therefore we must reconsider the impact of temporality on the spatial configurations of historicism and the geographic nation. Similarly, Innis in *Changing Concepts of Time* explores how cultural activity is subject to continuous and systematic (even "ruthless") destruction where the idea of change, across time and space, is the only thing of permanence.[25]

The place where time *and* space intersect lies at the heart of cultural production ("space without places, time without duration"[26]). The object is present in the here and now; it is tangible and historical; it occupies space and is a result of its environment, an environment that may be a local geography or perhaps influenced by spaces far beyond. The possibility of reaching across all sorts of geographical scapes in order to identify ourselves frees up our commitment to the nation-state as we know it. As Robert Sack suggests, to "explain

why something occurs is to explain why it occurs *where* [emphasis added] it does."27 Bhabha proposes to reach out to an interstitial gap from which to mark the moment, since for him the moment is always identified with a physical space. Edward Said too underlines the point when he says, "the nonessential energy of lived historical memory and subjectivity [is given] its appropriate narrative authority. We need another time of writing that will be able to inscribe the ambivalent and schismatic intersections of time and place that constitute the problematic 'modern' experience of the western nation."28

The problematic "experience of the western nation" is not only the larger, fixed, and geo-political (spatial) nation but also the fluid, destabilized individuals and smaller communities making up the larger *imagined community* to which Anderson refers.29 The fact is that smaller communities or individuals have not been recognized or are overlooked when configuring a modern nation simply because there is no sum total of their differences. These communities can indeed be geographically defined, or they can be identified by distance relationships (such as Internet communities). The concept of a nation being a basis for "many as one" is really nothing more than an imagined construction in a fictive space. Or rather, the *difference* of one community or another has been squeezed or forced to fit the "national" identity image. The concept of different component parts of a nation eliding, surrendering to the common thread (many as one) is something that no longer seems to make any sense – at the very least, it is a concept that conclusively no longer works – in increasingly aware cultural arenas that claim to know what its right (good) values are and should be.

Berlin, an urban space in the throes of intense cultural and physical upheaval, is such an example. A zealous urban building plan promises to change yet commemorate the physical site of the city but also to allow for a reassessment of its ethical, historical, and economic roles. Each time evidence of an historical event "registered" on Berlin soil comes to the fore (thanks to the interventions of scholars and actual construction site evidence), the interpretation of Berlin changes. Planning committees are plagued by controversial viewpoints (the Holocaust Memorial Committee was one of the more complex) and building schedules grind to a halt. Perhaps there is no more widely contested and deeply sensitive urban core in Europe today. This highlights the intensity of meaning in a physical space that was and is bound to a complex cultural heritage that not only extends that notion of space far beyond Berlin, beyond Germany, and even beyond Europe, but underscores the vacancy of the meaning of a nation bound to a political state. It also conveys the role ethics plays when a space between built object and human memory is to be negotiated. In an article about historic preservation related to three moments in the history of twentieth century Germany, Rudy Koshar describes how inescapable is the "inherent instability of collective identity formation, to which preservation is inextricably tied and from which preservation inherits its own peculiar tensions and formation ... because in the West nations (or classes, or other social groups) are seen as collective individuals

whose 'essence' depends on the things they appropriate and 'objectify' through display, performance, and preservation." He concludes by suggesting we view the problem "off-centre" so as to "defuse conflict in a situation in which states or ethnic groups [defend] ... what seemed to be absolutely irreconcilable collective positions."[30]

And what of the lasting value of landscape as exemplified by the work of the Canadian Group of Seven painters? Mainstream art historians, curators, and connoisseurs tend to uphold the Group conveying a sense of the Canadian spirit in their landscape impressions of the "nation." International art markets and the general public generally accept – across many different communities in the western world – that some of the great masters of painting include such illustrious names as Leonardo or Rubens; that their art value is unchanging is for many unassailable. What is important to demonstrate here is that while this may well be true (for some or even for many), current critical theory invites and even forces us to address this matter and question our perhaps previously unquestioned assumptions – such as the nature of landscape painting in Canada and what it is in the work of the Group of Seven that endears it to the general public; critical theory also invites questions about the status of landscape art, its relevance today, and the value of representational art. These approaches to art predispose us to allow for new criteria of evaluation to be considered, particularly when looking at, thinking about, or making art that defies existing standards of judgment – judgment that shaped decisions about recognizing the "value" of this work previously. Viewed with varying degrees of difference during early exhibitions, the Group of Seven was then re-evaluated by critics and historians, and new status was eventually conferred on the work during a time (post-war) when national values were being reassessed.

The former collective value, or that which stood for collective value (in evaluating, say, the canon of national art), was too narrowly conceived to adequately represent diverse interests and, paradoxically, not large enough to contain all the differences across the spatial and temporal spheres of the nation-state. With no clear, comprehensive temporal succession of events, beliefs, and *communion* to stand for the geo-political space known as nation (and the "philosophical poverty" of its political power),[31] the art that the canon comprises is not substantiated. It follows that what we generally consider to be "French" art, or "Italian" art, is problematic. The cohesiveness of a collection of art produced in the same country might indeed, if we test any of these ideas about how a nation really cannot represent us, not even be worthwhile upholding. As Barbara Herrnstein Smith describes, determining value or judging that which is best "is always both heterogeneous and variable ... [and] can never be better than a state of affairs that remained more or less that good for some people, or got considerably better for many of them in some respects, or became, for a while, rather better on the whole. If ... there can be no total and final eradication of disparity, variance, opposition, and conflict ... then the general optimum might well be that set of conditions that permits and

encourages, precisely, evaluation, and specifically that continuous process described here in relation to both scientific and artistic activity: that is, the local figuring/working out, as well as we, heterogeneously, can, of what seems to work better rather than worse."[32] Therefore, each judgment is a reflection of the speaker's own observation, grounded in that person's sets of experiences, and contingent, highly contingent, on a set of conditions.[33] This destabilizing position begs the question of what we do with labels such as "classic" or "masterpiece," since many of these were so categorized in an evaluative system that is in the process of being overhauled. When a broader or newer critical understanding of a work of art (literary, visual, musical, theatrical, and so on) is developed, the aesthetic value appreciates.

However, there are difficulties to point out in some of these new approaches, for I fear they are trapped by their own zeal to re-situate traditional values of interpretation. For example, I would argue that Stanley Fish's New Pragmatism takes the contingency to which Herrnstein Smith alludes to mean that reading – no matter how personal – is linked to a group. That is, it can be analysed historically and ideologically as characteristic of a group, or "interpretive community." Susan Rubin Suleiman, in an effort to locate political meaning in an interpretive context as well, describes Fish's concept further: "To be part of an interpretive community, one does not need a membership card; it is a matter of having learned, in the classroom or through scholarly exchange, or through more informal modes of communication, certain shared ways of approaching a text: asking certain questions of it, and elaborating a language and an interpretive 'strategy' for answering them."[34] Although Suleiman refers only to "reader-oriented criticism" for interpreting texts, it seems to me that it is quite impossible to sort out the artist or writer (in her example) from that community. The interpretive community reads as a formative group within which art or ideas about art are conceived, produced, exhibited, and distributed. Reading, she says, is a shared activity, and although done independently, she argues that it can be shown that it is part of a collective discourse.

In spite of the idealized tenets she suggests of this shared environment that is largely organic and subject to change, there is the ultimate danger that the "interpretive community" is not at all fluid but rather a fixed entity where traditional historical and temporal telling of the tale is ensured and mobility is undermined. We hear it boldly underlined in Suleiman's call for a new uniformity, a new language, and indeed a new "strategy" in responding to art, or what she refers to as the text. I don't want to diminish the dimensionality of Suleiman's or Fish's ideas here and specifically how they imagine the interpretive community to function. But one of the dangers in developing a new language and a new strategy for even small numbers within a community is that however fluid and mobile Fish claims is a practice of interpretation through situatedness and performance within that community, his quest for a plural community – where the reader is an agent actively engaged in interpreting texts – still foregrounds the terms of a currency, a test, or a template, however

modifiable, however temporally brief. It sets in motion yet again an authoritative sytem that on the flip side of the coin unifies and homogenizes individual expression, however much a part of a tradition, a community, or a nation-state that expression may be.

Barometers of Change: The Legacy of High Modernism

At the risk of stating the obvious, let me pursue in this section what accounts for – in my view – aesthetic legitimacy and therefore that which is valued. Can it be that there is such a thing as good and bad art? Until recently at least, uniform, monolithic value systems dominated the ways in which cultural production came to be codified. What once passed for universal values about good and bad art in critical theories, specifically indoctrinated during the period of high modernism, is today questionable, or at least questioned. It is no longer commonplace or simple, towards the end of this millennium, to support the claim that masterpieces even exist, at least not insofar as a group of accepted works of art form the body of "high" art and consequently the legacy of art history. In other words, it is difficult to resist conjecture that what once held as the conclusive grouping of masterpieces in art is not necessarily true or desirable. That is, the canon of great works is in the process of serious reappraisal, thanks to previous standards of aesthetic judgment, where the better and the best were separated from the lot of contenders and where what became accepted and mainstream necessarily left all else aside or where what stood as good for some meant good for all. The results of this attention may simply mean that we reassess previous valuations only to learn that they are indeed praiseworthy. And we are doing just that. But the way in which the "we" enters into the process makes all the difference. Consequently, those readings are beginning to indicate a variety of results and new meanings.

What cannot be ignored is the role played by art historians (as curators, academics, cultural policy analysts, corporate art consultants, etc.) in the system of evaluating art. The power of the printed word in publications such as the catalogue produced to comment on or accompany exhibitions rescues art from disappearance by guaranteeing its longevity. One exhibition may disappear permanently because no catalogue was produced for the occasion to assure its "timelessness"; yet another exhibition (or artist or group of artists) will enter the annals of that which is *real* and *historical* when a catalogue publication testifies *ipso facto* to its prior existence in a gallery space. So this exhibition or artist enters the ranks of history, whereas the first exhibition or artist is erased. Power lies in the printed word. Valuating not only art but the profession of art history, then, contributes to the power and interdependency between a market (a public) and the profession. When we interrogate the methods by which the profession operates, we expose some of the "intellectual cachet"[35] behind which the profession continues to operate – however unwittingly. This, of course, contributes to the notion that art history (and its related fields in curatorial practice, art criticism, art consultations, etc.) is a

practice that continues to wield considerable power.

Take, for example, feminist practice in Canadian installation art. It is unavoidably measured against the solidity, the unwavering dependability of the national (geographical) canon representatives such as the Group of Seven or other canonical works collected by the National Gallery of Canada in Ottawa (arguably one of Canada's most important art institutions, along with the Art Gallery of Ontario) among others. Whether it is worthy (should it be collected in other small galleries and museums across the country?) and, if so, how much space should be allotted to its exhibition are questions ultimately guided by the measurable quantity and quality of published documentation, its endurance (what is the effect of this work over time?), and unavoidably, perhaps even subtextually, the moral status of the work.

With that comment goes this caution: it is the flexibility and liberty of an institution to hold sway in order to build on or even invent a value marker for art. In other words, the choice to mount this or that exhibition, the choice to canonize work by the power or control of selection or acquisition of this or that artwork by this or that artist (as opposed to any other artist or artwork) reveals the ability to – automatically and by direct result – determine market and national value of an artist and an artist's work. So even though canons are not really fixed and do grow, they do so as a direct result of a considered historical past that appears to "represent" shared beliefs. At the same time, canons are built with a vision of the future based all the while in that historicized (sometimes romanticized, clearly imagined) recollection of the/a past based on nineteenth century nationalist art history, a nationalism, as Wölfflin pointed out, linked to a strong ethnic and politically determined boundary and its corresponding development in time. Ultimately, the canon reflects national, safe, and objectified valuations.

We have seen how historical, modern institutions wield power over the way we value and so contribute to shaping a canon of art. What happens to art that fails to meet such standards or mark time and space with the same currency? When national identity or figurative convention is abandoned, is art valued all the same? What of value, identity, or community expressions across temporal or spatial geographies that run contrary or elsewhere to existing nation-states, challenging the idea of one nation and one canon of art for all? Can the *Antiques Roadshow* experts attribute value to objects that do not "fit" within national, chronologically bound *textbook* examples that quite logically serve to define their individual areas of expertise and comfortably create a nostalgic place for the traditions and categories we hold dear?

Inevitably there will always be new spaces for cultural monopolies and, conversely, spaces of cultural resistance. Rather than see the idea of a nation as an immutable, narrowly political space and temporal entity, a new spatial hermeneutic must cut across, between, through, and without in as many conceivable and inconceivable imaginings possible to enable us to continually disturb the fixities of the traditions and criteria we find safe.

NOTES

1 Edward Soja provides a succinct overview of the subordination of space in his chapter, "History: Geography: Modernity" in *Postmodern Geographies*, 10–42.

2 Heinrich Wölfflin, *Principles of Art History*, vii.

3 Ibid., viii–ix.

4 An important text recently reissued, Rocker's *Nationalism and Culture*, was to have been published originally in Berlin during the autumn of 1933. Catastrophic events abruptly eliminated the possibility of its appearance at that time. Rocker's thesis expounds that the standard of value used to explore cultures and institutions must ultimately leave human beings the opportunity, at all costs, to be free and incalculable. Authority, as defined through nations, must be rejected so that freedom can be thoroughly explored by "man." The discussion of culture broadly and specifically put is meshed together throughout his project with nationalism and valuation. This book is particularly useful to trace the thread of nationalism within the historiographical passages and to see its most extreme expression in Nazi Germany.

5 Wölfflin, *Principles of Art History*, 235. In an important essay by Eric Michaud, "Nord-Sud," Michaud lays bare how nineteenth century art history constructed a nationalist and racist image of itself that is reflected in the everyday vocabulary and literature of the discipline and continues to be felt today.

6 Foucault, "Of Other Spaces."

7 Soja, *Postmodern Geographies*, 7.

8 Ibid., 8.

9 I am grateful to Eric Michaud for an exchange of these ideas. Many of them are articulated in his recent *Un art de l'éternité*.

10 An interesting case in point is described by Nelly Richard, a critic based in Santiago, who reviews the concept of "border" as a delimitation of identity specifically referring to the two images of modernity ("superimposed reference" and "intermingled force") and the history of cultural domination (colonization) and subalternity of Latin America ("forever ransomed"). Her concept of the "deterritorialization of the signs of cultural identity" is about the reconfiguration of meaning created when the relationship between what had been perceived as the "popular" and the "national" movements is subject, as it has been recently, to a new label. This results from a recombination of identities and frontiers due to the transnationalization of information and communication being marketed and disseminated as an image, however imaginary, of Latin American identity. Instead, she calls for something far more subtle and complex by exploding and fragmenting these mythologized representations of the past, particularly those that "serve as the basis for Latin American substantialism concerning Origin. Such 'originary' thought mythologizes the past ... and effortlessly converts it into folklore, a reservoir of guardians for a preset identity." See "The Cultural Periphery and Postmodern Decentring."

11 Soja, *Postmodern Geographies*, 1.

12 Soja reveals that his work is inspired by Jorge Luis Borges, specifically his description of "The Adelph," the site of simultaneity disturbed, as Borges despairs, because language that must recount the event is sequential (Soja, *Postmodern Geographies*, 2).

13 Although electronic media has permanently altered the nature of what we had considered to be "material" and "tangible," some trace in the physical world is still considered necessary, be it by way of a text to document an event, a photograph to visually record its passing in time, etc. There is considerable consternation over the potential invisibility of e-mail messages, for example. Yet hard-copy evidence still

ties its elusive quality to our need for
material evidence.

14 Nora, "Between Memory and History" 7.
15 Innis, *The Strategy of Culture*, 3.
16 Drache and Boyer, *The Power of
 Nations and the Future of Markets*, 3.
17 Bhabha, *Nation and Narration*, 292–4.
18 Fanon, *The Wretched of the Earth*,
 174–90, in Bhabha, *Nation and
 Narration*, 303.
19 Namely Letrosne's *Murs et tois pour les
 pays de chez nous*.
20 See the fascinating research by Golan
 in *Modernity and Nostalgia*, 23 *et seq.*
21 Ibid.
22 Bhabha, *Location of Culture*, 2
23 Foucault, "Of Other Spaces."
24 Bhabha, *Location of Culture*, 140
25 Innis, *Changing Concepts of Time*, 15.
26 Althusser, *Montesquieu, Rousseau,
 Marx*, 78.
27 Sack, *Conceptions of Space in Social
 Thought*, 70.
28 Bhabha, *Location of Culture*, 293.
29 Anderson, *Imagined Communities*, 6.
30 Koshar, "Building Pasts," 231.
31 Anderson, *Imagined Communities*, 5.
32 Smith, *Contingencies of Value*, 179.
33 Ibid., 96–8.
34 Fish, *Is There a Text in This Class?*
 192–3.
35 I would like to thank Yvonne Singer
 for coining this thought for me.

BIBLIOGRAPHY

Althusser, Louis. *Montesquieu, Rousseau,
 Marx*. London: Verso 1972.
Anderson, Benedict. *Imagined Communities*.
 London: Verso [1983] 1991.
Bhabha, Homi. "DissemiNation: Time,
 Narrative and the Margins of the
 Modern Nation." In *Nation and
 Narration*, ed. Homi Bhabha. New
 York: Routledge 1990.
– *The Location of Culture*, London and
 New York: Routledge 1994.
– ed., *Nationa and Narration*. New York:
 Routledge 1990.
Drache, Daniel and Robert Boyer. *The
 Power of Nations and the Future of
 Markets*. Montreal: McGill-Queen's
 University Press 1995.
Fanon, Frantz. *The Wretched of the Earth*.
 Harmondsworth, London: Penguin
 1969.
Fish, Stanley. *Is There a Text in This Class?
 The Authority of Interpretive
 Communities*. Cambridge, MA: Harvard
 University Press 1980.
Foucault, Michel. "Of Other Spaces."
 Diacritics 16 (1986): 22–7.
Golan, Remy. *Modernity and Nostalgia: Art
 and Politics in France between the Wars*.
 New Haven and London: Yale
 University Press 1995.
Innis, Harold A. *The Strategy of Culture*.
 Toronto: University of Toronto Press
 1952.
– *Changing Concepts of Time*. Toronto:
 University of Toronto Press 1952.
Koshar, Rudy. "Building Pasts." In
 *Commemorations: The Politics of
 National Identity*, ed. John R. Gillis.
 Princeton: Princeton University Press
 1994.
Letrosne, Charles. *Murs et tois pour les pays
 de chez nous*. Paris: D. Niestle 1924,
 1925, 1926.
Michaud, Eric. "Nord-Sud (Du national-
 isme et du racisme en histoire de l'art:
 une anthologie)." *Critique* 586 (March
 1996).
– *Un art de l'éternité: l'image et le temps du
 national-socialisme*. Paris: Gallimard
 1996.
Nora, Pierre. "Between Memory and

History: Les lieux de memoire."
Representations 26 (Spring 1989): 7.
Richard, Nelly. "The Cultural Periphery
 and Postmodern Decentring: Latin
 America's Reconversion of Borders."
 In *Rethinking Borders*, ed. John C.
 Welchman. Minneapolis: University
 of Minnesota Press 1996.
Rocker, Rudolf. *Nationalism and Culture.*
 Montreal, New York and London:
 Black Rose Books 1998.
Sack, Robert. *Conceptions of Space in Social
 Thought: A Geographic Perspective.*
 Minneapolis: University of Minnesota
 Press 1980.
Smith, Barbara Herrnstein. *Contingencies of
 Value.* Cambridge: Harvard University
 Press 1988.
Soja, Edward. *Postmodern Geographies: The
 Reassertion of Space in Critical Social
 Theory.* London and New York: Verso
 1989.
Suleiman, Susan Rubin. *Subversive Intent:
 Gender, Politics, and the Avant-Garde.*
 Cambridge, MA: Harvard University
 Press 1990.
Wölfflin, Heinrich. *Principles of Art
 History: The Problem of the
 Development of Style in Later Art.*
 Trans. M.D. Hottinger. New York:
 Dover 1950.

Certified Art
Ad Series by Johnny Vee

John Velveeta

1984 FORD RANGER PICKUP — V6, auto, ps, pb, am-fm, long box, solid body, will certify, asking $2300. Phone 905-427-3580.

T42CA203-rp-‡-TO

REAL NICE

1987 FREIGHTLINER FLC112 — 209" wheelbase, 350 cat., 15 spd. OD, 12 & 40,000 lb. axles, 11R22.5 tires, steel budd front, spoke rear, Hendrickson suspension, 42" bunk. T41H28-dp

1976 FORD F100 4x4 SHORT BOX — 390 motor, 4 spd., std., '82 stepside box, '78 cab & front clip, posi front & rear, 4" suspension lift, 3" body lift, good mud bogger or hunt camp truck. $800. as is. 416-349-2673. T42L201-rp-TO

MUST BE SEEN

1985 OLDS 98 REGENCY — 4 dr., auto, low kms., fully loaded, exc. cond., $3800. or b.o. or trade for pickup of equal value. (416) 781-9871. T22X143-TO

Contributors

BRUCE BARBER is an artist/cultural historian, professor in media arts and cultural studies, and director of the MFA program at the Nova Scotia College of Art & Design in Halifax. He has exhibited internationally since 1973. His critical work includes written essays and reviews in various magazines such as *Islands, Fuse, Parachute, ACT, Splash, Inter(vention), Borderlines, Inks: Cartoon and Comic Art Studies,* and *Harbour.* He has edited and published *Essays on [Performance] and Cultural Politicisation,* Open Letter, Summer-Fall 1983, 5th series no. 5 & 6 (Toronto: Coachhouse 1983), *Reading Rooms* (Halifax: Eye Level Publications 1992), *Voices of Fire: Art, Rage, Power and the State* (co-edited by Serge Guilbout and John O'Brian, University of Toronto Press 1996), and *Popular Modernisms: Art, Cartoons, Comics and Cultural In/Subordination* (forthcoming).

JODY BERLAND is associate professor of humanities at Atkinson College, York University, and is affiliated with graduate studies in the Faculty of Environmental Studies, Music, and Social and Political Thought. She has published numerous articles and book chapters on cultural studies, Canadian communication theory, music, radio and video, weather, new technologies, and feminism and the body. She is co-editor of *Theory Rules: Art As Theory, Theory and Art* (YYZ/University of Toronto Press, 1996) and editor of *Topia: A Canadian Journal of Cultural Studies,* launched in 1997. Her book on culture, space, and technology is forthcoming from University of Minnesota Press.

MICHAEL BUCKLAND was born in Saint John, New Brunswick; after giving up on everything else he became an artist. He has been described as a minor artist of the late twentieth century and is currently looking forward to the next millennium. His art work is a compendium of the unwanted: stale food, embarrassing moments, dirty books, and any cheap crap that comes down the pipe. In a bid to make himself a more sympathetic character he recently

had a post-hypnotic suggestion planted in his brain that would cause him to cry whenever he heard the French language. We are obliged to report that this was a failure in all respects. He is currently involved with a travelling business enterprise that inhabits galleries, providing him with the chance to buy gifts for friends and strangers. Michael lives and works in Brooklyn, NY. So far, so good.

MARK A. CHEETHAM is a professor in the Department of Visual Arts at the University of Western Ontario, where he teaches art theory and art history. He is the author of three books, *Alex Colville: The Observer Observed* (ECW Press, 1994), *The Rhetoric of Purity: Essentialist Theory and the Advent of Abstract Painting* (Cambridge University Press, 1991), and *Remembering Postmodernism: Trends in Recent Canadian Art* (Oxford University Press, 1991). He is co-editor of *Theory between the Disciplines: Authority* (University of Michigan Press, 1990) and *The Subjects of Art History: Historical Objects in Contemporary Perspective* (Cambridge University Press, 1998), as well as the author of articles in the fields of Canadian and European art and art theory of the eighteenth, nineteenth, and twentieth centuries. His current work includes a book on the influence of Immanuel Kant in art history and the visual arts – supported by a 1994 Guggenheim Fellowship – and the touring exhibition and catalogue *Disturbing Abstraction: Christian Eckart* (1996–98).

CAROLE CONDE AND KARL BEVERIDGE are artists who live in Toronto. They have collaborated with various trade unions and community organizations in the production of their work over the past twenty years. Their work has been exhibited across Canada and internationally.

THIERRY DE DUVE has written extensively on modern and contemporary art, with an emphasis on the work of Marcel Duchamp and its theoretical implications. He is the author of a number of works, three of which are available: *Pictorial Nominalism* (Minneapolis: University of Minnesota Press, 1991), *Kant after Duchamp* (Cambridge, MA: MIT Press, 1996), and *Clement Greenberg between the Lines* (Paris: Dis-Voir, 1996). He is also the editor of *The Definitively Unfinished Marcel Duchamp* (Cambridge, MA: MIT Press, 1991). He has been professor at the University of Ottawa (1982–91) and director of studies of the future Ecole des Beaux-Arts de la Ville de Paris (1991–93), a project abruptly cancelled by the City of Paris itself. He has since then been a visiting professor at MIT, at the Johns Hopkins University, at Reid Hall, Paris, at the Hochschule für Gestaltung, Karlsruhe, and at the University of Pennsylvania, Philadelphia. Recently he was the Ailsa Bruce Mellon Senior Fellow at the Center for Advanced Study in the Visual Arts in Washington, DC.

MICHAEL DORLAND is an associate professor at the School of Journalism and Communication at Carleton University. He recently edited *Canada's Cultural Industries: Policies, Problems and Prospects* (Lorimer, 1996), a collection of

essays, and is currently researching a history of the forms of rhetoric in the Canadian public sphere. His study of the emergence of Canadian feature film policy, *So Close to the State/s*, was published by University of Toronto Press in 1998.

NICOLE DUBREUIL is a professor of Art History at Université de Montréal. A specialist of nineteenth and twentieth century art and art writing, she has published in English "A Woman's Touch: Towards a Theoretical Status of Painterliness in the Feminist Approach to Representation in Painting," in *Re Imagining Women: Representations of Women in Culture* (Shirley Newman and Glennis Stephenson, eds., University of Toronto Press, 1993); "La scène de la peinture après l'éblouissement formaliste," in *Utopies modernistes-Postformalisme et pureté de la vision/Modernist Utopias-postformalism and Pure Visuality* (Musée d'art contemporain de Montréal, 1996); "Tightrope Metaphysics," in *Voices of Fire: Art, Rage, Power, and the State* (Bruce Barber, Serge Guilbaut, and John O'Brian, eds., University of Toronto Press, 1996).

JOHN FEKETE is Distinguished Research Professor of Cultural Studies and English Literature at Trent University in Ontario. He has published numerous scholarly articles and four books: *The Critical Twilight* (1978), *The Structural Allegory* (1984), *Life after Postmodernism* (1987), and *Moral Panic: Biopolitics Rising* (1994). His work is in literary and cultural theory (Anglo-American and European), including problems in modernism and postmodernism; science fiction (Hungarian and North American), including utopian narratives and the horizons of the technological imaginary; and social psychopathology in popular culture, including moral panic and censorship.

VERA FRENKEL in videotapes, installations, texts, and new media works explores the forecast work in human migration, the learning and unlearning of cultural memory, and the bureaucratization of everyday life. Interdisciplinary Studio Professor in the Faculty of Fine Arts, York University, until her 1995 decision to focus fully on her practice, Frenkel has been artist-in-residence at the Slade School of Art, the Chicago Art Institute, the CCA, Warsaw, the Institute of Museology, Vienna, and has lectured at MoMA, the Haus der Kulturen der Welt, Berlin, and the Royal Academy, Stockholm, where her *documenta IX* work *"... from the Transit Bar"* began its Scandinavian tour. Current projects include *The Institute: Or, What We Do for Love*, a polyserial video-web narrative on the travails of a large cultural institution, and the preparation of *The Body Missing Project*, and related website (www.yorku.ca/BodyMissing) for an exhibition at the Sigmund Freud Museum, Vienna. Vera Frenkel is one of six invited artists preparing a public computer-video projection for *Brussels 2000* on the Centre Borschette, the building where all the European Parliament, Common Market, and Commission translations take place.

JANICE GURNEY is an artist who was born in Winnipeg and has lived and worked in Toronto since 1977. Her recent ten-year survey exhibition, Sum over Histories, was organized by the Winnipeg Art Gallery and toured five Canadian cities from 1992–94. She is currently teaching at the Toronto School of Art and is represented by the Wynick/Tuck Gallery in Toronto.

SHELLEY HORNSTEIN is associate professor of Art History at Atkinson College, York University, and has served as associate dean, co-director of the Centre for Feminist Research, chair and co-ordinator of the Programme in Visual Arts. She has published widely on concepts of spatial politics and national identity in art, architecture, and urban sites, art nouveau architectural tendencies in Strasbourg, gendered and medicalized urban space in nineteenth century Montreal, mythologized leisure sites and workers' housing for a chocolate baron in Anticosti and France, and the nature of belonging in Canadian contemporary art. With Florence Jacobowitz, she is editing a book entitled *Representation and Remembrance: The Holocaust in Art* (Blackwell) that explores post-war visual art and film that challenge and shape history, collective memory, and personal and national identity.

JOHANNE LAMOUREUX is associate professor at the Art History Department of the Université de Montréal. She has written numerous catalogues and articles (in *Parachute, Trois, Artsmagazine, Artpress, October, Protée*), dealing with issues of site specificity and the contemporary rhetoric of exhibitions and other displays. Her doctoral thesis (École des Hautes Études en Sciences Sociales, Paris, 1990) discussed how the concepts of picture and ruin were articulated in the multifold practice of Hubert Robert (1733–1808). She is the author of *Seeing in Tongues/Le Bout de la langue*, on visual arts and the linguistic conjuncture in Québec (Fine Arts Gallery, UBC, 1995), *Biofictions* with Irene F. Whittome (Musée du Québec, 2000), and *Seeing through Art History*, with Donald Preziosi (Amsterdam, G+B Arts International, 2000).

BRENDA LONGFELLOW teaches in the Fine Arts Department, Atkinson College, York University. She has written extensively about women and film in *Screen, CinéAction!, CineTracts*, and the *Canadian Journal of Film Studies*. She is the director of *Our Marilyn, Gerda, A Balkan Journey/Fragments From The Other Side of War*, and *Shadowmaker: Gwendolyn MacEwen, Poet*.

JANINE MARCHESSAULT is the director of the graduate program in Film and Video at York University. Her writings have appeared in *CinéAction!, Public, Parachute* and *Screen*. She is the editor of *Mirror Machine: Video and Identity* (YYZ Press, 1995) and is currently completing a book on McLuhan.

JOHN MARRIOTT is a Toronto-based artist, writer, and curator. His practice has included a range of media: video, photography, performance, sculpture, and installation. Since 1990 he has participated in solo and group exhibitions,

performances, and screenings in Toronto, Halifax, New York, Glasgow, Belfast, Nurnberg, Wellen, and Vienna. In 1996, Marriott's work was featured in a solo show at The Power Plant in Toronto, and, most recently, at the Koffler Gallery, in a 1999 solo show entitled Soft Spots.

PAUL MATTICK teaches philosophy at Adelphi University. He is the author of *Social Knowledge* (1986) and has edited *Eighteenth-Century Aesthetics and the Reconstruction of Art* (1993). He is editor of the *International Journal of Political Economy* and writes for *The Nation, Art in America*, and other periodicals.

LUKE A. MURPHY was born in Boston, Massachussetts, and has resided in Halifax, Nova Scotia. Before entering the Nova Scotia College of Art and Design, he was pre-medicine, and graduated with a BSC from the University of Toronto in Physiology and English in 1985. He completed his BFA in 1988 and in 1991 received his MFA from the State University of New York at Purchase. He has taught at the State University of New York and at the Nova Scotia College of Art and Design. He is represented by Wynick/Tuck Gallery in Toronto, and in the collections of the Canada Council Art Bank and the Art Gallery of Nova Scotia, as well as numerous private collections. He currently lives and works in New York City.

YVONNE SINGER is an installation artist living and working in Toronto. Her installations arrest viewers at the precise point where public convention meets private memories. Combining texts with domestic items in architectural settings, she invites deeply unsettling collisions between subtexts of domination and nostalgia. She has been exhibited widely, both nationally and internationally. She is associate professor of Visual Arts at York University.

CHERYL SOURKES is a Toronto-based digital artist and independent curator. Her recent work includes back-lit wall works and animated video projections inspired by the chiasma between life sciences and computer sciences. She is currently producing a CD-ROM entitled: *Life after Artificial Life*. Sourkes curates exhibitions around questions of history, technology, gender, and memorialization. She is also the editor of visual art for *Tessera*, a feminist journal concerned with questions of language, representation, subjectivity, and power.

JOHN VELVEETA graduated from York University in Toronto with a BA in sociology and an MA in visual art. He is a practising visual artist living in New York City.

RON WAKKARY is director, co-founder, collaborator, and curator of Stadium (www.stadiumweb.com). Stadium explores the possibilities of the network as a site for aesthetic production and distribution. He has also collaborated on projects for the Dia Center for the Arts, the Museum of Modern Art in New York, the Banff Centre, and Eyebeam Atelier, and has published his works

widely in books and online. Wakkary is an associate professor in interactive arts at TechBC (Technical University of British Columbia) in Surrey, British Columbia, where his research is in network interactivity. He is co-director of then/else, an applied research centre at TechBC.

ANNE WHITELAW teaches cultural theory in the Department of Art and Design at the University of Alberta. She has written on articulations of national identity in exhibition policy and practice at the National Gallery of Canada. She is currently researching a book on the writing of Canadian cultural histories in the 1960s and '70s.

Three Works

Luke A. Murphy

Graphs are from a series of graphs and relations entitled
Money. Others in this series include "Relationships,"
"Spiritual Matters," and "Problems." Drawings are
digital works from a series entitled the 49 Androgynous
Cherubim.

Anx Garden, from the 49 Androgynous Cherubim series

Straightforward Relation of Relative Average Happiness and Cultural Complexity

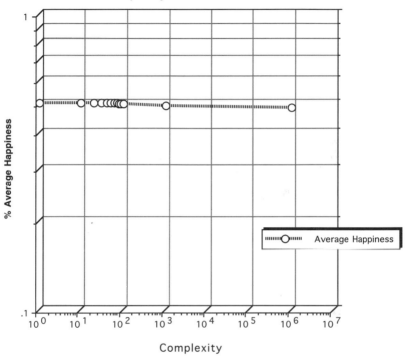

Straightforward Relation of Relative Average Happiness
and Cultural Complexity, Money series

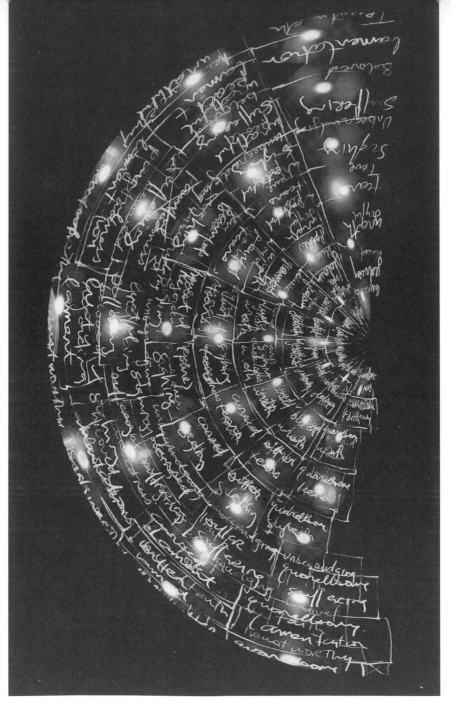

Radial 49 Androgynous Demons, from the 49 Androgynous
Cherubim series

Index

... it's still privileged art

Carole Conde
Karl Beveridge

A Curator has called to say he is coming over. Carole and Karl rush about to set up work. Each has their individual identity to establish. Each must fight for 'their' space, 'their' time.

DRAGGING UP OLD ARGUMENTS AND MARKETING THEM AS NEW MYSTERIES

I still like my previous work. It was good for what it was. I can't feel bad about it. But we've changed.

I also think it's important to understand that our previous work led up to our present position. What I mean is, we reached a point with that work at which it became totally impossible to generate ideas except for the monotonous reiteration of a single 'essence'—the formalist *ad absurdum*. When this dawned on us we started to question why . . .

There is a sense of 'crisis' in the air. A lot of artists are confused and uncertain. It accounts for the reactionary painting that has come about recently, the return of the old dogmas, the veneration of Malevich . . .

That's a good point. Either you become a reactionary, dragging up old arguments and marketing them as new mysteries, or you subvert the conditions that produced that 'crisis'. Art either becomes aesthetic—the maintenance of the status-quo—or political.

The Curator has arrived. This is business. Carole and Karl must 'sense' him out. They present a professional face, not to betray their underlying hesitancy and doubt. This is Art after all.

HOW CAN TWO PEOPLE BE CO-STARS?

How can two people be co-stars? That's a blunt but basic question for us. Stardom is one person living at the *expense* of the other. Of course, the whole notion of stardom, itself, is perverted.

I can see your dealer, Carmen Lamanna, saying 'look at the kind of work Karl did before. First rate sculpture! Now look at what happens when he works with his wife. I hope it doesn't continue!'

When you compete with someone you don't share everyday life with, it *seems* okay. But to be in competition with someone you live with is quite different. Competition is a function of alienation. It fragments sociality. Therefore it is impossible to maintain a living relationship and *at the same time* a competitive one. Either the relationship suffers, or one of the partners must sacrifice their competitive position, which in our situation was me.

We internalize the social oppression of competitiveness by assuming we are personally inadequate. We attempt to overcome this through individual achievement, pretending the social contradictions of such behavior are non-existent, or worse still, natural and unresolvable.

We're led to believe that such competition is a 'natural' state of affairs. Competition, however, has nothing to do with living, or learning . . . You can compete over the same idea—as I think we did. Competition simply enforces an exclusive will to succeed, and doesn't have anything to do with what might be morally right or socially rewarding. Competition means exploitation—you at the expense of me.

Carole has gone shopping and returns with the mail. Karl is elated at receiving a Canada Council grant. Carole must hide her jealousy and appear pleased. It's money to work with and live on.

WHO OWNS AN IDEA

There is a conflict over who 'owns' an idea. We end up trying to establish a 'democratic' rule where each has exactly half, each has the right to their half. But it still maintains 'privacy', only the *property* is divided equally.

The individual, it is believed, owns certain 'private' ideas and feelings. It's not that the individual can't have 'personal' ideas different from other people, but are they 'private property'? Shouldn't they be shared and used by the community. In recent art we sell ideas. LeWitt owns 'cubes', Rockburne owns 'folds', William Wegman owns a 'dog' . . .

Ideally we shouldn't determine who did what, but get the job done each according to their ability—you're right. But we're in a situation in which people put importance on the 'signature', and attempt to determine who did what and reward accordingly.

Even worse, we might be treated as a 'joint' individual. This is why it is important to refer the work outside of ourselves, and at least implicate others in our dialogue and embed our dialogue in others. It's not only to avoid the 'husabnd-wife' cliches, but to avoid being treated as a single entity.

Here we are discussing who did what. Yet it would be silly and pretentious not to recognize it. For example this whole idea of 'private and personal' I got from Mel Ramsden, which he got from someone else. Once things are in the open we can deal with them productively. Our 'culture' individualizes us, and deep inside we each take credit for what we did.

After lunch they go to the galleries to keep up with what's going on. The new Rymans' are damn tough, push-ing the 'materiality' of the paint even further. On the way home they meet a Collector and invite him over.

I RAN INTO BRUCE BOICE AND WE HAD LITTLE TO SAY

Have you noticed, now that our 'interests' have changed, that we have little to say to people who a year ago were our allies, to whom our work was similar? I ran into Bruce Boice last week and we stood there with little to say. That was because we had used *each other* for 'political' advantage in the artworld, rather than having something to say as human beings.

An art community does exist, but it is a 'corporate' community. **Friendships exist for** *use*. You jockey for position on the scale of success which determines your standing in the community and who you 'talk' to.

If you want to find out what's going on, you don't ask the artist; you go to a museum or a gallery, or look it up in a magazine, to see what they think. You're also told what counts as 'significant' art. You wouldn't have thought much of Olitski, Judd, Serra or most recent work, including our own, if you hadn't seen it at the Museum of Modern Art, The Art Gallery of Ontario, Castelli's, or Lamanna's. Our work doesn't mean a damn outside of specific cultural institutions.

We are no longer 'creative' artists. To be creative means to actively construct the world around you, to change how it is seen. We only reproduce the approved conditions of institutionalized culture, conforming to bureaucratized standards of practice and art history. We write 'history' then fulfill its 'prophesy'.

'Significant art' determined by cultural institutions – ie only when 'selected' does it become significant

Success! The Collector purchases a drawing. They show him other work, caressing his idiosyncracies and terrorizing his complacency (which he loves). However, he feels uneasy with Art. They gossip and eat instead.

It's amazing how well places like Toronto reproduce the New York art community. Look at the Art Gallery of of Ontario; grey carpets, linen walls, concrete, glass and blank spaces. It could be St. Louis, Paris, or Sao Paulo. The centralized artworld produces this kind of dependency. It makes art in places like Toronto sterile and in no way related to the specific community where it is made. Imperialist art is packaged in the wrapping of 'advanced' and 'free' expression, it is embodied in the very work itself. How can we reject and refuse it without being called half-witted amateurs, or amusing but quaint provincials? I've gained more respect for John Boyle's 'provincialism' recently.

✳ To-day the basis of art 'knowledge' is market knowledge, with its trade journals and fairs. Only through an understanding of the international art market can you understand recent art. Jack Bush is a 'great' Canadian artist because he shows at the Emmerich Gallery, and has been accepted by the 'international' cultural powers, but his paintings are nothing more than cosmetics for Canadian cultural dependency.

Splurging to celebrate their success. Somehow it's a long way from struggling to 'see the world'. But times have changed. Adavnced art is now respectable and accepted. But what are we supporting by being accepted?

IT'S STILL PRIVILEGED ART

We might be able to change the intentions of our work, but how much does it change if it is still available, for example, only to cultural institutions. The shift we are talking about in our work is at present on the surface. Its form is still institutional, it's still 'privileged' art. Because without changing the institutions as well as the art we cannot change how people, or for that matter how we, relate to that art.

Our work might be critical in its relations to The Art Gallery of Ontario, The Canada Council, but unless it goes *deeper*, to the *real social structures* underlying those institutions, it simply exists as a propagator of their ideology. Cultural institutions are particularly adept at subsuming criticism as long as it doesn't challenge their basic structure. They can now absorb our so-called change without changing themselves. In fact, contemporary art seems to function in exactly this way. It not only reproduces our present social hierarchy but strengthens that order by institutionalizing so-called 'radical' forms. By reducing them to ineffectual consumer items, it increases its own veneer of liberalism.

DIE CUT

DIE CUT